THE ANTI-RATIONALISTS

THE
ANTI-RATIONALISTS

edited by

J.M.RICHARDS • NIKOLAUS PEVSNER

UNIVERSITY OF TORONTO PRESS

ISBN 0 8020 1955 2 Microfiche ISBN 0 8020 02994

First published in Canada and the United States
by University of Toronto Press, Toronto and Buffalo

© Architectural Press Ltd 1973

Printed in England by Balding + Mansell Ltd, Wisbech, Cambs.

Contents

Photographic acknowledgements

The figures given below refer to illustration numbers within each chapter.

Introduction: 2 L'Architecture d'Aujourd'hui; 3 The Studio September 1893.

Hector Guimard: 1, 2, 3, 6, 7, 8, 16, 18, 19, 20, 22, 23, 24 Sherban Cantacuzino; 4 By kind permission of Alain Blondel; 5 Courtesy of the Courtauld Institute; 9, 12, 17 Casabella; 10, 11 Stan Riesnyc; 13, 14, 25 Laurent Sully Jaulmes; 15 Courtesy of the Cooper-Hewitt Museum of Design, Smithsonian Institution; 21 Emilio Colombo/Casabella; 26 Courtesy of the Museum of Modern Art, New York.

Art Nouveau in Italy: 1, 2, 4, 5, 6, 7, 8, 9, 10, 11, 12, 13, 20, 22, 30, 31, 32, 33, 34 35, 36 Manfredi Nicoletti; 18, 21 C. V. Meeks, 'Italian Architecture 1750–1914' Yale University Press 1966; 15, 19, 23, 26, 27, 29 Casabella; 14 Fototecnica Fortunati; 17, 24, 25, 28 Carla de Benedetti.

Berenguer: 2, 4, 5, 6, 7, 8, 9, 12 F. Catalaná Roca; 3, 13 Friends of Gaudí Photo Archive.

Luis Domènech: 1 Oriol Bohigas; 2, 15, 17 Maspons and Ubiña; 3, 4, 5, 6, 9, 10 F. Catalaná Roca; 7, 8, 11 Studio Pomes; 14 Courtesy of the Barcelona Historical Archives; 12, 13, 16 Foto Mas.

Wagner and the Vienna School: 1, 2, 3, 5, 6, 7, 8, 9, 10, 11, 12, 17 Courtesy of the City of Vienna Historical Museum; 13, 15 Rudolph Stepanek; 14 Bruno Reiffenstein.

Ödön Lechner: 1, 2, 3, 4, 6, 7, 8, 9, 10, 11, 12 Ferenc Vamos; 5 Mezö Sándor.

Aladár Árkay: 1–9 Balazs Dercsenyi.

Bohemian Cubism: 1, 2, 3, 5, 7, 9 Taras Kuščynskyj; 6 K. Kotiková.

Mackmurdo Gleanings: 1–15 Edward Pond.

The Early Works of Mackintosh: 1–32 Courtesy of The Architectural Review.

Mackintosh and Vienna: 1–6 Eduard F. Sekler.

The Soft Jewellery of Art Nouveau: 1–13 H. de Burgh Galwey/The Architectural Review.

Liberty Metalwork: 1–8 Courtesy of the Victoria and Albert Museum.

Art Nouveau in Essex: 1, 2, 4, 7, 8, 9, 10 Eric de Maré/The Architectural Review; 3, 5, 6, 11 John Malton/The Architectural Review.

Watts Chapel: 1, 2, 3, 8, 9, 10, 11 Eric de Maré/The Architectural Review; 4, 5, 6, 7 John Furnival/The Architectural Review.

The Black Friar: 1–10 Eric de Maré/The Architectural Review.

The Glass Paradise: 1 Oscar Kokoschka; 2, 3, 4 Bruno Taut.

Poelzig: 1, 2, 3, 4, 6, 7, 8, 9, 10, 11, 12, 13, 14 Julius Posener; 5 Courtesy of The Royal Institute of British Architects.

Nine Swallows No Summer: 1–11 Courtesy of The Architectural Review.

A number of the chapters in this book originally appeared in *The Architectural Review,* as follows: Berenguer, December 1964; Luis Domenech, December 1967; Ödön Lechner, July 1967; Aladár Árkay, March 1968; Bohemian Cubism, March 1966; Mackmurdo Gleanings, December 1960; The Early Work of Mackintosh, November 1968; Mackintosh and Vienna, December 1968; The Soft Jewellery of Art Nouveau, May 1962; Liberty Metalwork, February 1963; Art Nouveau in Essex, August–September 1959; Watts Chapel, September 1961; The Black Friar, November 1964; The Glass Paradise, February 1959; Poelzig, June 1963; Nine Swallows – No Summer, May 1942. Hector Guimard originally appeared (in Japanese) in *Architecture and Urbanism,* September 1971. The remaining chapters have been specially written and appear here for the first time.

INTRODUCTION

by Nikolaus Pevsner

In 1936 Faber & Faber published a book I had written. It was called *Pioneers of the Modern Movement, from William Morris to Walter Gropius*. The edition was not big, and it sold slowly. Early in the war it was sold out. In 1949 the Museum of Modern Art in New York suggested a reprint now to be called *Pioneers of Modern Design*. As far as I know those in favour were Philip Johnson, Edgar Kaufmann, Henry-Russell Hitchcock and Herwin Schaefer. Sales improved, and in 1960 Penguin Books took it on. In the next ten years four Penguin editions came out. The book has now had a life of thirty-five years – over a third of a century. So it is time for detached criticism, including self-criticism.

The book was originally called *Pioneers of the Modern Movement*; for there was then a Modern Movement, and I was of it, even if not as much as Sigfried Giedion. But a believer I certainly was. The dithyrambic last pages of the book in its original form prove that. This end was an *hommage à* Gropius. The start of the book was my *hommage à* Morris. Both of them, I might say, mean as much to me now as they meant then. The start, being about Morris, was violently anti-Victorian: 'profound artistic dishonesty', 'practically almost all industrial art bristled with atrocious vulgarity', 'this deplorable state of affairs', 'sham materials and sham techniques' and so on.

In fact, however, the book did not start with Morris. Chapter Five of a total of seven chapters took the story back to the users of iron for structural purposes: the factory builders of 1796 and after, the bridge builders of 1777 and after, the builders of iron façades of about 1850 and so to Viollet-le-Duc's *Entretiens* of 1863–72 and to skyscrapers and the Eiffel Tower. At that moment, i.e. about 1890, the Morris line and the iron line began to run parallel – soon to merge. These two events were the subject of Chapters Six and Seven.

But in the middle of the book was Chapter Four, and that was called Art Nouveau. That chapter must have helped a good deal to keep the book in public favour over the last ten or twelve years, and it is true that a summary of Art Nouveau was a new thing in 1936, at least for English-reading readers. In Germany my friend Ernest Michalski had taken up Art Nouveau as early as 1925 and Fritz Schmalenbach in 1935. But my chapter was the product of the historian's curiosity, not of the *aficionado's* passion. Here are a few passages from the edition of 1936 (in which Gaudí was not mentioned – in 1949 he had become a long footnote): 'The one lasting merit of Art Nouveau is its determined attitude in the face of all conventions. Art Nouveau is the "Transitional Style" between "Historicism" and the Modern Movement. It was not the only way of transition; later we shall see another way. But Art Nouveau deserves the greatest credit for the revival of handicraft and applied art on the Continent. What Morris had done for England, was done (under his influence) by the leaders of Art Nouveau for Belgium, Germany, France. So its effects ran parallel with those of the Arts and Crafts in England, in spite of the fact that the representatives of the Arts and Crafts loathed Art Nouveau and regarded it as the principal obstacle to a complete victory of their ideas and as fatal to all sound art. "The decorative illness known as l'Art Nouveau", is what Walter Crane says. Undoubtedly the Arts and Crafts, in fighting for honesty of work and simplicity of form, fought for higher moral values than Art Nouveau.'

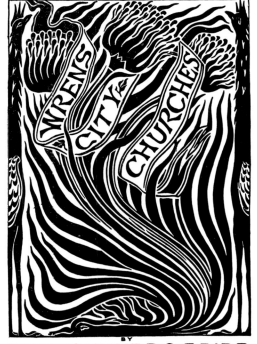

1. Mackmurdo's title-page for his book on Wren's City churches. Its date, 1883, makes it the earliest example of Art Nouveau.

1

What must be remembered of this is anti-convention – yes; anti-historicism – yes; but the higher moral values lacking. They are honesty and simplicity. Obviously I could not catch Gaudí with that bait. But I could catch Mackintosh, on whom I lectured in Glasgow, I think in 1935, with much local head-shaking. So here is a problem, and it is not only one for my Pioneers, but one for this book as well.

This book, which Sir James Richards and I have jointly compiled, is called *The Anti-Rationalists*. It consists of papers published in *The Architectural Review* between 1959 and 1968, except for No. 6, which is a very abridged version of Otto Antonia Graf's *Die vergessene Wagnerschule*, Vienna (1969), No. 3 (by Manfredi Nicoletti), written specially for this book, No. 2 (by Sherban Cantacuzino), previously published in Japan and No. 20 published thirty years ago in *The Architectural Review*.

This sequence of papers covers the same span of time as my own *Pioneers*, but it places all accents of acclaim contrariwise. My book began with the attack against Victorianism by Morris and the men of the Arts and Crafts, Webb, Shaw, Lethaby. It continued with attacks on Art Nouveau (qualified, it is true) by the men of the Arts and Crafts and the pioneers proper, and it ended with the victory of these pioneers, leaving the sequel unwritten, which would have been the brief interlude of Expressionism capable of luring even Gropius and Mies from their straight and narrow road (Gropius: Monument to the March Victims, 1921; Mies: Liebknecht and Luxemburg Monument, 1926). But the fireworks of Expressionism burned themselves out even more rapidly than those of Art Nouveau, and the Millenium dawned, i.e. what the Americans called the International Modern.

Except that Ronchamp and Chandigarh, Oscar Niemeyer and Kenzo Tange, Mr. Lasdun and Mr. Stirling are modern and internationally recognised – yet they are not the Moderns of my Pioneers. Their pre-history goes like this. The High Victorians after transitional years replaced Georgian boredom. They brought back individualism, plastic and sculptural values, picturesqueness (which includes asymmetry) and also fantasy. Morris, Ruskin before him and the Arts and Crafts after him were spoil-sports, but out of what was best in Morris and the Arts and Crafts Art Nouveau could evolve, individualistic again, plastic again, fantastic again. But then, with Wright, Perret and Garnier, Loos and Hoffmann, Behrens and Gropius my pioneers triumphed, or seemed to triumph.

However, in the years after the Second World War Expressionism rushed back, and individualism, and with them drama such had never existed in architecture since Guarini, Vittone, the Asam Brothers and later still Boullée and Ledoux. And so to end with: Down with International Modern – the boredom of Mies, as Charles Jencks says and feels – and up with Ronchamp.

This is the system of the co-ordinates of the new anti-rationalism. Within it I shall now embark on a conducted tour in my order of papers, not that adopted by Richards and myself for other (and good) reasons in the book.

Mackmurdo must start the cavalcade, even if Mr. Pond's are only gleanings, because he as early as in the years 1883–6 started Art Nouveau and at once showed a way firmly to contain it. The curves of this title-page of the Wren book, evolved from certain Morris and Burne-Jones details are Art Nouveau without any provisos or qualifications, but the exhibition-stand of 1886 (see page 111) provides a slender framework of uprights and horizontals which does not allow licentious serpentines to do what true Art Nouveau addicts would allow them[1] – the addicts being Horta and Guimard,[2] Belgian and Frenchman. Horta[3] born in 1861 could inspire the beginnings of Guimard, born in 1867; for Horta's famous staircase in No. 12 rue Paul-Emile Janson was ready in 1893, one year before Guimard's Château Béranger (see page 14) was started. They are both mature, i.e. *outré* Art Nouveau, but in one immensely important way they point beyond Art Nouveau, fortified by one of Europe's greatest High Victorians. Viollet-le-Duc in his *Entretiens* of 1863–72 had recognised that the structural use of iron offered the nineteenth century possibilities of a new style inspired by the last indigenous style

before the Renaissance gave in to the worship of alien gods. The Gothic style was indigenous and a style of skeleton and infill. So would an iron style have to be. Horta and Guimard were enamoured of the ornamental possibilties of iron, but they accepted its structural possibilities as well. In this regard their position is similar to Mackmurdo's. Professor Posener, in a brilliant paper, has recently written this of Horta's Maison du Peuple of 1896–99:[4]

"The masters of Art Nouveau, Horta in particular, appear to have best understood the nature of iron as a building material. In his buildings Horta made appear the essential quality of iron: that it is able to transmit great stresses in members of very small section; he wished to shape those members; and he did it according to the nature of iron he had so clearly grasped; but also as though the members of his metal structures were produced by nature: he moulded them, giving them the shape of a very slender bone or a plant stalk. This analogy to nature, he felt, might help to reconcile those slender supports to our inborn sense of what is solid, a sense which to him also appeared to be rooted in our very nature and, therefore, permanent. In the Maison du Peuple in Brussels he went further than any other architect prior to Mies van der Rohe in exposing to view the members of the metal skeleton, the profiles used exhibiting the usual riveted double T section. But the Maison du Peuple was an exception even in Art Nouveau; nor did Horta, even in this building, completely abandon his idea of shaping steel bars and trellised girders 'organically'."

This applies to Guimard as well who, incidentally, as Sherban Cantacuzino tells us, in 1898 recognised his debt to Viollet-le-Duc and Horta, and a few years later mentioned his awareness of Crane, Ruskin and Morris. For Guimard was a designer of furniture and light fittings as well as an architect. Guimard comes closest to Horta in his Humbert de Romans Concert Hall (page 19) of 1897–1901 (demolished four years later) and then in his celebrated *Métro* stations of 1900 – uncontained, incontinent Art Nouveau in iron, glass and ceramic – the new materials for the new means of communication.

1900 is the creative year for the *Métro*, 1897–8 for the Vienna *Stadtbahn*. So to

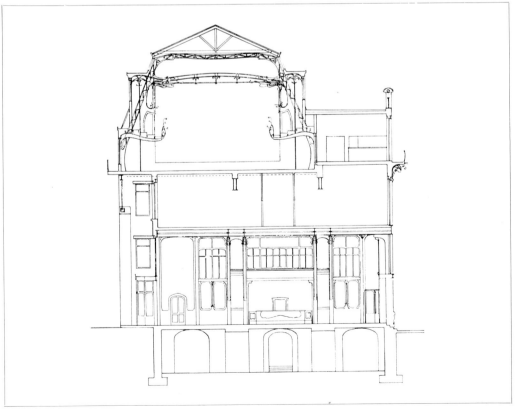

2. Section through Horta's Maison du Peuple.
in Brussels (1896–99)

Otto Wagner and yet a different combination of Art Nouveau and anti-Art Nouveau. Wagner[5] a full twenty years older than Horta, ten than Mackmurdo, said in a lecture in 1894: "Nothing that is not practical can be beautiful" and "All modern forms must be in harmony with . . . the new requirements of our time". The most significant *Stadtbahn* stations, i.e. Breitensee (1897 – Unter-Döbling 1895–6 not yet), Hofpavillon Schönbrunn (1898) and Karlsplatz (1898–9), are largely, or at least pointedly, using glass and iron and are cubic in general shape. But there are also a curious dome and curious vaults, and bold flat vegetable ornament. Wagner started with devotion to the Austrian Baroque; he ended, in the Postal Savings Bank of 1904–6, an out and out pioneer in my sense.

Olbrich and Hoffmann were his most famous pupils. But Dr. O. A. Graf has discovered, or at any rate made known, a whole forgotten *Wagnerschule* – dozens of names, and quite a number of remarkable designs. They reproduce the master's mannerisms and also the master's ambiguity – cubic shapes with stressed verticals and horizontals, especially for instance pergolas, bold flat vegetable ornament, weird domes and vaults, but also glass walls for stores and such twentieth-century tasks as stadia and even airports – one as early as 1904 (all shown on pages 85–96). Olbrich's Secession Building of 1898 must have inspired the *Schule* as much as Wagner's own work, and so must Hoffmann's.

But Hoffmann brings up the most fascinating historian's problem of Art Nouveau and anti-Art Nouveau – the role of Mackintosh, whose group was invited by the Secession to show in its eighth exhibition in the autumn and early winter 1900. Mackintosh is for Art Nouveau in the north what Gaudí is in the south – the man of genius and of enigmas. Anything to solve their yet unsolved problems must be welcome, and here in this book is David Walker who for the first time seriously considers the various Scottish and English buildings which must have interested Mackintosh before he found his own personal style.

But whatever else contributed to the formation of this style, Mackmurdo must have played a decisive part, though not even Mr. Walker knows quite how. His

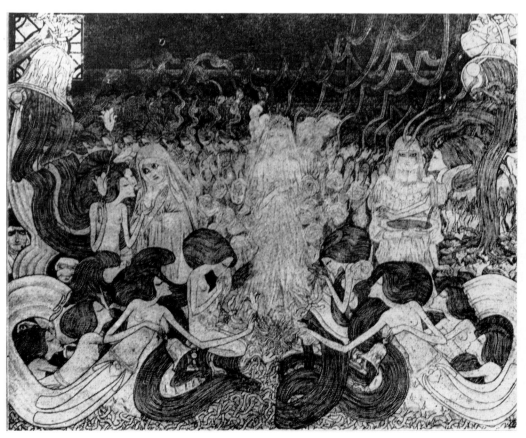

3. Toorop's 'The Three Brides', illustrated in The Studio *in September 1893.*

illustration 10 and Professor Howarth's plate 7 in his big monograph, if they are really of 1893, may just allow for influence from Toorop's *Three Brides* (reproduced here from *The Studio*, I, 1893, p. 247), but what points indubitably to Mackmurdo is the way the emaciated Toorop figures are set in slender panels. The unmitigated verticals and horizontals and the curvaceous infill panels had been Mackmurdo's domain, though Mackintosh added complexity and sophistication, not least in his exquisite colour-schemes. Now, to return to Hoffmann, he had discovered the spice of the grid in 1900 and was predisposed to the Mackintoshes when they came. The new evidence which Dr. Sekler offers on Mackintosh and Vienna is welcome and important.[6]

Influence from Vienna on Mackintosh on the other hand has never been seriously proposed nor is it at all likely. But Vienna did inspire, to the south and to the east. Manfredo Nicoletti's paper on Italy in the nineteenth century, culminating in d'Aronco and Sommaruga, is timely because the chapter in the late Carroll Meeks's *Italian Architecture, 1750–1914* (Yale U.P. 1966) is not as finished as Meeks would have made it, had he lived to see its publication. The pre-history of neo-Baroque links Italy to Vienna, and the Viennese influence in terms of Art Nouveau is total.[7] D'Aronco's dome of the main building of the Turin Exhibition of 1902 is inconceivable without Wagner's design for the Academy and without the Hofpavillon, both of 1898.

Easterly influence of the Secession helps to explain Ödön Lechner of Budapest. But the web of his architectural and ornamental patterns is more complicated: Victorian Gothic, Anglo-Indian decoration, Hungarian folk-art, as the late Ferenc Vamos explains. But Lechner was a personal friend of Wagner, and in any case his *chef d'oeuvre*, the Postal Savings Bank of 1900–01, is essentially original. What is most delightful is the undulating top fringe with infill of strongly coloured piro-granite. If a parallel – not a source – is to be proposed, it would have to be Gaudí's long curvaceous seat around the large open space of the Parque Güell. The date is exactly the same.

This book has no paper on Gaudí. The market must by now be saturated. In my *Pioneers* I listed six books of 1948–58 and six of 1960–6. Since then the following have come out: C. Martinell: *Gaudí – Su vida, su teoria, su obra*. Barcelona, 1967; J. Perucha: *Gaudí, an Architecture of Anticipation*. Barcelona, 1967; J. L. Sert, J. Gomis and J. Prats Valles: *Cripta de la Colonia Güell de A. Gaudí*. Barcelona, 1968; L. V. Masini: *Gaudí*. Florence, 1969; R. Descharnes and C Prévost: *Gaudí the Visionary*. Lausanne, 1969.

George Collins's (New York, 1960) is in my opinion still the best. But what was needed for English readers was information and illustrations of the work of other Catalans, two of them at least of considerable stature: Domenech born in 1850 (Gaudí's date of birth is 1852) and Berenguer born in 1866. The authors of the two papers in this book are partners in a Barcelona architectural practice.[8] Berenguer being younger might be called *Gaudíschule* – witness especially his iron-work; Domenech is a Catalan master in his own right. His Palace of Catalan Music ought to be visited as Gaudí's buildings are visited. It dates from 1905 to 1908.

1905 is a late date for this kind of building. Its nearest neighbour beyond the Pyrenees is probably Berlage's Amsterdam Exchange, and this dates from 1898 to 1903. These were the years in England of the acme of the Arts and Crafts in, say, Lethaby, soon to be followed by the collapse into domestic neo-Georgian and the Edwardian Classical-Re-Revival. The development of a new twentieth-century style was left to the Continent and America, that is to my pioneers. But there were some minor ones in England as well, and I tried, thirty years ago, to gather them in: Creswell of Honeywood fame, Edgar Wood who at last a few years ago got a paper all to himself,[9] the early users of exposed concrete grid-wise, Sir John Burnet for his Kodak Building in Kingsway and, as a postscript, Roger Fry's own

house near Guildford. Though they certainly cannot be called 'anti-rationalist' they come in aptly here as an unexpected episode in this mainly anti-rationalist period.

The years in which England did Art Nouveau rather than Arts and Crafts were those between 1895 and 1905, and it is to be found in decoration, not architecture. That Art Nouveau is 'essentially a style of ornament' Dr. Schmutzler decreed in his beautiful book *Art Nouveau-Jugendstil* in 1962 (English, London 1964). Robert Melville in introducing Art Nouveau jewellery enlarges on this theme, making admirable use of his sensitive eye and his suggestive pen. Deliquescent, sensuous, fleshy are only a few of his characterising adjectives. He applies them to jewellery not only from Britain; Grasset, van de Velde, Tiffany, Fabergé are illustrated, and rightly the article ends with a glance forward to Schmidt-Rottluff's Expressionism.

Of the English, Ashbee is included, though Ashbee belonged emphatically to the Arts and Crafts side of things. There we have again the Mackmurdo and the Mackintosh problem. Shirley Bury has a thoughtful paragraph on Ashbee in her paper on Liberty's Cymric silver and Tudric pewter. Cymric – the Celtic name reminds one of the Glasgow Group's Gaelic interest, and Jesse King, member of the group, worked indeed for Liberty about 1905. Cymric started in 1899.

Celtic is certainly one of the ingredients of the giddy mixture that is Mrs. Mary Watts's chapel at Compton in Surrey, designed and built by her in 1896, when her husband was nearly eighty. The other ingredients are Oriental – from Egypt to India – and some Romanesque. But the result is unquestionably Art Nouveau, though of a wholly individual kind. That distinguishes the Compton Chapel from the Great Warley Church and, if the rumbustious can stand up to the religious, the Black Friar pub in London.

The architect of Great Warley is Townsend of the Whitechapel Gallery and the Horniman Museum, but they are both more Art Nouveau than Great Warley. Great Warley John Malton calls 'Richardson Suburban'. I had a few years before, in introducing the church,[10] added Voysey's name. What makes Great Warley a shrine of Art Nouveau is William Reynolds-Stephens's decoration and equipment. Similarly what makes the Black Friar, by the unknown architect H. Fuller Clark, a prime container of the Art Nouveau as well is Clark's interiors, not his exterior, and Henry Poole's sculptural decorations. The Black Friar dates from about 1905.

Now in exactly that year *Die Brücke* was founded at Dresden by Heckel, Kirchner and Schmidt-Rottluff, and Expressionism was upon Germany – Expressionism in painting (and of course literature), but not yet in architecture. Schmidt-Rottluff I have already mentioned. In 1906 Nolde was invited to join. Nolde was the eldest of the group by far. He was born in 1867.

But yet another four years older was Max Scheerbart who died as early as 1914, and he, as Reyner Banham in one of his inimitable essays makes crystal-clear, is the father of glass architecture in its Expressionist aspects. In the year in which Scheerbart died Bruno Taut built his memorable glass pavilion at the Cologne Werkbund Exhibition, the exhibition better known for Gropius's so called model factory and van de Velde's theatre. But Taut's pavilion with its 'primitive geodesic dome of steel and glass, raised on a drum of glass bricks (and) containing staircases with glass treads and glass risers' deserves all Professor Banham's enthusiasm. Scheerbart dedicated his book, *Glass Architecture,* published in the year of his death, to Taut; Taut dedicated his pavilion to Scheerbart.

The Scheerbart-Taut story is one of the strangest of the bridge stories between the literary Expressionism of the early years of the century and the architectural Expressionism of after the First World War. For while the glass pavilion can no doubt be looked at in terms of my pioneers – though I didn't – Taut's *Frühlicht* and his *Stadtkrone* and the way he had respectable old houses at Magdeburg painted in strong colours and jagged forms – all this, and they are all events of 1919–22 – is high-tension Expressionism.[11]

Two other curious bridges linking Art Nouveau to Expressionism are the

subjects of shorter articles in this book: the Hungarian Aladár Árkay who moved from the Vienna Secession to the International Modern leaving on his way so delightful a monument as the portal of the Budapest Calvinist Church, wholly Secession and yet as late as 1911–13, and the Czechs Chochol, Gocar and one or two others who in exactly the same years, and long before Taut's Magdeburg spree, made normal houses Expressionist by setting their façades into Cubistic canted forward and backward motions.

But the most interesting case to me of these bridgings, and hence the end of my conducted tour, is Poelzig's case as set out personally, warmly and wisely by Professor Posener of Berlin, Paris, Jerusalem, Kuala Lumpur and again Berlin.[12] For Poelzig, as Professor Posener demonstrates, started as one of my pioneers with a water-tower and an office building of 1911 and a factory of 1911–12 – two of them actually illustrated in the first edition of *Pioneers* – moved on to the 'great spatial fantasies' (as Professor Posener calls them), the House of Friendship for Istanbul of 1916 and the designs for the Salzburg Festival Theatre of 1920–22, both of them of boundless Expressionism, actually built one of the two major monuments of Expressionism, the Grosses Schauspielhaus in Berlin of 1919 – Mendelsohn's Einstein Tower is the other – and then, like Mendelsohn, sailed into the port of the International Modern with the IG Farben Headquarters in Frankfurt and the Broadcasting Headquarters in Berlin of 1928–30.

Complex were the developments of the architects and intricate was the interplay of trends in the third of a century with which this book deals. Twenty authors in twenty papers have, it seems to me, done justice to that variety.

NOTES

[1] Gillian Naylor in her excellent *The Arts and Crafts Movement*, London 1971, has six pages on Mackmurdo and other groups of pages on Morris, Crane, Ashbee; also on many others and in the end Lethaby. Elizabeth Aslin's equally excellent *The Aesthetic Movement*, London 1969, has as its sub-title Prelude to Art Nouveau. So one will find Talbert, Godwin and Japanism, Lewis F. Day, Crane, Thomas Jekyll, Whistler's Peacock Room and of course also many others.

[2] Sherban Cantacuzino's chapter on Guimard first appeared, in February 1972, in a Japanese translation, in the form of an article in the Tokyo magazine 'Architecture and Urbanism' As published there, with the text in Japanese, it is probably the most comprehensively illustrated study of Guimard available anywhere.

[3] On Horta the most recent literature is F. Borsi and P. Portoghesi, *Victor Horta*, Edizione del Tritone, Rome, 1969.

[4] 'Architecture ou Construction', *L'Architecture d'aujourd'hui*, 158 1971, 39–47. I am grateful to Professor Posener for permitting me to make this quotation in its original English (or was the original German?).

[5] C. H. Geretsegger and M. Peintner: *Otto Wagner*, Salzburg 1964; an English translation was published in 1970. In the same year Adriana Giusti Baculo's *Otto Wagner* came out in Naples. One may also wish to refer to R. Waissenberger: *Die Wiener Secession*, Vienna and Munich 1971 and the catalogue of the Secession exhibition at the Royal Academy in London, January to March 1971.

[6] See also E. Sekler: 'Art Nouveau Bergerhöhe', *The Architectural Review*, CXLIX, 1971, 75–6, on a Hoffmann house of 1899, complete with its interior fitments, and all still pre-'Quadratl'. But the 'Quadratl' are prominently present in an illustration in *Ver Sacrum*, *III*, 1900, 68 which is reproduced in S. Tschudi Madsen: *Sources of Art Nouveau*, Oslo 1956, 401, erroneously captioned 1898.

[7] Rossana Bossaglia: *Il Liberty in Italia* (Milan, 1968) is totally unhelpful, inflated in its literary style and never coming to grips with the multitude of sources of the *Stile Liberty*.

[8] In Spanish the most recent general book is O. Bohigas and L. Pomés: *Arquitectura Modernista*, Barcelona 1968, splendidly presented. See also A. Cirici Pellicer: *1900 in Barcelona (Art Nouveau)*. On Domenech there is a double issue of *Cuadernos de Arquitectura* (C 11–C111, 1963). Also recent articles on two other Catalans: Raspall born in 1877 (O. Bohigas *Manuel Joaquin Raspall*, 1877–1937 'Cuadernos de Arquitectura' Barcelona, no, 44, 1961) and Jujol born in 1879 (J. M. Jujol: *Hogar y Arquitectura*, September to October 1969).

[9] J. H. G. Archer: 'Edgar Wood, 1860–1935' *Transactions of the Lancashire and Cheshire Antiquarian Society*, LXXIII–LXXIV, 1963–4, 153–187.

[10] *The Buildings of England;* Essex, first edition 1954, 196, where I gave it only the dedication date 1904, a mistake which in the revised second edition was not corrected.

[11] One will use now the Taut chapter in D. Sharp: *Modern Architecture and Expressionism*, London 1966. The *Frühlicht* has been reprinted in the Ullstein Bauwelt Fundamente (Berlin, Frankfurt

and Vienna 1963), and an exhibition of Visionary Architecture in the Circle of Taut, 1919–20, was held at the Academy of Art in Berlin and at Leverkusen under the title *Die gläserne Kette* in 1964.

[12] Recently Professor Posener has edited Poelzig's writings and buildings: Hans Poelzig; *Gesammelte Schriften und Werke,* Berlin, 1970. Theodor Heuss, the first president of federal Germany, was a friend of Poelzig and wrote *Poelzig, ein Lebensbild,* Tübingen 1955.

HECTOR GUIMARD

by Sherban Cantacuzino

An account of the career, achievements and influence of the French architect who is best known for his Paris Métro station entrances and who shares with Victor Horta and Henri van de Velde the leading place among the exponents of the Art Nouveau movement on the Continent of Europe.

Few of the travellers who arrive at the central Paris air terminal, the Invalides station, realise that they are standing on the site of an exhibition pavilion which marked the apogee both of a style and of a remarkable career. *La maison de l'Art Nouveau* was Samuel Bing's brilliant contribution to the 1900 Exhibition. The single-storey building was decorated externally by Georges de Feure with painted panels and a cornice of giant orchids in high relief and of extravagant size, but not markedly Art Nouveau in style. The interior was a different matter with its vintage handcarved Art Nouveau furniture by de Feure, Edward Colonna and Eugène Gaillard. These artists were each given separate rooms to decorate and furnish, and produced, according to contemporary accounts, ensembles of exquisite unity[1] some of which were later reassembled at Bing's shop in the rue de Provence. Bing, who was by then 62 years old (he died five years later), had been a key figure in the artistic life of Paris ever since the end of the Franco-Prussian War[2] (1871). It was Bing, more than any other single person, who disseminated the seeds of Japanese culture and art, without which Art Nouveau would have been impossible. When Hector Guimard was born in 1867 the established order, which had long been disintegrating in the face of Romanticism, was about to be challenged for a second time. This challenge appeared in various forms, some of which must be examined before turning to Guimard himself.

Joachim's dictum *einsam aber frei* (alone but free) neatly summed up that reaction, known as Romanticism, to the seventeenth- and eighteenth-century belief in a mechanistically ordered universe. 'The arena of literature', wrote Edmund Wilson, 'has been transferred from the universe conceived as a machine, from Society conceived as an organisation, to the individual soul'.[3] But whereas in German music this reaction was represented by a rejection of traditional structure – of sonata form, for example – in French poetry the metrics remained the same and only the expression changed. The real break-up of form had to wait for Stéphane Mallarmé (1842–98) and the Symbolists, whose inspiration was nourished to a large extent from the literature of the Anglo-Saxon countries where eighteenth-century Rationalism and the concomitant classical tradition in the arts had never rooted themselves as deeply as in France. In painting, too, Delacroix's and Géricault's work falls by and large into a well-established older tradition. We have to wait for Manet and the Impressionists in the 'sixties for a truly new visual experience, and for the Symbolists Moreau and Redon in the 'seventies and 'eighties for an art of 'ideas and mental images'.[4] Just as the Symbolist poets drew their inspiration from their Romantic precursors in England and America, so the Impressionists looked to Constable and to Turner, and the Symbolists to Blake and to Samuel Palmer, as their spiritual fathers. Never before had the arts come so close to one another. In Wagner's music-dramas the recurring *leitmotifs* can be seen either as images or as literary allusions. In Debussy's *Pélléas et Mélisande* no single ingredient – voices, orchestra, stage scenery – stands out, but all are fused to produce a series of images in sound. Symbolist poetry, which was deeply influenced by Wagner's music, abnegates the objective and the rational, and seeks to communicate the poet's unique feelings by unique means – a succession of very private images which were supposed to attain the condition of music.

In such an artistic climate it is hardly surprising to find a revival in the applied

arts by which alone architectural space could be given unity as well as elegance. Madsen has observed how the two most important characteristics of Art Nouveau the love of fine craftsmanship and the interest in visible structure, owe much to William Morris and to the Gothic Revival in England.[5] French craftsmanship, however, tended to be inspired by the eighteenth-century Rococo style, and in this context it should not be forgotten that both Edmond de Goncourt and the Sichel brothers were highly discriminating collectors of French eighteenth-century art before turning to Japanese art in the early 'seventies. Manifestations of the revival in the applied arts were many. In 1891 applied art and painting were exhibited side by side for the first time at the *Salon du Champ de Mars*. In 1892 Octave Uzanne founded *l'Art et l'Idée*, a periodical in which decorative art was given a central position; and in 1895 five artists and craftsmen formed the group *Les Cinq* with the intention of holding yearly exhibitions together, were joined the following year by Charles Plumet, an architect and furniture designer, and established themselves at the *Galerie des Artistes Modernes* in the rue Vavin. This, together with Bing's new shop *l'Art Nouveau*[6] in the rue de Provence (opened in 1898) and Julius Meier-Graefe's *la Maison Moderne* (also opened in 1898), provided the three centres where the most advanced applied art could be seen and bought. But perhaps the most remarkable manifestation of all was the *École de Nancy*, which

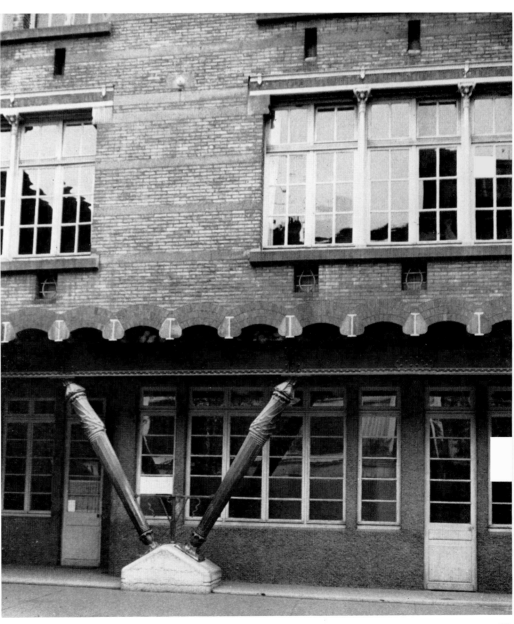

1. *The École du Sacré-Coeur, 1895. The façade with its exposed structure of cast iron is an adaption of a drawing from Viollet-le-Duc's* Entretiens. *The ground floor was originally open and provided both covered recreation space and access to the floors above.*

was active from the early 'nineties and numbered among its artist-craftsmen Louis Majorelle and Emile Gallé. A common characteristic of many of the personalities of this period is their ability to tackle several crafts. Thus Lalique started with jewellery but later turned to glass; Gallé made ceramics, glass and furniture; Majorelle was a designer of forged iron as well as furniture; and Guimard, as we shall see, stood apart from his architect-contemporaries in being able to forge or cast iron, mould ceramics and design furniture with equal brilliance.

Another challenge to the disintegrating order was the influx of Japanese art which began even before the Franco-Prussian War. Chinese and other Oriental influences had been absorbed by Western European art for over 100 years, but making no more than a superficial decorative impact. When after 200 years, provoked by the aggressive colonialism of the Great Powers, Japan finally emerged from behind her 'iron curtain', Europe was on the threshold of her greatest artistic revolution. The impact of Japanese art on Impressionism is too well known to need restating. In the graphic arts of poster design, book illustration and lettering the Japanese influence involved, as Madsen says, 'a radical break with traditional nineteenth-century European design, so that text and image now fused together to form an artistic whole, as formerly seen only in Blake's books and in medieval illuminated manuscripts.'[7] In applied art, and so indirectly in architecture, the Japanese influence was responsible for the entirely new conception of asymmetry so beloved of Art Nouveau artists. In Guimard's opus this tendency is seen most clearly in the entrance gate of the Castel Béranger of 1897 and in some of the furniture from the same period such as the settee of 1898. The same settee also reveals another Japanese trait which Madsen calls the *amor vacui* replacing the *horror vacui* of Historicism.[8] The sides and front have plain wood panels while the decoration in the form of free mouldings is restricted to the frame.

The Japanese exhibited for the first time at the World Exhibition in London in 1862, and in the same year Madame de Soye, who had lived some time in Japan, opened her oriental shop in the rue de Rivoli. In London the architect E. W. Godwin furnished his house in the Japanese manner, and Whistler began painting Japanese figures and objects. In the early 'seventies begins the long association between Edmond de Goncourt and Bing which led, amongst other things to de Goncourt's published studies of Utamaro and Hokusai. Bing was buying in Japan in 1875 and showed the best of his new collection at the 1878 exhibition. That year also saw the beginning of a spate of books on Japanese culture[9] which culminated ten years later with the launching of Bing's *Japon Artistique*. This monthly magazine in three languages, which ran to 36 issues, ceased publication in 1891 as Bing was about to leave for another long journey, this time to America as well as Japan. In the same year Guimard completed his first known building, the private house at no. 34 rue Boileau. We have no evidence that Guimard was directly influenced by Japanese art, and his early work does not suggest it. Allusions may be found in his applied art, especially his ironwork, but these are probably due to the influence of secondary sources such as Grasset's *La Plante et Ses Applications Ornementales*, which appeared in 1899, or his discovery of Horta's work in Brussels in 1895 and the latter's epigrammatic 'je laisse la fleur et la feuille, et je prends la tige.'[10]

Nor is there any evidence that Guimard ever met Bing, whose circle certainly included a number of younger men like de Feure and Brangwyn. Indeed Bing's attitude to architecture remains something of a mystery. On his return from America he published a book on American art (1895) full of perceptive architectural criticism in which he champions the work of Richardson and Sullivan. Yet in his reply to A. D. F. Hamlin's attack on Art Nouveau[11] he avoids any discussion of architecture by a deft footnote in which he maintains that architecture 'has not sufficiently acknowledged the progress of other branches of art which it should have assisted, since it had not, as leader and chief, been able to guide them by a bold initiative'.[12] This is a surprising statement to make as late as 1903 when Guimard

11

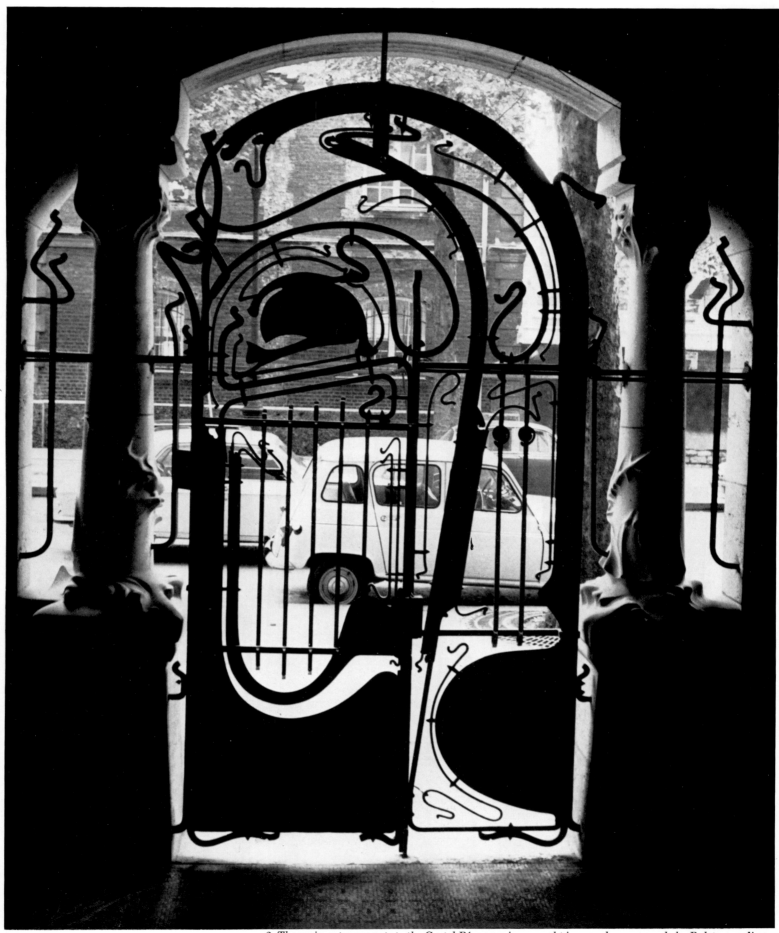

2. The main entrance gate to the Castel Béranger in wrought iron and copper made by Balet according to a drawing by Guimard dated September 23, 1896.

had already completed work as important as the Castel Béranger (1894–7), the *Métro* stations (begun 1899) and the Humbert de Romans auditorium (1900–1), and more especially when Hamlin had specifically attacked the Castel Béranger as 'a jumble of incoherent motives without grace or harmony'. The explanation may lie quite simply in Bing's advancing years and his consequent reluctance to assimilate new developments or to change his views.

It is significant that Guimard trained at the *École Nationale des Arts Décoratifs* for three years before entering the *École des Beaux Arts* in 1885, and that he left the latter in 1889, without obtaining his diploma, to work for a construction company where he could practice both as an architect and as a site craftsman.[13] Of his masters the elderly J.-A.-E. Vaudremer, who as a pupil of Blouet and Gilbert provided a link with the Neo-Classicism of the First Empire, and J.-E.-A. de Baudot – a pupil of Viollet-le-Duc and the architect of Saint Jean de Montmartre (1897-1904) – were the most interesting. That Guimard was more influenced by the second is evident from a letter he wrote to L. C. Boileau in 1898, in which he says: 'I have merely applied the theory of Viollet-le-Duc, but without allowing myself to be seduced by medieval forms.' Hitchcock has observed how de Baudot's church closely follows one of Viollet-le-Duc's projects, but in reinforced concrete instead of iron.[14] Viollet-le-Duc's writings, however, were far more influential than his buildings. His *Entretiens* in two volumes[15] was in wide circulation among architectural students during the last quarter of the century, and his advocacy of iron combined with Gothic principles of construction took a more convincing physical form in the buildings of other architects and engineers. One of the most remarkable was Jules Saulnier's Menier factory at Noisiel near Paris (1871) with its exposed iron frame, which Viollet-le-Duc mentions enthusiastically in the second volume of the *Entretiens*. Guimard must have known most of the iron buildings in Paris, especially L. C. Boileau and Gustave Eiffel's *Bon Marché* store (1876) in the rue de Sèvres, and the church of Saint-Eugène (1854–5) by his friend's father L.–A. Boileau. An even greater source of inspiration, as much for the industrialised building methods as for the form, must have been the magnificent iron and steel structures of the 1889 Exhibition when Guimard was about to set out on his architectural career – Contamin and Dutert's *Galerie des Machines* and the Eiffel Tower.

Guimard's life and work falls conveniently into three sections.[16] The first, from 1891 to 1898, notable for the undigested influence of Viollet-le-Duc and for a certain picturesque manner, culminates in the Castel Béranger, where the Art Nouveau style first appears in decorative elements. In the second and the most prolific period, from 1899 to 1914, Guimard's style matures at first to full-blooded Art Nouveau, rapidly sobering down to a Neo-Rococo or Neo-Baroque. Finally is the least productive post-war period, from 1919 to 1929, when Guimard tried unsuccessfully to keep up with the times.

Guimard's first building, no. 34 rue Boileau (1891), may have been influenced by a section of the 1889 Exhibition called *L'Histoire de l'habitation humaine*, which showed a wide selection of primitive dwellings from all over the world. The walls are red and brown brick with insets of red and blue glazed bricks, and two large arches are finished in a rough application of stone chippings and cement that imitates the weather-beaten texture of rock. The sedate symmetry of the left-hand bay seems to bear little relation to the eventful centre bay with its functionally expressive porch and sloping staircase link. More typically picturesque is the private house at no. 41 rue Chardon-Lagache (1893), now turned into a polyclinic, with its interlocking roofs, broken gables and quaint mixture of rusticated stone-work, random rubble and different kinds of brick. In contrast the façade of no. 39 boulevard Exelmans (1895) is conventional and may be accounted for by the fact that Guimard's client here was the widow of the sculptor Jean-Baptiste Carpeaux who had died twenty years earlier. But like the stepped windows of the other two examples, the large studio window on the second floor is expressive of what goes

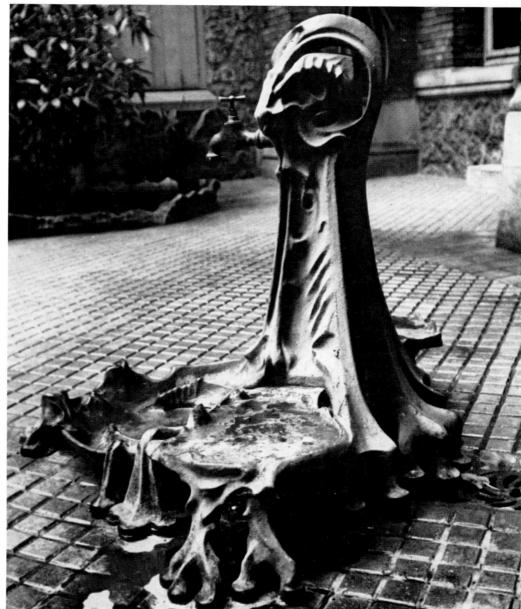

3. The cast-iron fountain in the courtyard of the Castel Béranger. The nearly abstract forms are reminiscent of water spilling over the edges. But Guimard's original tap has been replaced by a standard one.

4. The Castel Béranger, Paris, 1895–8. One of the 65 plates from the album Guimard published in 1898. It shows the main elevation to the Rue La Fontaine and the ground and first-floor plans.

5. The front corner of the Castel Béranger, with its diagonally-set bay windows which were a late addition in the development of the design.

6. No naturalistic suggestion whatever remains in the ceramic panels which decorate the walls in the vestibule of the Castel Béranger.

4

3

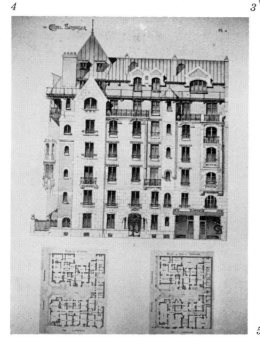

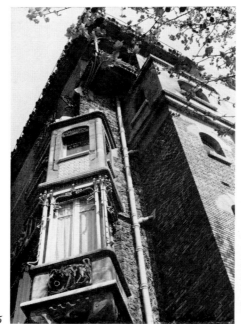

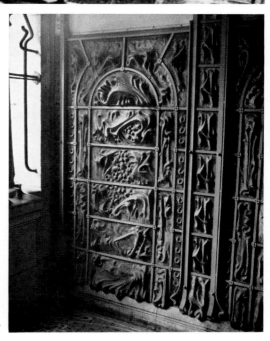

5

6

on inside and conflicts with the classicising exterior, just as the volumes of certain Frank Lloyd Wright houses conflict with the façades.[17]

By now Guimard was beginning to express his structure, and we find the lintel over the large window-opening at no. 39 boulevard Exelmans an exposed iron girder. Six months later,[18] possibly encouraged by the utilitarian nature of the job, he produced a design which proved a landmark in French architecture. The long and narrow site of the École du Sacré-Coeur in the avenue de la Frillière made Guimard stretch his building the full length on the rear boundary, raise it up on two floors and an attic, and wrap it round on three sides with a blind and monumental stone wall which rises above the lean-to roof in a parapet. All the rooms face a playground to which the ground floor, in its original open form, served as a covered extension. The front is supported on two pairs of ornamented cast-iron columns set in a V-shape on exposed concrete footings. Together with the end walls, they support a longitudinal girder which in turn carries the secondary structure – a very pretty 'cornice' of I-sections and brick arches representing the actual floor-structure of exposed iron girders and a series of small concrete vaults. In this structure Guimard adapted a drawing from the *Entretiens* and produced a better building than Viollet-le-Duc ever did. Except for the decoration on the upper part of the columns, there is no trace yet of Art Nouveau. Nevertheless the building was a decisive step in that direction. Viollet-le-Duc's interest in structure as expression anticipated both Horta and Guimard, and Madsen goes so far as to suggest that 'by replacing the Gothic foliage with leaves from his own imagination, he created a rhythm which is entirely in the spirit of Art Nouveau.'[19]

In the summer of 1894 Guimard visited England and came back with sketches of contemporary red-brick villas at Uckfield and Chislehurst, the latter including ground and first floor plans. The following year he went to Holland and Belgium where he found in Horta an equal admirer of Viollet-le-Duc. He must have seen Horta's Tassel and Frison houses in Brussels, completed respectively in 1893 and 1894, and the drawings of the *Maison du Peuple* which was then under construction. In a letter to Horta dated May 8, 1896 he asked for photographs of the Tassel house to exhibit in an international show which he was organising at the *Salon*. Horta's influence at this moment is proved by the fundamental changes Guimard made between March and October 1895 to the decorative elements of the Castel Béranger. Compare, for example, the first-floor balcony and window-arch on the side street, still in the same heavy 'medieval' style as the similar feature at no. 34 rue Boileau, with the main entrance on the rue La Fontaine with its freely carved column-bases merging into the plinth. Though vaguely reminiscent of foliage, the carving cannot be identified precisely with anything in nature, for Guimard was to come to believe that decoration should exist in its own right and that it is the more effective for being non-representational.

The Castel Béranger stands on the threshold between the representational and the non-representational in Guimard's work. The cast-iron balcony ornaments are recognisable as grotesque masks and the wall-ties are seahorses that with their pulling mouths and pushing feet actually seem to be doing the work. The fountain in the courtyard[20] on the other hand is nearly abstract, although there is a strong suggestion that the forms derive from running water spilling over the edges. No naturalistic suggestion whatever remains in the ceramic panels which decorate the walls of the entrance hall, and it is in decoration of this kind that the applied arts came nearest to music and certain kinds of poetry. Guimard's panels recall the mysterious images of Gerard de Nerval, precursor of the Symbolists, when he wrote nearly 50 years earlier 'Et comme un oeil naissant couvert par ses paupières/ Un pur esprit s'accroît sous l'écorce des pierres.'[21]

But whereas the decoration of the Castel Béranger is forward-looking, its architecture marks the culmination of Guimard's earlier picturesque style. It is also very cleverly planned about two axes, thus maintaining a degree of order within a

free romantic idiom. Along the first axis lie the entrances and staircases of the front and rear blocks, while the second runs at right angles through the courtyard which separates them. On it also lies the entrance and staircase serving the smaller flats which link the two blocks across the far end of the courtyard. Thus both axes divide the building into equal halves with three flats per floor on each side. On the right of the entrance gate in the rue La Fontaine is a large opening spanned by a plain iron girder for what was originally intended to be a shopfront but is now blocked in as part of a flat. Main and service staircases are placed back to back, and in the front block the service staircase is frankly displayed as an iron frame-and-panel structure jutting out into the courtyard from solid brickwork. To let light into the main staircase, the wall which divides it from the service staircase is pierced with glass bricks. This is one of Guimard's most effective devices which was to appear in his buildings over and over again. Koenig and Colombo maintain that it must be one of the earliest uses of glass bricks, pre-dating Perret's staircase at 5-bis rue Franklin by six years.[22] The space at the foot of the staircase has regrettably been spoiled by the insertion of a lift, which entailed the removal of a large mirror – another favourite device of Guimard's. Some idea of the effect can be obtained from the staircase of a much later apartment block, no. 18 rue Henri Heine (1926), where the mirror is still in position.

The flats themselves are astonishingly compact, with practically no waste circulation space. They were built for people of moderate income with rooms that are never large. But every flat is slightly different, and the floor below the eaves, as well as the attics which house four artists' studios, burst out with balconies, gables and dormers in a fantasy of individualism. Like the condition of the *Sacré-Coeur* school, the present excellent condition of the fabric bears witness to Guimard's technical skill and provides an interesting contrast to the early buildings of the Modern Movement twenty-five years later.

Whereas the Beaux-Arts tradition in design would automatically produce a building with a front and a back, Guimard's personal and picturesque manner enabled him to disguise this difference and to confront quite successfully the back of one block with the front of another across a courtyard. At the Castel Béranger the picturesque mode reaches its climax in the courtyard, where the variety of architectural incidents make this a stimulating space and a far cry from the contemporary light-well of somewhat similar proportions. In this context one should also note the treatment of the front corner, where at a rather late date Guimard inserted a diagonally-set bay window. His fondness for splaying corners can be seen both inside and outside the building, and may be related to certain plastic qualities in his emergent Art Nouveau style.

For Guimard the Castel Béranger clearly meant a great deal. Not only did he have his own studio there (in the front block on the ground floor, left of the entrance), but he also published in 1898 an album of 65 plates fully illustrating the building. In 1899 he held an exhibition of drawings, photographs and furniture at the salons of *Le Figaro*, and opened the show with a speech in which he acknowledged his debt to Viollet-le-Duc *and* Horta. It is fortunate that the care with which he detailed the interiors is recorded in the many plates, for there is little left today. The staircase decorations, including the carpet, have long since gone; fireplaces are no longer wanted; and Art Nouveau door knobs are an easy prey to collectors.

Even while the Castel Béranger was under construction, a competition was launched in 1896 by the *Compagnie du Métropolitain* for the entrances to their new stations.[23] The *Société Centrale des Architectes*, whose president was Charles Garnier, expressed the desire that the design of the buildings and viaducts of the new railway should be entrusted to the best artists. Garnier's own views were well-known. 'Le Métro . . . n'aura guère d'excuse que s'il repousse absolument tout caractère industriel pour devenir complètement oeuvre d'art',[24] he had written in a letter to the Minister of Public Works ten years earlier. It was hardly

surprising, therefore, that the first prize in the competition went to Durray, a dull academic architect despite the use of glass, iron and ceramic decoration in his entry. Guimard did not enter for the competition, but got the job because the fashion-conscious president of the company liked Art Nouveau, and Guimard's proposals brilliantly translated the decorative quality of the Castel Béranger both into three-dimensional form and into a plausible kind of industrialised building.

Guimard designed three basic types of station for the *Métro*: with open steps with railings, with enclosed and covered steps, and complete pavilions. The problem was not a new one. In London, Budapest and Vienna underground railways all preceded the Paris *Métro*. But the first had its early stations mostly incorporated in the ground floors of street buildings, the second does not appear

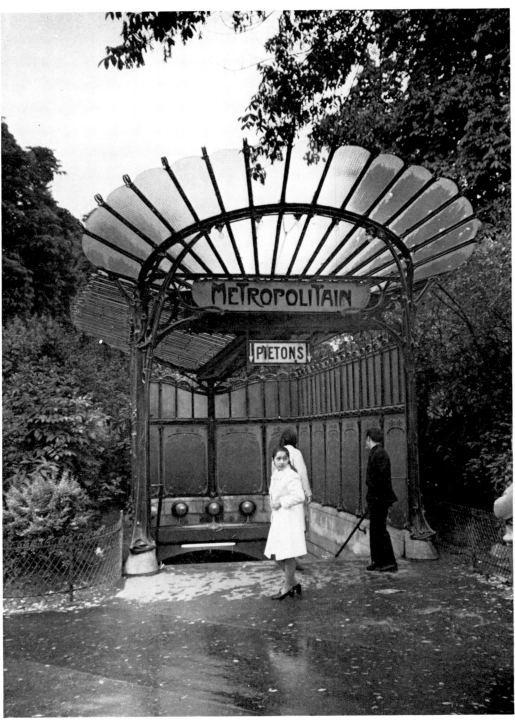

7. *The entrance to the Porte Dauphine Métro Station, Paris, 1900–1. This belongs to the second of three basic types and consists of a three-sided enclosure supporting a glazed 'butterfly' roof.*

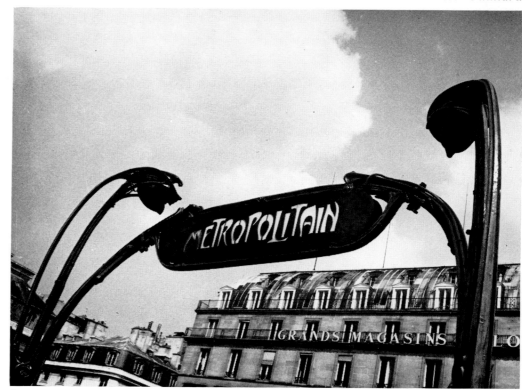

8. *The entrance to the Louvre Métro station designed 1900. This belongs to the first type which is not enclosed. It consists of railings on three sides and an arch over the entrance supporting the 'Métropolitain' sign flanked by 'stalks' which blossom into lamps.*

9. *Design for the Wagram-MacMahon station at the Étoile dated August 20, 1900. This belongs to the more ambitious third type and provides covered space and a waiting room.*

8

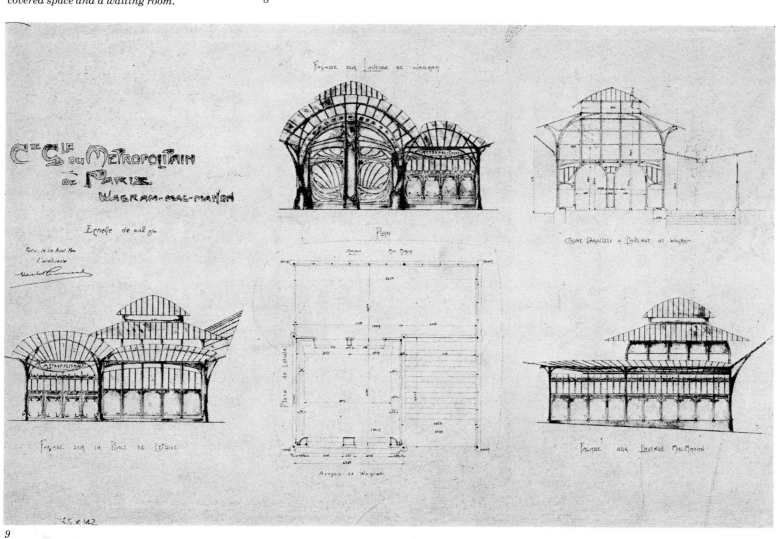

9

to have achieved any three-dimensional expression above ground, and only the third, with Otto Wagner's stations, could have provided any kind of model for Guimard.[25] His restless forms, however, are of a different order to Wagner's sedate little buildings, and they remain the most complete architectural expression of Art Nouveau.

The first type of station had several variations: railings with rectangular cast-iron panels decorated with snail-like motifs; railings with 'shields' decorated with an elaborate pattern of curves terminating with the letter M at the bottom; and railings of the second kind but with an iron arch over the entrance supporting the enamelled sign *Métropolitain* and two 'stalks' which blossom into lamps with amber glass covers. The enamelled sign was green and yellow, and the ironwork was painted fastidiously in different shades of green.

The second type, which is considered by some authorities the most elegant,[26] consists of an iron frame with enamelled lava panels decorated with a caligraphic pattern, and translucent wired glass. A 'butterfly' glass roof, supported from a central girder which incorporates a rainwater gutter, articulates this enclosure by never touching its top edge. The fact that each glass roof-panel is curved at the edge and of slightly different length to the adjacent one, gives the roof an unusually plastic form and shows how Guimard intended to combine character and expression with standardisation – a not inappropriate lesson for today.

The more ambitious third type provides waiting rooms and has a frame-and-panel enclosure which is similar to the second type. The main difference lies in the much more ample entrance arches, and in the tiered pyramidal roofs reminiscent of covered market structures. What is astonishing here is the way Guimard has projected a simple rectangular plan by means of flat glass and lava panels into a complex three-dimensional structure which seems to negate the right-angle at every turn.

Ninety of the stations are still in use, though unfortunately none of the third type[27] and only one, at the Porte Dauphine, of the second type. One station has been moved to the Sahara by the *Compagnie Française des Pétroles*, another to Montreal to serve the underground railway there, and three to museums in New York, Munich and Paris. When new these structures must have dazzled the eye, with the ironwork painted bright green, the panels orange on the inside and the pattern picked out in white, green and blue. Of particular interest is the fact that their design was modular and conceived for mass-production. But by no means everyone

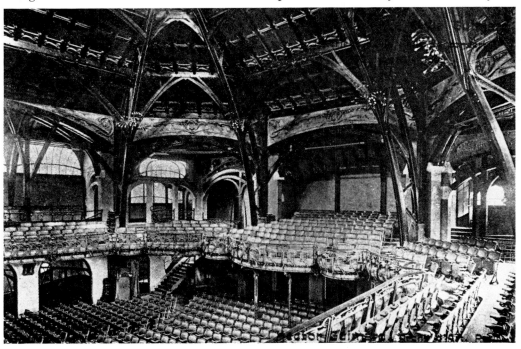

10. *The Humbert de Romans auditorium, Paris, 1897–1901. A masterpiece of Art Nouveau, it ranks with Horta's Maison du Peuple. During its short life – it was demolished in 1905 – it was also the largest hall in Paris, seating up to 1,500 people.*

approved. About the lettering André Hallay made the absurd comment in *Le Temps*, '. . . these undisciplined hieroglyphics are understandably most disturbing to all the little children whom we are trying to teach the French alphabet . . .' More serious was the fact that as early as 1904 Guimard fell out of favour when his design for the Opéra station was refused and the job given to another academic, Cassien-Bernard, whose design, it was said, would be more respectful towards Garnier's opera house. *Le Figaro*, who had on a previous occasion made its premises available for the exhibition of the Castel Béranger drawings, joined forces with the reactionaries and launched an attack on the whole style. Although stations of the first type went on being installed until 1913 (141 were installed between 1900 and 1913, according to Lanier Graham),[28] the story illustrates the persistence and the strength of the academic lobby in France, a lobby which found no difficulty in omitting all reference to the name of Guimard (although commenting on the stations in a derogatory manner) in an important book published soon after the First World War when Guimard was still active.[29]

Apart from the *Métro*, the work of Guimard's second and most prolific period can be conveniently divided into detached suburban villas, town houses, apartment blocks and three special buildings, the Coilliot house and store at Lille, the Humbert de Romans auditorium and the synagogue in the rue Pavée, the last two both in Paris. It is convenient to take the villas first because they belong in many ways to his earlier picturesque period. Of these the most remarkable is the *Castel Henriette* in Sèvres (1899–1900, remodelled *c.* 1903; demolished 1969). Lanier Graham suggests that Guimard's 'characteristic of tense complexity did not begin to influence his architectural volumes until he built completely three-dimensional country houses on open sites . . . At *Castel Henriette*, for the first time, all the elements of both plan and elevation are distributed with the same sense of spontane-

11. The Castel Henriette at Sèvres, 1899–1900. One of the highly romanticized suburban villas, built of a mixture of dressed stone, random rubble, brick and timber framing.

12. Ground-floor plan of the Castel Henriette, dated August 1, 1899.

11

12

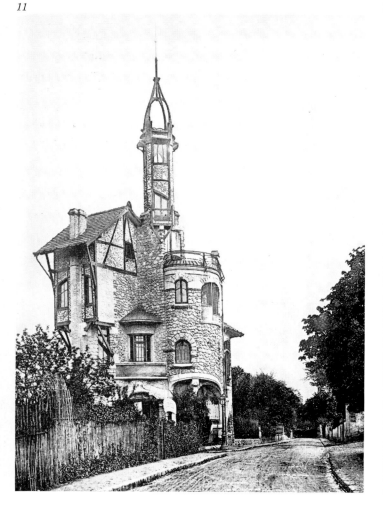

ous compression and release that had dominated his two-dimensional design.'[30] Both here and in the villa *La Houle* at Hermanville in Calvados (1899 and still standing) the traditional division into separate sitting and dining rooms is replaced by a *grande salle* with large windows giving on to balconies. The chalet *La Surprise* at Cabourg, also in Calvados (1903 and now destroyed) is more conventional,[31] but it demonstrates once again Guimard's determination to break up rectilinear forms, here by means of a powerful diagonal axis.

Now that it is possible to see Guimard's work as a whole (recent research has uncovered more than 50 buildings, hundreds of decorative objects, and over 2000 drawings[32]), it is clear that in matters of style he was an eclectic even during his most active Art Nouveau period. The suburban villas are highly romanticised versions of a northern vernacular. The projecting eaves often protect large areas of glass, but the solid walls are random rubble with ornate half-timbering, while decorative elements, like the panel over the porch of the Castel Henriette, are pure *style métro*. On the other hand the Hôtel Nozal, 52 rue du Ranelagh (1902–5, outfitting *c.* 1907, remodelled 1937, demolished 1958), is Neo-Baroque in its bold plastic plan-forms and in the way all the energy of the main façade (which is significantly symmetrical) is gathered first inwards, then upwards. Work like the Hôtel Nozal and the Humbert de Romans auditorium support Madsen's view that 'Neo-Baroque may be considered as the most important source of Art Nouveau's plastic conception of form in the French cultural sphere,'[33] even if the summit of this synthesis was the work of the Italian Raimondo d'Aronco.[34]

Guimard's own house at no 122 avenue Mozart was built and furnished between 1909 and 1912, after he had married the American painter Adeline Oppenheim. In the exquisite relationship of the two ovals in the first-floor plan (an ingenious fit on to an awkward triangular site), Guimard shows himself to be working in the Rococo tradition of French *ermitages* and *folies*. The first floor is also the *piano nobile,* while the raised ground floor below was Guimard's new office transferred from the Castel Béranger. His wife's studio under the eaves is expressed in the usual relaxed way, but it hardly relates well to the lower part which seems to be a somewhat laboured attempt to create a plastic effect out of stone and brick on a number of different planes. Guimard's synthetic vision, on the other hand, reaches its high point in the interiors of this building.[35] James Grady has observed how in the oval dining-room on the first floor, Guimard uses 'rhythmic contrasts of long and short lines in his plaster walls . . . starting above the panelling with free and graceful incisions gradually merging into the smooth plaster . . . the window curtains repeat this motif in their mesh design, graduating from the unpatterned cloth to open mesh by a series of long and short cut-outs.'[36] And, one may add, so do the chandeliers and even the upholstery tacks.

By comparison the Hôtel Mezzara at nos. 60–2 rue La Fontaine (1911) is quite sober. The façade is basically on one plane with a number of simple recessions, the stonework is lightly carved and decorated generally on the angle only, and as a result the virtuosity of Guimard's ironwork is seen to greater effect. The plan, too, is a straight forward arrangement of rectangular rooms, with a double volume in the centre which is top lit by a stained glass roof-light. It provides the main circulation-space as well as an exhibition-area for a client who was a textile manufacturer wanting to combine home and workshop. Perhaps because of this, the wrought-iron balustrade is a relatively simple one, and the decoration very delicate, with the exposed structural ironwork which supports the staircase and the roof painted white.

Of the sequence of apartment blocks dating from this period, those on the east side of the rue La Fontaine and in the streets immediately behind (1911) are in Guimard's most charming Rococo vein. The stone mullion of a first-floor window cascades down over the entrance of no. 17, and round the corner is preserved what must be the last original shop front. But the earliest and most interesting of these

buildings is the Jassedé block at no. 142 avenue de Versailles (1905). Its vigorous corner treatment – restless movement from one side to the other – should be compared to the weak duality of the lower corner windows in Guimard's own house. The windows on the first floor, are a further brilliant example of Guimard's fondness for contradicting a rectangular shape with a circular one – and not merely on one or two planes, but in a fully sculptural manner. Internally, the restoration in cream and white of the entrance hall and oval staircase well is not authentic, but provides nonetheless a pleasing background for the surviving mosaic floor, stained

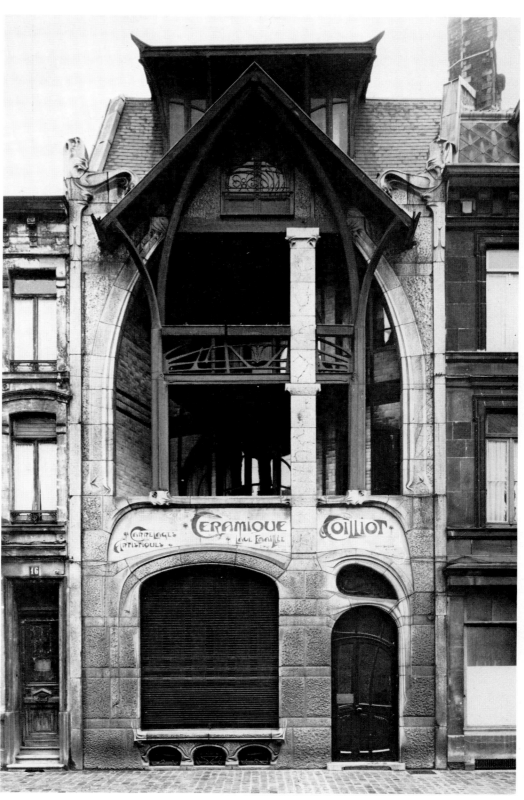

13. The Coilliot shop and house at Lille, 1898–1900. Built for a ceramics merchant, it combines the curvilinear elegance of his later town houses with some of the rustic idiom of his suburban villas. The façade is faced with bright green enamelled lava blocks that advertise the owner's merchandise.

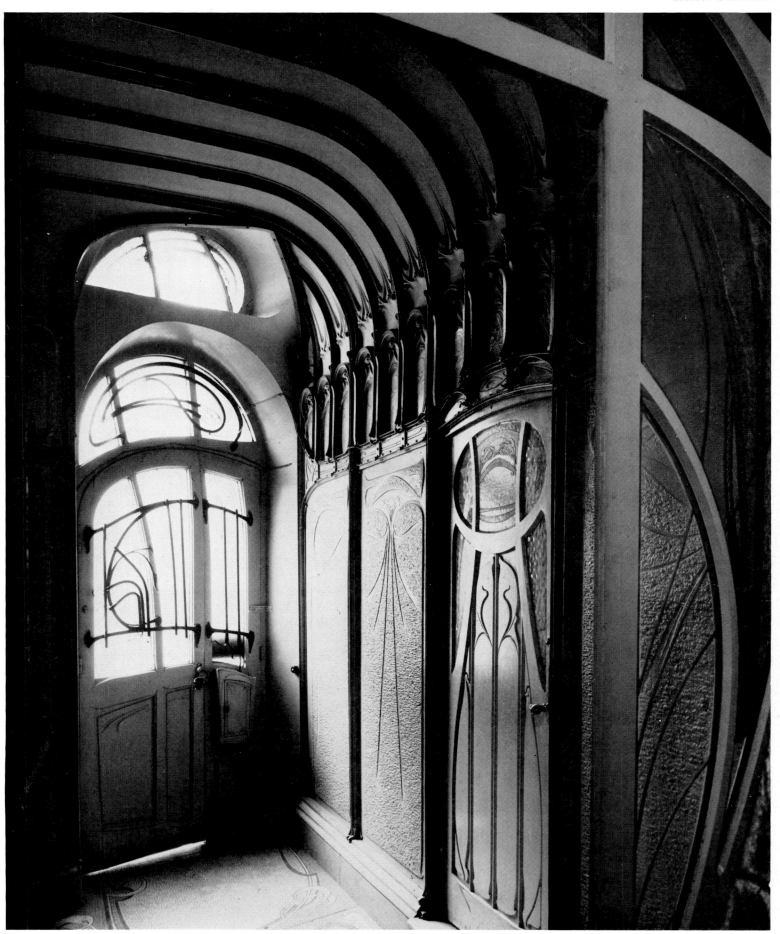

14. *The entrance hall of the Coilliot House. The construction consists of enamelled panels set in a cast-iron frame.*

glass windows and structural and ornamental ironwork.

The Jassedé apartment block was also the occasion for Guimard to launch into the design of cast-iron fittings of every imaginable kind, giving full vent to his fertile imagination and leading ultimately to the publication of an impressive catalogue that carried the title, photograph and overall dimensions and weight of every piece. The firm that made the castings was the Société Fonte Saint Dizier, but Guimard's hope that other architects and builders would order regularly from the catalogue was never fulfilled. Among the items listed were the palm-leaf ornaments in the hall of the Jassedé block, balcony cartouches, street numbers, bell-pushes and garden urns.[37]

Of the three special buildings, the Coilliot house and store at Lille is the earliest (1898–1900, outfitting 1903). A narrow site receding diagonally from the street may have given Guimard the idea of a balcony recess to regularise the internal planning on the upper floors. Otherwise the façade is essentially on one plane, faced with enamelled lava panels like the *Métro* stations, and displays the characteristic overlapping of motifs – the urban below and the rustic above. The house was built for a ceramics merchant, and the ground-floor contains a shop which is accessible, like the living quarters above, through a common entrance-hall. Perhaps because it is not in Paris, the building was largely ignored by historians writing about the period until the recent Guimard exhibitions. If not one of his masterpieces, it is surely vintage Art Nouveau and one of his most original works.

Undoubtedly a masterpiece, however, and ranking with Horta's *Maison du Peuple* (1895), was the Humbert de Romans auditorium at no. 60 rue Saint-Didier (1897–1901, demolished 1905). Intended as a school of divine art, its founder, Père Lary, was banished by episcopal order before the building was even finished, and it was used briefly for concerts at a time when it was the largest hall in Paris (1200–1500 seats). According to a contemporary account,[38] the acoustics were excellent and the organ was built with the advice of Saint-Saens. The hall was 'formed of a visible structure, springing from the ground at each corner and spreading in graceful curves like the branches of an immense tree, in a way which gives somewhat the idea of a corner of a druidic forest. The main branches, eight in number, support a rather high cupola, pierced, like the sides, with bays filled with pale yellow stained glass, through which an abundance of light finds its way into the hall. The framework is of steel, but the metal is covered with mahogany . . . the result is the most elaborate roof ever conceived by a French architect'. Madsen has seen in it ' . . . fanciful asymmetry, a Baroque feeling for form, Gothic-like construction, Art Nouveau in iron and abstract ornaments.'[39]

The last and least remarkable special building is the synagogue in the rue Pavée, a narrow and unattractive street in the Marais. Built between 1911 and 1913, it retains few of Guimard's sculptural tendencies in the façade, and none at all inside the building, due perhaps to the restraints imposed by a reinforced concrete structure. The façade is gently undulating and expresses both the symmetrical programme and the high central volume of the interior in the disposition and shape of the windows. The challenge of this upward sweep is unfortunately not met by the feeble expression of the porch and roof. Internally, the synagogue itself is a very high and narrow top-lit space (reminiscent of the courtyard at the Castel Béranger) flanked on both sides by three tiers of galleries. In spite of certain positive qualities of space and light, one already senses in this building the War as a watershed which brought forth a new rationalism, and delivered the *coup de grâce* to Art Nouveau's and Expressionism's lingering death.

The clearest sign that a change was on the way is the decline in Guimard's activities as a furniture designer. Except for the Hôtel Mezzara and for his own house, production virtually ceases after 1909, never to start up again in a significant manner. In his early furniture, before the turn of the century, the carving was bold and the parts tended to be articulated – for example the back-rest, seat and

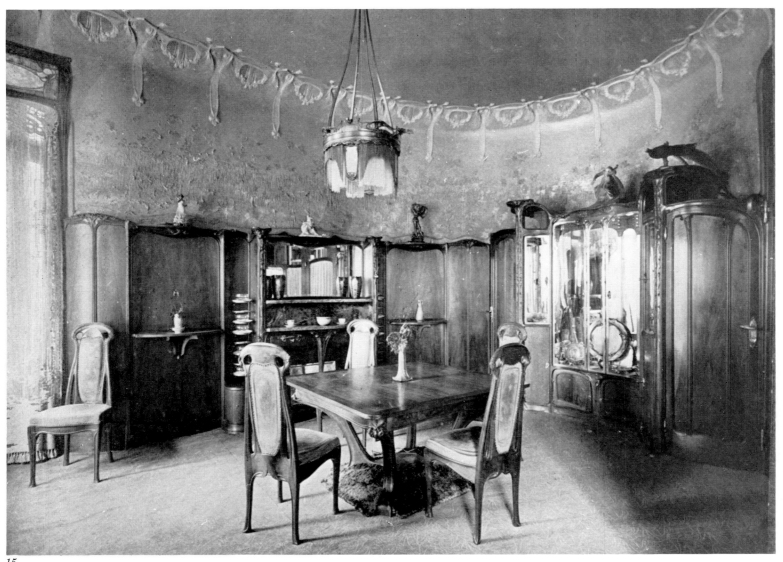

15

16

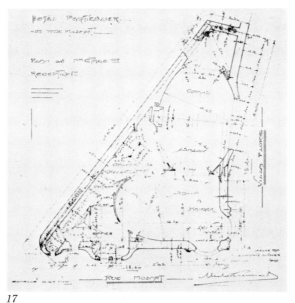

17

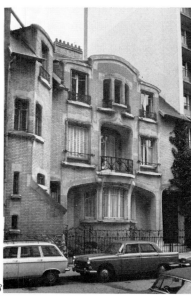

18

15. *The oval dining room on the first floor of the Hôtel Guimard, furnished 1912. In contrast to the unsatisfactory exterior, here Guimard's synthetic vision reaches its high point.*
16. *The Hôtel Guimard, Paris, 1909–10. The disparate elements at the top prevent the exterior from fusing into a satisfactory whole.*
17. *First-floor plan of the Hôtel Guimard. The relationship of the two ovals recalls the French Rococo tradition of ermitages and folies.*
18. *The Hôtel Mezzara, Paris, 1911. The symmetry and relative flatness of the central part of this façade suggests a turning point in Guimard's career.*

25

arms in an 1899 chair are clearly separated. The decoration, which is limited to the wooden frame, consists of lines, folds, twists and occasional high points of abstract carving. The continuity is so complete that no part can be isolated from the whole. This early period also shows Guimard at his most original in pieces like the *banquette de fumoir* for the Castel Béranger and the chimney piece cum side-board still in place at the Coilliot house. With their strong suggestion of natural forms, both these examples seem to embody Guimard's rhetorical question, 'for construction, do not the branches of the trees, the stems, by turn rigid and undulating, furnish us with models?'[40] In his later furniture, for the Hôtel Nozal for instance, or for his own house, the separate parts tend to merge more into one another, there is a greater emphasis on comfort, and the decoration becomes at the same time more delicate and more elaborate, 'as though the entire piece is enveloped in a mysterious veil.'[41] The forms become less personal and follow the general trend of Louis XV and Biedermeier. Like those of his contemporaries de Feure and Gaillard, his pieces are always superbly executed, and they represent no doubt some of the last significant examples of craftsmanship. Except where the multiple nature of the problem required it, as in the seating for the Humbert de Romans auditorium,[42] in this field Guimard seems to have shown no interest in problems of mass-production.

After the War Guimard's work declined in interest. Although he was unable to associate himself wholeheartedly with the new rationalism, his housing projects for post-war reconstruction were based on a standardised system of dry concrete block construction and prefabricated elements like doors and windows. There are over 60 drawings for houses built in this manner at the Cooper Union Museum in New York, but the only known surviving example is no. 3 Square Jasmin (1922). The walls are concrete block fair-faced inside and out, and laid dry with the help of metal ties which also act as anchors for projecting decorative features.[43] Into this category also fall the projects for low-cost apartment-blocks that Guimard carried out as part of the *Groupe des architectes modernes* which included Jourdain, Sauvage, Sédille, Roerich and Brachet. The same group was entrusted with the design of the 'typical modern French village' for the 1925 *Arts Décoratifs* exhibition. The town hall for this 'village', Guimard's personal contribution which surprisingly still made use of his standardised system, has nothing 'modern' about it and is a far cry from Le Corbusier's *Pavillon de l'Esprit Nouveau* at the same exhibition.

The suddenness with which Guimard's forms lose their plastic exuberance and become rectilinear or angular is surprising. Already in 1919, though admittedly restrained by post-war shortages, his office block at no. 10 rue de Bretagne[44] abandons all traces of Art Nouveau and follows the manner of Perret with its tall stacks of bay windows. The best work of Guimard's last active period is probably the apartment-block at no. 18 rue Henri Heine (1925–6). The façade is disappointing with its coy symmetry crowned by a weak ziggurat form, but it may be worth noting that the high-level balconies which Guimard used all his life, and which in works like the Castel Béranger and his own house are complex formal devices for bridging the picturesque roofscape and the more formal lower parts, here and at no. 10 rue de Bretagne merely act as a full stop to a comparatively simple rhythm of parallel vertical features. The skilful L-shaped plan has its vertical circulation node where the rear servants' wing joins the front block and, as so often in the past, it is here that the main interest lies. The service staircase and external service lift back on to the main staircase which is lit once again by hexagonal glass bricks in the wall between. In the balustrade Guimard's newly refined calligraphic style reaches the summit of economy and elegance, and shows up the crude quality of so much contemporary design that now passes under the name of 'Art Déco'.

The third-floor flat at no 18 rue Henri Heine was the Guimards' last home in Paris. The *légion d'honneur* was conferred on him in 1929 in recognition of his services to the arts, and in 1931 his name appears on the honorary committee of *L'Archi-*

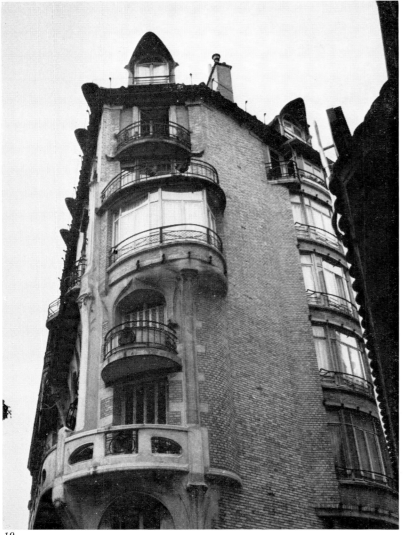

19

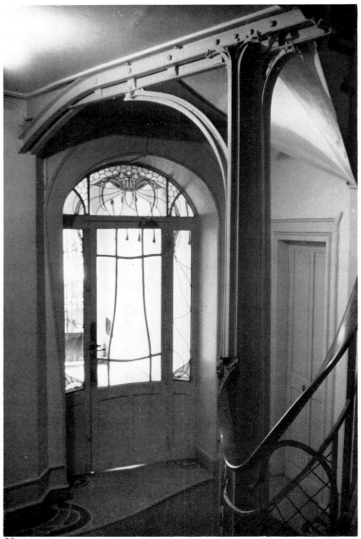

20

21

19. The Jassedé flats, Paris, 1903–5. The earliest and most interesting of a series of apartment blocks by Guimard in the Rue La Fontaine and in the streets immediately behind.

20. The entrance hall to the Jassedé flats. It shows the characteristic way in which Guimard makes one form flow into another.

21. Typical floor plan of the Jassedé flats.

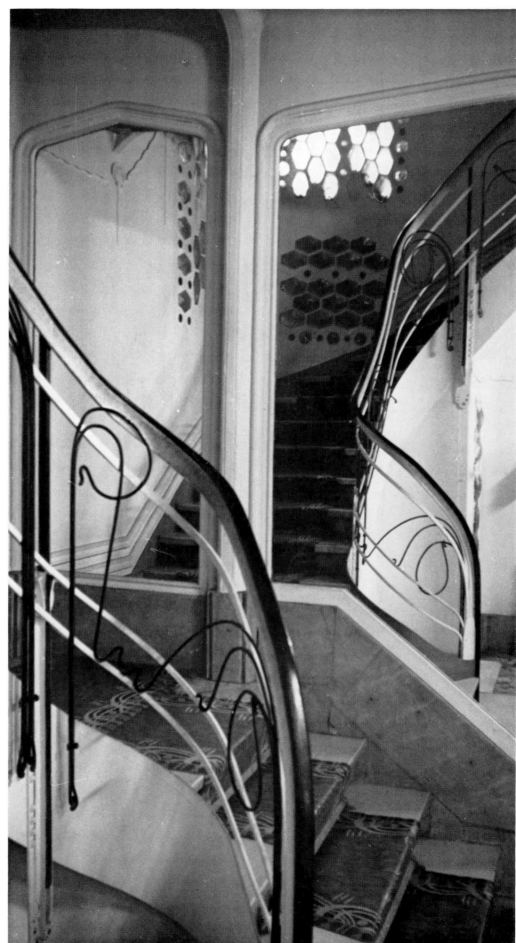

22. *18 Rue Henri Heine, Paris, 1925–6. After the utilitarian office block in the Rue de Bretagne, this seems like a return to plastic forms, though of a heavier kind.*

23. *The entrance hall of 18 Rue Henri Heine where Guimard's newly refined calligraphic style reaches the summit of economy and elegance.*

22

23

24. *A Fireplace in cast iron with enamelled lava panels in the Castel Béranger.*

25. *The* banquette de fumoir *designed for the Castel Béranger. Compared to the extravagant forms of the mahogany frame the actual carving is restrained, with the more elaborate passages occurring at or near the joints.*

26. *Design for a fireplace in the Coilloit House. In this drawing one feels that Guimard's ornament did not arise out of the intrinsic qualities of the material and that a fireplace which was intended to be made in cast iron could equally well have been carved in wood.*

24

25

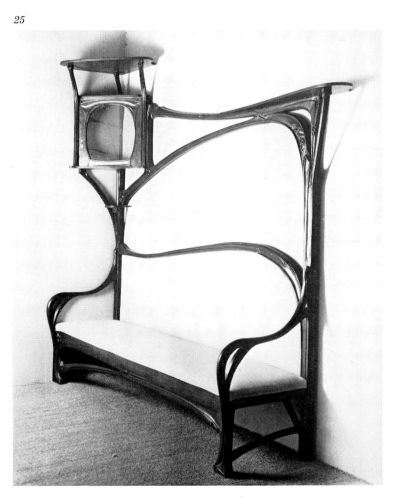

26

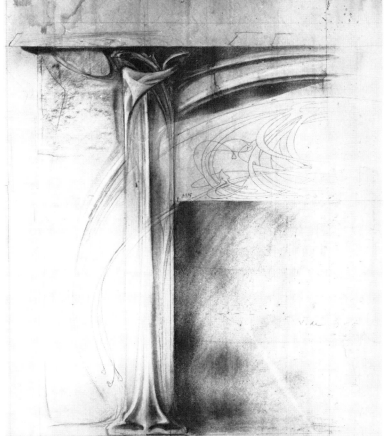

tecture d'aujourd'hui. After 1930 there seem to be no more buildings that can be attributed to him. He left with his wife for New York in 1938 or 1939, where he died a forgotten man on May 20, 1942, barely a decade before the revival of Art Nouveau was underway.

To conclude, some assessment of Guimard as an architect and artist must be made. In an article[45] which he wrote for the American *Architectural Record* in 1902 (in which he refers to Ruskin, Walter Crane and William Morris, showing that he was well acquainted with English sources) Guimard adapts Vitruvius's three conditions of firmness, commodity and delight, to logic, harmony and sentiment. It is the last – sentiment – which is of interest here. 'Sentiment', he says 'which, partaking at the same time of logic and harmony, is the complement of both, and leads by emotion, to the highest expression of the art.' Here Guimard shows himself clearly to belong to the Romantics, to the tradition of an *architecture parlante*, and the proof is that his work was popular, that his clients were mostly satisfied and that the people who lived in his buildings liked them precisely because of their emotional content. Guimard's ability to turn his hand to almost anything should not make one overlook the fact that his ornament was 'applied' and did not arise out of the intrinsic qualities of the material. A drawing for a cast-iron fireplace could equally well have been carved in wood. Nevertheless, Guimard must rank very highly as a furniture designer, and he occupies a unique position as a designer of castings. For the latter, and for the *Métro* stations, he remains a pioneer of industrial design. He is more difficult to assess as an interior designer because so many of his interiors have disappeared with time. But he was probably the equal of the best Rococo designers of the eighteenth century. He was not a great architect, because his interest in pure architectural values was not strong enough, and his ability at three-dimensional organisation was always circumscribed by his fondness for ornament. Yet his best buildings show a remarkable fusion of structure, ornament and space, and possess all the attributes of fine architecture. If this study has concentrated on Guimard the architect, it is because his place in the applied arts is already assured.

NOTES

[1] The only discordant notes in this little building, which also included glass by Tiffany, appear to have been José Maria Sert's overpowering murals in the vestibule. Sert, like all the best painters of that time, remained apart from the Art Nouveau movement.

[2] The exact date of Bing's arrival in Paris is not known. He was born in Hamburg in 1838 and worked for a while in a German ceramics factory. Robert Koch, in his Introduction to *Artistic America, Tiffany Glass and Art Nouveau* by Samuel Bing (MIT Press, Cambridge, Mass., 1970), maintains that he settled in Paris before the Franco-Prussian War, and it is certainly hard to imagine a German and a Jew making such a move immediately after so humiliating an experience for the French and the Parisians especially; for by 1875 it is known from Edmond and Jules de Goncourt's diary that Bing was running a shop in the rue Chauchat.

[3] *Axel's Castle* by Edmund Wilson, 1931 and Collins, London 1961.

[4] *Modern French Painters* by R. H. Wilenski, Faber, London 1947.

[5] *Art Nouveau* by S. Tschudi Madsen, Weidenfeld and Nicolson, London 1967.

[6] The artists involved in decorating and furnishing the shop were Georges de Feure, Frank Brangwyn, Charles Conder, Albert Besnard, Louis C. Tiffany and Henri van de Velde.

[7] Madsen, *op. cit.*

[8] Madsen, *op. cit.*

[9] R. Alcock's *Art and Industries in Japan* (1878), Dresser's *Japan, its Architecture, Art and Art Manufactures* (1882) and L. Gonse's *l'Art Japonais* are merely some of the titles.

[10] 'I leave the flower and the leaf, and I take the stalk.'

[11] A. D. F. Hamlin: 'L'Art Nouveau: Its Origin and Development.' *The Craftsman,* Vol. 3 no. 3 (1902).

[12] M. S. Bing: 'L'Art Nouveau.' *The Craftsman,* Vol. 5. no. 1 (1903).

[13] Auguste Perret was to do the same thing a few years later.

[14] *Architecture Nineteenth and Twentieth Centuries* by H. R. Hitchcock, Penguin Books, Harmondsworth, 1958.

[15] The first volume was published in 1863 and the second volume, with plates, in 1872.

[16] In the dating of Guimard's buildings I am much indebted to G. K. Koenig and E. Colombo's admirable monograph published in *Casabella,* no. 329, 1968. Together with the catalogues referred to in notes 26 and 28, this is the best source for illustrations of Guimard's work other than my own article – see note 2, page 7.

[17] The Warren Hickox house, Kankakee, Ill of 1900, for example.

[18] The drawings for no. 39 Boulevard Exelmans are dated, June and July 1894; those for the Ecole du Sacré-Coeur, February 1895.

[19] Madsen, *op. cit.*

[20] The tap was originally designed by Guimard in the same style, but has unfortunately been replaced by a standard one.

[21] From the sonnet *Vers Dorés.* 'And like a nascent eye hidden under its eye-lid a pure spirit grows under the stone's crust.'

[22] See note 16.

[23] I am indebted to Roger H. Guerrand's book *l'Art Nouveau Europe,* Plon, Paris, 1965, for the story of the competition.

[24] 'The Métro . . . will have no excuse unless it rejects absolutely all industrial tendencies and goes all out for the work of art.'

[25] The iron frame and prefabricated marble and stucco panels of Wagner's Karlsplatz station entrances bear close resemblance to Guimard's stations, but the date of design is 1898, and more research will have to be done to find out whether Wagner influenced Guimard or vice-versa.

[26] See the Catalogue of the exhibition *Pionniers, du XXᵉ Siècle: Guimard, Horta, Van de Velde* held at the Musée des Arts Décoratifs in Paris from March 10 to May 31, 1971.

[27] The last surviving station of the third type at the *Hotel-de-Ville* was only dismantled three years ago, to be re-erected when certain major roadworks are completed – so the authorities say.

[28] See the catalogue of the exhibition *Hector Guimard* by Lanier Graham held at the Museum of Modern Art in New York from March 10 to May 10, 1970.

[29] *L'Architecture et la Sculpture en France de la Revolution à nos jours* by Georges Gromort, André Fontainas and Louis Vauxelles.

[30] See note 28.

[31] The model of the roof and porch was made by Alain Blondel.

[32] This work of research and documentation has been carried out by Alain Blondel, Ralph Culpepper, Lanier Graham, Laurent Sully Jaulmes, Yves Plantin and Stan Ries. It provided the basis of Koenig and Colombo's monograph in Casabella to which my own debt has already been acknowledged in note 16. I would also like to thank Alain Blondel, Ralph Culpepper and Stan Ries for valuable additional help they have each given me direct.

[33] Madsen, *op. cit.*

[34] See the chapter on Art Nouveau in Italy, by Manfredi Nicoletti, in this volume (pages 32–70).

[35] The house is now empty and somewhat derelict inside. But thanks to Madame Guimard, who wanted to make it into a Guimard museum, there is a full photographic record.

[36] James Grady, 'Hector Guimard, an overlooked master of Art Nouveau,' *Apollo,* April 1969.

[37] I am indebted to Alain Blondel for the information in this paragraph. See also the catalogue prepared by Alain Blondel and Yves Plantin for the exhibition *Hector Guimard, Fontes Artistiques,* held at the *Galerie du Luxembourg,* 98 rue St. Denis, Paris, in April and May 1971.

[38] Fernand Mazade, 'An Art Nouveau Edifice in Paris', *Architectural Record* Vol. XII no. 2, 1902.

[39] Madsen, *op. cit.*

[40] Guimard to Victor Champier, *Revue des Arts Decoratifs,* 1899. Quoted by Lanier Graham (see note 28).

[41] Madsen, *op. cit.*

[42] The cast-iron frame for this seating formed part of the 1907 catalogue of castings (see note 37).

[43] From an article by A. Goissaud, *La construction moderne* November 8, 1925, referred to by Koenig and Colombo (see note 16).

[44] Koenig and Colombo (see note 16) have discovered evidence which suggests that the building may even have been designed as early as 1914.

[45] *Architectural Record,* vol. XII, no. 2, 1902.

ART NOUVEAU IN ITALY

by Manfredi Nicoletti

The Italian contribution to the Art Nouveau movement, and the others that broke away from academic historicism at the end of the nineteenth century, have received too little attention; in fact this is the first full account of them to be published in English. The leading personalities, whose pioneer design are here put into historical perspective, were Giuseppe Sommaruga and Raimondo D'Aronco.

The rise of an exasperated nationalism in Italy in the second half of the nineteenth century was bound to affect movements in the arts. Italy's political union, proclaimed in the spring of 1861 but only completed with the annexation of Rome nine years later, was at first more a formal image than a social reality. With the ensuing search for a national identity and the radical transformation of a backward economy, the role of the State in both spiritual and economic life inevitably became prominent.

In 1861 feudal modes of agriculture still prevailed, and industrial development hardly existed. Confronted by the gathering forces of capitalism in Europe, Italy seemed condemned to poverty. A land heavily corrugated by mountains made both farming and communications difficult, nor was it richly endowed with minerals or other basic raw materials. Italy appeared to be richly provided only with historic memories and natural beauty. And there was no strong middle-class nucleus capable of stimulating intellectual and financial enterprise as in France or England. In 1871, fifty per cent of north Italians were illiterate, eighty-five per cent in the south. Foreign investment saw little incentive in such unrealised natural and human resources and such a climate of political instability. In almost every area of Italian life, the State had to become the promoter. That necessity shaped Italian life until the end of the Second World War.

State action directed not only the course of the economy and the gradual emancipation of the working classes, but also the development of art and particularly of architecture. The nationalist spirit that inflamed the Risorgimento, nourished on liberal ideals and reaching toward international brotherhood, was soon channelled by the State, hoping to reinsert Italy among the great Powers, into the reactionary chauvinistic stream of the new nationalism of Europe. Under the new State-propelled industrialism, Italy began to have two specialities: the exploiting of water power for electricity and the use of reinforced concrete.

From 1871 to the end of the century, all the major cities doubled their population. Architects and artists were summoned to give a new form to the new national unity. But how? Italy was still one of the most primitive countries in Europe, where rich foreign tourists in search of the picturesque luxuriated in the ignorance and poverty which vegetated around the proud relics of the past. State pressure to revive the heavy heritage of one of the world's most prestigious historic traditions, and the contrast between that old glory and the frustrating present, mingled in a tragic inferiority complex. The result was a sort of irresistible love of gigantism and an eclectic celebration of the past; all public buildings had to demonstrate this, and later monumentality inspired Sant'Elia's architectural dreams as well as Mussolini's imperial realities.

In such a situation, the most progressive wing of the intellectuals was not so much engaged in fruitful debate with the conservatives, as in resistance to a flood of pathetic traditionalism and boastful rhetoric. A meagre field was left for the European trend to an Art Nouveau. Anti-monumental by its very nature, this new expression at first shaped the design of minor private works, villas and town houses of the rising bourgeoisie, cafés and hotels, and especially the temporary fragile stage-sets of innumerable exhibitions.

This interlude with the bourgeoisie did not last. Around the second decade of this

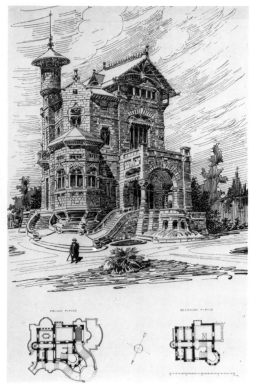

1. The mixed styles of Ernesto Basile: his Villino Florio at Palermo, 1907–9.

century, private initiative was too much conditioned by the State, which on average was about twenty per cent involved in every important art venture. Inevitably the new rich formed a conservative establishment strictly bound to the central power. The internationalistic whims of Art Nouveau were merged with a Renaissance eclecticism and called *Floreale all'italiana*. Eclecticism, not merely in the area of art, was an attitude that had seemed fatally congenial to Italian culture in the nineteenth century. Even political union was eclectic: an intricate play of making and breaking alliances culminated paradoxically in the republican Garibaldi's offer of the territories conquered in revolutionary enthusiasm to the King of Sardinia. As Raffaele Pareto had put it in 1858,[1] 'Nations sometimes have moments when they grope in the dark and lose the way to progress, and their philosophy becomes eclectic'. In this climate Art Nouveau was just another style, the most recent one, in the international melting-pot. In Italy all the different expressions of Art Nouveau, the French *coup de fouet*, British Pre-Raphaelite undulation, *Jugendstil* heaviness, the horizontal lines of the Chicago school, the fashion for orientalism, were all reproduced at random and mixed with a good deal of classicism.

It is hard to say whether a lack of technological awareness or the burden of tradition crushed the formation of a modern mentality at that point. Long before, in 1853, Pareto had founded a magazine *Il Giornale dell'Ingegnere Architetto Agronomo*[2] that commented on Italy's architectural evolution in theory and practice for more than fifty years. The pages of the *Giornale* do clearly bear witness to the fact that quite advanced problems of modern culture were not unknown in Italy. Until 1870, the possibility that science and technology might create new architectural forms in an autonomous way was much debated. The attention to English attitudes and experiments, and frequent sharp articles and commentaries by Trelat and Viollet-le-Duc on the artistic potentialities of new materials and construction methods, revealed a genuine interest in a new form of democratic beauty. But immediately after the annexation of Rome, the eclectic ideas of Pietro Selvatico and his disciple Camillo Boito[3] began to dominate: 'Modern style cannot renovate [architectural] plans, which in order to acquire a perfectly national character must be freely connected with one of the architectural expressions of the past, whose elements will be used . . . in such a way as to harmonise with the modern world'[4] the latter said.

In 1887 professional qualifications for architecture and engineering were separated and, as Corrado Maltese[5] pointed out, there was also a division between technical expertise and good taste within the popular conscience. Beauty was divorced from technology. Boito's formula for superimposing an aesthetic symbolism upon an archaic skeleton converted architecture into civic decoration, its basic function the embellishment of public spaces. Such ideas had the power of official edicts. Official architecture slowly became symbolic scenography. Technology was, officially, under-rated. The only great Italian architect-engineer of the nineteenth century was Alessandro Antonelli,[6] whose cathedral at Novara and his Mole Antonelliana, the domed building which is the principal landmark of Turin, attained the utmost refinement and boldness of masonry technique, but who found no follower and scant recognition. In general architects were encouraged to be manipulators of skins. The rationalist exercise of a serious Gothic Revival did not occur in Italy. Nor was there any strong Italian concept of space.

Therefore, many critics doubt the real presence in Italy of an Art Nouveau, except for superficial imitation of foreign forms of it. But that implies some precise point of reference instead of the multifaceted international situation that existed: what indeed was the common denominator of Art Nouveau? Was it not a search for new expression in many directions, a negation of the concept of 'style'? It was at once a current of fashion, a mere decoration, and a philosophy from origins oscillating between neo-illuminism and romanticism. Its formal expression hesi-

tated between an abstract vocabulary and the interpretation of natural forms.

Italy lived the Art Nouveau experience in its own way. Side by side with its provincial *style pompier* were personalities who participated in the most advanced intellectual life of the Western world. D'Aronco, Rigotti, Sommaruga, and Moretti were publicised in America, England, France, and Germany. Alongside local bombast or eclectic whimsy, there was a thoughtful, if subdued, development in understanding the organic qualities of construction and urban environmental values, and the seeds of a dynamic vision of forms were planted. These were to have a delayed spring. The first Futurist Manifesto condemned all previous styles in words right out of the *Floreale* repertory.[7] The ideas of Previati, Balla, Boccioni, and Sant'Elia were deeply embedded in the Art Nouveau tradition. Moreover, it was to this type of tradition that much Italian architecture and urban planning immediately after the Second World War was, directly or indirectly, related. In the end, Art Nouveau in Italy had a remarkably long run, coexisting with other movements and surviving drastic socio-political changes.

To put it schematically, there were three major phases. The period from 1895 to 1914 started under the auspices of English Pre-Raphaelite influence, softened around 1898 by the Franco-Belgian curvilinear taste. In 1901 the rationalist trend of the Darmstadt School prevailed, yet intermixed with the *Floreale*, with French taste, and with the dynamic linearity of the Prairie domestic style. The *Floreale* triumphed after 1907 primarily by combining Renaissance elements and Deutscher Werkbund severity. The third phase, after 1914 until the early 'thirties, can be called the after-effects. Many quite important buildings were erected, slightly or strongly related to Art Nouveau. Among these were the National Library at Florence, the Railway Station of Milan, and the quarter in Rome named, for its designer, the Quartiere Coppedè – a curious cocktail of artful artlessness and medievalising 'organic' *Stile Liberty*. And for about a decade after 1948, with the introduction of the 'organic movement' inspired by Frank Lloyd Wright, architects looked back to Art Nouveau not only in reaction against Fascist pompousness but in search of the roots of modern architecture. As in the 'nineties, a new strong bourgeoisie was demanding an individualist expression of its power and well-being.

Above all else in 1948 were the two vast problems of urban reconstruction and the rehousing of the workers. Freedom of composition, refinement attained by simplicity of structure and material, environmental respect that often overdid the local colour, a break with rationalist geometrical rigidity and an intellectual taste for history all strongly attracted the architects engaged in the rebuilding of

2. Interiors of the Grand Hotel Santa Lucia at Naples, by G. B. Comencini, 1906.

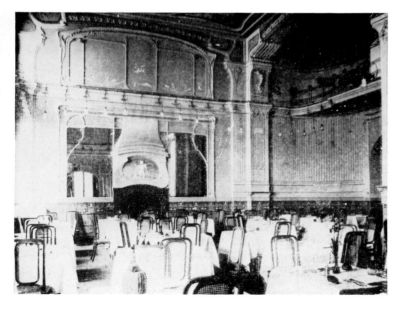
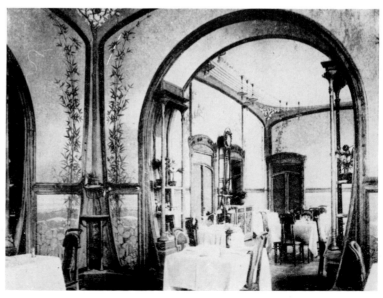

their devastated country. This new 'style', the well-known controversial 'Italian Neo-Liberty',[8] revived the spirit of the earlier *Stile Liberty* that had taken its name from the English shop.

This recent Neo-Liberty movement was in a sense a delayed Arts and Crafts Movement. In fact, the influence of Ruskin and the Pre-Raphaelites had arrived in Italy quite late, oddly enough as a reverberation from the Chicago Exhibition of 1893, and affected primarily graphic art and furniture design. When architecture, with its complexity and natural time-lag, responded to the new stimuli the wind of fashion had already shifted. So in the 'nineties, French interpretation of natural forms altered the trend to structural linearity. Neo-gothicism as an approach to a new aesthetic became impossible. With this quick survey of trends, we now return to 1895.

The year 1895 is generally accepted as the birth date of Italian Art Nouveau. In that year *Emporium*, a magazine inspired by the British *Studio*, was founded in Bergamo by Vittorio Pica. *Emporium* represented in Italy until the 'thirties the most authoritative sifting of national and international debates about the visual arts. It first appeared at a time of political crisis for Italy. Two decades before, in 1876, with the public budget balanced and the leftish wing heading the Government, new hopes for a period of economic and social progress had been aroused. One year later, the Milanese Piazza del Duomo, flooded by electric light, celebrated the completion of Giuseppe Mengoni's Galleria, while Italy's first department store, the present Rinascente, was being planned by the Bocconi brothers. New trades and industrial ventures were flourishing all over the peninsula. But compromise soon blurred leftish policy, and political eclecticism was back. The death of the King of the Unification was a unique occasion for rhetoric and for an astonishing proliferation of celebratory monuments in all the Italian piazzas.

3. An early work by Annibale Rigotti: the theatre at Varna, Bulgaria, 1895.

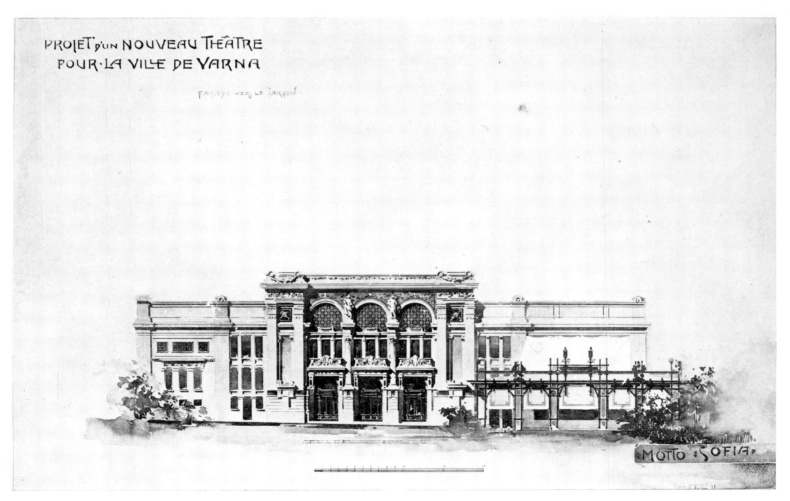

PROJET d'un NOUVEAU THÉÂTRE POUR·LA VILLE DE VARNA

FAÇADE vers LE JARDIN

MOTTO : SOFIA.

In 1881, an international competition for the monument to Vittorio Emmanuele II in Rome was announced to the world.[9] In 1882, having signed a political alliance with Austria and Germany, Italy was opened to Germanic cultural influence. The authoritarian theories of Heinrich von Treitschke – worship of the State, cult of race, militarism – found fertile ground. Italy, supported by her most popular poets and disregarding left-wing opposition, started its imperialistic adventure in Africa.

The most active architectural schools around 1890, alert and sensitive to suggestions coming from beyond the Alps, were in Naples, Bologna, Palermo, and particularly Milan and Turin. There a strong concentration of trades and industries and an extremely skilful craftsmanship stimulated the promotion of new artistic ventures as an expression of flourishing capitalism.

The year 1895 opened in a dramatic confusion. The revolution of the *fasci* in Sicily – the desperate protest of thousands of workers, bloodily suppressed by the army – and the defeat of Italy in Ethiopia invited meditation upon chauvinistic dreams of grandeur and desperate social realities. While Carducci thundered for military revenge in Africa,[10] Vittorio Pica proclaimed the 'new style' to be a rising 'Socialism of Beauty',[11] Pelizza da Volpedo started his famous picture 'Quarto Stato' as a symbol of social protest, and *Emporium* published the furniture of the Liberty firm, noting its good lines and modest prices. Beauty was not necessarily a privilege of the rich. This first period of the Italian Art Nouveau, which the Paris Exhibition of 1900 sumptuously concluded, was perhaps one of the richest in experiments.

This period of the last six years of the century included buildings in Palermo, Florence, Milan, and Turin. In Palermo in 1898 Ernesto Basile[12] built the Hotel Villa Igiea and the Villas Florio and Paterno. His mixture of Gothic, Mauresque, and Catalan – more to be expected in Sicily than on the mainland – created odd effects which had wittiness more than any sort of stylistic resemblance to Art Nouveau. But the critic Savarese in 1902 detected[13] in them a kind of classical inspiration, thus pleasing Basile who was now searching for a more severe national vocabulary. Actually, eclecticism of that kind, Romanesque, Gothic, Russian or Oriental, influenced by Viollet-le-Duc's theories of 'rational' architecture, was not an escapist solution but rather a necessary way toward a freer language of composition.

In this experimental period symmetry was abandoned, building materials were frankly exposed and worked with 'organic' gusto. Raimondo d'Aronco,[14] having experimented in this way in his design for the Milanese Porta Tanaglia, was working in Turkey where the anti-classical influences of the Near East softened – or corrupted – his severe vocabulary. Meanwhile, at home, a rationalist-eclectic mode following Viollet-le-Duc informed cast-iron kiosks and railway stations, especially in Bologna and in Rome, where Leonardo Paterna Baldizzi completed in 1899 a *palazzina* for the sculptor Ximenes near the Via Nomentana with simple lines and some structural frankness. But the fashion for a medieval structuralism had a short life. Official taste in Italy, supported by a deep stratum of public opinion, was for classicism, although completion of the unfinished cathedral façades in Florence and Milan had aroused a certain popular enthusiasm for historicism.

In Rome the problem was to find a compromise between the heritage of ancient Rome and the artistic legacy of the Popes, although the latter had been politically unpopular ever since Pius IX opposed the unifying of Italy. When in 1889 Giuseppi Sommaruga and Luigi Broggi[15] presented their design for a new Parliament House, they felt it necessary to explain that, the architectural tradition of the Caesars being unsuited to modern practical needs and that of the papacy being unsuited to the ideals of the Risorgimento, they had chosen to adapt Caesarian grandeur to present requirements as the preferable alternative. Giuseppe Sacconi's Victor Emmanuel Monument offered one solution by interpreting the idea of Rome in

Hellenistic guise as symbol of Risorgimento purity and ardour. Guglielmo Calderini resorted to heavy Tuscan and Imperial Roman borrowings to express in the Palace of Justice the severity of the Law. And in the rigid Piedmontese grid pattern of new residential quarters, multi-storey boxes reared for the new bureaucrats to live in were covered with monotonously repeated Renaissance details. It was the so-called *Stile Umbertino,* with Daniele Donghi's *Manual of Architecture*[16] in one hand and a wink at some enterprising monsignor, that destroyed the ancient patrician pleasure-grounds and gardens lying in Baroque abandon within the perimeter of the Aurelian Wall. It was then, with this greedy irrational occupation of vast green spaces, that Rome lost forever any hope of becoming a truly modern metropolis.

For architects still able to avoid classicism, and not interested in the sort of structuralistic interpretation recommended by Viollet-le-Duc, the Art Nouveau language, especially from France, was an acceptable compromise. Forms dictated not by function or by technique but by an elegant feeling for plasticity became the fashion particularly in Milan and Turin. The firms of Valabrega, Dellera, and Carlo Bugatti produced furniture inspired by Feure and Majorelle, without discarding whimsical cocktails of Slavic or Egyptian forms. Oreste Pisio and Giacomo Cometti[17] of Turin, though, remained attached to the English school of Voysey and Ashbee; with a taste for simple verticals and a genuine faithfulness to the nature of materials. Their furniture was basically linear with the curve only discreetly used.

In the personality of Pietro Fenoglio of Turin, perhaps the finest architect of those years, English simplicity and Victor Horta's inventiveness were mingled. After a beginning inspired by the Pre-Raphaelites, at the end of the century he designed three buildings – completed much later – that displayed a full mastery of the potentialities of the new trends: the *villino* of the Società Finanziaria Torinese, the Casa Pecco, and his own house (finished in 1902) – this last according to Rossana Bossaglia[18] probably the finest surviving example of Art Nouveau in Turin. Here natural forms were 'interpreted', not imitated: butterfly wings and dragonflies shaped windows, surfaces, balustrades, delicate curves animating the asymmetrical volume. Yet the interior spaces did not follow the outer sinuousity as Horta's did. The lesson of Antonelli, who designed, 'like working with glass', interiors that were outwardly perceptible, was forgotten.

Alfredo Premoli, also in Turin, was attracted by the plant-growth curves of Guimard, which also influenced Giovanni Michelazzi in Florence, in spite of his love for Early Renaissance forms. In Naples, Giovan Battista Comencini from Udine imparted a remarkable free vigour to the interiors of the Hotel de Londres, which combined Scottish verticality with French curvilinear lavishness. In this varied mosaic in Italy, a touch of the Baroque was bound also to occur. Genoa was the cradle of an extreme flamboyant version, academically and pompously treated. At the same time in the Palazzina Vitale, Annibale Rigotti experimented with a delicious Rococo.

Yet something new was in the air. Rigotti himself, with many others including the young Sommaruga, felt that a more rational discipline was needed. By the end of the century such a desire for rationality brought most of the various trends into two main channels, one inspired by the German and Austrian schools, the other engaged in *Floreale* versions of the Renaissance. Sommaruga, in the Milanese Villa Comi,[19] adopted the formula which he faithfully elaborated in most of his future works: a classic simplicity vitalised by asymmetries and excellent details, the bareness of masses relieved around openings by delicate or voluptuous efflorescence rigidly confined in rectilinear frames or bands. Rigotti, instead, had his eye on the *Secession* and the *Jugendstil.* His cultural alertness warned him that in the interchange between the *Floreale* and the Renaissance the latter was likely to prevail and expose the young vanguard to academic ambush. The work of Otto Wagner, Rigotti admitted, became his model. Annibale Rigotti was considered by

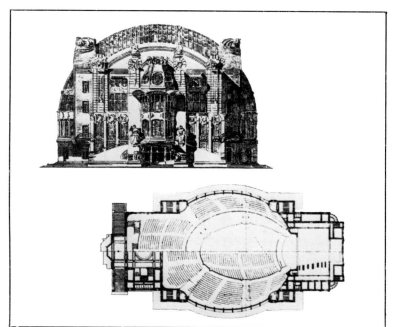

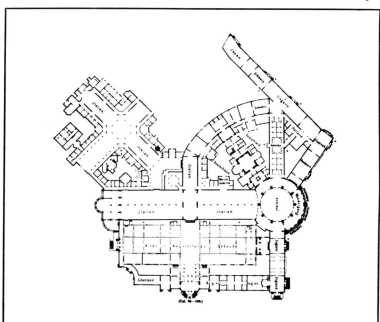

4. *Raimondo d'Aronco's preliminary design for the Turin Exhibition of Decorative Arts of 1902: the influential event that established Italian Art Nouveau internationally. This design was made in 1900.*

5. *Plan of the main building with central rotunda.*

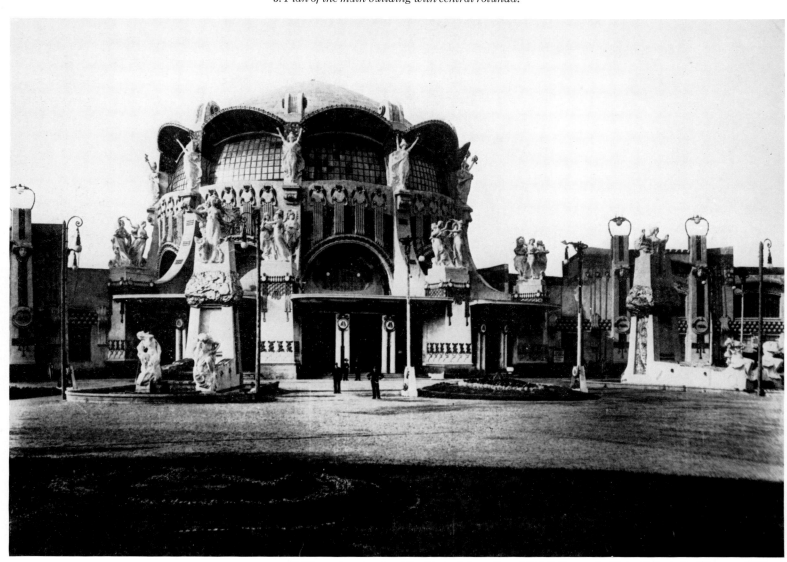

6. *The main rotunda of the Turin International Exhibition as built, by Raimondo d'Aronco, 1902.*

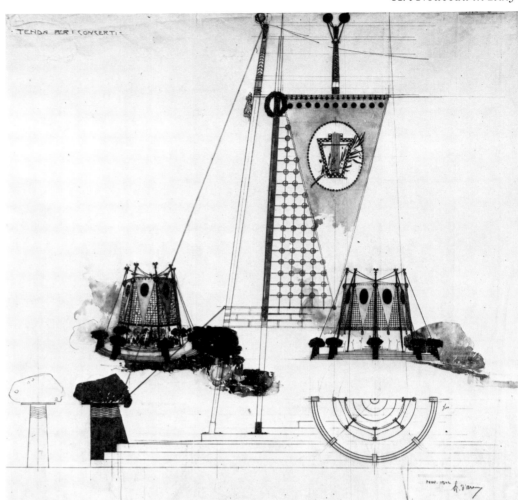

7. Design for the Music Pavilion at the Turin exhibition, also by d'Aronco.

8 & 9. Pages from the daily letters to Bonelli in which d'Aronco explained his designs for the 1902 Turin exhibition.

7

8, 9

many to be the leading figure in Turin, though he left few finished works; for his drawings – full of his personality – were widely published at home and abroad. Between the years 1893 and 1898 he executed in Turkey the railway station at Konya, and in Bulgaria the theatres of Varna and Sistow. At the beginning of the new century, in Turin, as supervisor of the erection of d'Aronco's exhibition pavilions while the latter was still in Turkey, Rigotti was involved in one of the most explosive events of Art Nouveau anywhere: the Turin Exhibition of Decorative Arts in 1902.

This event suddenly made a dramatic splashdown in the still waters of Italy's intellectual life. The genial and joyful lines of those pavilions gave a delightful shock to Italians and foreigners alike. Only two years before, at the Paris exhibition of 1900, Italy had been represented by Ceppi's much-praised imaginary reconstruction of the Basilica in Venice. Now it was suggested by Antonio Fogazzaro that 'Abandon memory all ye who enter here' should be written in Dantesque paraphrase on the entrance to the Turin exhibition. Italy had suddenly become an international leader.

Raimondo d'Aronco, the brilliant creator of this architectural exploit, was selected in 1900 by a committee that consisted of a small group of artists, architects and critics who felt that it was time for the modern style to be recognised. The *Studio* (16 June 1902) reported that the aim of the exhibition was to review the work of the past ten years 'by artists of various states of Europe and America inspired by . . . the movement inaugurated in England some forty years ago, in every branch of decorative and industrial art' The programme, that sounded like heresy to conservative guardians of tradition, was drawn up in inspired words: 'Nothing would be accepted but original work showing a decided effort at renovation of forms . . . every reproduction of historic styles would be rigourously excluded . . . every product exhibited of any industrial craft should be designed with true aesthetic feeling.' Another twelve years were to pass before Sant'Elia's Manifesto echoed such lucid ardent enthusiasm.

The ambitions behind the Turin exhibition were stimulated by the hope of finding the magic key that would convert industrial machinery into a modern cornucopia of beauty and grace for the benefit of the poor. Leonardo Bistolfi, who designed the exhibition poster, proclaimed the advent of Vittorio Pica's utopia, the Socialism of Beauty.[20] William Morris, Walter Crane, C. R. Ashbee, Horta, Lalique, Otto Wagner, Behrens, Eckmann, Olbrich, Mackintosh, Tiffany, and many others besides the most skilful Italian vanguard were invited to take part. But even before the exhibition closed it was realised that beauty was expensive. At least in Italy. There was a twofold ambiguity about such a utopia, paternalistic and naïve at the same time: an aristocratic beauty was to bring salvation to the masses; and an aesthetic movement rooted in intellectual ideas not in precise market demand was to persuade industry to engage in high-quality, low-cost production. Italy was not prepared for the industrial production of commodities. That was not to happen until after the First World War. Besides that the hope of reviving the all-creative, all-powerful Renaissance artist was not compatible with the logic of industrial design. A world well balanced for the artisan to derive inner satisfaction from producing a totally finished product – the utopia of Robinson Crusoe shaping his environment with his own hands – could not marry industry's repetitiveness and economy. The democracy of aesthetic well-being was still a dream. Nevertheless, this collection of international works, so wildly various and of such quality and all inspired by such an ideal, assured for the Turin Exhibition of 1902 unusual importance in the history of art.

D'Aronco's pavilions superbly complemented their contents. At the beginning of 1901 he completely revised his first design (published in the magazine *Memorie di un Architetto* in 1900)[21] which had repeated the Baroque vein of his project of 1894 for the First Ottoman Exhibition in Constantinople,[22] yet with some sur-

prisingly modern details such as cantilevered slabs and cable-suspended structures. Now his language became more coherent, almost severe within a joyful exuberance. He designed the whole complex from his office in the hills of Pera, in Constantinople. In Turin, Rigotti developed the drawings, the engineer Ernesto Bonelli was in charge of construction, and Filippo Vacchetta executed the pictorial decoration; and this faithful and skilful team successfully carried out d'Aronco's ideas for a stream of changes and additions requested by the organising committee, the press and local politicians. The original scheme grew continually. To the symmetrical purity of the main building, dominated by a vaulted rotunda, galleries and arcades were later linked in a rambling way. Additional pavilions were commissioned only a few months before the opening, d'Aronco meanwhile being almost suffocated by an enormous task of reconstruction after an earthquake at Constantinople. For more than a year up to March 1902 he kept up a daily correspondence with Bonelli; in these letters, entirely preserved, he carefully explained his plans, pedantically illustrating and commenting on every detail, inspiring enthusiasm in his colleagues, strenuously opposing any gratuitous change.

D'Aronco considered the rotunda to be the outstanding part of the whole exhibition. In a letter dated August 15, 1901, giving instructions to Vacchetta for the design and the choice of colours of the *Floreale* decoration of its interior, he added: 'I was inspired by the dome of Saint Sophia . . . its dark-yellow background resting on a luminous base . . . like an immense sail pushed by the wind, floating in the air, only anchored by slender supports to the upper cornice . . . flooded by a golden light . . . I should like to attain the same effect.' At the end of August the design for

10

11

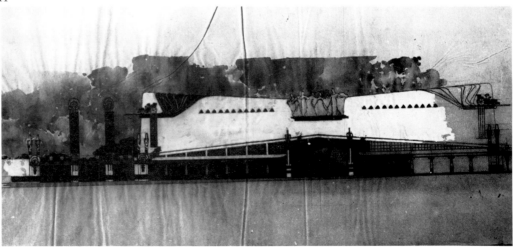

10. D'Aronco's design for the Automotive Pavilion at the Turin exhibition – a complete departure from traditional forms.

11. D'Aronco's design for the entrance to the Gallery of Furniture. The hand-written note at the bottom reads, in translation: 'Do not deny us that freedom that you have always accorded'.

the outdoor pavement leading to the rotunda was completed: 'the geometric paving will be made of white and green cement . . . and for the flowers you must have geraniums and poppies.' By September the rotunda was almost done, its tense floating dome anticipating the lightness of thin shell structures.

Then the restless committee gave d'Aronco an unexpected chance by commissioning still another pavilion, this time for 'automotive' exhibits (that is – already – motor-cars). It was to be the best building of all. The design was conceived in a week, the details of construction sketched in letters to Bonelli: a very simple space was screened by a semi-transparent, structurally tidy, façade, its lines converging to the centre like butterfly wings. While the rotunda was a classical organism, the new addition clearly declared its transience. Its clean volumes were enlivened by abstract 'graphic' reliefs and a Klimt-like colour scheme: gold, blue, pale green on a white background.

In December, encouraged by Bistolfi, d'Aronco realised his concept for the main entrance: short dynamic towers intersected by energetic square slabs. In January 1902 he detailed all the light fixtures and designed another small pavilion dedicated to photography. In February there was one more addition, a gallery of furniture for the main building. D'Aronco seemed to be stimulated by difficulties. The curvilinear entrance, he specified, was to be illuminated by 'rings of fire' connected by invisible supports to an antenna. At the foot of it was to be a tent-like tapered toy, a pigeon-house 'to give a bit of life . . . and if to the pigeons you could add two peacocks, then it would be perfect!' His frank enthusiasm changed to desperation when he returned to Turin in May and found many details badly done. Nevertheless, this work represented the very best architectural achievement of the entire Art Nouveau in Italy. And, for a moment, it catalysed genuine hopes for drastic renovation of the country's academic, provincial cultural habits.

The Exhibition of 1902 was, in a sense, the culmination of a long dramatic fight for democracy and dignity that united intellectuals and the working class. The idea of such an exhibition was generated in the shining hopeful moment following the tormented period 1897–1900. In the winter of 1897, the Ethiopian emperor had returned his Italian war prisoners; their disembarkation at Naples took place secretly in the night for fear of popular reaction against their defeat. A delayed reaction in 1898 was a nation-wide workers' revolt against rising unemployment and taxation, supported by a revolutionary Socialist Party. When the army was sent to put down the rebels, the wave of strikes became civil massacres. Milan, Bari, Bologna were placed under martial law, and a strong leftish wing in Parliament, supported also by Gabriele d'Annunzio,[23] strenuously opposed this military government. Then at Monza in 1900 King Umberto was assassinated by an anarchist. In the grim shadow of that event was announced the programme of the new monarch, Victor Emmanuel III: a return to the liberal ideals of the Risorgimento, freedom for the 'irresistible rise of the working classes'. The idea of a Socialism of Beauty, the rejection of past architectural styles, d'Aronco's unconventional pavilions, all belonged to this new bright atmosphere.

Yet only two years later the country was sliding towards an authoritarian form of pre-Fascism again. Once more proletarian protest was brutally repressed, this time not only by soldiers and policemen but by privately organised squads of scabs and terrorists, forerunners of Mussolini's militia. In 1904, the Papacy decided to enter the political arena. In the ensuing elections, conservatives crushed the progressives in a defeat that was to last about forty years. The first time in modern Italian history that a high Vatican official took part in a civic event was on the occasion of the ceremonial opening of the Milan International Exhibition of 1906. Now the art magazine *Nouvissima*[24] had become the arbiter of fashion: extremely sophisticated, graphically inspired by the *Jugendstil*, it consistently and skilfully propagandised the need for an italianised art instead of 'international taste and the insane abandonment of tradition'. One of its collaborators was Enrico Corra-

dini, pre-Fascist doctrinaire editor of the paper *Il Regno*, known for his vindictive war-slogans that were to be revived in the rhetoric of Mussolini. 'We are a proletarian Nation, and Nationalism therefore is our Socialism' was one.

But the nationalism that inspired the Milan Exhibition was far from proletarian, being conceived as a celebration of the new establishment. Stylistic compromise moulded the sugary cakes of the pavilions, mostly inspired by the Paris Exhibition of 1900 and the St Louis Exhibition of 1904. Sebastiano Locati,[25] coordinating site plan and architecture, imitated Gilbert and Paulin, and in the main entrance the Hellenisticism of Sacconi, as well as details from Paulin's Château d'Eau and Girault's Petit Palais. Bianchi, Magnani and Randoni masked honestly designed steel structures with orientalised mannerism. The Socialism of Beauty was nowhere. Italian art was to be expensive, plutocratic, nationalistic and Baroque. Among the stuccoed banalities was one truculent presence: the S. Pier d'Árena Pavilion of Gino Coppede, a ferocious but personal interpretation of the aggressive potentialities of metallic construction. So the only truly original contribution was an extravaganza – a trait typical of the contemporary Italian mind. Indeed the new Italian originality was defined by the magazine *Edilizia Moderna*[26] as something 'which is not precisely the Modern Style, but deriving from the Renaissance, has an affinity with foreign examples but in a different mood'.

Such a 'mood' consisted primarily in the skin-deep *Floreale* treatment of classical organisms and mouldings. Provincial towns, in general, had a taste for the *Floreale* Baroque. The Milan pavilions of Locati[27] – a very minor architect himself – expressed this peripheral culture, its delayed receptivity to stimuli from the cities, its hesitations and slight suspicion of modernity. Widely published French models, syntactically similar to classical ones, were considered both up to date enough and agreeable enough for both private and public buildings, in a reliable mode of design that provided adventure without risks. Carbone[28] and Gussoni[29] in Genoa well represented this trend, which in the southern parts of the peninsula went in more for orientalist and Mauresque whims. An example of such a taste was the Villa Calderari in Rome, designed by A. Calcaprina:[30] a rigid, dryly cut volume adorned by a pastiche of friezes and exotically flaring cornices, and by stucco-reliefs combining Endell's type of decoration with the shapes of Hankar.

12. The Milan exhibition of 1906, in which Bianchi, Magnani and Randoni masked their steel structure with stylized ornament, representing a retreat from d'Aronco's pioneer conception four years earlier at Turin.

The most sophisticated cultural groups, in the major cities, were very sensitive to German influence. Peter Behrens's work had a great reputation in Italy, and his designs appeared in the Turin Exhibition of 1902. With the insecurity of those who are searching for a dignified image of themselves, Italians were fascinated by his strict formality. As Rossana Bossaglia[31] noted, his sphinxes were immediately imitated all over Italy, taking the place of caryatids. His formula for brutal simplification of the classical organism, shaved to complete bareness, was to be welcomed most in Italy by academic designers. At first this modernised classicism was softened with sculptural light and shade, but later the Duce's architects erased such bourgeois feebleness. All the Case de Fascio until the 'forties, with their red plaster walls and white travertine bands, imitated Behrens's designs of the first decade of the century. His dry simplicity also affected Italy's three most important buildings of that period: Giuseppe Sommaruga's Palazzo Castiglioni[32] of 1903, Ernesto Basile's addition to the Palazzo Montecitorio (1904–11)[33], and Gaetano Moretti's Hydro-electric Power Station of 1906 at Trezzo d'Adda.[34]

The Palazzo Castiglioni, in Milan, was considered to be revolutionary. This opinion did not derive from the little scandal of the aggressively contorted female figures originally flanking the entrance[35] – others were soon substituted for them – but primarily from the plain bulk of the whole and the variety of sculptural elements extruded, as if growing, from the structural surfaces. Its appearance of inner strength and frankness was, at that moment, quite shocking. The asymmetric end bays set back on the top storey emphasise the basic symmetry of the main volume under its robust cornice that acts as energy-giving focus for the whole composition. This façade seems to have been generated by the counterpoint of two opposite and simultaneous actions. The one, imposed from without, cut into the block its severe angular openings; the other pushed from within exuberant sculpture that emerged from the secret crevices of the stones like the efflorescence of volcanic magma. Such a sculptural theme oscillates between the delicate 'stone moss' covering the Romanesque façade of San Zeno at Verona and Bernini's dynamic *non-finito*. Other elements, sculptural and architectural at the same time, such as the loggia columns and the connecting bandage-frieze, seem to be inspired by oriental traditions.

Indeed, one of the recurrent Western fascinations with Asia prevailed in Europe and America in the first decade of the century. Italy was certainly involved with the Orient. Old channels of trade were revived: Italy could provide few mechanical products but much artistic production and some technicians. D'Aronco worked in Turkey, Rigotti in Bangkok. Barzini and Borghese travelled overland from Paris to arrive triumphantly in Peking. To obtain a commercial concession in Tientsin, the Italian army took part in the international suppression of the Boxer Rebellion. Italian art absorbed some superficial orientalism. In general, the mingling of the Far East with the Baroque *Floreale* was nothing more than fashionable snobbish playing. Yet orientalism in the hands of men like Sommaruga and Moretti and Basile became a polemical instrument against classicism and a vehicle for structural experience.

Sommaruga, in many funerary chapels and in the competition project for the government palace at Montevideo, adopted a pyramidal stepped composition with an exposed structure consisting of superimposed, interlocking elements of carefully sculptured stone. His main sources seem to have been the temples of Angkor-Vat in Cambodia and Hindu religious buildings of the tenth to the fourteenth century. A volume is conceived as a stratification of large building elements, carefully and dramatically embedded and mutually entangled, dominated by many horizontal bands and a few vertical ones, animated by forceful technical details and varied surface treatments confined within the limits of individual stone monoliths.

Moretti's Power Station derives as much from the East as from Behrens's severity. Its elongated volume, reflected in the water and divided into wide, well-

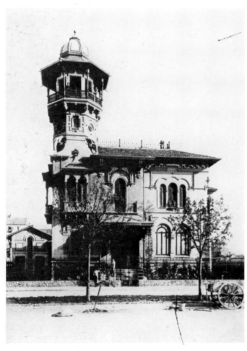

13. The Palazzina Francetti-Frova at Milan, by Sebastiano Giuseppi Locati, exemplifying the 'Floreale' style.

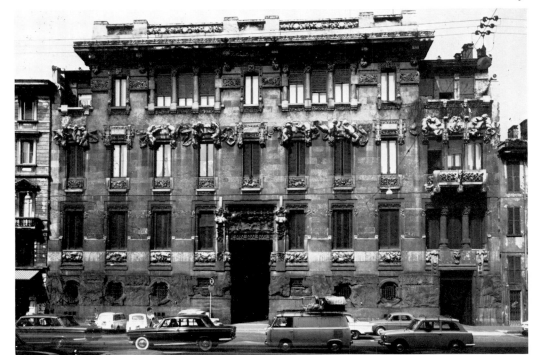

14

14. *Giuseppe Sommaruga's Palazzo Castiglioni,*

Corso Venezia, Milan, 1901–3, one of the most influential Italian buildings of its period.

15. *Palazzo Castiglioni: frontage facing the Via dei Baschetti.*

16, 17. *Interiors showing characteristic sculptural detail.*

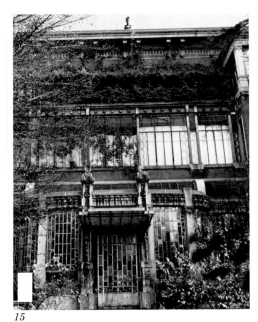

15

16

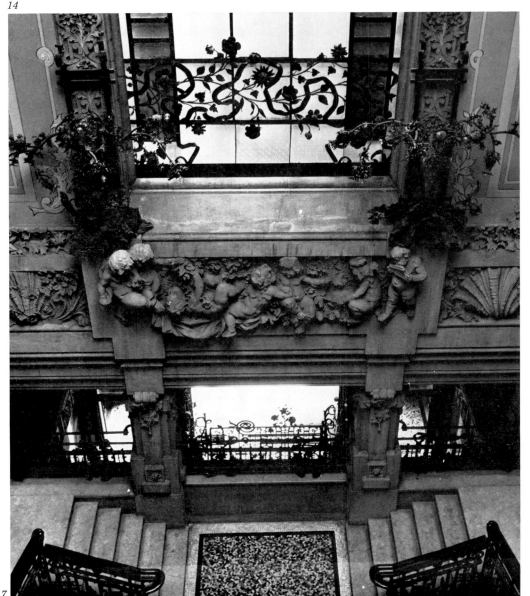

17

proportioned units, resembles a Mogul palace. Each module is generated by a deliberate multiplicity of structural details. This almost obsessive repetitiousness, as in Hindu temples of Madura or in the Deccan, paradoxically regains unity and simplicity by means of *horror vacui.*

This trend is far from the Gothic Revival, not because voids never dominate masses, but primarily from a congenial indifference toward identifying the inner dynamic energies of structures. The Italian mentality was too solidly anchored to the Renaissance to abandon classical serenity entirely, or to express the drama of an architectural organism fighting for a tense balance, as in the work of Gaudí. The Italian melodrama was epidermic, superficial, intended to produce rapid catharsis. Italian structuralism was therefore above all a constructivism emphasising the way in which a classically conceived building was actually put together. Constructivism and a sense of a serene classical cleanliness are particularly evident in the modular and simple volume of Basile's Parliament House (added to Bernini's Montecitorio) in Rome. Perhaps Basile had already purged his early orientalism in Sicily and now preferred anti-rhetoric with a strong classical theme. His constructivist research was expressed by a breaking down of elements according to function, analysing especially the differing role of supporting and supported members. This analytic method was to be revived after the Second World War under the influence of Scandinavian examples. In his time, Basile's work was considered extremely daring: in one of the nation's most representative buildings to discard the official formula. It was also a fighting criticism of the empty stage-set of Sacconi's Monument to Victor Emmanuel, called the *Vittoriano,* still then in the process of being built. Sacconi's style was even more directly censured by Sommaruga, when he ironically adopted the complete Vittoriano repertory of forms for

18. Addition to the Palazzo Montecitorio, Rome, by Basile, 1904–11.

the plaster-and-cardboard architecture of the Italian pavilion at the 1904 Exhibition in St Louis.

The Vittoriano became the thermometer of intellectual and political temperature in those years. Cesare Lombroso, bitterly criticising Italian psychology in his *Il Momento Attuale*,[36] sees his compatriots swinging from wretchedness to megalomania, the latter symbolised by the Monument to Vittorio. On the occasion of the Turin Exhibition in 1902, Enrico Ferri, editor of the Socialist paper *Avanti*, was writing: 'The Vittoriano Monument is a classicist rumination, inferior – artistically as well – to Victor Horta's Maison du Peuple.' Later, in 1911, when the Socialist party had lost little by little its revolutionary drive, and Sacconi's white marble mountain was inaugurated, Ferri commented with unintentional realism: 'This monument symbolises our Country . . . contemporary Italy does not display within modern civilisation any new and original character like Germany, North America or Japan . . . she is a noble orchestration of historic social forms and renewed traditional energies.'[37] That is, a country of progressive conservatives working within a revived tradition. Exhibitions in 1911, celebrating the first fifty years of national unity, summed up this monumental compromise, a compromise that deformed Italy's official face, while fresh unconventional efforts – like the Futurist Manifesto – were germinating.[38]

In 1911 Italy – with a population of thirty-four million of whom half could not read – was rapidly approaching a war with Turkey over Tripoli. Both conservatives and progressives converged on the path to war. The official intelligentsia rationalised a war policy in the name of the 'imperishable glory of Rome', while a verse in d'Annunzio's play *The Ship,* 'Let us make of all seas, the *Mare Nostrum*', poetically inflamed nostalgic dreams of a revived Roman Empire. The political struggle now was fought primarily outside Parliament by organised squads, protected by the police and financed by industrialists and landowners: the future nucleus of Fascist reaction. On the other side of the barricades, the Futurists, whose programme despised everything existing in the present, decided for the 'futuristic reconstruction of the Universe'. War they adored as 'sole hygiene of the world', its goal the total annihilation of the existing establishment. Battleships went to the

19. Hydro-electric power station at Trezzo d'Adda, by Moretti, 1906.

Aegean to intimidate the decadent Ottoman Empire, and war against Turkey for the conquest of Libya was begun.

In that moment so full of warlike rhetoric, Sommaruga's work, contesting tradition and the Renaissance, presented a remarkable statement of spiritual independence. So the less conservative wing of Italian architects considered Sommaruga the only personality able to translate modernism into acceptable terms. Milan was the most fertile ground for Sommaruga's stream of followers: among them the young Sant'Elia[39] and Ulisse Stacchini, the future designer of the Milan Railway Station. The Sommarugan trend found official celebration in 1912, in the results of the competition for a New Monumental Cemetery at Monza. Stacchini and Sant'Elia – the latter in collaboration with Italo Paternostro – took part.[40] Both designs are obvious offshoots from Sommaruga's work: low horizontal masses dominated by pyramidal forms emphasising either an entrance or the crossing-point of rectilinear volumes – a typical orientalising organisation. In both designs Sommaruga's structuralist approach – the accurate identification of each element of the building-assembly – becomes the obstinate quality of the whole. Stacchini's design was more involved with classicism and less inventive; sculptural details seem to corrupt or to put a brake on the structuralist impetus. In Sant'Elia's magnificent drawings for this competition, sculptures emphasised instead a dynamism already embryonically anti-classical. His grandiose volumes, in spite of their expressionistic brutality, are crisp and rational. Those characteristics appear in Sant'Elia's later drawings: persistent use of pyramidal forms and well-defined energetic masses and a lucid, analytic treatment of surfaces reminiscent of the drawings of Otto Wagner, while confining ornament in geometric frames in Sommaruga's manner.

Stacchini, too, retained his Sommaruga-derived vocabulary, but his vision of space evolved away from dynamism towards the static and the grimly monumental.

20. Sommaruga's competition design for the government palace at Montevideo, about 1909.

In 1912 he won the competition for the Milan Station over the quite lifeless entries of Boni-Radalli, Giovanni Greppi and Dovara-Laveri-Avanti. This competition demonstrated how far technology was from the cultural attitudes of contemporary Italian architects and what virulent reactionary Baroquism pervaded the official iconography for public buildings. Stacchini's design, evoking something of Eliel Saarinen's project of 1904 for the Helsinki station, was certainly the best and the least vainglorious. Only in 1918, after the First World War was over, was construction begun. No remarkable changes were made in the original design, although the whole was slightly revised, under the influence both of Behrens and of a stronger taste for the *Floreale*. Thus exterior mouldings lost most of their constructivist logic to become decorative, while interiors acquired the tenebrous monumentality of the German master.

Lack of coherence and eclectic confusion characterised the artistic personality of Sommaruga himself. Contemporary critics were aware of that. The monograph dedicated to his memory (published in the December 1917 issue of *Emporium*)[41] recognised his pure volumetric intuition of architecture, but blamed his 'search for

21. Competition design for a cemetery at Monza, by Antonio Sant'Elia, 1912.

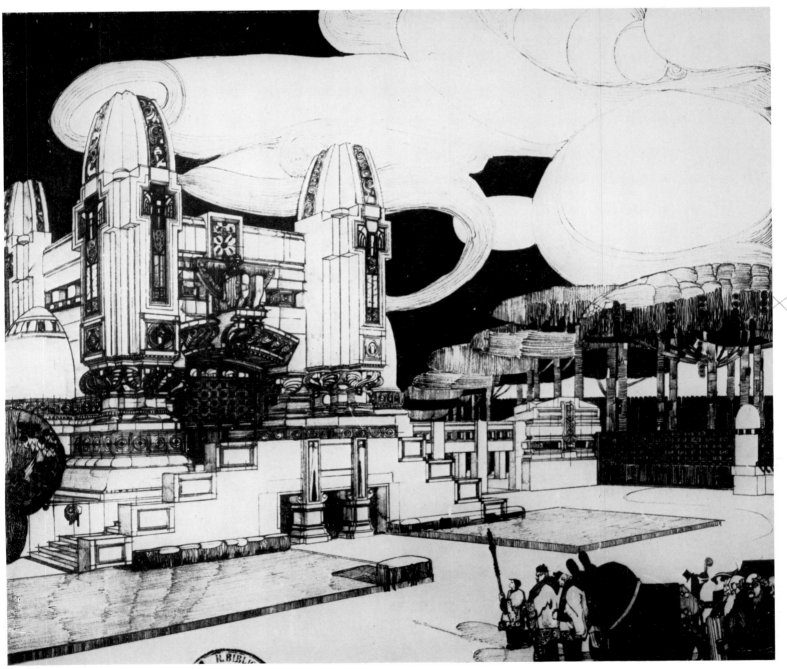

plastic richness . . . for an abundance of plant forms diminishing the original strong cutting of the masses'. After the Palazzo Castiglioni, perhaps his most consequential work, Sommaruga executed in Milan *c.* 1907–09 the elaborate Villa Romeo, a work superbly detailed and extremely pleasant on the whole; yet its marriage of the *Floreale* with constructivism is awkward. An excessive number of sculptured human figures seems to hang on the skilfully treated volumes without belonging there. In 1912 he started his last and most grandiose work, the Grand Hotel Tre Croce, at Campo dei Fiori, near Varese. A rigidly articulated volume seems to fight inelegantly against interior pressures. Details designed in superb constructivist language are so numerous that they war with one another. The building gives the feeling of a fierce medieval castle full of mysterious ghostly corners, evoking Piranesi's gloom in the entrance porch, or the monstrous phytomorphic plasticity of Gaudí or Guimard in various balconies and the undulating upper terrace. Impressive though it is, this building is more a collection of restrained intentions than a single statement.

Sommaruga was important on the Italian scene just then because he tried to find an acceptable meeting point between advanced European trends and Italy's attachment to classical tradition. When he was in the process of designing the Palazzo Castiglioni and travelling in France, Belgium, Austria and Germany, he understood that modern culture meant the abandonment of any idea of style – that is, style as a body of predetermined signs – in favour of expressions whose validity must be sought in the essential functions of a building. From the modern trend that considered language as something to be newly invented in each new situation, the Italian mind turned away in search of a system of codified elements to be organised in a well-balanced composition. The quality of Sommaruga's best work was mainly based on volumetric purity and an honest sense of construction. It was a delicate and dangerous balance that, like every compromise, had either to be quickly evolved or suffered to degenerate. This position was particularly dangerous where traditionalist forces were officially sustained by the central political power. With the exception of the St Louis Exhibition, Sommaruga never participated in the major public works of Italy.

At the end of the first decade of the century, as his performance on the tightrope became less sure-footed, no other corresponding personality capable of translating new ideas into Italian terms appeared. The role of Sommaruga could not be in-

22. Stacchini's winning design in the competition for the central railway station, Milan, 1912.

23, 24. *The Villa Romeo, Milan, by Guiseppe Sommaruga, 1907–12.*

25, 26. *Grand Hotel Tre Croce, near Varese, by Sommaruga, 1907–12.*

27. *The Mausoleo Faccanoni at Sarnico, by Sommaruga, 1907.*

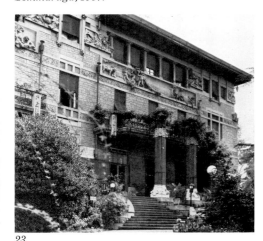

23

24

25

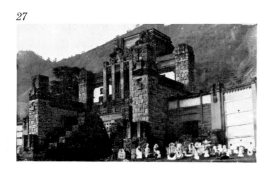

27

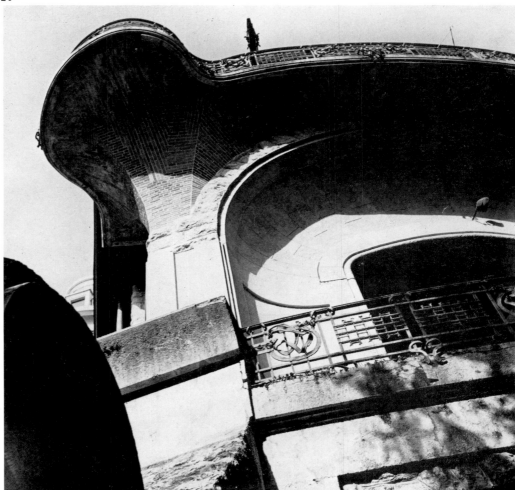

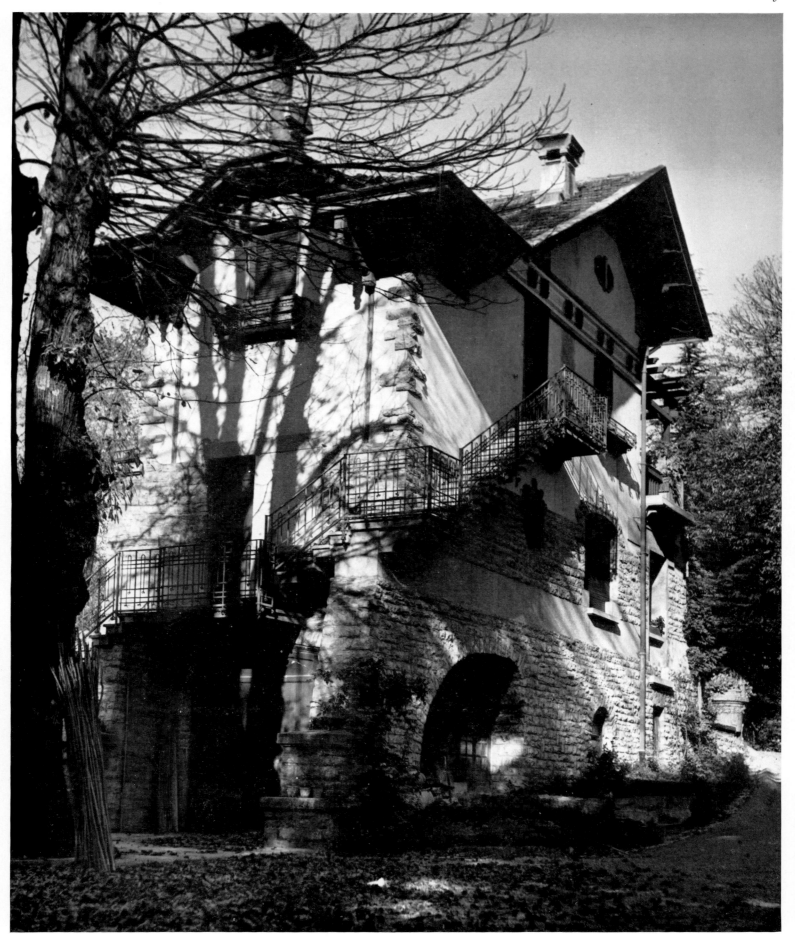

28. Villino Poletti at Portineria, by Sommaruga, 1915.

herited either by Rigotti or by d'Aronco, both being on the periphery of the State's official artistic policy. In 1908 Italy took part in the well-known exhibition of modern architecture in Vienna. In a pamphlet *Opere di Architettura Moderna,*[42] on this exhibition, Ugo Monneret de Villard complained that the best Italian architects, including Rigotti and d'Aronco, were not invited to represent their country and that the Italian entries consisted of the pastiches of Calderini and Sacconi along with restorations of medieval and Renaissance buildings. Moreover, said he, this was not the fault of the organising committee: 'There is a much higher offender, that offender that we always find whenever we consider the development of the arts in Italy: the Government . . . It was not an exhibition of modern architecture but rather . . . a pathological display . . . of moral decadence . . . almost comical.'

Particularly striking was the position of d'Aronco, when we consider the undisputed success of his pavilions of 1902 at Turin. He became an outsider in the cultural milieu of his own country precisely because the best characteristics of that work denied the traditional concept of style. In 1902 he was importing the most brilliant and vivacious spirit of the Austrian school, an interesting but incomprehensible lesson for Italians. Daniele Donghi's opinion reflected the general view: 'The Arte Nova is not a new thing . . . indeed, thoroughly dissecting the new forms, we cannot find those elements which – either in a structural or in a decorative sense – gave life to the Styles' (*L'Architettura pratica*, 1903).[43] In Turkey between 1901 and 1907 d'Aronco did his best work, other than the Turin pavilions: the 'fountain and library' at Yildiz, the mosque in Karakeny Square at Galata, the Santoro house at Pera, and the house at no. 6 Anadol Street in Constantinople.[44] The maturity of the designer, with his international experience, especially his familiarity with Austrian and Belgian work, and the influence of the East expressed without sentimentality or triviality, are the outstanding qualities of these works, probably the best by any Italian architect before the First World War.

Yet their influence in Italy was nil. His main pavilion of the National Exhibition at Udine of 1903, a classic of Art Nouveau, belonged culturally and geographically more to Austria than to Italy. D'Aronco came back in 1908 during the Young Turks' revolt which eventually dethroned his protector Abdul Hamid. D'Aronco was soon deep in the mounting classicist reaction in Italian architecture. Now Basile's constructivism appeared like an heretical parenthesis, while Cesare Bazzani's classical *Floreale* of the new National Library in Florence represented the official Italian style. Other architects too, Armando Brasini and Pio Piacentini, were ready to become the interpreters of the Fascist regime, finding in Mussolini continuity from pre-war authoritarianism and imperial ambition. The first work d'Aronco was offered in 1908 certainly contributed to his renunciation of modern research. It was the commission for a town hall at Udine, to be inserted in one of the most celebrated historic piazzas of the peninsula, renowned for its classical harmony. Representative theme and environmental problem determined the architect's choice of classicist language, parsimoniously enlived by a few *Floreale-Secession* details. He justified his abdication from modernity, reporting on the building in 1911, thus: 'It was the most important building put up in Udine for centuries, in the very heart of the city, close to noble monuments. With ancient audacity, we wanted to make this building the tangible sign of our time . . . symbol of continuity . . . that would not look out of place near works inherited from the fifteenth, sixteenth, and seventeenth centuries. A terribly ambitious task that could only be truly carried out by a Renaissance artist with a very large sum of money.'[45]

D'Aronco lived until 1932 but, so far as the international scene is concerned, he actually disappeared when he left Turkey and the free expressive vein he found in that milieu. After his repatriation, although he was elected to the House of Representatives and became a professor at the University of Naples, he never really

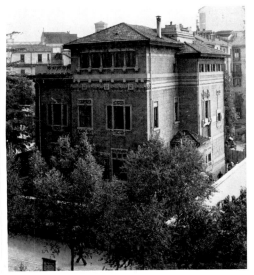

29. *Palazzina Salmoiraghi, Milan, by Sommaruga, 1906.*

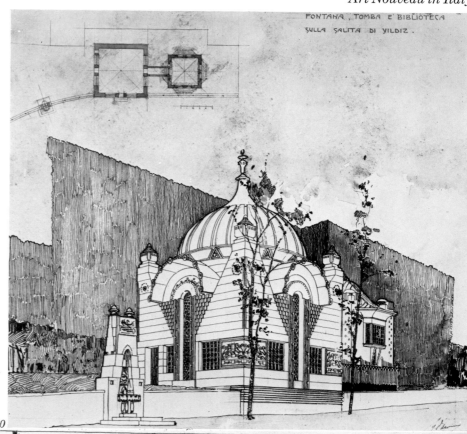

30. Design by Raimondo d'Aronco for a fountain,
tomb and library at Yildiz, Turkey, 1907. Some
of d'Aronco's best work was done in Turkey.

31. Project for a 'Casa degli Amici dell'Arte' at
Turin, by Annibale Rigotti, 1907.

31

30

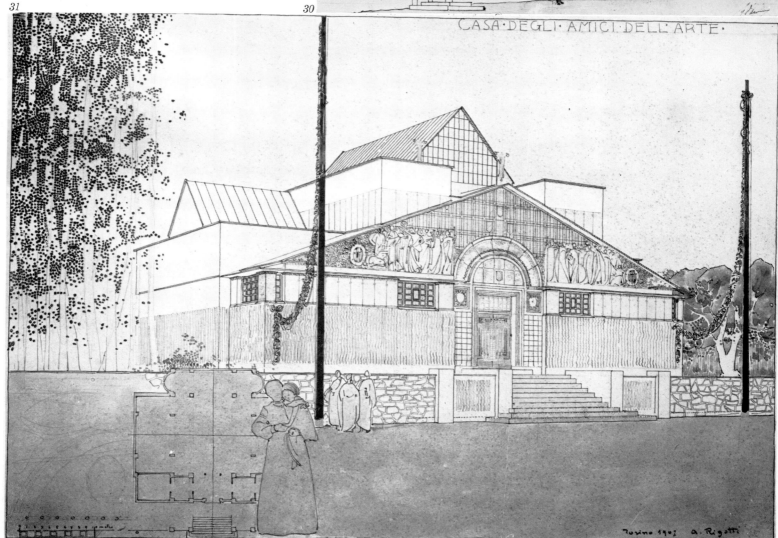

took part in Italian political or cultural life. His latest work was thoughtful, correct, and nostalgically romantic: an honest but ineffectual way of opposing the truculent Baroquism of the new Italy.

On the threshold of war, in 1914, Sant'Elia proclaimed his Manifesto for a Futurist Architecture. With the support of the *Nuove Tendenze* group he exhibited in Milan his programmatic drawings. The event went unnoticed by most of those who had been involved in the Art Nouveau debate – noticed least of all by architects. Not one of them was able to recognise in Futurism the only valid alternative to the existing cultural crisis, even an extension of their own ideas. Indeed the Futurist programme, not based upon accepted models but deriving from a method of research, openly denied any traditional conception of 'style'. Therefore it aroused suspicion, hostility, and the accusation of superficiality. The truth of the matter was that no intellectual awareness of any philosophic principles in Art Nouveau had ever really developed in Italy, among either artists or critics. Futurism had actually absorbed two important elements from Art Nouveau: the expression of dynamism and the dream of the total artistic construction of the human environment. The Futurist revolution consisted in applying these ideas of integration to the totality of life. Thus dynamism was represented, not only by energetic winding lines in the visual field, but as a concept extending to every field of human activity including ways of thinking. Within the Futurist concept there was also an urban vision of the expressive power of all communication-streams and the calculated transience of structures. Dynamism might become, not just an aesthetic symbol, but the basis of a comprehensive philosophy. Also, the demiurge of the artist to design in every detail each part of the human environment, a function propounded particularly by van de Velde and Saarinen, was translated in Futurist terms into the 'total reconstruction of the Universe'. Thus the integrating effort of Futurism might have extended beyond the mere planning of a tridimensional physical world, into every aspect of art and life, from literature to city planning, from painting to music to politics. Futurism saw life as a unit, and the unity of the arts – as in the dreams of Art Nouveau – was to be found in the spiritual union of thought and action. The heroic consequence of such a theory was Sant'Elia's and Boccioni's death at the front: a tribute paid to the Futurist ideal of purifying war.

One of the most significant contributions by the Futurists was the attempt to integrate architecture and urban planning as parts of the same vast process of planning social existence. In this way, theoretically, Futurism could have represented the link between Howard, Garnier, Geddes and Italian culture, by virtue of its integration of the three basic urban ideas crystallised at the beginning of the century. Indeed, in the multifaceted programme of Futurism, the ideal cities of Howard and Garnier, the first conceived as an instrument of social reform, the second as the most rational expression of an acceptable and perfectible society, could have coexisted with the more scientific approach of Geddes. But the utopia of the Futurist city always remained a literary dream, a magnificent sketch in highly inspired words never worked out as a design. There was an obvious discrepancy between Sant'Elia's manifesto and his drawings. Many of his ideas, particularly those concerning motion and programmed transience (or built-in obsolescence), did not find their urban and architectural expression until the 'fifties. Sant'Elia adopted almost completely the vocabulary of Art Nouveau; his originality consisted primarily in the dynamic organisation of architectural masses and in their interpretation in technological terms. Nevertheless, the structures in his drawings neither have the fragility of temporary objects nor fit into any coherent urban pattern.

The shortcoming of Futurism reflected a more general cultural reality; in Italy there was no valid background from which vast modern town-planning ideas could develop. Such a consciousness, restrained after the First World War by

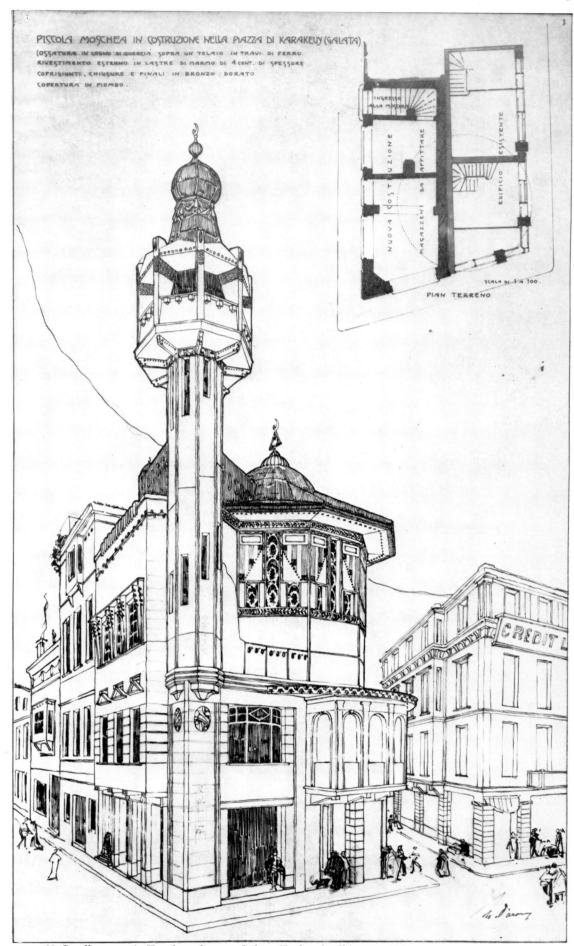

PICCOLA MOSCHEA IN COSTRUZIONE NELLA PIAZZA DI KARAKEUY (GALATA)
(OSSATURA IN LEGNO DI QUERCIA SOPRA UN TELAIO IN TRAVI DI FERRO
RIVESTIMENTO ESTERNO IN LASTRE DI MARMO DI 4 CENT. DI SPESSORE
COPRIGIUNTI, CHIUSURE E FINALI IN BRONZO DORATO
COPERTURA IN PIOMBO.

32. Small mosque in Karakeny Square, Galata, Turkey, by d'Aronco, 1907.

Fascist pressure, was not stimulated as in other countries by an industrial revolution originated by free enterprise. Italy's delayed industrial development was rather timid at first, and at its height completely conditioned by the State.

It is immaterial whether or not a type of urban planning belonging peculiarly to

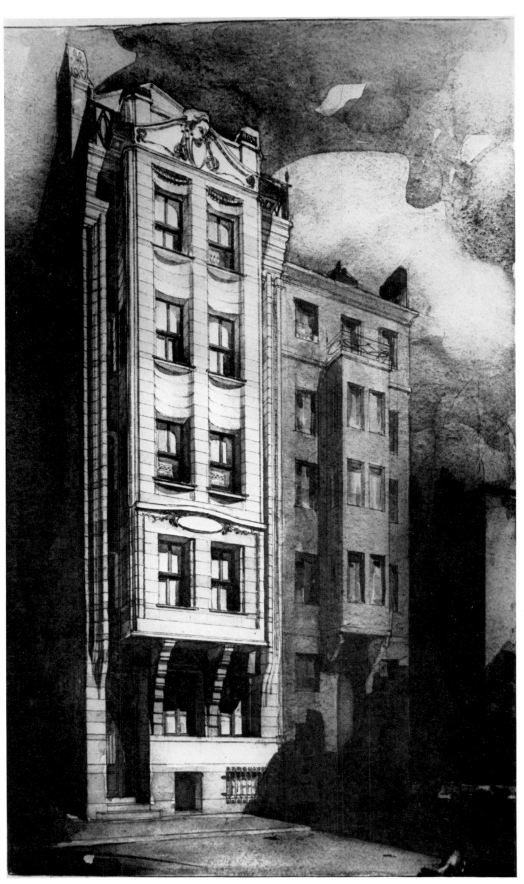

33. House in Anadol Street, Istanbul, by d'Aronco, 1907.

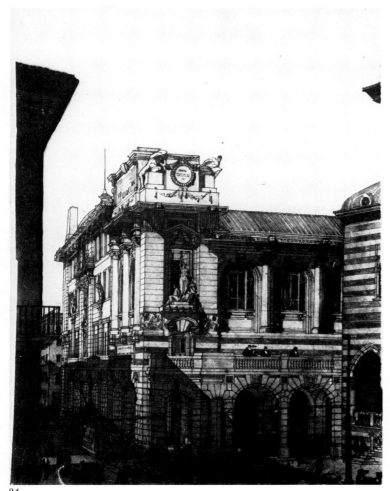

34

35

36

34. *Town hall at Udine, by d'Aronco, 1908, marking his renunciation of modernism.*

35. *A late example of the 'new style': the Casa Fonda in Trieste, by Umberto Fonda, about 1913.*

36. *D'Aronco's main pavilion at the National Exhibition, Udine, 1903, a classic of Art Nouveau.*

Art Nouveau could be isolated. Perhaps Art Nouveau, centred upon aesthetic preoccupations, did not generate any modern sense of urbanism. Nevertheless, between the years 1895 and 1915, urban expansion and renewal activities were quite numerous in Italy. A few new towns were built: Milanino,[46] conceived on a radiocentric pattern of merely aesthetic Baroque origin, failed on the functional level with an insufficient communications network. This is not surprising, Italian city planning of those years being still attached to formalist visual schemes and incapable of technically facing vast organisational problems. The planning of the major cities, Florence, Milan, Rome, Naples, oscillated between Haussmann's drastic solutions and the functional distribution of self-sufficient nuclei as exemplified by Berlage.[47]

In Rome the neoclassical love of vast green spaces disappeared, as most of the green spaces themselves did: from 1870 to 1914, almost all existing open spaces were absorbed by radiocentric or radial quarters. Yet the new sections and the remodelled historic centre were based on a module sensibly smaller than that adopted by Haussmann. Thus the various parts, inefficiently connected, did not attain the fluidity of traffic which is the most important functional element in both the Paris and the Amsterdam plans. The expansion of Rome was the result of fragmentary and often incoherent interventions. Milan had the same fate. Encircled by a regular and continuous system of city walls, Milan could have adopted a solution similar to the Viennese Ringstrasse, creating an outer belt and preserving the central nucleus while permitting a more rational expansion on the outskirts. The radiocentric pattern adopted had no unifying discipline, and uncontrolled developments on the periphery soon crushed the central part.

Yet if overall planning was shortsighted and deficient, local solutions, often adopted on the occasion of some international exhibition, were generally quite remarkable. Milan in 1906 sited the exhibition halls in areas that are still used today by the *Triennale* and the *Fiera*, areas with a very efficient system of local traffic connections. Rome owes to its Exhibition of 1911 the excellent solution of the Villa Borghese park, integrated through a beautifully conceived sequence of spaces to the Modern Art Gallery,[48] the Villa of Julius III, and the new Mazzini Quarter across the river. For its diagonal wide boulevards designed with gardening in the Olbrich style, focusing points of attraction and efficiently interconnected, this section can be considered still one of the best of modern Rome.

But scattered episodes do not make the urban history of a nation. Provincialism, lack of culture and corruption heavily damaged Italian cities and trivialised the quality of their architecture. Art Nouveau died in Italy with the exhibitions of 1911, triumphs of Baroque melodramatic brassiness. Authoritative critics praised the new academic energy, defined by Daniele Donghi as 'extremely elegant'. The old vanguard defected. D'Aronco's abdication has been mentioned. Rigotti in Bangkok designed the Hong Kong & Shanghai Bank in a heavy Renaissance style.[49] Fenoglio, together with Salvatori and Molli, was responsible for sugary pastiches in the Valentino park at Turin.[50] Rome was already dominated by an academic papacy that was to remain in power until the 'fifties: Marcello Piacentini, Arnaldo Foschini, Pietro Bazzani. In small towns there occurred a few revivals of 'the new style' and there were Umberto Fonda[51] in Trieste and Giovanni Betta in Turin.

The First World War concluded the agony of a confused, incoherent, and seldom generous period. That period's best legacy was to be assimilated only after the Second World War.

NOTES

[1] *Lavori e Progetti di valenti Architetti Italiani,* Milan, 1858 (essays by several authors).

[2] Printed in Milan from 1853; in 1875 retitled *Il Politecnico, Giornale dell'Ingegnere;* published until the turn of the century.

[3] Pietro Selvatico Estense (1803–80): architect and architectural critic, the most important Italian theoretician of eclecticism, professor at the Academy of Venice. In his practice he

followed a romantic trend.

Camillo Boito (1836–1914), also an architect and a critic, disciple of Selvatico, whom he succeeded in 1855 at the Academy of Venice. His eclecticism was based on an historical analysis of the architectural 'content' of the building. In 1880 he published *The Architecture of the Middle Ages in Italy,* whose introductory chapter, 'The future style of Italian Architecture', had a great influence on Italy's architectural development. He divides the 'organic' from the 'symbolic' part of a building. The first is 'the logical structural skeleton, more rational than artistic'; the second the tension towards beauty expressed through 'allegorical abstract analogies'.

[4] *Il Giornale dell' Ingegnere-Architetto e Pagronomo,* 1872 xx, page 605.

[5] Corrado Maltese, *Storia dell'Arte in Italia 1785–1943,* Torino 1960 – Einaudi.

[6] *Alessandro Antonelli* (1798–1888), professor at the Academia Albertina from 1836 to 1857, was a 'scientist' of structures as well as a political man. His work is widely publicised (cf. Corrado Maltese: *Storia dell'Arte in Italia, 1785–1943* – Turin 1960, Einaudi; C. V. Meeks: *Italian Architecture 1750–1914* – New Haven & London, Yale U.P., 1966; Bruno Zevi: *Storia dall'Archiettura Moderna,* Turin, 1950, Einaudi. Excellent illustrations in Vittorio Gregotti and Aldo Rossi: L'influenza del romanticismo europeo nell'architettura di Alessandro Antonelli', *Casabella,* 214, February to March 1957, p. 62–81. In the magazine *Torino* cf.: C. Merlini, 'La Mole Antonelliana ed il suo architetto' xiv, 1934, no. 6, p. 16–22; C. Mollino: 'Incanto e Volontà di Antonelli', xix, 1941, no. 5, p. 27–38.

[7] This manifesto, signed by F. T. Marinetti, was published for the first time in Paris by *Le Figaro,* February 20, 1909.

[8] For the debate on Italian Neo-Liberty see: Paolo Portoghesi: 'Dal neo-realismo al neo-Liberty', *Comunità,* 1958, no. 65, p. 65; Reyner Banham: 'The Italian retreat from modern architecture,' *Architectural Review,* April 1959; Ernesto N. Rogers 'Risposta al custode dei Frigidaires', *Casabella* 288, June 1959; 'Neo-Liberty: The Debate,' *Architectural Review,* December 1959; B. Zevi in *L'Architettura, Cronache e Storia:* 'L'andropausa degli architetti moderni italiani' no. 46, August 1959; 'Fifa allo specchio. I Frigidaires ed i pannicelli caldi,' no. 47, September 1959; 'La storia non volge a ritroso,' no. 56, June 1960.

[9] Paul-Henry Nénot (1853–1934) won the first competition, which did not specify the precise location of the monument in Rome. In 1883, after the Capitoline Hill had been selected, a new competition was launched and the design of Giuseppe Sacconi (1854–1905) received the first prize. An illustration of d'Aronco's design for the second competition is in C. Meeks, *op. cit.,* fig. 191.

[10] Giosuè Carducci (1835–1907): Message to the Italian Red Cross – March 1, 1896; speech celebrating the 'centenary of the Tri-colour (flag),' Reggio Emilia, January 7, 1897.

[11] *Vittorio Pica:* 'La Pittura dell'Esposizione di Parigi,' *Emporium* 1901, Vol. xiii, p. 261.

[12] *Ernesto Basile* (1857–1932) son of Giov. Battista – His work is published in B. Zevi, Bossaglia, Meeks, Maltese (*op. cit.*) cf. Also: V. Ziino: 'La cultura architettonica in Sicilia dall'Unità d'Italia alla la Guerra Mondiale' *La Casa,* no. 6, p. 96.

[13] R. Savarese: 'Arte Nuova Italiana – Il Movimento Moderno in Sicilia' – *Arte Decorativa Moderna,* 1902.

[14] The work of d'Aronco is commented on and illustrated in the following monographs:

Manfredi Nicoletti: *Raimondo D'Aronco* Milan, 1955, Il Balcone.

Manfredi Nicoletti: 'Raimondo D'Aronco', *Metron* no. 52, anno x, July to August 1954, p. 4–9.

Marcello Piacentini: 'L'opera di Raimondo D'Aronco', *Emporium* Vol. xxxvii, April 1913, p. 221–61.

David Gebhard: 'Raimondo D'Aronco, L'art Nouveau in Turchia' – *L'Architettura, Cronache e Storia,* no. 134, December 1966, p. 551–4 – no. 135, January 1967, p. 621–4 – no. 136, February 1967, p. 690–4 – no. 137, March 1967, p. 760–4 (pictorial documents of D'Aronco's work in Turkey).

Emilio Mattioni: 'Liberty segreto di Raimondo D'Aronco '(Udine Communal Palace), *L'Architettura, Cronache e Storia,* no. 7, May 1956, p. 42–5.

'L'Exposition Internationale des Arts Décoratifs Modernes à Turin, 1902' – *Arts décoratifs modernes* – directeur Alexander Koch, 1902, Darmstadt, Librairie des Arts Décoratifs, pages 1–16.

[15] *Giuseppe Sommaruga* (1867–1917) and *Luigi Broggi* (1851–1926) – For the competition for the new Parliament House in Rome, see, besides C. Meeks, *op. cit.,* U. Monneret de Villard: *L'architecture de Giuseppe Sommaruga,* Milan 1908, Bestetti e Tuminelli and also L. Broggi – 'G. Sommaruga, Pregetto del Nuovo Palazzo del Parlamento in Roma, relazione'.

[16] Daniele Donghi – *Manuale dell'Architetto* – 1906, Turin – Unione Tipografica. Several volumes, abundantly illustrated, concerning not only technique but particularly 'architectural typologies' exemplified by innumerable examples. The books of Donghi were considered an architectural Bible in the 'thirties.

[17] Illustrations of furniture executed at the turn of the century in Turin and Milan, as well as the remarkable productions of Ernesto Basile and Gaetano Moretti, can be found in R. Bossaglia, *Il Liberty in Italia,* Milan 1967; Il Saggiatone Italo Cremona: *Il tempo dell'Art Nouveau,* Florence, 1964. The chapter 'L'art industriel italien à l'exposition de Turin 1902' p. 217–242 in *Exposition de Turin 1902, Arts Décoratifs Modernes,* directeur A. Koch, Darmstadt 1902, has similar illustrations, as also have the magazines *Edilizia Moderna* ('Memorie di un Architetto'), *l'Ambiente Moderno, L'Architettura Italiana,* and also V. Pica: *L'Arte Decorativa all'Esposizione di Torino,* 1902 – Bergamo, 1903.

[18] Rossana Bossaglia, *op. cit.* fig. 18–19–37–38.

[19] The work of G. Sommaruga is illustrated in the following monographs:

Ugo Monneret de Villard: *L'architettura di Giuseppe Sommaruga* Milan, 1908, Casa Editrice d'Arte Bestetti e Tuminelli; Francesco Tentori: 'Contributo alla storiografia di G. Sommaruga', *Casabella*, no. 217, December 1917, p. 70–87.

Luigi Angelini: 'Artisti contemporanei', G. Sommaruga, *Emporium*, no. 276, Vol. XLVI, December 1917, p. 282–298.

E. Cattò – L. Mariani Trani – 'Immagini di Sommaruga', *L'Architettura, Cronache e Storia* no. 143, September 1967, p. 341–4 – no. 144, October 1967, p. 411–4 – no. 145, November 1967, p. 481–4 – no. 146, December 1967, p. 551–4 – no. 147, January 1968, p. 620–4.

A reproduction of Villa Comi can be found in R. Bossaglia, *op. cit.* fig. 15.

[20] L. Bistolfi: 'Lecture at the Alfieri Theatre', Turin, June 1902. His poster can be seen in *Exposition de Turin 1902* – Darmstadt 1902, *op, cit.* p. 1. In the same book the Italian and the foreign participations in the Exhibition are widely illustrated. (In Turin Morris's personal work was exhibited rather than the products of his firm. This is the impression given by the above-mentioned book, where 'The Four Seasons' is reproduced. The text underlines Morris's influence on Walter Crane).

[21] R. D'Aronco – Concorso per gli Edifici della la Esposizione di Arte Decorativa Moderna – *Memorie di un Architetto* 1900, Vol. XI, fasc. VI, fasc. VI, tav. I–II.

[22] This project was never executed. Pictures of the 1902 Turin Exhibition can be found in already mentioned publications by M. Nicoletti, M. Piacentini, R. Bossaglia, C. Meeks, B. Zevi, C. Maltese, Exposition de Turin 1902 Darmstadt; and also in M. Nicoletti 'Esposizioni e Fiere campionarie' in *Architettura Pratica* (directed by P. Carbonara) Vol. IV, Part II, Turin 1962, UTET, p. 873–6, and M. Nicoletti 'Mostre ed Esposizioni, in *Rassegna Critica di Architettura*, no. 22. November to December 1951, p. 18–19.

[23] Gabriele D'Annunzio was on the extreme right wing in Parliament as a 'Representative of Beauty'. On March 21, 1900 he dramatically joined the extreme left saying, 'As an intellectual, I go towards life'.

[24] First published in 1901 in Milan, the director was Edoardo de Fonseca. Among the collaborators were E. Corradini, G. D'Annunzio, C. Pascarella, V. Pica.

[25] Plans and pictures of the pavilions can be found in: Daniele Donghi, *Manuale dell'Architetto*, Vol. II, Parte Ia, Turin 1925, UTET, p. 483–91; *Costruzioni – Casabella*, no. 159–160, March to April 1941, p. 29–30; M. Nicoletti, 'Esposizioni e Fiere Campionarie', *op. cit.* p. 870–1.

[26] *Edilizia Moderna*, 1903.

[27] The eclectic style of Giuseppe Sebastiano Locati, before the Exhibition of 1906, is exemplified by the Palazzina Francetti-Frova and the Casa Reininghaus, both in Milan (see *Edilizia Moderna*, 1898, anno VII⁰).

[28] Cf. Prof. Dario Carbone – *Costruzioni e Progetti* – Milan, 1914, Bestetti e Tuminelli (monographic publication abundantly illustrated).

[29] Cf. R. Bossaglia, *op. cit.* fig. 55–6.

[30] Cf. *L'Architettura Italiana*, 1905.

[31] R. Bossaglia, *op. cit.* fig. 41.

[32] For illustrations of the Palazzo Castiglioni see the above-mentioned monographic bibliography and also C. Meeks (*op. cit*) and R. Bossaglia (*op. cit.*) and also R. Bossaglia 'Corso Venezia 47' in *Pirelli*, anno XXIII, March–April 1970, a publication with excellent pictures of the iron works of Alessandro Mazzucotelli.

[33] Cf. C. Maltese fig. 146, *op. cit.*; C. Meeks.

[34] Monographic publications: Maurizio Calzavara – L'Architetto Gaetano Moretti – *Casabella* no. 218, March 1958, p. 69–83; A. Annoni: Gaetano Moretti, Luca Beltrami, Camillo Boito – *Metron* 1950, no. 37; R. Bossaglia, *op. cit.* fig. 55 *La Lettura* – October 1906, anno VI, no. 10.

[35] The original entrance-door of the Palazzo Castiglioni can be seen in *L'Edilizia Moderna*, anno XIV, tav. XX.

[36] Cesare Lombroso – *Il Momento Attuale*, 1904 (a volume of essays on particular aspects of modern life).

[37] See Marcello Venturoli – *La Patria di Marmo*, 1957. Pisa, Nistri-Lischi.

[38] A complete bibliography on Italian architecture, design and the visual arts from the turn of the century until 1910 is in R. Bossaglia 'Tendenze critiche dell'Era Liberty in Italia (1895–1910)' – *Arte in Europe*, 1965, Milano, p. 903–50.

[39] Antonio Sant'Elia (1888–1916), Professor of 'Architectural Design' at Brera (1922), worked in the office of C. Cantoni around 1912–13, participating with him in the Milan railway station competition. Later opened an office of his own. References:

L'Architettura, no. 2, July to August 1955: F. Tentori: *Le origini Liberty di A. Sant'Elia*, p. 206–8.
L. Mariani: *Disegni inediti di A. Sant'Elia.* p. 209–15.
M. Drudi Gambiello, T. Fiori: *Gli archivi del Futurismo*, Vol. II. p. 441–88, 1958, Rome, De Luca.
C. Maltese: *Storia dell'Arte in Italia*, Turin 1960, Einaudi, p. 296.
L. Carmel and A. Longatti: *Catalogue of the permanent Exhibition at Villa Olmo, Como*, 1962, Como.
J. P. Schmidt-Thomsen: *Floreale und Futuristische Architektur – Das Werk von Antonio Sant'Elia* – Berlin, 1967.

[40] The designs of V. Stacchini and Antonio Sant'-Elia for the competition of the Cemetery of Monza and for the Milan Railway Station as well as those of the other architects mentioned above can be seen in: 'I Concorsi di Architettura in Italia', Bestetti e Tuminelli, Milan, 1914.

[41] L. Angelini, see note 19.

[42] Ugo Monneret de Villard: *Opere di Architet tura moderna,* Milan 1909 – Società Editrice Tecnico-Scientifica.

[43] Daniele Donghi – *La Esposizione di Arte Decorativa a Torino – L'Architettura Pratica, Anno IV,* 1903, Categ. IV, Serie 4⁰, Div. 1⁰ Turin, Canilla e Bertoleo Edit.

[44] Pictures of the executed works of R. D'Aronco in Turkey can be seen in: David Gebhard – *L'Architettura* 134 (see note 14).

[45] Raimondo D'Aronco – Il Palazzo Comunale di Udine, Udine 5 marzo 1911.

[46] In 1908, in Milanino (5 miles from Milan) 130 hectars of land were divided into 150 building lots to be two-fifths covered by a 'palazzina' not more than three storeys high. Urban scheme: radiocentric pattern inserted in an elongated rectangle. In the centre there was a 'piazza' with Union House, School and Church.

[47] For master-plans of the nineteenth century of Rome, Milan, Florence, Naples and Turin see: Mario Morini: *Atlante di Storia dell'Urbanistica* – Milan, 1963; V. Hoepli, p. 350–5.
C. V. Meeks: *Italian Architecture, 1750–1914* – New Haven, London, Yale U.P., 1966; *Urbanistica* no. 27–28–39 (special issue);
P. Portoghesi: *Un'altra Città – Roma* 1968;
L. Quaroni: *Immagine di Roma,* Bari 1969, Laterza.

[48] Plans and pictures of the exhibition of 1911, in Rome and Turin, can be seen in D. Donghi: *Manuale dell'Architetto* – Vol. II⁰, part I, Turin 1925, UTET, p. 491–9.

[49] *L'Architettura Italiana,* 1915–17, anno XI, p. 58–9.

[50] See Donghi, *op. cit.*

[51] See *L'Architettura Italiana,* 1912–13, anno VIII, p. 123.

BERENGUER

by David Mackay

The enlargement of the reputation of the Catalan architect Antonio Gaudí in recent years has had the effect of almost wholly eclipsing that of Francesc Berenguer, his lifelong friend and collaborator. The aim of this essay is to redress the balance, to give an account of Berenguer's own work and, by doing so, to clarify the nature of the movement of which he and Gaudí were part.

Antoni Gaudí and *Modernisme* are two names that should always go together, but most who are familiar with the name of Gaudí are strangers to the *Modernisme* movement of which he was a part. Yet the link between Gaudí and the *Modernisme* movement is of great importance, because it gives the clue to what Gaudí was. If this link did not exist, then both his followers and his severest critics could point him out as an isolated genius, to credit or discredit him depending on the desired result. However the link does exist, and the major part of it is in the very solid person of Francesc Berenguer.

He and Gaudí were lifelong intimate friends and collaborators. Their strong personalities complemented each other; Gaudí emotional, idealist and a fervent talker, Berenguer quiet, a careful organiser and a fervent worker. Both came from the same small market town of Reus, where Berenguer's father had a school to which both had gone.[1] In their later years, when Gaudí lived in the Güell Park itself, incidentally in a house designed by Berenguer, they breakfasted together every day, after Gaudí had walked down the hill to Mass at the parish church of Sant Joan in Gracia.[2] Berenguer's home was on the way between the church and the Sagrada Familia. After his illness in 1911 Gaudí had almost all his meals with the Berenguer family. When Berenguer died on February 8, 1914, the shock was very great for Gaudí, who exclaimed that he had lost his right hand. Afterwards Gaudí retired from the world to dedicate himself solely to the Sagrada Familia.

The isolation of Gaudí from the *Modernisme* movement for various religious and political reasons, as well as the obvious personal ones, brought him fame but at the expense of his contemporaries and the movement as a whole.[3] The movement lasted more than half a century, spread itself into every corner of the nation's life and made Catalunya, and especially Barcelona, an 'Athens of Art Nouveau'.[4] The architects Doménech, Puig, Gaudí, Berenguer, Raspall, Jujol, Moncunill, Granell, Massó and many others equal, and on occasions surpass, the works of their European contemporaries. In the other arts we find the painters Casas, Nonell, Utrillo and the young Picasso, the decorator Homar, the sculptor Llimona, the poet Maragall, the playwright Rossinyol and in music Clavé and Millet. A measure of the importance of Barcelona at the beginning of the twentieth century is the fact that Gropius once admitted to a group of architects in Barcelona that it was while on a visit to Spain in 1902, and after meeting Puig and seeing current examples of ceramic tile and textile design, that he 'found his line'.[5]

Francesc Berenguer y Mestres was born on July 21, 1866, at Reus, and was baptised the following day in the church of St. Peter. He was the youngest of three children. The eldest, Joan, later became a lawyer; the second was a sister, Anna. His father, Francisco Berenguer, who married Mariana Mestres, was the schoolmaster who taught Gaudí, who had been born at Reus fourteen years before. When Berenguer was fifteen the family moved to Barcelona, and in the same year, 1881, he entered the Escuela Oficial de Bellas Artes and attended courses till 1886. During this time he also studied at the Escuela Superior de Arquitectura. In 1887, when he was twenty-one, he married Adelina Bellvehi and rented the ground-floor flat with a garden in the two-storeyed house in Encarnació Street, number 20 (now demolished). This was a crucial point in his career, because it was about this time that he gave up his studies at the School of Architecture to assist Gaudí.

1. Fransesc Berenguer at the age of 47, just before his death.

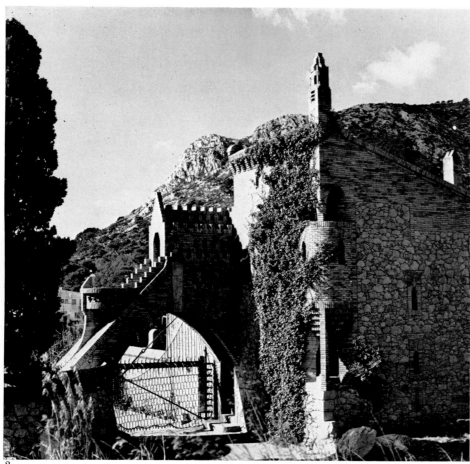

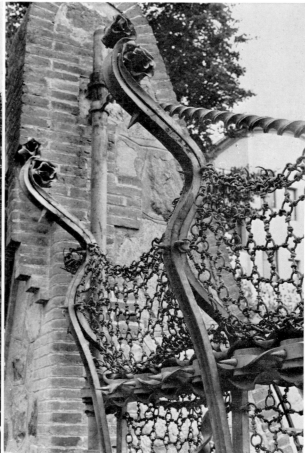

2

3

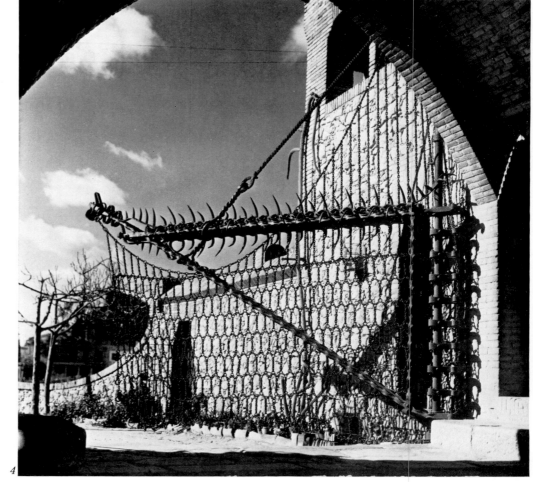

2. *The porter's lodge at the Bodegas Güell, Garraf, 1888. (Garraf is between Barcelona and Sitges.)*

3. *Ironwork at the Torre Mateu, Llinás del Vallés, 1906.*

4. *Close-up of the Bodegas Güell entrance gate.*

4

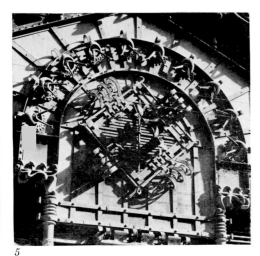

5

6

7

5. *Ironwork at the Mercat de la Libertat, Barcelona, 1893.*

6. *Masonry detail from the chapel of S. Joan de Gracia, Barcelona, remodelled by Berenguer in 1909.*

7. *Wine cellars and chapel at Garraf, 1888.*

It has been said that Gaudí, realising that Berenguer was a superb draughtsman, selfishly persuaded him to give up his studies to work for him with the assurance that he, Berenguer, would never be without work. However, it is more likely that the decision was mutually welcome, as Berenguer wanted to marry. No doubt his failure to obtain his professional degree hurt the pride of his family, who saw him as an exploited man, but he had a sufficiently strong character to overcome this handicap. A humble and religious man, fame apparently did not concern him. Father of seven children born between 1889 and 1905, he did not live to see his eldest son, Francesc, qualify as an architect only one year after his death.

In order to support such a large family Berenguer had to work hard. However, he still managed to dedicate much spare time to religious work which he always did free of charge. He became vice-president of the important Barcelona youth club *Central Moral de Gracia* which he eventually redesigned about 1909: he was also president of the local St. Vincent de Paul Society, many of whose programmes, banners, etc. he designed.

At first he worked for the architect Augusto Font in the mornings and for Gaudí only in the afternoons. In 1892 he left Font to work in the Architect's Department of the Barcelona borough of Gracia. The municipal architect was Miquel Pascual who signed many of Berenguer's works. Another who was entitled to sign was the Clerk of the Works, Senyor Graner. But the important question for us is to what

extent Berenguer worked under Gaudí and to what extent he collaborated with him. No doubt he nominally always worked under Gaudí, but if Berenguer's own buildings are studied and a distinction is attempted between those buildings of Gaudí's with which he was integrally concerned and those he had nothing to do with, Berenguer's personality can be discerned. So it is perhaps no coincidence that Berenguer's death coincided with the end of the most intensive building phase of the Sagrada Familia. After his death only the towers were completed, and yet Gaudí did not die till 1926. Also after 1914 Gaudí did no other work of importance.

It is claimed that one of the first designs of Berenguer's was for the famous iron railing around the Casa Vicens. This may seem surprising, as the house was built between 1878 and 1880, but the garden railing was in fact added later, as early photographs bear out.[6] Berenguer's daughters and friends repeated the family story of how one day, while in his garden, he noticed the chemaro palm tree in the garden next door, and this inspired him to the design for the railings. His daughters remembered him drawing it. His first larger work for Gaudí was the drawing of the street elevation of the Palau Güell (1885–9) which he re-drew twenty-five times. The other works in which he collaborated with Gaudí were the Finca Güell Pedralbes (1887), Bellesguard (1900–1902), the crypt of the Colonia Güell (1898–1914), the Güell Park (1900–14), the schools by the Sagrada Familia (1909) and, of course, the Sagrada Familia itself. Besides doing most of the drawings for Gaudí, Berenguer used to explain Gaudí's ideas to the builders on the site. In particular for the Sagrada Familia he managed all the builder's accounts.

His own works may be listed as follows:

Altar of Sant Josep in the Monastery of Montserrat.
Bodegas Güell, i.e. wine cellars, porter's lodge and chapel at Garraf, 1888.[7]
Mercat de la Llibertat, 1893.
Casa Torre i Poal for the Conde de Güell, 1900.
Casa Rectoral S. Joan de Gracia, 1900.
Project for the Casa Diez at Gijón, 1902, followed by four chalets also at Gijón.
House in the Güell Park, later bought by Gaudí, 1904.
Flats, 77 Major de Gracia, 1905.
Torre Mateu at Llinás del Vallés, 1906.[8]
Entrance to Finca Juan Peix, Travesera de Dalt 32, 1906.
Casa Rubió, Berenguer's own country house, 1908.
Flats, 44 Carrer d'Or, 1909.

8. House at Santa Coloma de Cervelló, about 1911.

9. One of Berenguer's own drawings of the Torre Mateu at Llinás del Vallés, built 1906.

8

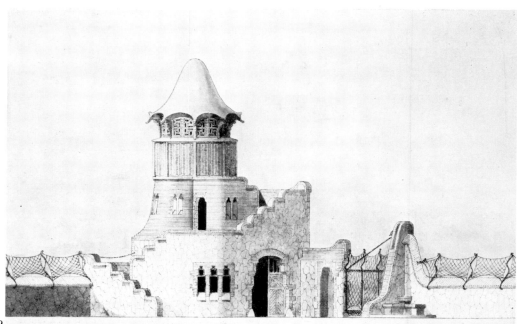

9

Chapel for the Baronesa de Almenar at Hostalet, 1909.

Remodelling S. Joan de Gracia, 1909.

Central Moral de Gracia, 1909.

Real Sanctuari de S. Josep de la Muntanya in collaboration with Pascual, 1910–14.

At Santa Coloma de Cervelló (where Gaudí's famous crypt is), the Casa del Mestre, the co-operative building and the decoration of the Conde de Güell's house, 'Masia-Güell,' all 1911.

Theatre for the Central Moral de Gracia, 1913.

Blessed Sacrament Chapel in S. Joan de Gracia, 1914.

Among undated works may be included:

Flats 13, 15, 50, 61, 196 and 237 Major de Gracia.

Torre Berenguer Carrer Puixet.

Interior decoration 92–94 Rambla Catalunya.

Projects for the façade for the church of Jesus, Gracia.

Mausolea for the Regordisa and Cucurella families.

Flats, Ronda S. Pere, Carrer Gerona.

Coat of Arms for the Güell family.

Project for flats in Carrer Badajoz.

Restoration of Campins, Mas Rifer.

Projects for various farm buildings.

Parish church of S. Coloma de Gramanet in collaboration with Pascual.

Façade, Town Hall, Gracia.

Flats, 14 Carrer Torrijos.

Of these buildings the most important are undoubtedly the Bodegas Güell, Torre Mateu, flats in Carrer d'Or, the chapel at Hostalet, the Central Moral de Gracia including the Theatre, the Co-operative building in Santa Coloma de Cervelló, the Rectory and remodelling of S. Joan de Gracia, and the Llibertat Market.

The most notable characteristics of Berenguer's work are his rational approach to design and the use of materials, his discipline of decoration, his tendency to exploit the parabolic arch when the opportunity is offered, and his masterly handling of brickwork. His decoration clearly falls into two distinct categories – his three-dimensional cubist forms, exploiting many variations on the cylinder, cube and prism, and his personal stylisation of two-dimensional, Art Nouveau curves. The latter he applied to his wall surfaces using the popular technique of sgraffito, and also in the design of tiles and plaster coves. In this form of decoration there was probably a mutual influence between him and Jujol, Gaudí's other great collaborator. However, it is Berenguer's three-dimensional cubism which gives us the most valuable clue to his collaboration on the Sagrada Familia. The forms apparent in the Bodegas Güell, the Gracia Town Hall and the Rectory and re-modelling of S. Joan de Gracia are clearly those of the interior elevation of the south (i.e. visually south) wall of the Sagrada Familia. Gaudí himself never used this cubism.

Berenguer was a fanatic for metal. His handling of ironwork surpasses that of every other architect of the epoch. The mysterious, enchanting giant mobile forming the entrance gate to the Bodegas Güell is surely one of the seven wonders of the world in metal sculpture. Every piece, twisted section and suspended chain has its function, but each has been magically transformed into breathtaking beauty. Another version of these gates is at the Torre Mateu, and further examples of Berenguer's masterly handling of iron can be seen in the Güell Park.

One of the most interesting works of Berenguer is the small workers' village of Santa Coloma de Cervelló, the Colonia Güell, where for economic reasons building had to be restricted to a purely functional minimum. There is a quiet beauty about the whole village brought about by its humane scale, unity of material and grid plan. Here indeed, within the framework of an architectural-social responsibility, *Modernisme* seems to have found its finest rational response.

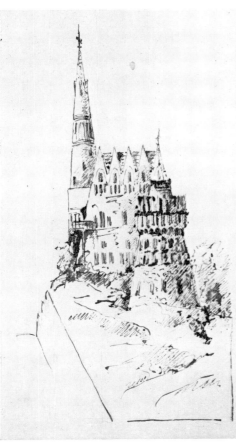

10. Sketch by Berenguer – project unknown.

11. Sketch design by Berenguer for an armchair.

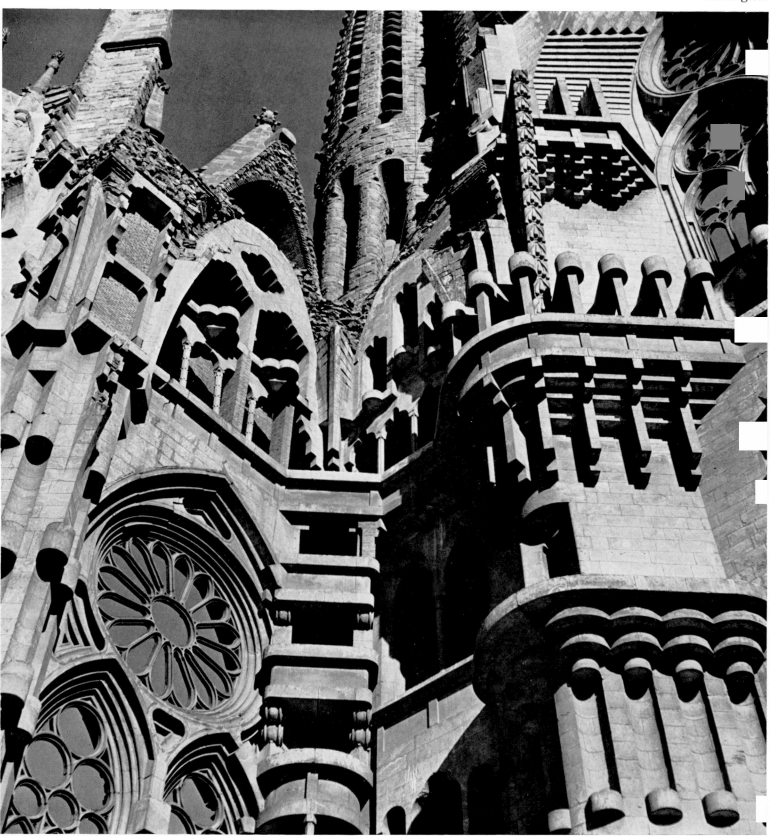

12. Close-up of part of the church of the Familia Sagrada at Barcelona, on which Berenguer collaborated with Gaudí and for which he made most of the drawings. The details shown here are more typical of Berenguer than of Gaudí.

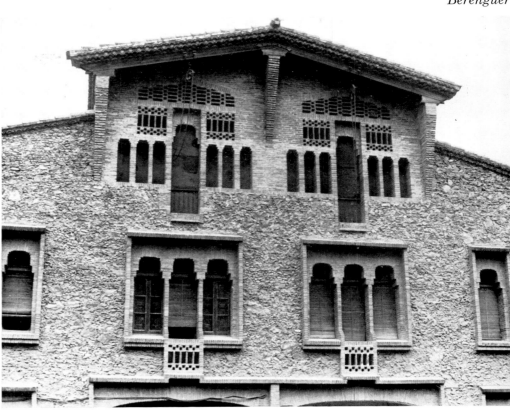

13. Cooperative building at Santa Coloma de Cervelló, 1911.

If one is ready to agree that *Modernisme* is one of the forerunners of the Catalan Modern Movement, then Berenguer should be classed among the leaders, not only for his rationalising influence on Gaudí but for his realism in handling materials and for the cubism of his decoration. He broke with historicism as radically as, if not more radically than, Gaudí, Domenech and Puig. Had he lived longer, he would no doubt have conducted *Modernisme* into the social architecture of the Modern Movement. It is a great pity that the work of this man who was heart and soul an architect, even if not in name, should have been eclipsed by that of his great friend. In 1928 and 1929 the Barcelona art critic Feliu Elias (Joan Sacs) publically defended Berenguer against these admirers of Gaudí, but unfortunately he was none too sure of his ground and his supporters shied away from him when the controversy became too heated.[9] Today Gaudí's worldwide popularity makes it all the more imperative to give back to Berenguer what is his due.

NOTES

[1] J. F. Ráfols in his standard work on Gaudí published in 1929 made no reference to Berenguer's father. However, Berenguer's family insist that it was precisely because Berenguer's father was Gaudí's early teacher that the two men knew each other and that when the Berenguer family moved to Barcelona Gaudí helped his former teacher to find private pupils.

[2] The Güell Park was inspired by Count Güell's admiration of the English garden suburb. The house designed by Berenguer was meant as a demonstration house to encourage the sale of plots. The scheme fell through, and in the end Gaudí bought the house himself. It has now been bought by the 'Amics de Gaudí' to house the Gaudí Museum.

[3] The religious and political background of Gaudí is alluded to by J. F. Ráfols, third ed., 1952, p. 126. The right-wing patriotic group which formed the basis of the Lliga party probably used the emotional content of the Sagrada Familia and Gaudí as a rallying point to capture the support of the poorer working-class who contributed to the building of the church. The rise and fall of support for the Lliga is parallel to that for the Sagrada Familia. Further investigation of this point would be interesting.

[4] This phrase was first used in a satire on the modernists themselves in the review *La Esquella de la Torratxa*, June 17, 1898.

[5] Gropius mentioned the date 1902 to the author. The occasion of this first visit to Barcelona was the termination of his studies and his wish 'to find himself' by experiencing completely strange surroundings. George Collins has suggested that the date was 1908.

[6] See photograph on p. 32 in J. R. Ráfols *Gaudí*, ed. 1929. The photograph on p. 28 could have been taken at a later date.

[7] Le Corbusier in his introduction to *Gaudí* by Gomis and Prats (1958) notes that he was intrigued by a modern house by Gaudí. He was, in fact, referring to these buildings by Berenguer. The date 1888 was the date of the beginning. They were completed before 1900.

[8] Now demolished. The metal gate and railings are in the Güell Park.

[9] *L'Escultura Catalana Moderna*, Vol. II. p. 237, 1928. F. Elias, followed by articles for and against in *L'Opinio*, May 26, 1928. *La Nau* December 12 and 21, 1928, January 2, 9, 1929. *La Veu de Catalunya*, March 2, 6, 10, 19, 22, 29 and 30, 1929.

LUIS DOMENECH

by Oriol Bohigas

Much that has been written about Antonio Gaudí has taken him out of his Catalan context and has therefore ignored the work of Luis Domènech y Montaner, the other dominant figure of the Catalan movement of which Gaudí's work was essentially a part.

This essay discusses Domènech's work and his place in history – a far more significant one than has hitherto been acknowledged outside Spain. It logically follows David Mackay's essay on Francesc Berenguer, another important figure in the same movement who was also Gaudí's link with it.

In spite of the studies of Ràfols, Cirici and Collins,[1] the Catalan cultural movement known as *Modernisme* remains very little known outside its own territory, except in the case of Antoni Gaudí, its most important, though not most representative, figure. The world-wide publicity so enthusiastically accorded to Gaudí as a genius unique in Spain at the turn of the century has contributed to the neglect of that extensive, though exclusively Catalan, movement from which Gaudí himself sprang – and without which, indeed, his work would be inconceivable.

This modernist phenomenon has all too often been included under the heading of Art Nouveau, without being granted its own special characteristics. This view, while apparently justified, at least in part, is based on a fundamental error. Modernism is clearly a movement parallel to those which in other countries were known as Liberty, Art Nouveau, Modern Style and Secession. Not only does it share with those other local movements a strong personal touch, but it is distinguished from them by two very pronounced characteristics: first, by its uniquely widespread popularity, which sprang from its remarkable identification with the social and political realities of its country – thus enabling it to embrace, within one coherent approach, everything from poetry to economics – and, secondly, by a stylistic complexity which allowed the co-existence and reinterpretation of the so-called 'revivals,' of the social and ethical reforming impulses of Arts and Crafts, of floralising carried to the point of delirium, of rationalist machine-worship, and of the most advanced and revolutionary Expressionism.

All this is largely to be explained by the historical circumstances of Catalonia, circumstances without parallel in any other part of the world. After a prolonged decadence stemming from the unification of Spain and the discovery of America, a colonial enterprise it took but small part in, Catalonia had lost its political personality, its traditions and – almost – its language. But through a series of events which cannot be described here, it was the only part of the Iberian peninsula prepared, in the eighteenth and nineteenth centuries, to take part in the great revitalising drive of the industrial revolution, while the rest of Spain, in the death-throes of its wrecked empire, grew further and further away from Europe.

In this way, from the opening years of the nineteenth century, Catalonia achieved a comparatively European standard of industrial development, set its economy moving on a large scale, savoured both the joys and sorrows of an industrial society and gradually massed its forces towards a collective re-birth (*la Renaixença*) which affected all spheres – economy, culture, politics – and bore fruit, in the last quarter of the century, in a nationalist programme opposed to the domination of Castile. (Therein still lies, even today, the unfinished drama of Catalonia.)

The *Renaixença* represented a truly titanic effort, in which the whole country took part and from which came great cultural achievements. Catalonia had to improvise in fifty years what the other European nations had achieved in the course of five centuries: namely, the standardisation and modernisation of the language, the setting-up of a university, academies, scientific research, museums and art-galleries, an aristocracy and a new proletariat, political parties, and a form of government. Also – naturally – its own artistic expression, an indigenous expression based on its own traditions but yet in keeping with the progressive outlook of an industrialised society – and, thus, opening the door to modern European

1. Luis Domènech y Montaner, 1850–1923.

culture. *El Modernisme* was, then, the artistic expression of the whole Catalan recovery; it became, for the first openly nationalist generation, *their* style; and that is why it became so popular; that is why it sank its roots so deep in local realities, and that, too, is why it plunged so deeply and in so many directions into the recesses of an art at once new and very much its own.

The first of these two characteristic features is overwhelmingly important: none of the countries now considered fundamental to the architectural history of the period in question can boast of so rich an ensemble of works as Catalonia – not even the England of William Morris, the Scotland of Mackintosh, the Belgium of Victor Horta nor the Austria of Otto Wagner can be said to possess such *fin-de-siècle* 'density.' And nowhere did the style go so thoroughly into the very details of daily life as in Catalonia. Modernist architects and artisans were still working in the Vallés up to a comparatively recent date, ranging in a variety of styles from the constructive severity of Moncunill to the ornamentalism of Raspall. Gerona began with bursts of flowery linealism, and then followed up with Secessionism and Masó's valiant versions of Mackintoshism. Valencia filled its *Exeimple* (its modern centre) with the same kind of Baroque Modernism so marked in the *Exeimple* of Barcelona. Mallorca not only welcomed the personal contributions of Gaudí and Domènech, but also the several variations on them by local architects.

There are still more than two hundred Modernist shops in Barcelona, some of them very original and some very mannered, but all attesting to the quite fabulous influence of the Modernist style. By the same token, it is impossible to find examples of Modernism anywhere else in the peninsula, if we leave aside works by

2. Street façade of the Montaner y Simón publishing office, Barcelona, 1881–5, Domènech's first important building.

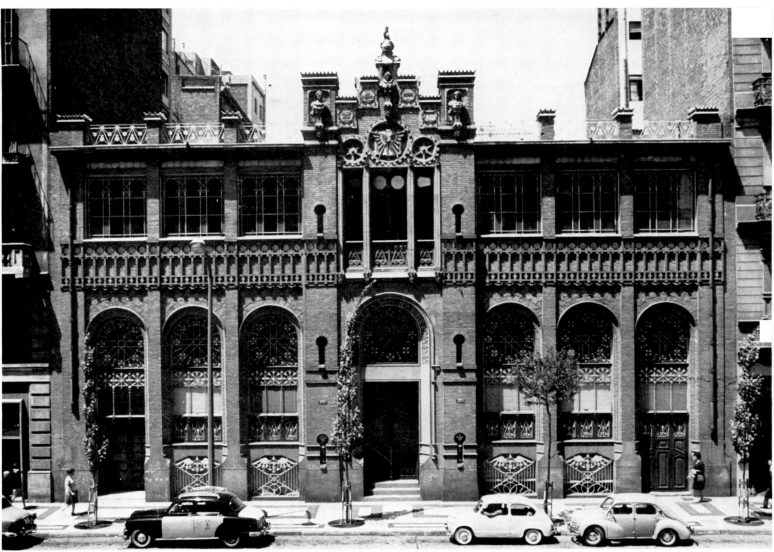

Gaudí and Domènech at León and Santander (the result of the chance presence of a Catalan bishop and the patronage of the Marqués de Comillas), a couple of unique works in Madrid, whose Catalan provenance would need checking, and some strange 'colonial' variants in the Canaries – doubtless the first fruits of some architect who had studied in Barcelona during the peak years of the irresistible Modernist euphoria. The movement can safely be described, then, as a phenomenon integrally and exclusively Catalan.

The second characteristic feature is mainly important in situating Modernism precisely within the general picture of the European culture of its time. As Cirici says,[2] the transition from *revivals* to a new style was marked, between the years 1880 and 1885, by the following five works: the Casa Vicens by Gaudí (1880), the Balaguer Museum by Fontseré (1882), the Academy of Sciences by Domènech Estapá (1883), the Francisco Vidal Art-Industries building by Vilaseca (1884), and the Montaner y Simón Publishing House, by Domènech y Montaner (1885). From that time onward, Modernism was tirelessly trying out new possibilities, searching for a new style, absorbing the mutually contradictory influences of local art, local history and literature, new movements abroad and the isolated inspirations of certain exceptional creative geniuses.

The enthusiasm for things medieval, caused both by the reigning aesthetic of the moment and by the nationalist claims based by Catalans on the brilliant history of their own Middle Ages; the machine-mindedness and structuralism deriving

3. Café and restaurant building at the Barcelona fair of 1888. It is now a zoological museum.

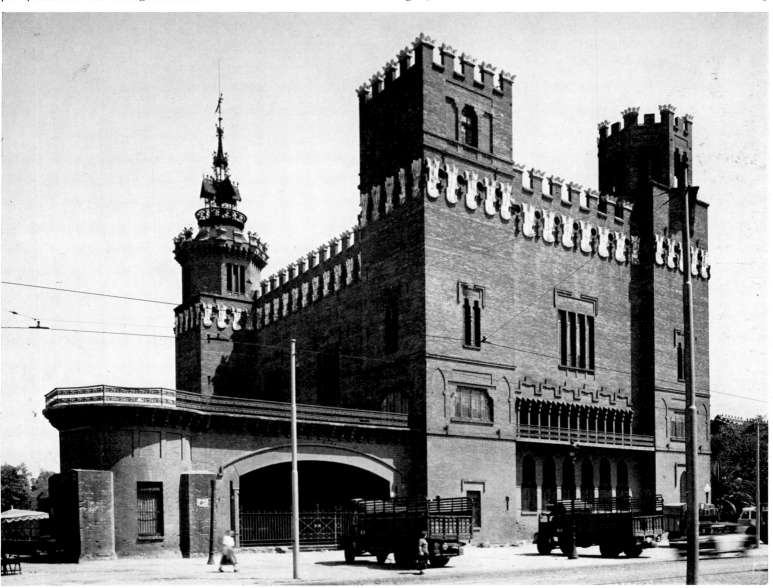

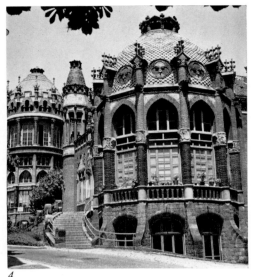

4

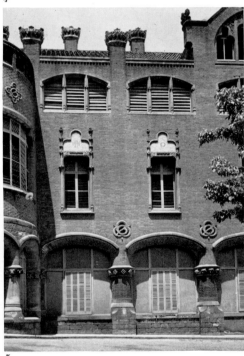

5

4. *Ward pavilion at the Hospital of S. Pau at Barcelona, 1902–12. (The part in the background was completed by Domènech's son.)*

5. *Part of the ward pavilion. On the ground floor are consulting rooms.*

6. *A wing of the administration block.*

7. *Sculptural enrichment at the end of the administration block.*

8. *The main entrance hall and staircase balustrade.*

from the ideas of Viollet-le-Duc and then developed by the nascent Catalan metallurgical industry; flowery ornamentalism and the *coup de fouet* of Art Nouveau, which arrived here early on; deliquescent or wraith-like sculpture; the revindication of brick architecture – vault and balancing arch; the simplification, if not suppression, of mouldings in an architecture that was gentle, smooth and restrained; a taste for plain surfaces and pure volume; the appearance of Expressionism; the return to the intimately domestic, as also to the cult of landscape; morbid decadence; the forms evolved by Mackintosh, Wagner, Hoffmann or Olbrich – all these factors coexisted and interacted at boiling-point in the immense cauldron of *Modernisme*. We can no more speak of a 'pure' movement than we can hope to disentangle with complete clarity the various tendencies involved. What we are dealing with is a collective cultural situation, the restless quest for a new architecture.

Within the Modernist school, Gaudí and Domènech represent what came to be, in a sense, the two fundamental and even warring trends at the origins of the movement. These two main tendencies led respectively, by the inescapable course of events, to Expressionism and rationalism (and even today they can spark off a polemic, though a polemic much less vital and useful than three generations ago).

Much has been made of the constructive element in the work of Gaudí, and frequent efforts have presented him as the protogenius of a certain kind of rationalism. Nothing could be more mistaken. Among his near-contemporaries, a group of critics and architects kept on proclaiming that Gaudí's ideas represented a decisive step in the history of architecture, meaning by this in an exclusively technical-cum-rationalist direction; mankind, they would have it, was about to experience a new and definitive style, now that those tentative gropings, Romanesque and Gothic, had come to grief. After the Romanesque vault, supported by the thickness of the walls; after Gothic, which concentrated is thrusts diagonally on the piers, came Gaudí with his system of balancing vaults and counterthrust – eliminating buttresses – and all this within an unexampled unity of space and structure. This was, of course, an ingenuous and very fragmentary interpretation, applying as it does to only a minute part of Gaudí's work.

The truth of the matter is that his anxiety to improve on the stone-structure systems of the various traditional styles was Gaudí's major defect. His indifference to new materials, in particular to the possibilities of iron, makes of him, in the field of technology, not so much a great precursor as the last genius of the past. On the other hand all his masterpieces, those basic works such as the Palau Güell, the Pedrera, the Casa Batlló, the Güell Park, the chapel of Santa Coloma, the school by the Sagrada Familia, mark the dawn of Expressionism, for dramatic forms, for pictorial and sculptural values – and mark it at times with a majestically brilliant contempt for structure which reveals him as the predecessor, not of Gropius or De Stijl, but of the more extreme Mendelsohn, of Steiner, de Klerk, Poelzig, and even perhaps of Le Corbusier's latest phase; that is, they make him the most important Expressionist figure.

Domènech, on the other hand, was, almost from the outset, very differently received. The generation after his (the *noucentistes*, as they were dubbed) were often unable to see anything more in his work than unbridled decoration, a purely epidermic style totally lacking in basic architectonic concepts. This view was mistaken: first, because this Domènechian 'epidermis,' which so shocked that generation of 'good taste' and neo-classical 'discretion,' now seems to us rather a symptom of positive cultural development, a total absorption of the most advanced European trends, from Morris and the Pre-Raphaelites to the decorative products of Art Nouveau. If, moreover, we make a mental effort to eliminate the anecdotal aspect of the ornamentation, we find in Domènech two main elements: on the one hand his concept of space and treatment of planes and, on the other, his highly intelligent use of the new technology, which placed him far ahead of the rationalist revolution.

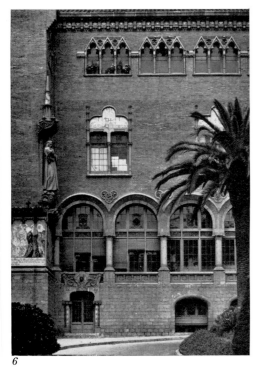

6

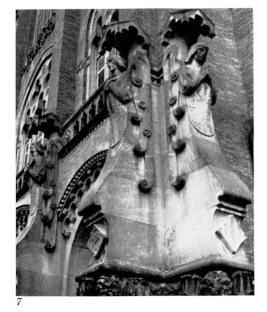

7

8

These facts granted, we can see that the Café and Restaurant for the Barcelona exhibition of 1888 presupposes a complete re-assessment of planes, of pure volume, and also, that the *Palau de la Música* was the most important seed of an architectonic concept which was to give rise, some years later, to much controversy: rectangular metal structure, open plan and enclosing walls without loads – in fact a curtain of continuous glass. And that is why Domènech, contrary to usual opinions, represents the true evolution of Catalan architecture by way of structuralism, rationalism and even, one is tempted to add, of purism. If Gaudí, or his disciples, were fated to end, in their final stage, with a vociferous Expressionism whose social and technological significance had already vanished, Domènech on the contrary was destined to set the pattern of an evolution which bore fruit all over Europe, right up to the *Fagus Werk* of Gropius, which at last opened the gates to the new style in its fullest development. The Domènech line,[3] though interrupted in Catalonia by *noucentisme*, continued, thin but coherent, through Rafael Masó and Josep M. Pericás, with their secessionist forms and memories of Mackintosh; through those who, like Ramón Puig Gairalt, echoed Loos; through independent freebooters like the early Francesc Folguera; and culminated in the brilliant orthodox rationalism of GATEPAC.

Domènech qualified in 1873. In 1878 he published an article entitled *En busca de una arquitectura nacional* (In Search of a National Architecture), in which he defined his architectural thought and explained his experimenting, heavily marked as it still was by eclecticism. Between 1874 and 1880 he collaborated with Josep Vilaseca (1848–1910) on the plans for the Instituciones Provinciales de Instrucción Publica, the competition for which they had jointly won. These plans, representing a true membership of Europe, made a great impact on Catalan architectural circles. In this connection, Puig y Cadafalch wrote, in an article in 1902, that, when he was a young architect, his Catalan colleagues followed three main tendencies: first the archaeological, represented by Elías Rogent (1821–97) and the reconstruction of the Romanesque monastery at Ripoll, coupled with the continuation of the neo-Romanesque University of Barcelona (from 1859 onward); second, what might be termed the eclectic tendency, as championed by Joan Martorell (1833–1906), designer of the church of the Salesas (Barcelona, 1885); and, thirdly, an authentic effort at renewal, linked to the general European movement – and especially to the Germanic; this last being ushered in and presided over by Domènech and Vilaseca's plan for the Instituciones Culturales.[4]

Not, indeed, that this design could be described as Modernist – but it does represent a break with past styles and the determination to express the new technology in architectural terms. It is worth emphasizing the direct use of elements whose significance and application up to then had been confined to engineering – as for instance the great chimney on the compositional axis of a façade, the desire to demonstrate everything rationally and, above all, the urge to escape from all taint of stylistic formulae, seeking instead a radically true form of expression. There can be no doubt that this design – which was never carried out – was for both of these architects the starting-point for their first mature works: Vilaseca's Industrias de Art de Francisco Vidal and Domènech's Montaner y Simón publishing house.

The publishing premises, carried out between 1881 and 1885, are therefore, along with Antoni Gaudí's Vicens house in the Calle Carolinas in Barcelona (1878–80), an important historical landmark. The Gaudí building contains the germ of all the later Expressionist developments, while Domènech's, with its completely 'architectonic' use of iron and its great continuous glass surfaces, triggers off those of rationalism. They are the first two works to use fair-faced brick on a large scale, but in Domènech this material takes on a constructional logic and an ornamental severity which may be seen as a hint of what was to come in the Café and Restaurant for the 1888 Exhibition.

In 1888 a great international Exhibition was held in Barcelona. It offered a splendid opportunity for the revelation *en masse* of a whole new generation of architects. The directing architect of the exhibition was Elías Rogent, with whom collaborated a most efficient and distinguished team – the active participation of Domènech, Fontseré, Font y Carreras, Gallissà, Vilaseca and (though somewhat less committed) of Gaudí made it possible for the Parc de la Ciutadella to show a fairly unified collection of buildings which might serve as a definition of that flourishing moment in Catalan architecture.

Domènech was responsible for two important buildings: the Hotel Internacional in the Passeig de Gràcia, now no more, and the Café and Restaurant which today, after many vicissitudes, lingers on in the guise of a Zoological Museum.

The Hotel Internacional was certainly one of the most important constructional adventures of the *fin-de-siècle*. A five-storey building, with a façade of about 500 feet, it was built in sixty-three days. This incredible record was made possible not only by Domènech's extraordinary capacity as an organiser, but also by the intelligent way he had envisaged the whole design from the start and made use of industrial

9. Detail from the entrance hall of the Hospital of S. Pau.

methods of prefabrication. Confronted with the need for speed and the poor quality of the ground on which he had to build, he evolved an ingenious system of foundations with a grille of railway-tracks, later recoverable; on these he stretched a series of chambered countervaults which transmitted to the ground uniform loads of 0.20 Kg./cm². The whole project took ordinary brick as its staple element, so that all the walls could be built without fragmentation. To have brought the carpentry, the roof-structures, and even the ornamentation all into line together, as he did, meant a gigantic effort, given the under-developed state of the building

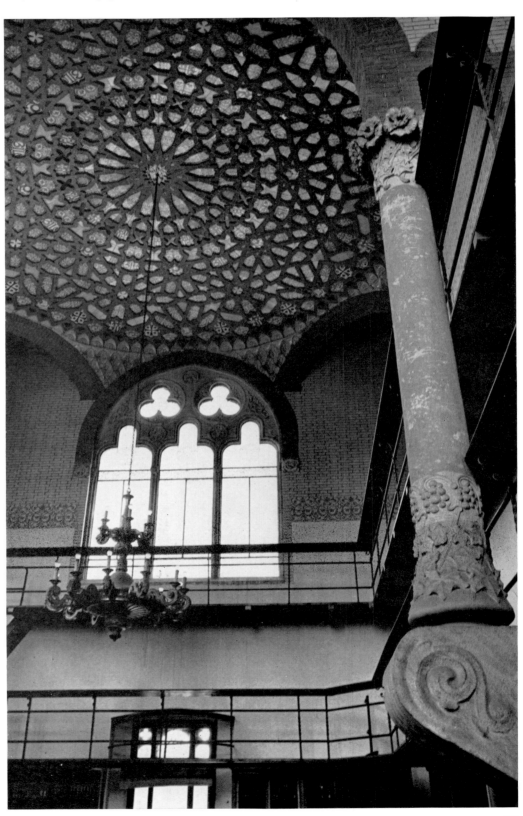

10. The library in the administration block.

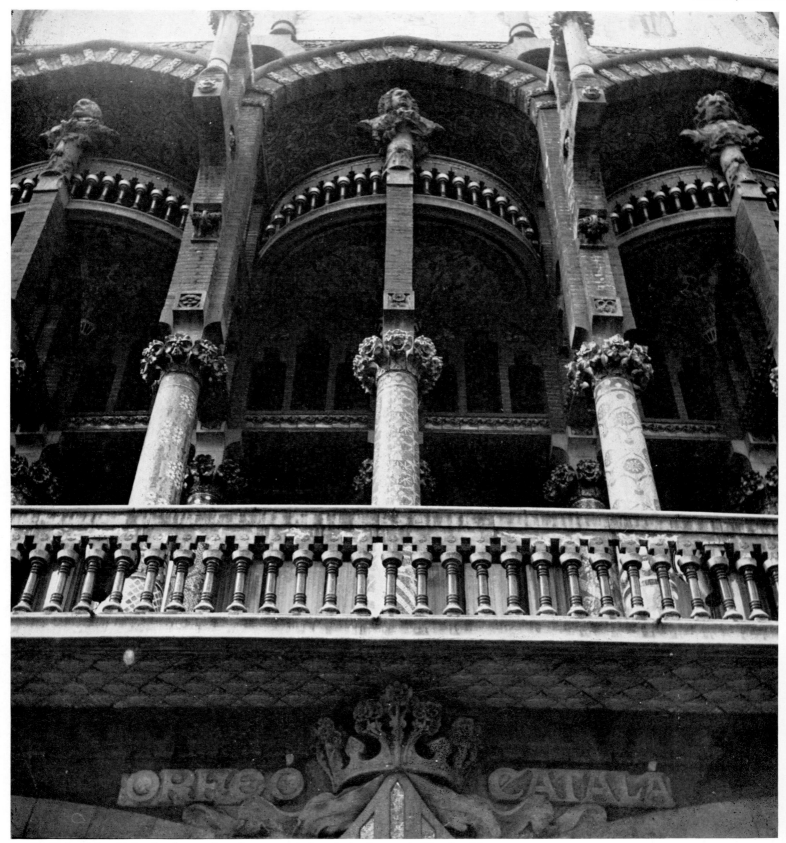

11. The Palau de la Música Catalana at Barcelona, 1905–8, the culminating work of Domènech's career: the main façade, looking upwards to the first-floor gallery in front of the interval room or promenade.

industry in Catalonia at that time. The hotel was completely dismantled after the exhibition closed.

If the Café and Restaurant has today an even greater effect than the hotel, the reason is that it was never entirely finished and therefore spared the ornamentation that might well have spoilt it. What remains is the fact that the volumetric and spatial skeleton of the building, the quality of its material and construction, make it, historically speaking, one of the most important works of its time in Europe. The use of exposed iron, not only in the roof arches but even in the façade lintels, is particularly remarkable.

The whole composition has a strange quality, a feeling of respect both for structural rigidity and flexibility of design. The façades are consistently treated as a volumetric whole, based on two parallel walls, and this lends the interior of the building a rather fantastic atmosphere. But perhaps the most striking thing is the new treatment of planes. The Café and Restaurant is without doubt the first work in which the plane is regarded as a fundamental element in architecture. In both the sculptural and structural sense the plane is shown to be autonomous. The sparse ornamentation is subdued to this criterion, and at the wall-surface the mouldings are suddenly cut as if guillotined by the unifying continuity of the plane.

The fact that Domènech must have taken his bearings from Catalan Gothic, and may therefore be to some extent open to the charge of archaeologising, is of the merest anecdotal interest, because he quite consciously made any such influence secondary to his urge to give the plane its proper architectural value. It took ten or twelve years before Berlage hit on the same values in his Amsterdam Exchange, which gave *De Stijl* the basis of its true three-dimensional style. The resemblance between the Barcelona Café and Restaurant and the Amsterdam Exchange is surprising, and has already been remarked on more than once. For Catalonia, Domènech here ushered in the rationalism that was shortly to produce its most remarkable example in the *Palau de la Música Catalana*. This latter sparked off a whole series of works in brick and iron by various architects, and led to the purism of the 'twenties and 'thirties.

Between the 1888 Exhibition and the 1914 War, Domènech became one of the leading figures of Catalan cultural and political life. It was no accident that the Modernist architects were closely involved in the social, cultural and political movements in Catalonia; for they were all caught up in the collective enthusiasm for the claims made by the nationalists. Gaudí, for example, from being a simple architect turned himself into a sublime beggar in the cause of an impossible *Catedral dels Pobres* (Cathedral of the Poor), thus anticipating a whole religious and patriotic movement. Puig y Cadafalch was President of the *Mancomunitat*, the first united Government of Catalonia, and his position in the *Institut d'Estudis* gave him great cultural influence. Domènech y Montaner was for a time the living embodiment of his country's spirit, the chief of the combined forces. It is essential to take all this into account if one desires to understand Catalan Modernism; if, that is, one is to realise that, far from being a mere depersonalised echo of foreign movements, it was the result of a social and political situation and represented a united cultural front with a whole people behind it.

In 1892 Domènech was named president of the *Unió Catalana*, and in that capacity took the chair at the momentous Assembly of Manresa, where the 'bases' were drawn up that gave Catalan autonomy its first programme and guided all Catalanist policy for many years. In 1901 he was elected Deputy to the Cortes, as one of those famous candidates, 'the four presidents,' whose political triumph was the first for the Catalanist movement, and marked the beginning of a new era in the political struggle of Catalan nationalism, which was to culminate, after the collapse of the Dictatorship of Primo de Rivera, in the autonomy of 1931 – so soon and so dramatically cut short by the Civil War.

Concern for the problems of industrial art showed itself very early on in Cata-

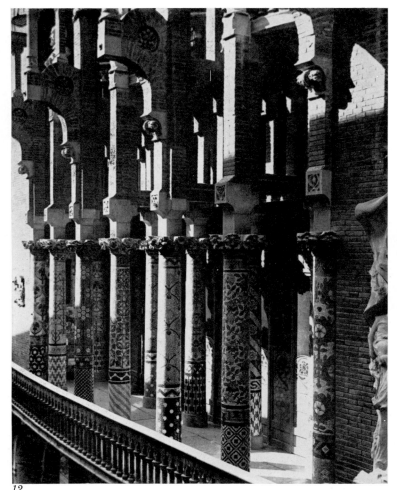

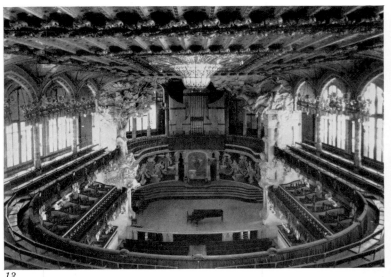

12. *The columns of the first-floor gallery of the Palau de la Música Catalana.*

13. *The auditorium, looking down from the gallery.*

14. *The fully glazed walls of the first-floor interval room.*

12

13

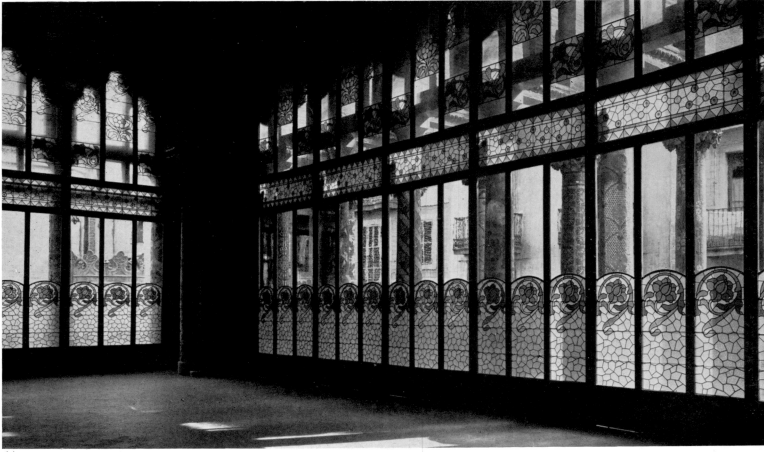

14

lonia, in keeping with the progressive outlook of Catalan industry. There is room for research into the writings and achievements, in this field, of Catalan aesthetic theorists, economists and sociologists of the last century. Worthy of note, for example, if only as a precedent, is the first Exhibition of Industrial Products, which was organised by the Board of Trade in 1852. Another such exhibition was held in 1854 by a group of industrialists; and in 1851 by the Industrial Institute of Catalonia. In 1860, the 'Art and Industry Exhibition of the Principality of Catalonia' placed its main emphasis on furniture.

In 1869 a new building was erected in the Gran Vía with the express purpose of housing an exhibition of industrial art. Practical proof of Catalan concern with industrial art was given when in 1871 the Diputación (provincial council) sent the critic Sanpere y Miquel on a tour of England, France and Germany to study the institutions set up there to deal with relations between art and industry. The same year another critic, Miquel y Badía, published several articles on the same question in the *Diario de Barcelona*, and in 1873 and 1875 the Ateneo held competitions. In 1881 Sanpere y Miquel brought out a very important small book on the same subject. Then exhibition followed fast on exhibition – 1881, 1882, 1884 – and from then on at regular intervals. The Art and Industry Exhibition of 1892 even included a series of lectures aimed especially at workers and delivered by various architects and designers.

The objects shown in these exhibitions are interesting when studied with an eye to what was on offer at similar shows in London and Paris, where the influence of Ruskin and Morris and the theories of Laborde could be plainly seen. Between Barcelona and the other centres there was a close relation, because in Barcelona as elsewhere forces were propelled by a keen awareness of what was happening in England. In Catalonia the cult of naturalism and the harking-back to craftmanship, as a reaction against the new industrial civilisation, reached its zenith with the Exhibition of 1888, and was, practically speaking, presided over by Domènech y Montaner. Here, as with Morris, the plea for a return to craft was based not only on aesthetic but on moral and social grounds. Each is, however, special to Catalonia in that here there existed in addition the political urge to evoke medieval history, i.e. Catalonia's lost sovereignty. So the return to craftsmanship, to the medieval guild idea, was part of a general determination to get back into the continuity of a broken history.

This revitalisation of the industrial arts had its focus in Domènech's Café and Restaurant. After the exhibition it was occupied for a while by Domènech, who used it as a workshop for objects of craftsmanship with which to embellish other buildings he was then engaged on. There, with the constant collaboration of the architect Antoni Gallissà, he concentrated on the forging of iron, the casting of bronze, on terracotta, glazed ceramics with lustre effects, Dutch tiles, majolica, glassware and so on. To this workshop came old craftsmen from all over Spain to give their decaying crafts a new industrial meaning.

The climax of Domènech's production was from 1895 to 1905. During this period he planned, built or finished the Institut Pere Mata, at Reus, the Casa Thomas, the Casa Navás, also at Reus, the Hospital of S. Pau, the Casa Lleó Morera, and the Palau de la Música Catalana. These masterpieces taken together establish the characteristics of his style. In each and all of them is to be found – beneath the clamour of floral ornamentation – a strict constructional rationalism and a highly advanced way of posing architectural problems.

To study the development of floralism in Domènech, one would have to make a detailed examination of his famous capitals in chronological order. In all of them we can see a development from Corinthian forms, through Gothic stylisation, towards an absolute naked purity, coupled with a gradual intervention of structural rationalism. The function of the first capitals is still sculptural: that of passing from the stem to the springer of an arch in a clear and radical manner (as in the porch of

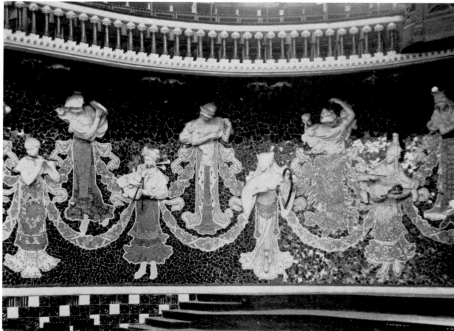

15 16

17

15. *A pilaster base in the entrance vestibule of the Palau de la Música Catalana.*

16. *Background of the stage.*

17. *Central rooflight in the auditorium.*

18. *Section and plans of the Palau de la Música Catalana. 1, vestibule. 2, main staircase. 3, café. 4, offices. 5, recital room. 6, light-well. 7, interval room, or promenade. 8, foyer. 9, auditorium. 10, stage. 11, promenade. 12, organ.*

19. *The Casa Fuster, Barcelona, 1908–11. The building was saved from demolition by a students' protest in 1963. The interior has been remodelled.*

the Casa Navás at Reus). The floral ornamentation, here, is an almost independent collar, but behind it persists the moulding of the capital. In the Casa Lleó Morera, on the other hand, the architectonic structure of the capital has almost disappeared and been replaced by a series of great round flowers in a strictly geometrical arrangement. Though the arabesque of these flowers may be reminiscent of the Corinthian, one can yet claim that here the typical Domènech capital has been born. It may seem paradoxical, but this capital is the result of firmly rationalist thinking. The process begins by the refusal to admit that the capital is a necessary element from the point of view of resistance. But as the polemic in favour of rationalism had not yet come to a head, Domènech, faced with the weight and prestige of tradition, hesitated, finally deciding to replace architectural mouldings by an element of ornament which might act as a mere reminiscence of them, clearly and specifically non-constructive and even gently ironic.

The most significant moment in this development is to be found in the capitals of the Hospital of Sant Pau and the *Palau de la Música*, both designed during Domènech's peak period. The majority of these capitals, typically, are chains of round or square flowers entirely detached from their background, so that behind them the column passes on, insensibly, with no gaps, toward the arch-springer. But the final step in this simplifying drive was taken with the columns of the façade at the back of the Casa Fuster, in the carrer Jesús in the Barcelona district of Gràcia. Here the capital has practically disappeared, and all that remains are light and fleeting incisions between geometrical and vegetable forms. This extraordinarily smooth façade, of an extreme lineal perfection, was almost Domènech's last work and, culturally speaking, may be taken as his utmost point.

Domènech's two most important works are, without any doubt, the Hospital of S. Pau and the *Palau de la Música Catalana*. Their importance resides not only in the fullness of the architectural ambition behind them but also in their being landmarks on the road to structural rationalism, and especially to the bold use of hitherto unused materials.

The Hospital is important in two ways: in the architectural and city-planning ideas behind it, and in its constructional requirements. As to the first, it must be remembered that Domènech and his contemporaries found themselves at a crossroads – of doubt between the hospital conceived as a centralised unit and as a collection of scattered pavilions. Domènech tried to overcome the technical difficulties of communication by means of an impressive underground system, preserving in each apparently independent annex the proper degree of human contact. As to the structural interest of the hospital, it may be true that it could be called not only traditional but even archaeologistic, but what must not be forgotten is that Domènech was striving passionately for the revitalisation of the crafts and techniques of his country, not only for aesthetic but mainly for ethical reasons.

A similar meaning could be drawn from the Institut Pere Mata, at Reus, done to almost exactly the same plan as the hospital. Here there is admittedly a hint of a certain archaic, Mannerist quality and more than a hint of carelessness in detail and finishing-off; all of which conspire to render it distinctly inferior to the hospital. Nevertheless, the requirements of construction would seem to have been envisaged with care.

These constructional requirements were studied to further effect in the *Palau*, where various new elements were brought into play at will. The *Palau* surprises by its floral ornamentation, its polychromy, the unity of its spaces and the impressive way they follow one upon the other, but above all by its courageous structural planning. The structure is rectangular, with beams and girders of laminated steel, so as to make possible a succession of spaces – penetrated only by the great volume of the auditorium – enclosed on the outside by a simple curtain of glass. The very fact of using iron structure in a non-industrial building so early is extremely important. But even more extraordinary is the use of the open plan and the glass walls.

Nor is this absolute transparency of the *Palau* in any way accidental, or even a mere product of exclusively sculptural criteria. From the sketch it is easy to ascertain that Domènech fought the obstacles which the site put in the way of a design that would satsify the rigid purist in him. The result is this clean, rectangular structure, wrapped entirely in glass, a structure unparalleled anywhere in Europe in the year 1905, when it was designed.

Translated from the Spanish by Pearse Hutchinson

NOTES

[1] J. F. Rafols: *Modernismo y Modernistas*. Barcelona, 1949. A. Cirici Pellicer; *El Arte Modernista Catalán*. Barcelona, 1951. George R. Collins; *Antonio Gaudí*. New York, 1960.

[2] A. Cirici Pellicer: *El edificio de la Editorial Montaner y Simón*. Cuadernos de Arquitectura, Barcelona. Second and third quarters, 1963.

[3] Domènech has been virtually ignored by international critics. H. Russell Hitchcock, for example, in his *Architecture of the Nineteenth and Twentieth Centuries*, pigeon-holes him as a mere extravagant disciple of Gaudí.

[4] *Hispania*, December 1902. Puig i Cadafalch (1869–1956) was yet another Modernist architect, archaeologist, expert on Romanesque art and Catalanist politician; he rose to be president of the *Mancomunitat de Catalunye*.

BIBLIOGRAPHICAL DATES

1850:	Born.
1873:	Qualified as architect.
1874:	Prizewinner in the competition for the Instituciones Provinciales de Instrucción Pública (collaborator, Vilaseca).
1875:	Professor at the Escola de Barcelona.
1881–5:	The Montaner y Simón publishing house, carrer Aragón, 255, Barcelona.
1887–8:	Café-Restaurant for the Barcelona Exhibition (now the Zoological Museum).
1888:	Hotel Internacional, Barcelona (no longer extant).
1892:	President of the Unió Catalanista: with the autonomist 'Bases' laid down at its Assembly in Manresa.
1893:	Palau Montaner, carrer Mallorca, 273, Barcelona.
1897–9:	Institut Pere Mata, Reus.
1899:	Casa Thomas, carrer Mallorca, 291, Barcelona.

1900:	Head of the Escola de Barcelona.
1901:	Deputy at the Cortes.
1901:	Casa Navás, Plaça Espanya, 7, Reus.
1902:	Casa Lamadrid, carrer Girona, 113, Barcelona.
1902–4:	Decoration of the Fonda España, carrer S. Pau, 9, Barcelona.
1902–12:	Hospital of S. Pau, Barcelona.
1905:	Casa Lleó Morera, Passeig de Gràcia, 35, Barcelona.
1905–8:	Palau de la Música Catalana, Plaça Amadeu Vives, 1, Barcelona.
1902–12:	Gran Hotel, Plaça Weyler, 7, Mallorca.
1908–11:	Casa Fuster, Passeig de Gràcia, 128, Barcelona.
1913–14:	Alterations to the Casa Solà, Firal, Olot.
1923:	Died, Barcelona.

For further details of Domènech's life see the *Cuadernos de Arquitectura*, second and third quarter 1963 (Barcelona).

WAGNER AND THE VIENNA SCHOOL

by Otto Antonia Graf

This addition to the many published studies of the work of Otto Wagner, pioneer at the end of the last century of the revolutionary developments that took place in Vienna, deals particularly with the architectural ideology that he and his disciples had evolved by 1900. New light has been thrown on it by a number of unknown projects recently discovered.

The work of Otto Wagner, who was born in 1841 and died in 1918, and even more that of his students at the Vienna Academy where he taught from 1894 till 1912, offer an ideal opportunity to watch the basic thought processes leading to that so-called Modern Architecture which is now a closed chapter of architectural history. For already in the work of the Wagner school, the conventional concepts of 'art' and 'architecture' were left far behind, and this in spite of the fact that the Wagner school stood apart from the clamour made by the Secession and its enemies.

From 1963 about fifty hitherto unknown projects – several hundred drawings – have appeared in private hands, so that one can now observe creative processes which took place between 1860 and 1917 and which Wagner himself had hardly ever before made public. The result amounts to a major discovery. What we have before us now seems to have nothing to do with what used to be called the Wagner school, i.e. the styles of Olbrich, Hoffmann and the Vienna *Werkstätte*, and it is becoming patent at last what Wagner in 1895 meant by '*Naissance*'. Drawings by Wagner himself in particular had, prior to 1963, scarcely been known. They demonstrate how firmly Wagner was anchored in the Imperial Viennese style of the early eighteenth century.

This relation must be kept in mind if one wants to understand Wagner's moderate historicism. Sketches of about 1898 for alterations of, and additions to, Semper's Hofburg in which Art Nouveau and Baroque meet, stand side by side with suppressed fantasies (of about 1897) circling round a National Monument inspired by the tomb of Augustus in Rome, the pyramids, and Fischer von Erlach's varia-

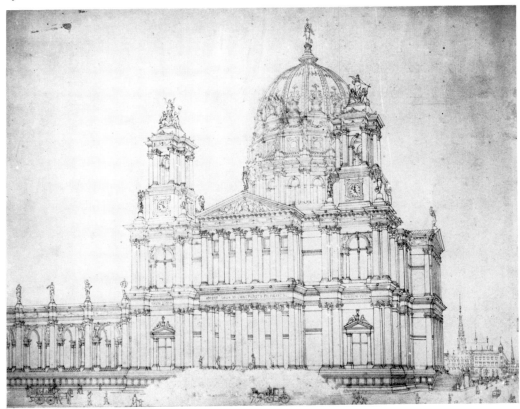

1. Otto Wagner's design for Berlin Cathedral, about 1860.

tions on a triumphal Mediterranean world architecture. From here development leads to the churches, academies and museums which Wagner designed later on. Since Wagner saw himself in a line of descent from the Late Baroque as the Viennese *genius loci*, we can understand why, in spite of having worked for Theophil Havsen, the architect of the Cinquecento Academy of Art and the Neo-Greek of the Houses of Parliament, Wagner never really was a historicist in the sense of the then current pathological distortion of the concept of time.

The nature of Wagner's moderate rationalism in the *Stadtbahn* stations (*c.* 1892–1902), the Danube Canal (1895–1905), the Postal Savings Bank (1903–12) and the book called *Modern Architecture* (1895 and further editions in 1898, 1902 and 1913) is familar. Olbrich's buildings at Darmstadt and in Vienna, Hoffmann's buildings and those few designs of the school which can command only local interest belong to the same trend. A different trend is represented by some early Wagner designs and a variety of utopian and experimental ideas of the school which can't be separated from the Master. There are for instance designs for banks done about 1880, which are among the most progressive of any rationalist technologically-orientated designs anywhere. Behind orthodox façades there are spatial systems far removed from the classical tradition.

Thirty-five years later this anti-formalist rationalism in the Girobank and

2. Flats at Schottenring no.23, Vienna, 1877.

the *Länderbank* reappears in the design (of 1917) for a temporary church, a box-like skeletal structure devoid of any historicist connotations. Here is the final termination of a process of reduction which occupied Wagner throughout his life. A similar endeavour at reduction is to be found in the designs of his pupils between 1898 and 1905, handled with extreme radicalism. Forms of geometrical abstraction, constructivist metaphors, rotating structures, skeletal variations in glass, concrete and iron, skyscrapers of concrete and glass and designs for such dynamic buildings as airports, sports arenas, car-racing tracks and industrial cities were turned out. Demands for a machine aesthetic were formulated. Even formulae of Vitruvius were bent that way. Neglected phenomena of the pre-morphous and sketchy on the one hand, social, pacifist utopias on the other, were investigated.

The answer to the question why all this had until now hardly been noticed is easy. There are still plenty of white patches on the map of recent architectural history anyway, but the web of late Baroque Imperial and pre-cubist abstraction would not fit into the system of modern architecture as it was current. There are complicated interactions. One process starts from the classical system as developed from Piranesi's hallucinations of sinister spaces and the so-called French architecture of the Revolution – an anticipated Royalist self-punishment in terms of terrorist fantasies. These trails of disintegration are neither terminated nor yet fully comprehended. They are planetal and work towards a transformation of the surface of the earth. No history of modern architecture can be adequate unless it takes notice of two opposite planetal events, for which the Wagner school allows us – so I believe – to present crucial evidence.

If such evidence has until now been neglected, the reason is a chauvinistic and sentimental handling by the Austrians of their art and architecture in the twentieth century. Otto Wagner, Schönberg, Kokoschka, Karl Kraus, Freud fought not just narrow-minded, intellectually lazy surroundings, but an unavoidable, tragic destruction in a bitter civil war. An attempt to hold up the flow, to make matters rigid once again, was nowhere as urgently needed as in the last years of the Habsburg régime. Austria was sufficiently industrialised to face new conflicts, and ever since the revolution of 1848 sufficiently nationalist to face other conflicts. In the Ringstrasse – syndrome of contradictions and *locus* of political romanticism – lay the destiny of Wagner and his school.

In 1879 Wagner designed the celebration tent for the Makart Procession, a parody of the social and industrial reality of Austria in terms of Dürer's Triumphal Procession for the Emperor Maximilian. This was Wagner's first success. His diaries and letters tell of his inner conflicts and of wild discussions about the meaning and the possible progress of art. In 1882, for the first time, à propos the design for the *Reichstag* in Berlin, Wagner slated 'architectural lies' and pointed out that architectural form results automatically from care for function. In 1889 Wagner pronounced against 'experiments with diverse stylistic trends as they have been hurriedly picked up in the last twenty years.' He knew that what is exposed was a capitalist exploitation of the past – destruction of true history. In *Modern Architecture* he called this kind of exploitation by the upper bourgeoisie 'an insane structure'. Those who accepted it called a modern style of building 'an Assyro-Babylonian idiot style' and 'l'art juif'. No wonder that Freud at that moment was speculating on the relations between culture and insanity.

Wagner's fifty years of warfare started in 1863 with a restaurant stylistically dependent on the Vienna Opera House and ended with the First World War and the designs for the War Ministry, the last of the huge buildings along the Ringstrasse. Wagner belonged by origin and self-stylisation to that upper bourgeoisie which retained faith in democracy and permanent progress. Hence the many massive hatreds which he contracted and which cost him the realisation of nearly all his later projects. Those who hated him stood solidly in the line of development which had destroyed the fruits of the 1848 revolution. Architecturally that development

3. Study for a façade, about 1877.

showed itself first in barracks and military camps round the city, and then in the demolition of the fortress walls behind which the revolution had barricaded itself. The fortified ring was replaced by a historicist landscape, ideologically magical, but also implying a threat which history holds out at us.

The first building along the Ringstrasse – dated 1856 – was the *Votivkirche*, neo-Gothic and commemorating an unsuccessful attack on the Emperor's life by an anarchist. The last – dated 1907-13 – was the War Ministry. The true conclusion of thinking in terms of monumentality and eternal duration was the innumerable designs by Hoffmann and the Vienna *Werkstätte* for soldiers' gravestones – voluptuous *Kitsch*; now no more. This, abridged by me for the purpose of this paper, was the environment of art and architecture in Vienna between 1890 and 1914 – a scenario of gruesome self-destruction.

For a short time, when the problems of town-planning could no longer be solved by liberalism and the exploitation of the past, it looked as if modern solutions might have a chance. The rise of the lower bourgeoisie fostered by the mayor of Vienna, the great demagogue Lueger (who was a friend of Wagner) coincided with the nationalisation of urban enterprises and the development of metropolitan transport. Wagner worked from 1894 on the fifty-mile-long *Stadtbahn* and the Danube Canal. Not a single one of Wagner's projects, related to the cultural and historical identity of Vienna, was he able to carry to fruition except the Postal Savings Bank and the church of the Steinhof Asylum. No success rewarded the plans for a municipal museum (in secret competition with the Imperial Museums), for a Gallery of the Twentieth Century, for exhibition palaces, theatres, academies, civic halls, churches and ministries. In fact, about 1898, Wagner himself designed for dynastic representation, i.e. the *Hofburg* and the sepulchral vaults of the Habsburgs.

However, in the middle of all the ugly fighting, unnoticed almost, the liberation of youth took place in the Wagner school, even though all they achieved remained on paper. It can be seen as a fulfilment at last of the 1848 revolution – Semper built barricades and accepted 'only one master of the arts: necessity'. The Ringstrasse was built as a reaction against 1848, a demonstration of power preserved. No modern feature was allowed a place, at least in official architecture. Rarely, before the era of Hitler to whom, remember, the architecture department of the Academy refused admission, could one see so clearly that architecture and war

4. Länderbank, 1882: rear view. An early example of Wagner's rationalist outlook.

always stand under the sign of power. But the rule also applied to the Old Austria of the years which occupy us in this paper. According to how aggressively energies shift from the one to the other, first architecture, then war, will dominate. Wagner and his school must have been aware of these dangers.

So it is totally wrong to enthuse over the charm of Vienna and its late-bourgeois culture (whose true values are undesirable) and at the same time to regret the lack of understanding of modern creativity. Of the two reactions to the shock of the revolutionary changes occuring in modern times, the one gazing into the future proved too weak to succeed. Wagner and his pupils faced these problems as they hoped to achieve an *Ausgleich*, to use the term then current in political discussion. What such an *Ausgleich* was after can best be circumscribed by abolition of all

5. Neumann clothing store, Vienna, 1894.

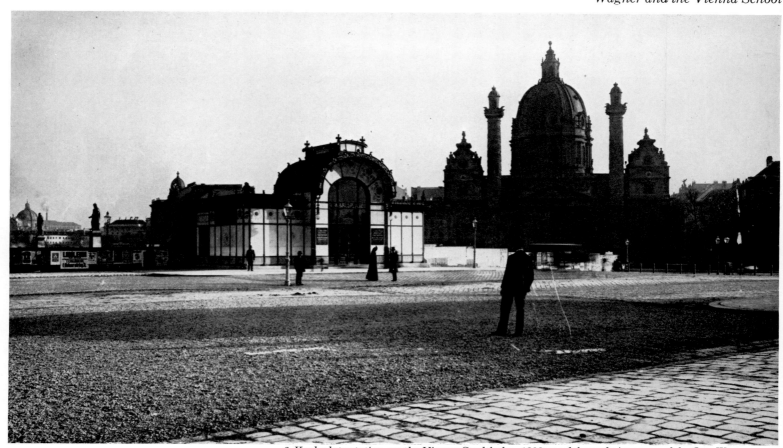

6. *Karlsplatz station, on the Vienna Stadtbahn, 1898: a celebrated pioneer work by Otto Wagner.*

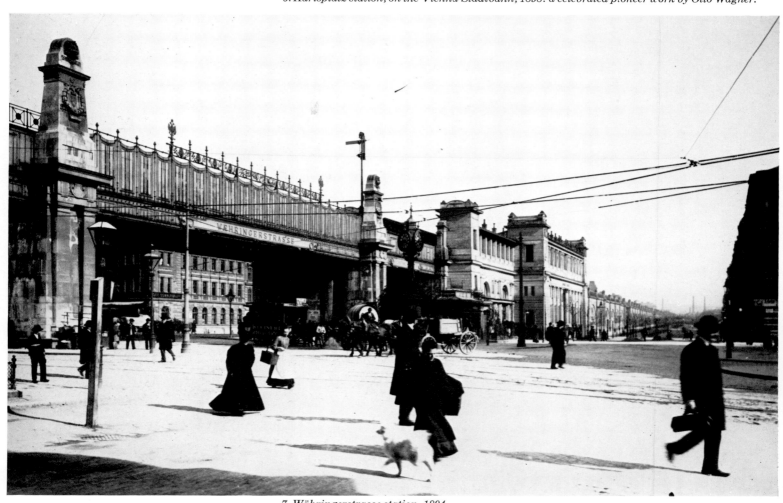

7. *Währingerstrasse station, 1894.*

cases of non-contemporaneousness. As Wagner was appointed to the chair in the Academy, he saw the chance of an *Ausgleich* between his 'Naissance', as it demonstrated itself in science, technology and politics on the one side, and on the other the conscious acceptance of history and the appreciation of the structures of the past. Wagner drew attention to the fact that artists hitherto 'had been pleased to dissect with a magnifying glass instead of feeling the pulse of the living.' The wish implied in such a statement is to heal social suffering – just as to heal suffering was the aim of the great Austrian pacifist Bertha von Suttner, and of the great medical experts of Vienna, including Freud.

Nearly all that Wagner did from 1898 onwards was concerned with buildings serving the new culture, and hence with the *Ausgleich* between the architecture of the Imperial past and of the modern world. Wagner saw, like the medical explorers, the psycho-pathological attitude of Central Europe towards it history. So, if Wagner tenaciously clung to certain classical principles of form, his reason was that he wanted an alliance of tradition with the modern world of democracy. The tragedy of Wagner and his surroundings during the last twenty years of his activity was that nobody retained any interest in the efforts at synthesis of past and present. Thus while Wagner could cope with *Stadtbahn* and Canal, his endeavours towards synthesis were doomed from the start.

The Vienna Academy, when Wagner joined it as a professor, expected a man firmly adhering to Antiquity. He never did, but the jobs he had to cope with – the *Stadtbahn*, the Canal, even the development plans for Vienna – made it entirely impossible to be satisfied with historicism and monumentality. Hence such designs by his pupils as an airport and a reinforced concrete control tower. The beginnings of the Secession also belong to his school. Success among the young could not be denied. It is said that about 1907 more than 200 foreigners who wanted to join Wagner's school had to be turned down.

Projects set by Wagner were always for the first year a typical block of flats, for the second year a public building. As a final project quite utopian schemes were worked out, going in daring far beyond Wagner himself. Especially during the peak years 1902–5, the degree of originality of the students poses many problems. We know the students only from the publication of their projects in eight not very bulky volumes and in the journal *Der Architekt*. About seventy students are represented. Nearly all of them, except those actually working in Wagner's own studios,

8. Gumpendorferstrasse station, 1895.

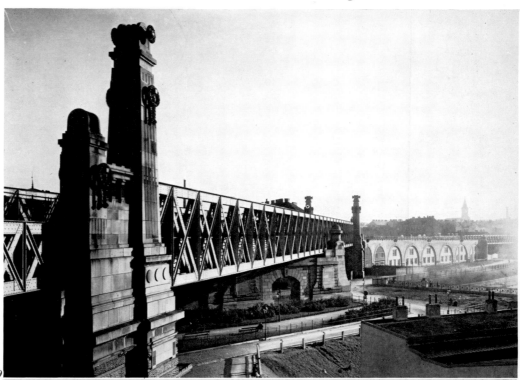

9. *Vienna Stadtbahn: bridge over the Wienfluss, 1895.*

10. *Flats in the Wienzeile, 1898.*

11. *Design for the rebuilding of the Hofburg, 1898.*

12. *Sketch for the Kapuzinerkirche, 1898.*

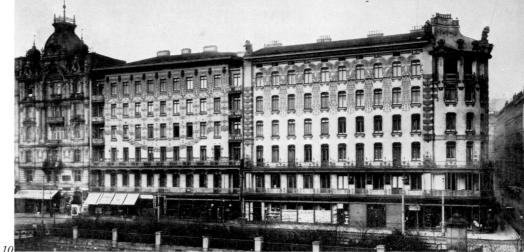

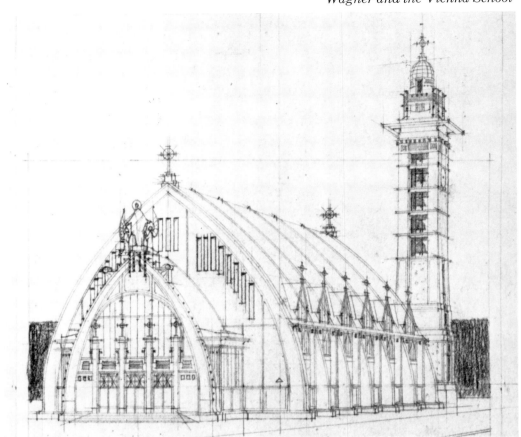

13. *Temporary church, 1905–6.*

14. *Post-Office Savings Bank, Vienna, 1903–6.*

14 13

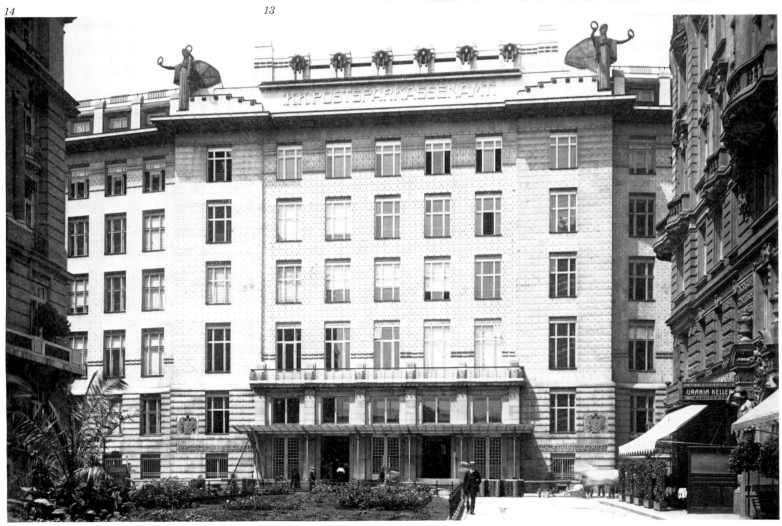

are lost to us in the darkness of history. As for the best of them, nothing at all is known.

One of the most objectionable aspects of Austrian art is its conviction that theory and philosophical thought can be dispensed with. The Wagner school on the other hand, thanks to Wagner's view of history and the tasks he set, evolved a comprehensive theoretical foundation including investigation of topical social phenomena. Here lies the greatest importance of the school, greater than the art-historical importance – which, after all, in the situation of the twentieth century, is bound to be secondary. The school was aware of the possibilities of transforming the alienation of historicism into the positive foundations of a new architecture. The most interesting of the students, Karl Maria Kerndle, put it this way: 'It is school projects we are submitting here to the public, and that means not full achievements . . . eager, searching endeavours carried by hope and by a serious persevering will. The emphasis and the ideal value . . . lie in the vista of, and the possibilities for, further progress . . . We send out into the world propaganda for the thoughts of modern art which after all is not static and retrospective, but evolving, looking forward and marching forward . . . We, the Wagner school are guided by this modern spirit . . . One purpose is to view, perceive, recognise human needs and then to solve the tasks thus analysed in an aesthetically valuable way . . . No intention is implied to create anything like a type, a "modern style".'

15. The War Ministry, 1907–13, the last of the series of buildings designed by Wagner along Vienna's Ringstrasse.

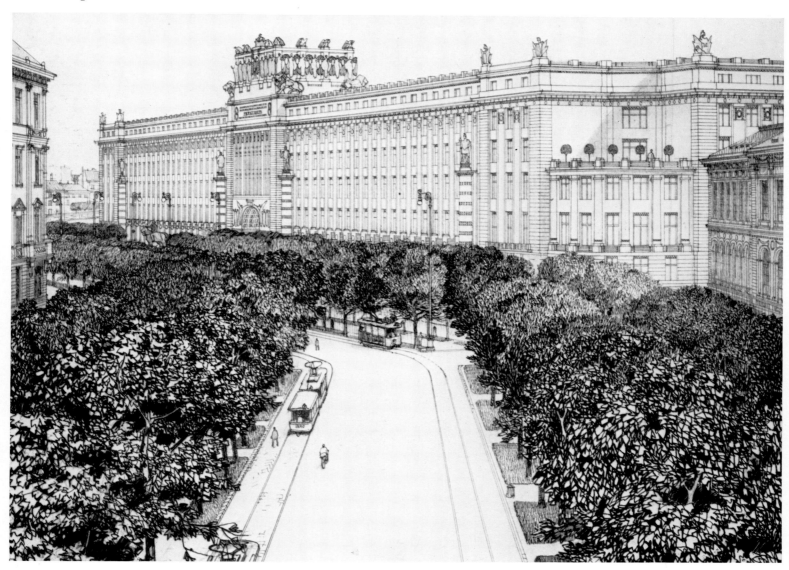

Joseph Lux, the biographer of Wagner, formulates the aesthetics of the school in Vitruvian terms: 'Otto Wagner is a conqueror and a liberator, He reduces his aesthetics to three terms: purpose, construction, poetry. These three terms as the headline of an artists' profession of faith set the highest demands.' By pointing firmly to Vitruvius – a move which must have annoyed their enemies considerably – the Wagner school could oppose traditionalism and historicism. Architecture is not a *depositum fidei*, such as academics never tire of stressing. It must serve social needs, and never-ending progress. Thus Kerndle thought he could remove the dichotomy of art and the modern world. This new formulation, not diluted by traditionalism (as happened to Loos) nor by reforms in mere decoration (as happened to Hoffmann), changed the process of architectural design into a never-ceasing dynamic. Architecture is a process of cognition whose material is the whole of human life and whose evolvement must be open-ended.

Architecture therefore is to Kerndle the poetic form of scientific effort, and the architect must steadfastly work towards the future; i.e. the unknown. Thus the past, the accumulated material of history, disappears. A passage on hotel design proves how far Wagner and his school ventured forward: 'There are three principles behind the problem; the building must function like a perfectly constructed machine; it must in its installation be on the level of the wagon-lits; and it must in matters of hygiene and cleanliness, of all objects for use, be up to clinical demands. What is needed is a synthesis of hospital, sleeping-car and machine. Perhaps in fifty years we shall reach such excellent hotels, always assuming that progress increases with today's tempo. It should be evident that the problem is not one of good taste or aesthetics, but entirely of technical and constructional execution, of the ground-plan and of the highest comfort achieved with a minimum of time and means ... The technical servants and helpers in our lives, the lifts for food, for people, for goods, light and sound signals, cold and hot running water, central

16. *Lupus Hospital, Steinhof, near Vienna, 1909.*

17. *Franz Joseph Foundation military hospital, 1915.*

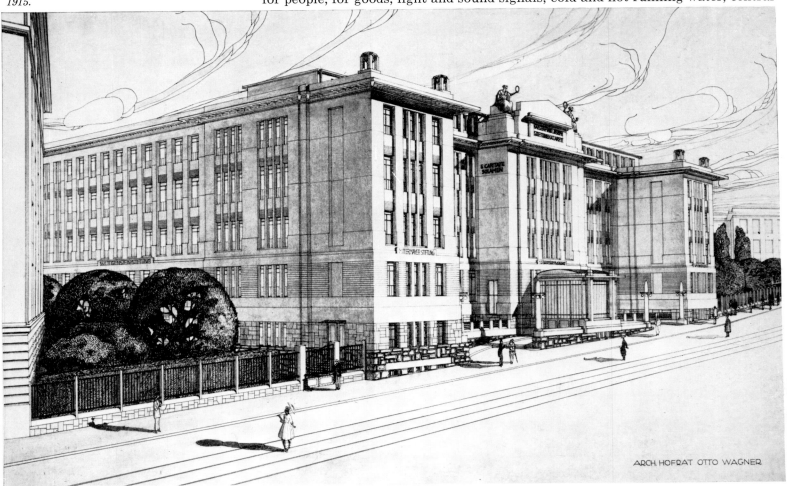

ARCH HOFRAT OTTO WAGNER

95

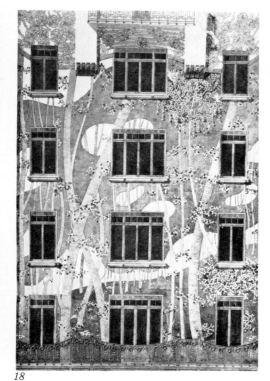

18

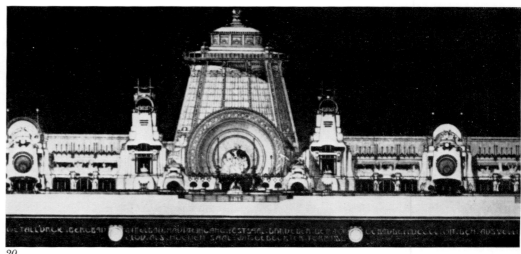

20

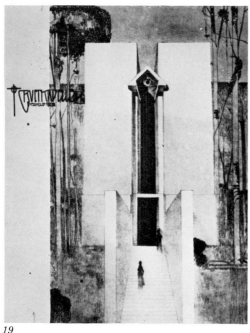

19

18. *Façade in terracotta, by Hans Schlechta, 1900. Its simplicity derives from Wagner's work at that time.*

19. *Design for a burial chapel by Karl Maria Kerndle, 1903, a work by one of Otto Wagner's students clearly showing his influence.*

20. *International exhibition building by Rudolf Melichar, 1899.*

heating, internal telephones – all those mechanical and electric systems which are the nerves of the building give it a certain apparatus quality, quite apart from the kitchen in the basement which looks like a boilerhouse, from the laundry, the domestic offices and the store-rooms, all essentially in the basement' . . . in short, an American-style hotel of 1950.

A pupil of Wagner, finishing his studies in 1913 with the design of such an hotel, wrote in the description of his project: 'Architecturally there is straight simplicity. All coquettish, superficial efforts and all individuality are avoided. Like a machine, a good chair or a musical instrument, the architectural form must be a uniform designed after the criteria of need and material, capable of changes when new needs arise and always, in changing, working towards greater purity.'

Here already one enters the orbit of the calculations and analysis of industrial, physiological and emotional functions and leaves behind the old co-ordinates of idealisation and monumentalisation. In the great years between 1898 and 1905 the school had an intuitional knowledge of the many varied problems bound to appear in a 'Naissance'. The research of the best of the students was concentrated on three directions. One was the problem of form, as it posed iself to all radical artistry about 1900, i.e. opened-up spaces, interpenetration of space and volume, and forms processual, plasmatic, geometrical, abstract, elementary. The second direction was the relation of construction to form or, better, the demonstrative raising of construction to poetry. Never since the end of the Gothic period had this synthesis been aimed at. Now the problem was how to integrate art with the inventions of the nineteenth century. The Wagner school did in fact find some highly significant constructivist gestures: skeletal towers held by ropes, a form heralding radio masts; concrete shells of elliptical section, nearly 500 feet long; towers about 750 feet high surrounded by curtain walling. Finally the third direction was towards analysis for planning for dynamic new fields. Students who could think in terms of the time-space dimensions of the *Stadtbahn* could visualise sports grounds, car-racing tracks, airports and techno-commercial world centres of trade – and, oddly, of peace.

It is evident that all this, in the self-destructive reality of Central Europe about 1900, went far beyond the capacities of society. However, that is not what matters. What matters is the fact that the Wagner school penetrated into a consciousness of new dimensions in architecture and planning. It succeeded indeed in visualising architecture as an open-ended synthesis of mass systems, traffic systems and technical organisation. In this sense, Kerndle's 'recognition of needs' and 'pioneering for further progress' must be understood. This is one pole of Viennese thinking seventy years ago; the other is the careful shaping of an intimate domestic environment as we know it in the works of Hoffmann and Loos.

Translated from the German by Nikolaus Pevsner.

ÖDÖN LECHNER

by Ferenc Vámos

Lechner, the leading Hungarian architect at the end of the last century, has been called Hungary's Gaudí, but he is almost totally unknown in Britain. A major book on him by J. Kismarty-Lechner was published in 1961, but only in Magyar; Mr. Ferenc Vamos, who here introduces him to English-speaking readers, had written on Lechner as early as 1927.

Can Ödön Lechner have seen any work by Gaudí? It is just possible; for Lechner, who was born in 1845 and had gone in 1868 to Berlin to study at the *Bauakademie*, had left there disappointed, and in 1874 had moved to Paris. He returned to Hungary only in 1878, but he was in Paris at the time of the International Exhibition of 1878, and there Gaudí did appear with an exhibit.[1] Gaudí was at that time still a Gothicist, though in a free, original and fantastic way – and so was Lechner. But wheras Gaudí's father was a small artisan, Lechner's was a high civil servant and the confidant of the Archduke Joseph, Viceroy of Hungary. Lechner's Kecskemét town-hall of 1892–93, in spite of its big central Renaissance gable, is Gothic in most of the detail. The same is true on the whole of the exterior of the great Museum of Decorative Art at Budapest, which dates from 1891–96. But here some of the details turn quite fantastic, and the interior is full of Indian borrowings, inspired by such Anglo-Indian buildings as the Calcutta railway station.[2] It is interesting to see how, in his next principal work, the Geological Institute of 1896–98, Lechner turns these elements into something entirely his own. Of outside inspiration one can here sense only a touch of the Baroque, but filtered through the folk-arts of Hungary, textiles as well as carvings. Lechner, though a personal friend of Otto Wagner of Vienna, was critical of the *Sezession* building by Wagner's pupil Olbrich. He said that in it Assyrian forms were made use of, but all consideration of rational or folk elements was lacking.

The Postal Savings Bank is the climax of Lechner's work and one of the most resourceful and successful examples of Art Nouveau architecture anywhere. The original plans are dated 1900; the inauguration took place in 1901. Inspiration came from diverse sources, but has been merged with Lechner's own mature style – from Hungarian folk art, and even from the Austro-Hungarian Romanesque (cf. the relief above the entrance to the cemetery-church at Mödling). There is also some nice and easy symbolising, such as the bees, exemplary savers, at the top. The effect of the façade is determined not only by the curvaceous top cresting but even more by the use of materials, small yellow brick and coloured pirogranite, a

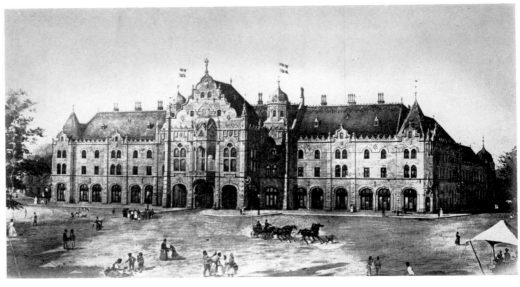

1. Town-hall at Kecskemét, 1892–3.

very hard artificial cast stone, or rather terra-cotta, made in Hungary. The whole exterior is gay with strong colours. The interior is symmetrically composed. The centre, just as in Otto Wagner's famous, slightly later, Vienna Postal Savings Bank, is a glazed banking hall, seen in the section; but whereas Wagner's demonstrates his radical turn away from Art Nouveau, Lechner's (as far as it survives; the roof was rebuilt wrongly) is Art Nouveau in the extreme.

Yet Lechner was on the way into the twentieth century too. His church of St. Elizabeth at Bratislava, the first projects of which (later altered) date from 1906–08, has concrete vaulting – two cradle vaults one at right angles to the other – and already in 1902, in an address at Szeged, he had said: 'The fantastic achievements of technology, such as iron construction, have caused a revolution in architecture. The development started in England and spread rapidly to Germany, Austria, and afterwards France. . . The new materials require new forms. . .' Lechner's pupils such as Béla Lajta moved effortlessly into the style of the new century.

NOTES

[1] It was a showcase for gloves – see R. Pane *Gaudí*, p. 13.

[2] The connexion was indicated by Lechner himself; see an essay of his written in 1892 and published by me in *Müvészet*, September 1964.

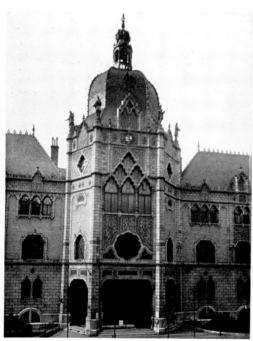

2. *Museum of Decorative Art, Budapest, 1891–6.*

3. *Roof Detail.*

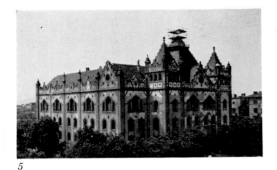

5

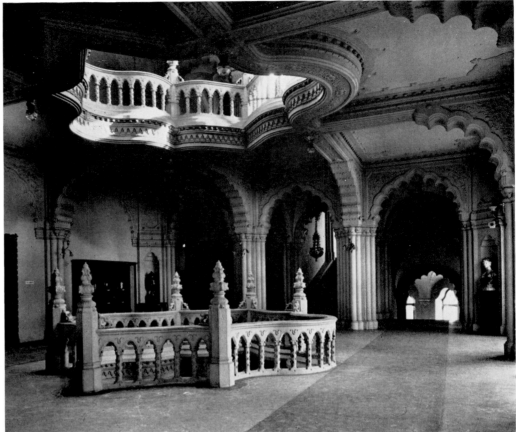

4

6

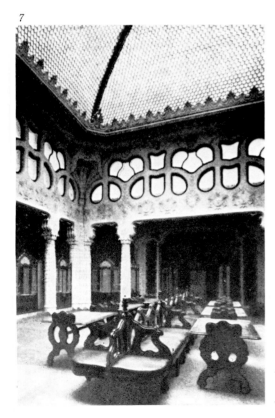

7

4. *The central hall of the Museum of Decorative Art.*

5. *Geological Institute, Budapest, 1896–8.*

6. *Staircase.*

7. *The interior of the Postal Savings Bank, Kecskemét.*

8. *Postal Savings Bank, Kecskemét, 1901.*

8

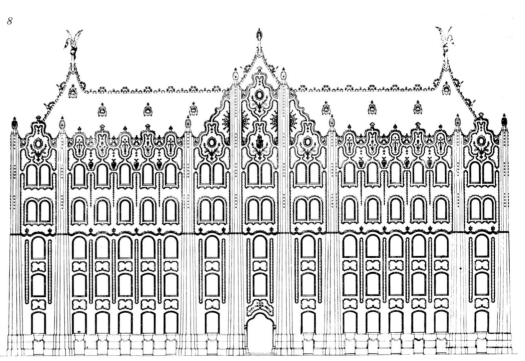

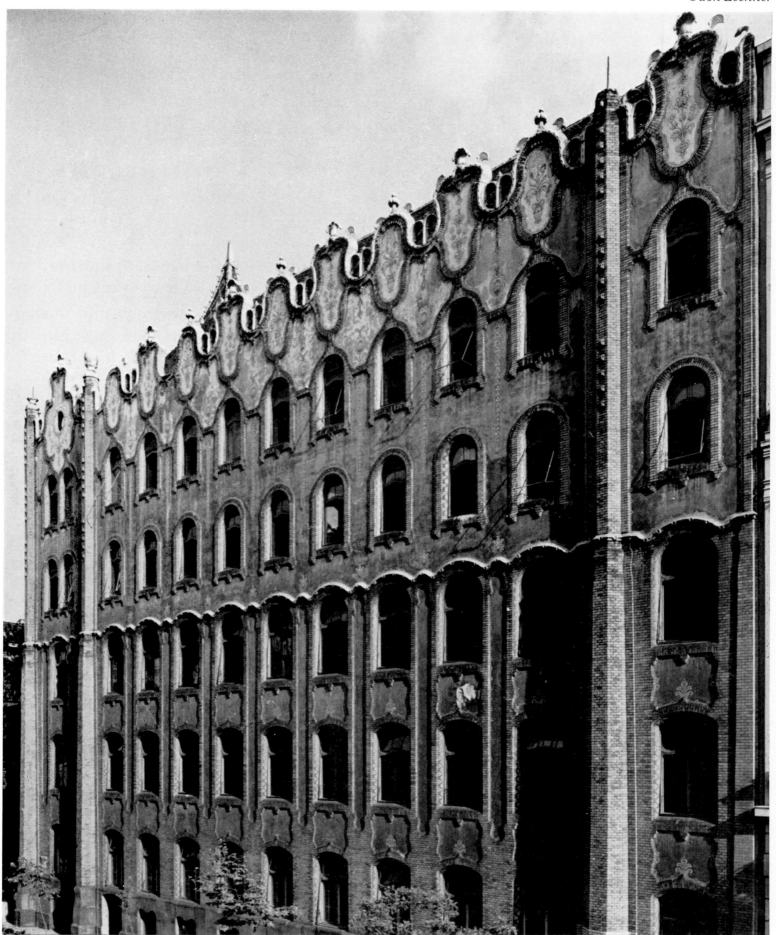

9. The street façade of the Postal Savings Bank, Kecskemét.

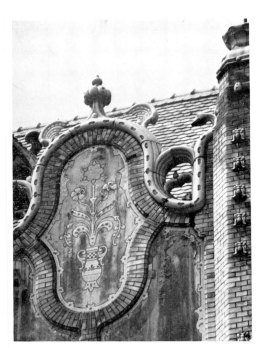

10. Detail of parapet.

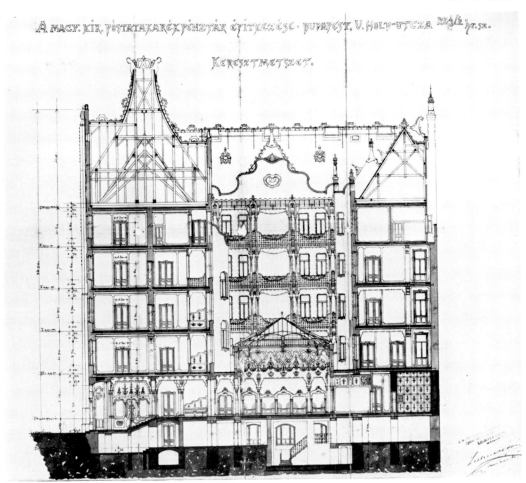

11. Lechner's own delineation of the section through the Postal Savings Bank.

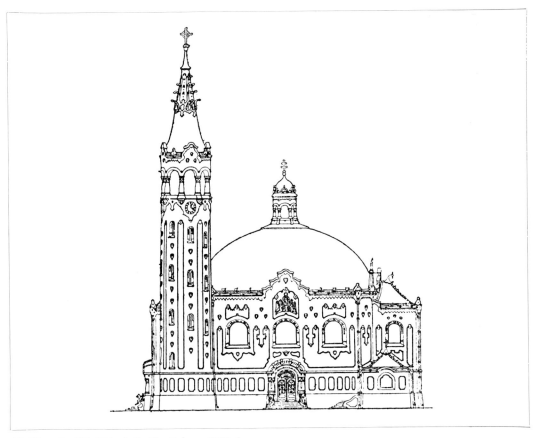

12. Church of St. Elizabeth, Bratislava, 1906–8.

ALADÁR ÁRKAY

by Balazs Dercsenyi

In the person of Ödön Lechner, as the preceeding essay makes clear, Hungary produced an Art Nouveau architect of international calibre. The continuation of what he had attempted, but also the reaction against Art Nouveau, is represented in Hungary first and foremost by Aladár Árkay, who is introduced to countries outside Hungary in this essay.

Art Nouveau reached Hungary in the 'nineties. In the designs of Ödön Lechner European inspiration is matched by a deep understanding of Hungarian folk art. Influence from Lechner, amongst those half a generation younger than he, was balanced by powerful influences from the Vienna of the Sezession and also from Scandinavian, and especially Finnish, architecture. Lechner's example – a parallel to the attitudes of Bartók and Kodály in music – led a group of young Hungarian architects to Transylvania; i.e. Hungarian Karelia. They explored the peasant architecture of the mountainous countryside, investigated materials, functions and structural solutions, copied the ornaments on the houses and things of everyday use and made sketches of the remarkable shapes of the roofs.

The most richly gifted member of this group was Aladár Árkay, who was born in 1868, exactly the same year as another architect inspired by the motifs of his native countryside: Mackintosh in Glasgow. His buildings of between 1905 and 1910 still bore the imprint of eclecticism, though an incipient antagonism to historicism can also be detected; his façades are calmer and so is his decoration. Lechner's influence is still noticeable. Árkay's cornices and window-heads undulate, and large areas of wall are covered with stylised vegetable decoration.

When, between 1910 and 1913, he built a colony of large villas for judges and attorneys on the slopes of the Buda hills, Árkay used motifs borrowed from peasant embroideries and roofs of many shapes. But whereas these villas might still be left unnoticed by a traveller from Western Europe, as no more than progressive architecture of a generally Austro-Hungarian character, it is different with the Calvinist Church of the Sixth District in Budapest, which Árkay built in 1911–13. Here is a building which no architectural visitor will overlook, as powerful and as original as Lechner's. The plan is a Greek cross, and this fully met the functional requirements of the Calvinist service. The altar with the pulpit and organ behind it stands in the centre. The congregation is seated in the arms of the cross, both below and on a gallery. The central space is covered with a dome, over 60 feet in height, which rests on the barrel vaults of the cross arms. The huge windows on the front and on the sides provide sufficient light. The main façade is similar to that of Lars Sonck's church at Tampere, being tripartite, with a bastion-like tower on the left, a portal with a pointed arch rising direct from the ground in the middle, and a short turret on the right. The decoration as well as the furnishings of the church were designed by Árkay.

These furnishings include the large faience panel below the semi-circular window of the façade. It seems to stand on eight stubby columns without bases or capitals, and the portal cuts into it. Faience facing is repeated inside above the pulpit. Equally remarkable and equally inspired by folk-art are the main doors.

The First World War nipped in the bud the promising work this group had begun, and after the war they could not carry on from the point where they had stopped. They were unable to rise to the height of Bartók's later music. In the post-war years Hungary's economic position was precarious; little was built, and most architects accepted any work that came along whatever the client's wishes. This explains the imitation Baroque of so much that was built in those years. But Árkay never accepted this situation. When in 1923 he designed a Catholic church in Városmajor Park, at the foot of the Buda hills, he stuck to his blocky masses

1. Villa in the Buda Hills, c.1910–13.

2. *Calvinist Church of the Sixth District, Budapest, 1911–13: the entrance front and tower.*

3. *Contemporary stylized sketch of the same church.*

3

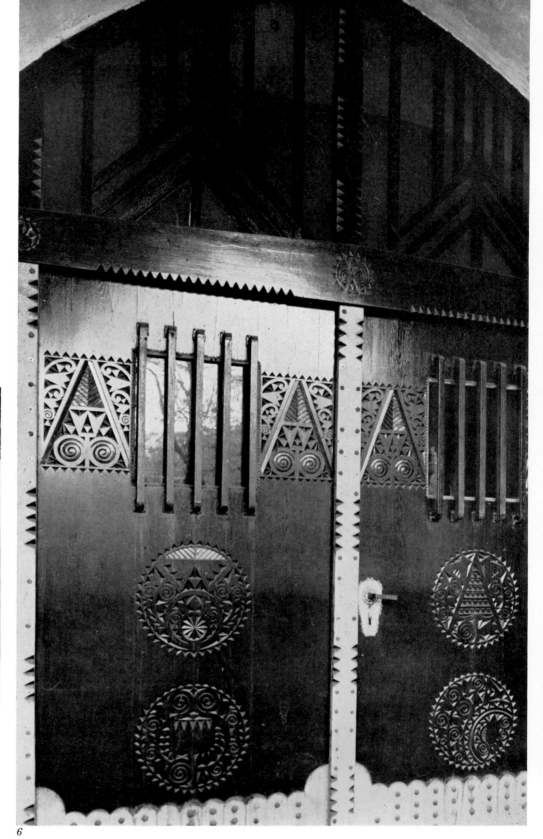

6

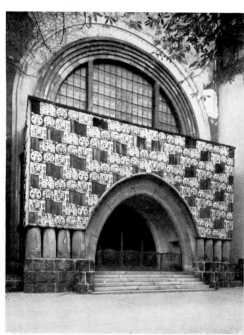

4

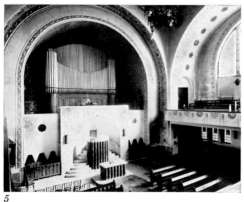

5

4. *The main entrance porch of the Calvinist church, Budapest.*

5. *Interior of the church.*

6. *Close-up of the main doors.*

7

and lively roof shapes of Transylvanian origin. Then, in 1925–26, thanks to the stabilisation of the country's economy and under the impact of West-European architecture, and especially of the Bauhaus, modern Hungarian architecture emerged, and up to the Second World War numerous such buildings were created.

As for Árkay, in 1925–26, he was able to travel and see the new French, Belgian, Austrian, Dutch and German architecture. Under the effect of what he saw he realised that an independent national architectural style was out of the question in the twentieth century. There could no longer be a French or a German style. The only possibility was a national variant of the one style of all civilised nations. Árkay advocated this idea in lectures and articles alike, and made every effort to bring about a new Hungarian architectural style of international validity. Together with his son Bertalan Árkay, he began in 1931 a large Catholic church in Városmajor Park, next to that of 1923. He worked on it until his death, which occurred in 1932, and the church was completed about 1937. That it is both internationally modern – see the detached campanile – and yet, with its arched portal, not without originality, needs no pointing out. It forms a fitting end to the development of so genuine an architect.

8

9

7. *Church in Városmajor Park, Budapest, 1923.*

8. *Another design for a church.*

9. *Catholic church in Városmajor Park, 1937.*

BOHEMIAN CUBISM

by Jaroslav Vokoun

The present Czechoslovakia, then part of the Austro-Hungarian Empire, shared the interest in the Art Nouveau movement described in its Hungarian manifestation in the two preceding essays. But there also arose in Bohemia a departure from traditionalism of a different kind; an attempt, discussed below, to adapt the current cubist movement to the needs of architecture and furniture.

There is in Bohemia a group of buildings which, dating as they do from the early years of the twentieth century, present a marked contrast to the architectural styles current at the time. Their façades are broken up into a series of projecting and receding angular surfaces, and the windows have the same angles. The furniture designed by the architects of these buildings is still more extreme.

The architectural situation in Bohemia – still at this time part of the Austro-Hungarian Empire – was much the same as in the rest of Europe. Art Nouveau flourished and, as well as the normal architecture of the day, there was a strong group of architects working in traditional styles. Jan Kotera (1871–1923), who played a major part in the revival of Czech artistic life at the end of the nineteenth century, was himself a pupil and follower of Otto Wagner in Vienna, and stirred enthusiasm in young Czech architects. By 1911 several of these – particularly those who tended towards the Wagnerian theory – left the modern artists' association, *Manes*, and together with painters and sculptors formed the independent Artists' Group. From 1911 to 1914 they published their own magazine, *The Artistic Monthly* (*Umelecky mesicnik*), which was completely devoted to articles attempting to explain cubism not only in terms of painting and sculpture but also of architecture. The cubist painter Emil Filla, writing in 1911 in the first number of the magazine, said: 'The body in its final appearance is tranquil, but its spatial value is a token of movement, although of movement in our mind only.'

The theorist of the Artists' Group was the architect Pavel Janak (1882–1956). Born in Prague, he studied architecture at the College of Technology, where at first he was taught by architects interested in historical styles. He was a pupil of Otto Wagner in Vienna from 1906 to 1907 and then spent some time in Italy. In 1908–09 he worked with Jan Kotera in Prague. Even before the foundation of the new Group, Janak began to question the Wagnerian theory of 'Zweck, Konstruktion und Poesie.' In 1910 he wrote an article 'From modern architecture to Architecture,' in which he called for discipline and unity in architectural design. 'We need a new theory. There has been enough poetry in modern architecture, but too little architectural beauty. Poetry improves architecture only by adding details, but architectural beauty must be constructed; and we reach it through the structure of the material. Architectural beauty is a dramatised balance of materials. Olbrich and Hoffmann used ornament, where we feel there should have been a plastic form. The creative mind and abstraction will take the place of the previous predominance of purpose (decorated by poetic details), and architecture will continue in its efforts for plastic form.'

Czech architecture has always shown a preoccupation with plastic form; the Baroque developed in Bohemia to a superb level and its forms dominate the country and particularly Prague. The Late Gothic with its cellular vaults was already exploring the possibilities of construction resulting in spatial complexity, and even in the unsettled times at the end of the fifteenth and the beginning of the sixteenth century Benedikt Ried developed his famous vaults with double-curved ribs; the columns of his porch in the Old Town Square are strikingly similar to those of four hundred years later. The powerful Baroque Gothic of Santini after 1700 is the climax of these efforts. Interest in historical architecture was, at the beginning of the twentieth century, strengthened by the growing nationalism of the

1. Block of flats in Neklanova Street, Prague, by Josef Chochol, 1912.

2. Detail of the street façade of the flats, Neklanova Street.

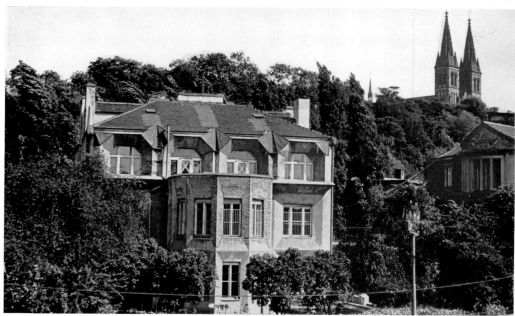

3. House at Prague-Vysehrad, by Josef Chochol, 1912–13.

Czechs and their dislike of the domination of Vienna. There was an active movement for the care of monuments, for which the Cubist architects were enthusiastic.

The basis of the theory which resulted from these influences was expressed by Pavel Janak in two articles: 'Prism and Pyramid' (1911) and 'Revival of the Façade' (1913). In 'Prism and Pyramid' he called for a reappraisal of the Baroque. He did not mean the rich decoration, but referred to the approach to form and space, in which the material has no importance and the architect aims at optical effects. In 'Revival of the Façade' Janak was more concise; he defined two approaches to architectural design. In the first, the spectator is supplied immediately with an objective knowledge of the form and space, tangibly accurate – for example, in the space of a central plan. The second approach, which demands the active participation of the spectator, is exemplified by the relation between a longitudinal plan and its façade. Here the façade supplies only some knowledge of the space but gives important hints. Thus, for example, the blank arcades on the façade of San Michele at Lucca define the dimensions of the church, and by using our visual perception create an impression of the space behind – as if we were looking at a bas-relief. Baroque took this idea a step further; the façade elements which had been mere additions to the internal space combined with it into a unity, some thereby becoming more important, some being reduced to a secondary role.

Before the third dimension was actually exploited, the Baroque used tricks of perspective. Even the central plan was expressed through a façade, as in the church of St. Charles Borromeo in Vienna, or in Kilian Dientzenhofer's church of St. Nicholas in the Old Town at Prague. Janak concluded this analysis by defining the purpose of Cubist architecture: 'Space is always three-dimensional, but it is necessary to add to it; space must be created by the plastic shaping of its limiting surfaces.' It was according to these principles that the Group worked.

Janak himself designed some small Cubist houses, and the remarkable locks and barrages at Obristivi (1911) and Predmerice (1914), but he was more of a theorist than an architect. His major importance lies in furniture design (his table and chair of 1913 are a good example) and in the organisation of the Artists' Group. The most important architect of the Group was Josef Chochol. Born in 1880, he also studied at the College of Technology in Prague, and then in Vienna under Otto Wagner. His house in Prague-Vysehrad, designed in 1912 and built a year later, and especially the block of flats nearby in Neklanova Street, also of 1912, are the most outstanding realisations of Cubism.

4. Lock and barrage at Predmerice, by Pavel Janak, the leading cubist theorist, 1914.

Josef Gocar, also born in 1880, was a disciple of Jan Kotera at the Academy of

5

6

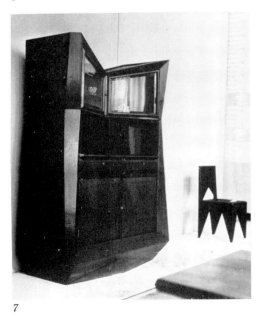

7

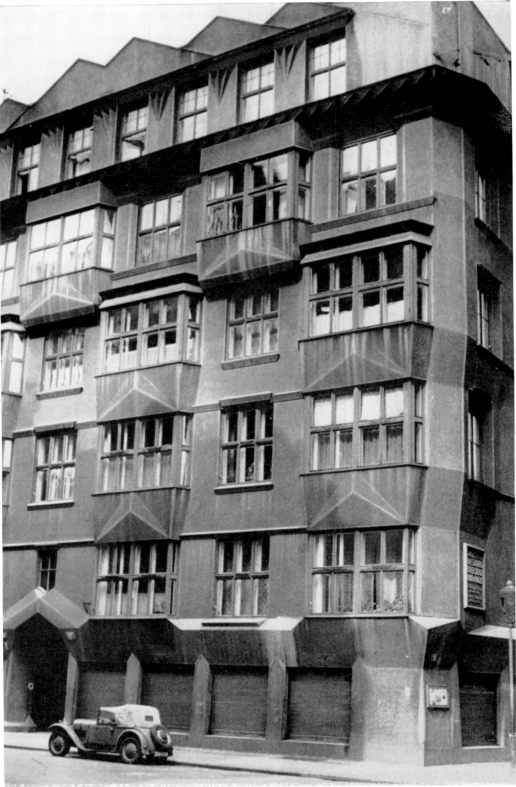

8

5. *Table and chair designed by Janak in 1913.*

6. *Building in Celetna Street, Prague, by Josef Gocar, 1912.*

7. *Sideboard in red oak, by Josef Gocar, 1912.*

8. *Flats in Bilkova Street, Prague, by Otakar Novotny.*

Arts in Prague and, after finishing his studies, he worked until 1908 in Kotera's studio. Before joining the Group he produced, in the years 1910–11, many designs in the Wagnerian style and became established as a successful modern architect. His Wenke store of 1909 at Jaromer was a bold foretaste of the curtain wall. In fact, Cubism as a movement seems to have been only an episode in his work. He exploited the Cubist principles for his own artistic purposes, but very skilfully. Two Cubist buildings were built after his designs, both of 1912: a building for medical care at Bohdanec Spa near Pardubice, and the building in Celetna Street in the Old Town of Prague, which was called *U cerne matky Bozi* – 'By the Black Mother of God.' He also designed a great deal of furniture such as a sideboard in red oak in 1912, table and chairs in 1911, and a chandelier in 1913. Blending admirably with an old thoroughfare full of Baroque buildings, Gocar's building in Celetna Street proves the close harmony in practice between Bohemian Cubism and Bohemian Baroque. Pfeiffer's cubist framing of a Baroque statue in the same year makes the same point in sculpture.

Besides these major cubist architects, there were other less important figures. Vlastislav Hofman (1884–1964) studied architecture at the College of Technology in Prague, designed some furniture, and made some designs for buildings, never executed. Otakar Novotny designed one building in Prague, in Bilkova Street in the Old Town, inspired by Cubist ideas, but he never returned to the style again.

In furniture design more was actually achieved. There were more opportunities, especially in the workshops founded and led by two members of the Group, Janak and Gocar. The materials on this small scale allowed more freedom to an architect – as far as the manufacturer allowed it. The early Cubist furniture was designed without any consideration for its surroundings; each object was an independent piece of architecture. It was shown to Europe at the exhibition of the Deutscher Werkbund in Cologne in 1914.

Although these Bohemian works were quite exceptional for their time, it must be remembered that behind them was not just the eccentricity of one mind. There was a more general movement in reaction against the decorative richness of Art Nouveau, the objectivity of Wagner's architecture, and the dullness of conventional work – and the movement was not merely negative. The aim was to achieve an architectural synthesis along the lines of Janak's ideas. Although these ideas were developed only as far as the façade was concerned, it was an important beginning. The whole activity of the Group lasted little more than three years. They were not given the opportunity for larger commissions and it was very difficult to find a contractor for such extravagant buildings. The materials available were another severe limitation. At the time of most promise, the war stopped it all.

The influence of the Cubists continued, however, although in another direction. 'We have got rid of detail,' Josef Chochol wrote, 'and we have begun to work with larger surfaces.' The analytical way of developing a façade was continued by the first Czech functional architects such as Oldrich Tyl, and especially Bedrich Feuerstein at the Nymburk crematorium in 1922. The Czech functional architecture continued the Cubists' efforts for modern architecture far more convincingly than the so-called 'national' form of Cubism, which appeared soon after 1918 as a by-product of the strong nationalist feeling in the works of the two former Cubist leaders Janak and Gocar.

These two themselves eventually came to functional architecture, each of them by his own way, though Gocar as late as the 'thirties designed an addition to a Baroque building in Prague using the plastic elements of Cubism. Josef Chochol, the most important of the Group, stayed relatively silent. Vlastislav Hofman became an outstanding stage designer in the Expressionist style, where his dramatic talent was well applied. Otakar Novotny was all his life a follower of Jan Kotera. All these architects are now dead, Hofman being the last survivor.

9. Canopy for a baroque statue in Prague, by A. Pfeiffer, 1912.

MACKMURDO GLEANINGS

by Edward Pond

The results of Professor Pevsner's pioneer paper on Arthur Mackmurdo, published in The Architectural Review *in 1938,[1] have been taken over fully by recent literature[2] but have not been added to. This article, based on research undertaken when the author was at the Royal College of Art, contributes new information on a number of points.*

Mackmurdo, it will be remembered, was born in 1851. His mother was a Carte – hence his connexions with D'Oyly Carte and the Savoy Hotel. He went to Felsted School and, after about one year with T. Chatfield Clarke, to Oxford, where he was not attached to any college and underwent the influence of Ruskin whom he knew personally and with whom he travelled in Italy in 1874. He had meanwhile exchanged Brooks's for Chatfield Clarke's office, but set up in practice on his own in 1875.

His two earliest houses, both illustrated by Professor Pevsner, were built at Enfield. Their addresses were unknown to Professor Pevsner, nor was he aware of the survival of drawings for them. These are now at the William Morris Gallery at Walthamstow. Both houses are in Private Road. The earlier one, called Halcyon House, is no. 6 in the road and was built for his mother; the later one, called Brooklyn, is no. 8 and was built for his brother. Their exact dates are still a mystery. Mackmurdo told Professor Pevsner that they were done about 1873 and about 1887. The drawings for Halcyon House have a handwritten note by Mackmurdo: 'The first house I designed, 1871,' but also a signature: 'John Bentley, 1876.' On the other hand, Brooklyn, or a design almost identical with it, was published in *The Hobby Horse*, no. 5, in 1887, and so it may be more likely to have been designed shortly before that date. In that case one would have to reckon ten or more years between Halcyon House and Brooklyn. Brooklyn is characterised by a total absence of the Shavian trappings of Halcyon House, by a remarkable emphasis on horizontals and by the overhang of the upper storey carried on verticals which are set slightly in front of the wall of the ground floor. Judging by the sparing classical details, the house might be closer in date to the design for a house for an artist published in *The Hobby Horse*, no. 1, 1884, than to the revolutionary designs of 1886, which are known and which culminated in the exhibition stand for the Century Guild at the Liverpool International Exhibition.

1. Stand designed by Mackmurdo for the Century Guild at the Liverpool International Exhibition of 1866.

The British Architect, in illustrating this, calls it 'a pretty strong protest against the redundant vagarisms of modern Renaissance,' and the protest must have been even stronger when the little building was new; for it was painted a bright yellow to set off the rich, dark colours of the furniture and fittings. Less familiar are the exhibits of Cope Bros., the tobacco importers, at the same exhibition, also designed by Mackmurdo. They had an exhibition stand, similar in design and painted light lemon yellow, and, in addition, an outdoor pavilion called Cope's Cabin. This was of wood framing, faced with zinc and strips of redwood, and had a strangely horizontal superstructure on the same thin posts with far projecting thin abaci as the two exhibition stands. The interior is worth recording too, with its exposed and unrelieved timbers.

Of about the same time as these revolutionary structures at Liverpool is Sandhill, a cottage at Formby, outside Liverpool, built for Albert Crompton, founder of what called itself the Church of Humanity. The exact date is not recorded, but it is supposed to be of before 1890.[3] This is a much more conventional job, with exposed timber framing and a long verandah. The only unusual thing for its date is perhaps the long narrow shape of the house. The verandah posts have curious bulgy shapes almost reminiscent of Dietterlin, and the eaves of the verandah are wavy.

1890 is the date of the Gymnasium, which was incidentally not at Liverpool, as Professor Pevsner says, but at St. Helens. It has now been demolished. Its interior is illustrated in Professor Pevsner's article, but its exterior also deserves recording, with its reeded brick strips instead of normal pilasters and its naughty shortened pilasters on the door lintel.

The last date of these buildings in Lancashire has taken us actually beyond the date of the Savoy Hotel, which was begun in 1884 and completed in 1889. That Mackmurdo had something to do with it seems certain, both from his own remarks and from his family relation to D'Oyly Carte, but Professor Pevsner is

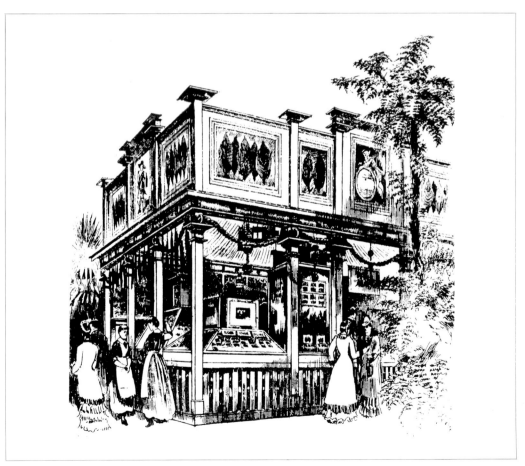

2. Mackmurdo's stand for Cope Bros., tobacco importers, at the same exhibition.

entirely wrong in attributing to him the architecture of the building; that is, the river range, which was the original part. He may, on the other hand, well have advised on such features as furnishing, as described in Professor Pevsner's *Buildings of England, London: The Cities of London and Westminster.*

Of Mackmurdo's work in London during the 'nineties the houses at no. 12 Hans Road (1891) and no. 25 Cadogan Gardens (1899), are known. In the mid-nineties a much less attractive building went up, the Olde Swanne in Sloane Street, close to the corner with the underground station. This is in a neo-Wren taste with detached giant columns. The house in Hans Road is of course distinguished from its neighbours designed by Voysey by its heavy, classical pedimented doorway and other classical details. The very elongated oriel window through two storeys is, on the other hand, a Norman Shaw motif, and this is repeated in the house in Cadogan Gardens.

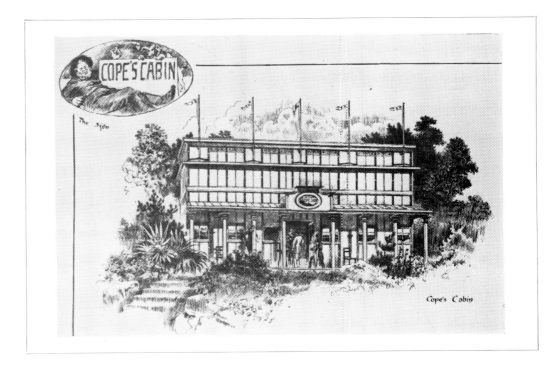

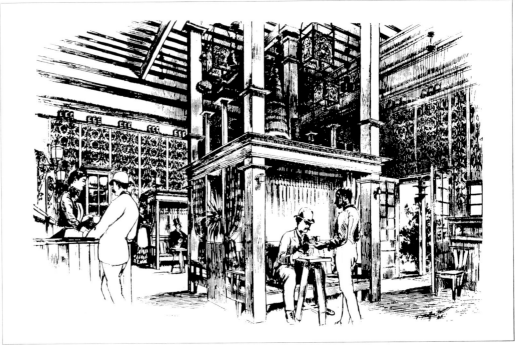

3. Outdoor pavilion for the same exhibitors, also at the 1866 Liverpool exhibition, called Cope's Cabin.

4. Interior of Cope's Cabin.

The general tenor of this, and especially its mansard roof with dormer windows, connects this house with another, so far entirely unknown: no. 12 Redington Road. This comes fairly close to the neo-Georgian façade conventions then gradually being developed. It was built for a Mrs. Geddes, no doubt a relative of Patrick Geddes with whom Mackmurdo was in touch over his plans for building 'regional communities;' i.e. something like New Towns or at least New Villages. Mr. John Brandon-Jones possesses drawings for this house and helped me to trace it. It was occupied later by Hamo Thornycroft, the sculptor.

Mackmurdo's turn from the innovations of the 1880's to the safer ground of Italian styles is also obvious in the Chapel of the Ascension, Bayswater Road, built in 1890–3 for Mrs. Russell Gurney as a chapel for quiet worship. Professor Pevsner attributes the building to Mackmurdo's partner and friend Herbert Horne, who later lived in Florence and whose collection is now the Horne Museum there, but correspondence published in the parish magazine shows that Mackmurdo certainly claimed it as his own. The façade was in a pure Quattrocento style; the interior was burnt out during the war and the whole building subsequently demolished.

5

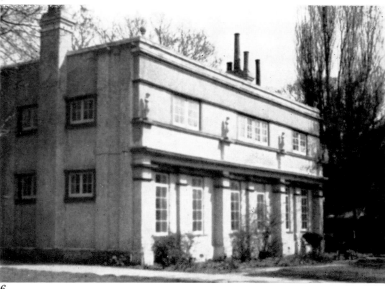

6

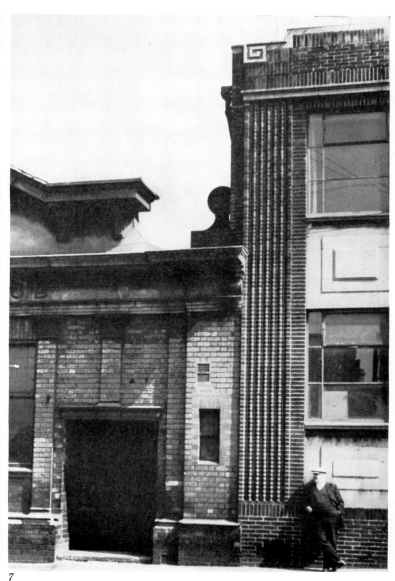

7

5. *Mackmurdo's first house: Halycon House, Private Road, Enfield; date unknown, probably about 1873.*

6. *Brooklyn, Private Road, Enfield: a house designed by Mackmurdo for his brother, probably in 1887.*

7. *Exterior detail of Mackmurdo's gymnasium at St. Helen's, Lancs., 1890 (now demolished).*

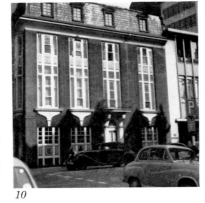
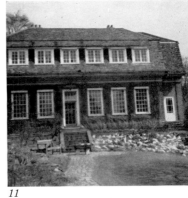

8 9 10 11

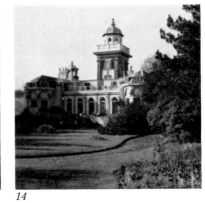
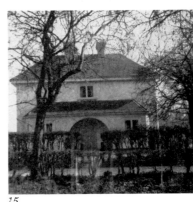

12 13 14 15

8. Cottage at Formby, Liverpool; date unknown but probably before 1890.

9. House in Hans Road, London, 1891.

10. House in Cadogan Gardens, 1899.

11. House in Redington Road.

12. Chapel of the Ascension, Bayswater Road, 1890–3 (destroyed during the Second World War).

13. Cold-storage warehouse, Charterhouse Street, 1900.

14. Great Ruffins, Mackmurdo's own house at Wickham Bishops, Essex, 1904.

15. Lodge at Wickham Bishops, c. 1920.

With the Cold Storage Warehouse at 109–13 Charterhouse Street the year 1900 is reached, and a job in a very restrained Wren style with giant pilasters, little garlands above the windows and an attic curving up towards the centre. Mackmurdo was proud to relate that this had been the first cold storage warehouse in London. Shortly after this building had been designed Mackmurdo bought himself an eleven-acre estate at Wickham Bishops in Essex. His house – or intended house — Great Ruffins, was ready only in 1904, but already by about 1900 he had built Little Ruffins as stage one of his plan. Great Ruffins was everything that Mackmurdo had dreamt of. It had seven bathrooms and as many changes of floor-level between what, from the outside, are the ground and first floors. The lantern overlooks the estuary of the Blackwater for miles and was intended to hold cupboards for charts where Mackmurdo could pursue his hobby of astronomy. However Mackmurdo at this time lost most of his money and had to go on living at Little Ruffins (and later in a yet smaller cottage, now called Mackmurdo's.)

He built little after that. Beacons at Wickham Bishops of about 1920 is no more than a hotch-potch of motifs, although a lodge belonging to it is simple, straightforward and has remarkably fine proportions. The Village Hall at Bradwell, Essex, built in 1932 or thereabouts, is the only late design of personal character. It was built under the Essex Rural Community programme and, with its brick piers supporting the roof, is reminiscent of his very early work of nearly fifty years before.[4]

NOTES
[1] Vol. 83, 1938.

[2] e.g. H. Tschudi Madsen: *Sources of Art Nouveau*, Oslo, 1956; *Jugendstil*, edited by H. Seling, Heidelberg, 1959; also, in THE ARCHITECTURAL REVIEW itself, papers by R. Schmutzler, Vols. 117 and 118, 1955, and by R. Baurmann, Vol. 123, 1958.

[3] I owe this information and the photograph to Mrs. Webb, occupier of Sandhill Cottage when this was written.

[4] My thanks for help are due to Miss Elinor Pugh, Mackmurdo's niece, and to Miss Bridget Goshawk of the William Morris Gallery.

The early work of
CHARLES RENNIE MACKINTOSH

by David Walker

After three major books, numerous exhibitions and adulation abroad, Charles Rennie Mackintosh, Glasgow's greatest architect, may be thought to have been explored to the ultimate. But the following scholarly analysis of the inspiration for Mackintosh's early designs and uniquely personal architectural idiom, and the many reattributions it puts forward, proves that this is not so.

It is over a hundred years since Charles Rennie Mackintosh was born and sixty-five since his last major architectural work was finished. Since, sadly, in 1928 he reminded us of his meteoric ten years as an independent designer in Glasgow by dying, a great deal has been published about him, culminating in Professor Pevsner's book in 1950,[1] Professor Howarth's in 1952[2] and Robert Macleod's[3] in 1968. To Howarth we owe a particular debt. He was in the right place at the right time. A little later would have been too late to collect the personal recollections on which every subsequent biographer must depend. But of Mackintosh's precursors and contemporaries, of how he built up his uniquely personal architectural idiom, and why, there is perhaps something left to add.

With a designer so intensely inventive as Mackintosh, quoting firm precedents for his mature work after 1895 is hazardous. Yet no designer can shake off subconscious memory, training and custom altogether. Indeed in his early years he did not try to do so. Howarth tells us that the heroes of his youth were James Sellars and John James Burnet.[4]

The earliest building in which we know Mackintosh was concerned, the Wylie Hill Store in Buchanan Street, Glasgow, was modelled by his first employer John Hutchison (or rather his assistant Andrew Black, Hutchison himself being no designer) on Sellars's Wylie and Lochhead building of 1882–4 across the street. The excellent decorative sculpture suggests Mackintosh's hand; he would then be in the final year of his apprenticeship, and one or two detail drawings he made for it are still remembered.

His interest in Sellars would be further stimulated by his becoming an assistant in Honeyman and Keppie's firm in 1889; for Keppie had assisted Sellars during his tragic gamble with his health in 1888 and had been entrusted both with the design of his tomb and with the finishing of the Anderson Medical College. These twin allegiances show very clearly in Mackintosh's student designs for competitions in 1890. The Thomson Scholarship design is pure Sellars Grecian – down to the lamp standards; the Science and Art Museum is of the same family as J. J. Burnet's Beaux Arts designs of the early 1880s, but the columnar arrangement appears to be related to Burnet's design and also to Sellars's designs for the Glasgow Municipal Buildings competition. Sellars was briefly a Beaux Arts convert, but finding no success with it in competitions promptly gave up. Keppie may well have had some of these designs about the office, as well as some from his own Beaux Arts days which seem to have profited him little.

So far relatively little attention has been paid to the designs of Honeyman and Keppie's office in 1890–4. They have been generally regarded as 'work of the firm'. It is wrong, however, to look at them as such; for they tell us a great deal about Mackintosh's development. Of that office Honeyman was an Italian Renaissance and neo-classical man, and (given a little money) a very able Goth, interested no doubt in the modern movement but too old to be in touch with it. The office books show that, except for the Brechin Cathedral restoration, nearly all the important jobs after 1890 were handled by Keppie or Mackintosh. Alexander MacGibbon, the senior assistant, was a brilliant draughtsman, but suffered chronic indecision in matters of design; and Keppie in his independent work of 1889–90 at 33–9 Greendyke Street, Glasgow, and the Fairfield Shipbuilding Offices at Govan, shows us

1. The first building in which Mackintosh is known to have been concerned: the Wylie Hill store in Buchanan Street, Glasgow, designed by Andrew Black, assistant to John Hutchison to whom Mackintosh was apprenticed.

116

that he was a rather unimaginative follower of Sellars and J. J. Burnet. This leaves us with Mackintosh, with whom Keppie was, as an inscribed watercolour shows, then on terms of exceptional friendship, frequently invited to Keppie's house at Ayr to work uninterruptedly, particularly on competition designs, leaving Honeyman in charge of the office. Keppie had few ideas of his own; Mackintosh had many. Niceties of employer and employed were sunk, we may be sure, in friendship, the expectation that he would become his brother-in-law and the desire to win.

The oldest of these competition designs (now in the Glasgow University Collection) is for the rebuilding of Glasgow High Street. The competition was won by Burnet & Boston (a different firm from J. J. Burnet's) but the design, entirely in Mackintosh's hand, is of some interest; for it shows appreciative study of Sydney Mitchell's Well Court, Edinburgh (*British Architect,* August 23, 1889), though the prescribed street lines prevented Mackintosh from emulating Mitchell's romantic courtyard grouping.

More interesting is the Glasgow Art Galleries competition, for which Honeyman and Keppie at first competed separately. Honeyman's (*Builder*, June 25, 1892) was a Greek design equal in quality to anything by Sellars and almost approaching Alexander Thomson himself.[5] It is unlikely, though Howarth noted that it is akin to Mackintosh's Thomson Scholarship design in 1890, that Mackintosh did more than draw the friezes and sculpture which appear to be in his hand; Honeyman had already designed the Paisley Museum in this idiom in 1868. Keppie's was also published (*British Architect*, December 2, 1892) and, despite its sculptured frieze below the entablature apparently copied from Burnet (Glasgow Fine Art Institute 1878) and a big dome rather too obviously borrowed from Rowand Anderson's addition to Adam's Edinburgh University (1887), shows considerable evidence of Mackintosh's hand.

The double-transomed windows are those of the design for a Science and Art Museum of 1890 and so are the French square dome roofs and Sellars-type pedimented doorpiece. The treatment of the main portals seems to be Keppie (cf. Fairfield), the organ case has details like the Glasgow Art Club work of 1893, which was largely designed by Mackintosh. It is already hard to tell where, beyond plan and general outline, Keppie ends and Mackintosh begins.

These designs secured separate places in the final competition for their authors, but they produced one joint design, quite unrelated to the previous schemes. The drawings as published (*British Architect*, June 10–July 8, 1892) are entirely in Mackintosh's hand, and there can be little doubt that beyond the general arrangement the whole design is his. The brilliant penmanship, the unmistakable

2. Mackintosh's entry for the Thomson Scholarship, 1890: one of the competition designs he made as a student.

117

lettering, the fluent design of ornament and sculpture, the awareness of the contemporary London work of J. D. Sedding, Henry Wilson, and in a few details J. M. Maclaren, are far removed from the work of either of the partners.

Alfred Waterhouse was the assessor. Mackintosh took a good look at what Waterhouse was known to like: the recent transition from Gothic to early Renaissance in Waterhouse's own practice together with the general outline and Romanesque treatment of the Natural History Museum in South Kensington and two competition successes by Aston Webb in which Waterhouse was the assessor. These were the Law Courts at Birmingham and the original design for the Victoria and Albert Museum which had been published in the very week the Glasgow competition was announced, and which also formed the foundation of Edgar Wood and Thomas Taylor's design for the Whitworth Institute at Manchester. Mackintosh managed to encompass all these elements in his design. The combination of strong Romanesque and Late Gothic elements may surprise, but it had the authority of Belcher (whose work Mackintosh acclaimed in his lecture notes of 1893)[6] in a design for Maida Hill, London (*British Architect*, May 10, 1889). Mackintosh put his Italian sketch-books to good use: the interior detail can be directly related to his sketches at Pavia, Verona and elsewhere, while the apse on the east elevation is directly based on his sketch of S. Fedele at Como.[7] His enthusiasm for Michaelangelo shows in the sculpture, which has curves familiar in his decorative work a little later, while other details are recognisably developed from his competition design of 1891–2 for a chapter house which itself appears to have had its origins in studies of the apse of Como Cathedral.

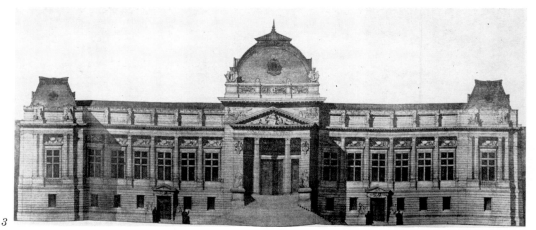

3

4

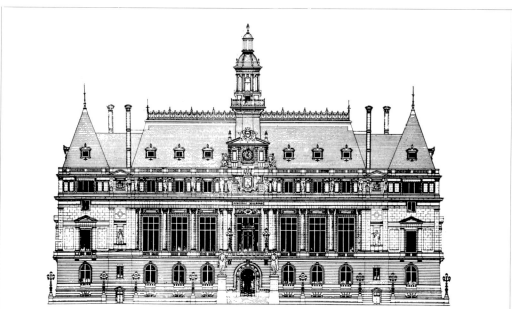

3. Design by Mackintosh, when a student, entered in a competition for a Science and Art Museum, 1890.

4. J. J. Burnet's design entered in the same competition.

The origin of the Art Gallery towers is harder to identify. They may be Italian; for some of the sketch books are lost; or they might go back to Sellars's unsuccessful competition design for Renfrew County Buildings at Paisley of 1888. Mackintosh's Soane Medallion design of 1893 for a railway terminus is in some degree related to this design, but save for the lower turret features, which are derived from Maclaren's Stirling High School and which we shall meet again in Mitchell Street, the architectural features are largely inspired by Henry Wilson and to a lesser degree by Leonard Stokes, whose work also received enthusiastic notice in Mackintosh's lecture notes of 1893. The Art Gallery design has perhaps rather more of the 'living fancy' which Mackintosh sought, and confronted with the present building (Sir John Simpson at his very coarsest) it is impossible not to regret that Honeyman and Keppie did not win. Yet perhaps it was as well; for the pleasure Mackintosh had in working in this eclectic idiom is very evident from the drawings, and the prolonged period of construction might well have retarded his search for a more personal expression.

A little-known Honeyman and Keppie design of this period is that for the Manchester Technical Schools which the *British Architect* published on November 4, 1892, expressing mild surprise that it did not win the competition and suggesting that the assessor might have given his reasons. The unusual combination of early Venetian Renaissance windows at first floor with François Ier detail above strongly recalls Rowand Anderson's similar experiment at Glasgow Central Station, while those at the centre have been re-used from Keppie's Art Gallery design. All these features could be either by Keppie or Mackintosh. The hand of Keppie is recognisable at the portal, features of which go back to his warehouse at Greendyke Street; the unbroken figure frieze above and the centre top floor can be related to other Mackintosh schemes. The big Italianate tower is probably a Mackintosh reminiscence of Italy, though no related sketch survives; the treatment of the angle strips of the octagonal turret we shall meet again. The whole design seems very much a joint product, but the interesting roof gallery to the internal courts with

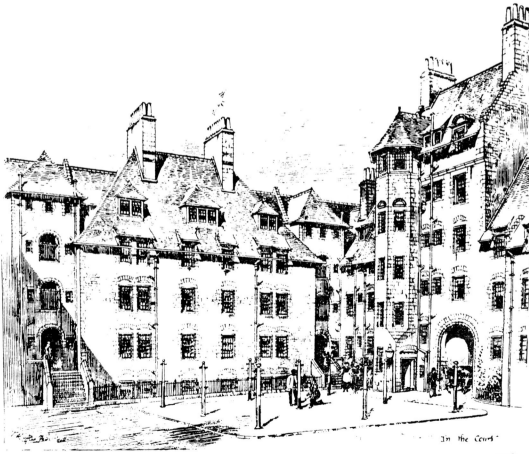

5. Well Court, Edinburgh, by Sydney Mitchell, 1899, which influenced Mackintosh's Glasgow High Street competition design.

119

perky Art Nouveau turret features is plainly Mackintosh.

The year 1893 brings us to the Glasgow Herald Building in Mitchell Street, and here Mackintosh comes much closer to his final style. The memorable feature is the tower, which Professor Howarth believes derived from features in Henry Wilson's design for Victoria (BC) Cathedral of 1893. But this was published late in 1893, by which date Mackintosh had already used the motif in miniature form in his railway terminus design. The real origin was no doubt the angle turret of the High School at Stirling by J. M. Maclaren, in whom Mackintosh apparently took considerable interest.

The expansion of such a turret into a big tower is of course a bold and wholly original stroke, well considered in relation to the constricted nature of Mitchell Street, where a tower of conventional proportions would have been two-thirds hidden. The deep swelling form of the corbelling, with elongated shields at the angles, is unprecedented.[8] The lower floors are a determinedly non-period effort, but the recessed bays were not entirely novel: Ricardo had introduced this feature in his design for a Westminster office (*British Architect,* May 18, 1888), and several others followed.

The top floor is controversial; it is generally believed to be Keppie's, but Mackintosh's sketch-books show clearly that this is not the case. It may be that Keppie did not like the Ionic eaves-gallery proposed in the first sketch, but the second sketch leaves no doubt that the final treatment was Mackintosh's. In any event the

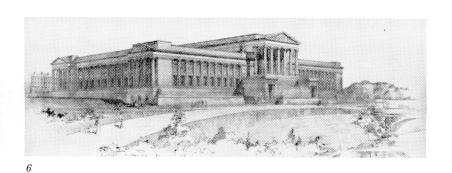

6

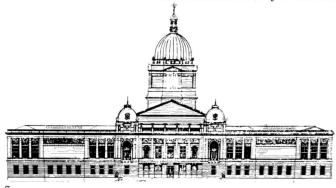

7

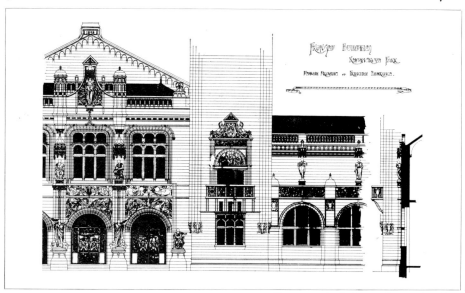

8

9

6. *Honeyman's design, submitted in the Glasgow Art Galleries competition, 1892, for which he and his partner Keppie entered separately.*

7. *Keppie's design in the same competition.*

8. *A detail of the combined scheme entered by Honeyman and Keppie in whose office Mackintosh worked, 1890–94. Ornament and penmanship are unmistakably by Mackintosh.*

9. *Belcher's design for a church at Maida Hill, London, 1889: a precedent for Mackintosh's combination of Romanesque and Late Gothic elements.*

120

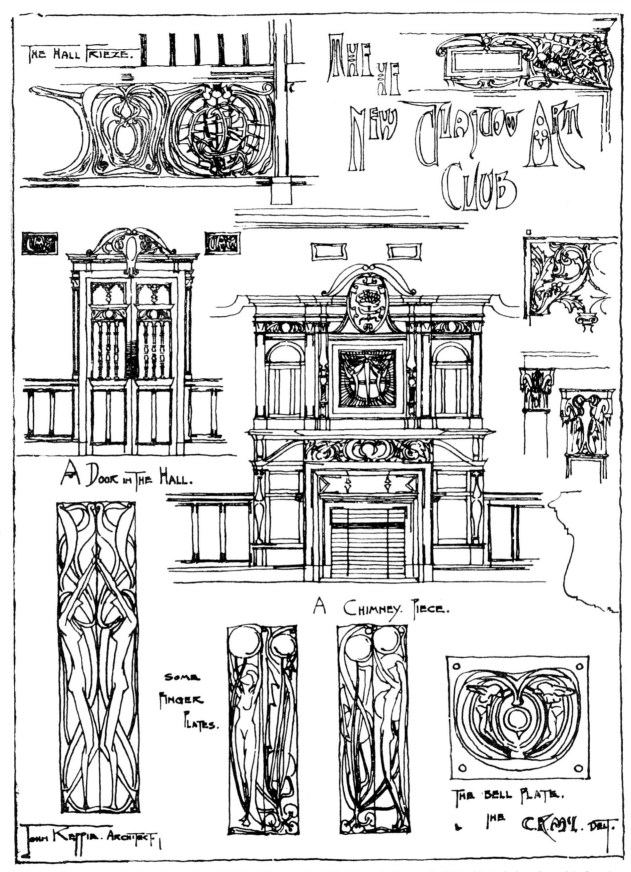

10. Details for Keppie's New Glasgow Art Club, largely the work of Mackintosh, by whom this drawing is signed.

swirling Art Nouveau forms of the pediments, developed from Scottish seventeenth-century details, are far beyond anything devised by Keppie unassisted, while the concave-ended balconies (adopted from Burnet and Campbell's Athenaeum Theatre of 1891) and the depressed ogee architraves were to be features of Mackintosh's Martyrs' School.

That Mackintosh admired Belcher, (or rather, though he evidently did not know it, Belcher's assistant Beresford Pite) may surprise some people. Belcher gets very favourable notice in Mackintosh's lecture notes of 1893. I have noted a possible hint of his influence in the Art Gallery design, and the house designs published in the *Architect* in 1890 must also have impressed. Belcher's use of crowded figured friezes could have influenced Mackintosh, but Colcutt and others also favoured such friezes at the time. A much more obvious borrowing is to be seen in the corner dome of the competition design for the Royal Insurance Building of 1894; for here the aedicules of the subsidiary domes of the Belcher-Pite competition design for the Victoria and Albert Museum have been adopted with only slight modifications. Howarth believes that this was a Keppie design, but in some ways it is the most interesting of all these competition designs. The corner treatment is quite clearly related to the Glasgow Herald, while on the Buchanan Street frontage the wall head without cornice, and the slightly advanced bays with curved tops, point forward to the east gable of the School of Art.[10] The side elevation is more orthodox (in consideration no doubt for the Wilson and Elliot buildings opposite), but the rustication-linked windows were to reappear in the Martyrs' School of the following year.

I do not suggest that these are entirely Mackintosh's designs. They are the result of that 'happy phase of close collaboration' of which Howarth was told by people then still alive, with Keppie concentrating on the planning and technical, and Mackintosh, we may be sure, on the decorative aspects. There would be suggestions and changes, no doubt, which Mackintosh absorbed into the elevations in his own way. The end of this phase is easily seen in the dull academic design for the Paisley Technical Schools of 1896 in which Mackintosh conspicuously had no hand. From that year, perhaps because of his broken engagement to Jessie Keppie, they seem to have moved apart. The answer to the persistence of the motifs evolved in 1890–4 is that Mackintosh moved on; Keppie left to himself did not. Studies for 'Keppie' detail in Mackintosh's Italian sketch books leave little room for doubt. In the trial and error of joint designing, Keppie may not himself have realised how much Mackintosh had contributed.

Except for the Glasgow School of Art, in which he collaborated with Honeyman on the planning, Mackintosh henceforward became in a large measure autonomous. The Queen Margaret College (now enveloped in additions and poorly recorded) and the Martyrs' School are generally regarded as his. In the College is the

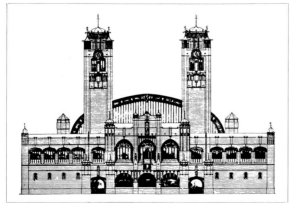
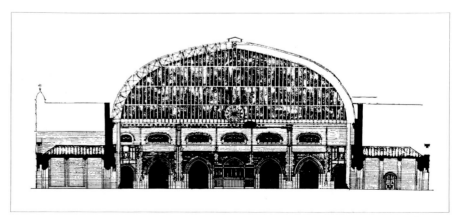

11. Mackintosh's Soane Medallion design for a railway terminus, 1893.

first appearance of Mackintosh's characteristic gable set back behind a plain parapet – a feature which goes back to such early Scottish tower-houses as Liberton and had already been re-adopted by Maclaren at Glenlyon. The stepping of the stair windows and the crowning turret might derive from Maclaren's large studio house in Avonmore Road in London, but is more likely to be independently worked, since the turret is a Sellars motif derived from the Tolbooth at Dysart. Most of the other details except for the very original flowing of the roof through an arched opening in the parapet[11] can be paralleled in earlier designs and were to persist in Keppie's work thereafter. The widely spaced Scottish balusters are of a type reintroduced by Sir J. J. Burnet and re-appeared in even more characteristic Burnet form as part of a solid parapet wall curved at the angle (as at Burnet's University Gardens, 1887, the Western Infirmary Pathological Building, of 1894 and so on) in the Martyrs' School.

There are no other special features in this design except for the boldly projecting eaves (Burnet also started using broad eaves about this time), but the section containing this feature is of interest in that the turret feature seems to lead on to the centre bay of the School of Art. Apart from the remarkable roof-truss, the

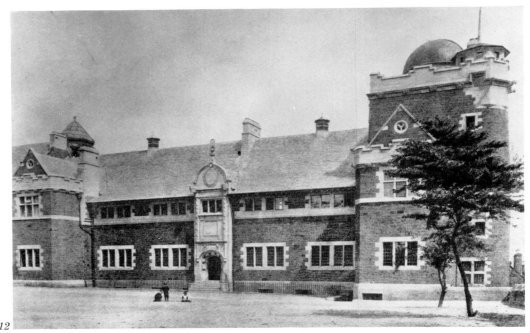

12

13

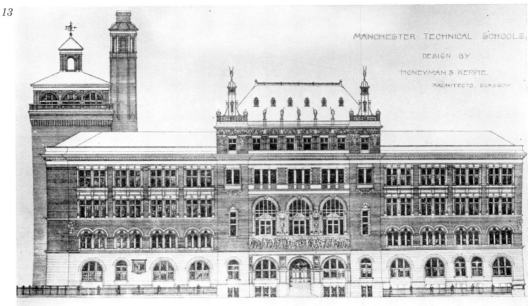

12. Maclaren's Stirling High School, one of the influences on Mackintosh's Soane Medallion design.

13. Honeyman and Keppie's competition design for the Manchester Technical Schools, 1892, with features that could have been by Keppie or Mackintosh.

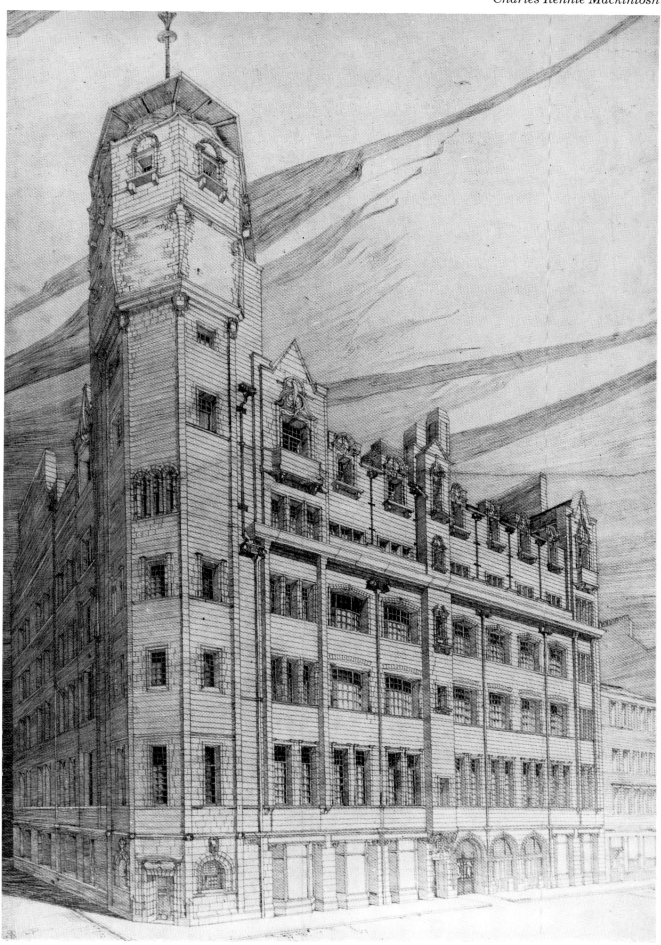

14. The Glasgow Herald building, 1893, in which Mackintosh's final style begins to emerge.

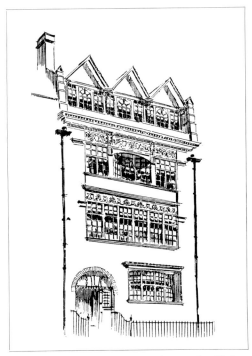

15. *Office building in Westminster, by Halsey Ricardo, 1888: a precedent for the recessed bays used by Mackintosh in his Glasgow Herald building.*

doorway is the most interesting feature with the familiar depressed ogee architrave, here given the characteristic Burnet profile, but flanked by extraordinary consoles stretched far beyond anything that Burnet would then have contemplated. The doors themselves show that Art Nouveau had invaded the joinery work in no uncertain terms.

So much has been written about the Glasgow School of Art, which was designed between March and October, 1896, that it might at first sight seem difficult to add anything new about it. But something more might be said on the difficult question of sources and something about the competition itself. While the design must have stood out startlingly from the others, we should not imagine them all as academic palaces. H. E. Clifford had already designed in the Modern Movement manner[12], Henry Mitchell had followed Mackintosh closely (see his College design in the *British Architect,* February 23, 1894) and was building a Modern Movement tenement in Castlebank Street; Salmon and W. J. Anderson had already shown experimental tendencies and were to design Modern Movement work within the next twelve months and Burnet had used very modern horizontal windows without mullions in the Western Infirmary Pathological Building of 1894 and had visited the United States in that very year. His design may well have had modern characteristics.

The importance of the financial restrictions on the School of Art cannot be overstressed. The challenge was to design a building which would be a worthy image for the School and yet cost much less than an ordinary board school. It had to be achieved virtually by simple mass and void. Had it not been for the peculiar nature of the competition, it is possible that Mackintosh's style (except in its internal decorative aspects which were already well advanced) would have become established rather later than it did, and that such drastic simplifications would not have been acceptable to the partners. This radical simplification is evident in the earliest known study for the school, the preliminary sketch illustrated by Howarth, the significance of which has hitherto gone largely unnoticed in print. The centre-and-ends treatment may be conventionally British, but the fenestration is of the kind we think of as American, though the Gage Building, whose fenestration it most nearly resembles, dates from two years later. Such mullioned façades were not entirely unknown in Glasgow: there is a badly mutilated example in St. Enoch Square and another in Govan Road, both as yet unattributed, and a warehouse at 50–76 Union Street (of *c.* 1855) where long window bands are divided by widely spaced strips of superimposed orders, but it is hard to believe that this sketch could have been influenced by such unfashionable designs. Although Burnet had been in the United States in 1896, he did not adopt a fully American mullioned treatment until McGeoch's in West Campbell Street in 1905.

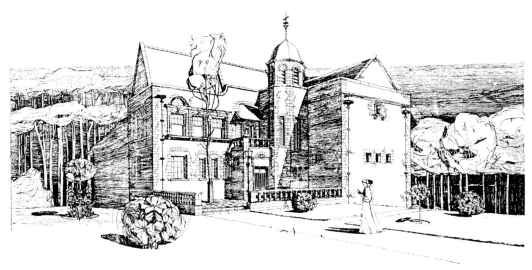

16. *Queen Margaret College, one of Mackintosh's first autonomous buildings, with characteristic features like the set-back gable appearing for the first time.*

Mackintosh's early sketch must date from the second quarter of 1896, which would seem to exclude any possibility of his being aware of a similar drastic simplification made by Townsend, from the American Romanesque Bishopsgate Institute of 1894 to the curious first design for the Whitechapel Gallery with its odd turrets (borrowed from a caprice by Raffles Davison in the *British Architect* of 1893), which was published in *The Builder*, May 30, 1896.

There is nothing obvious in the building journals of that year to account for this simultaneous change, but this is perhaps the place to discuss them. The *British Architect* had a very strong Glasgow following thanks to Thomas Gildard, an elderly senior assistant in the Master of Works Office who was its Glasgow correspondent, and it was in that journal that Keppie and Mackintosh's work was most widely noticed. It also had a special value in that Voysey sent them his designs for publication.[13] But *The Architect* (which curiously ignored both Voysey and Lutyens except for brief appearances in 1890) is in many ways more important; for in it the Architectural Illustration Society ran a remarkable pictorial campaign for better architecture from roughly 1890 to 1894. Ordinary commercial work to flatter the readers was largely excluded: apart from carefully selected historical examples, everything was heavily weighted on the side of a profound appreciation of vernacular building in modern work, very high-quality academic work, and what might, for want of a better term, be called the simple style of Muthesius's *Sachlichkeit,* based on the work of contemporary architects.

Devey, Nesfield, the very simplest of Shaw, George's Devey-type country houses, Sedding and Wilson, Newton, Webb and Ingress Bell, Bentley, Bodley, G. G. Scott Jun., Colcutt, McCartney, Belcher, Ricardo, E. S. Prior, Leonard Stokes, Edgar Wood, J. M. Maclaren and his successors Dunn and Watson[14] were particular favourites. The mention of some five of these names in Mackintosh's lecture notes of the time seems indicative of the profound effect this cult of simplicity was having upon him. No specific influences beyond those here pointed out can be quoted, but the freshness and twentieth-century feeling of much that they published goes a long way to explaining the attitude of mind which made the School of Art and his two most important houses possible. And as Robert Macleod has just shown, Mackintosh was being profoundly influenced by Lethaby. It is significant that he holidayed in England each year from 1894 to 1898 studying the inspiration of this school at first hand. The first known hint of the coming transformation in Mackintosh's work was a small inn (now destroyed) at Lennoxtown near Glasgow, remodelled in 1895. This simple little house with its plain roughcast walls was very much in the style the *Architect* was propagating. Its unusual design with sign-

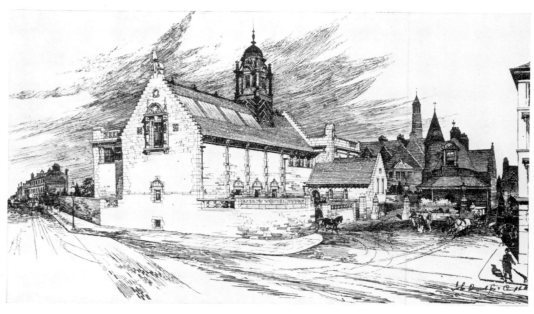

17. Sir John Burnet's Western Infirmary Pathological Building, 1894, which introduced various Scottish features later used by Mackintosh.

board hanging above the eaves had its origin in a sketch he made of the Rising
Sun Inn at Wareham, Dorset, earlier in the year.

In searching for the sources of the final design Howarth draws attention first to
the windows of Voysey's studio design (*British Architect,* December 2, 1892).[15]
Certainly there is nothing in the building journals of the time more like the School
of Art windows, but it should not be forgotten that Newbery, the headmaster,
was instructed to make suggestions regarding the size and nature of windows,
and it is not at all unlikely that for functional reasons he requested that mullions
should be avoided. So the basic studio window might have been common to all the
designs.

Howarth's second suggestion is J. A. Slater's 'Town Mansion' design published
by the Architectural Illustration Society in 1891. Slater illustrated rather than de-
signed in the *Architect*, and from the 1892 notes to the plates we learn that this
design had been made as long ago as 1885 and dedicated to Lethaby. At such a
date it was probably prompted by Godwin's White House for Whistler of 1878,

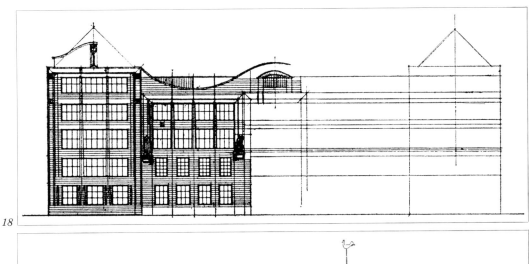

18

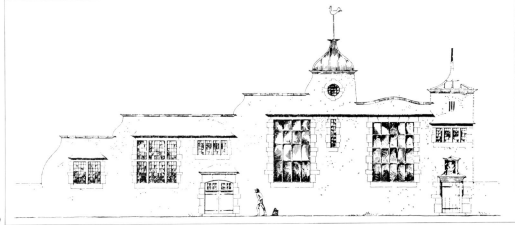

19

20

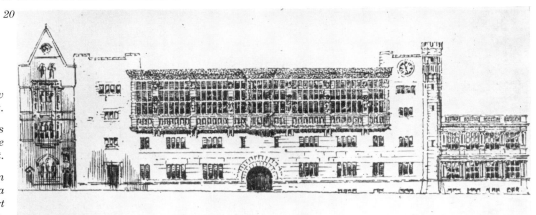

*18. Early sketch for Mackintosh's Glasgow
School of Art.*

*19. Studio by Voysey, 1892, with windows
resembling those in the final design for the
Glasgow School of Art.*

*20. Ricardo's unsuccessful competition
design for Oxford Town Hall, 1892; it has a
closer affinity with Glasgow School of Art
than any other contemporary British design.*

but it has an arched porch recognisably American and other details of more debatable provenance. This aggressively non-period design may well have had some influence by its use of large unbroken masonry surfaces and its absence of any crowning feature, but it should not be forgotten that Burnet had introduced a topless tower in the Queen Margaret Union Building of 1887, and that Keppie and Mackintosh had dispensed with the customary cornice in the Royal Insurance design of 1894 – a design which has no other feature in common with Slater's. Mackintosh seems to have been interested in the Union Building, for his early 'Redclyffe' design of 1890 appears to have been suggested by the original southern frontage of the Union.

More interesting in certain respects than any of these is Ricardo's unsuccessful competition design for Oxford Town Hall (*British Architect,* June 3, 1892)[16] which, despite the Jacobean treatment of the large windows and other significant differences, has more affinity with the School of Art than any other contemporary British design in its concentration of glazed area framed in unadorned masonry and the strong eaves line between raised plain parapets. But the question of outside influence on these plain parapets is a difficult one. The drawings of March 1897 for the School of Art show that the northern half of the east elevation was to have a

21

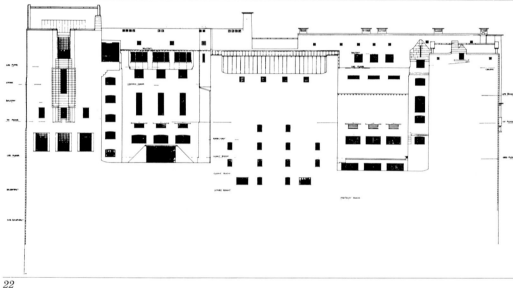

22

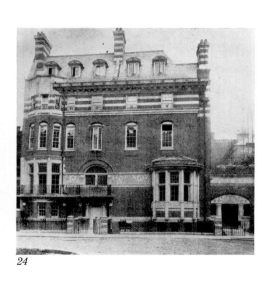

24

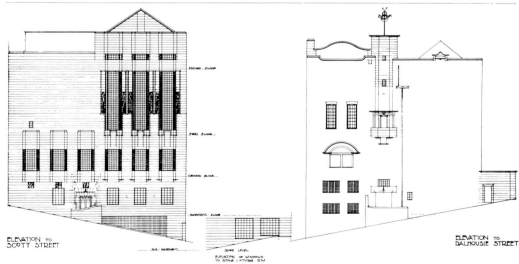

23

21. *1897 drawing for Glasgow School of Art, showing a gable on the eastern elevation.*

22, 23. *Final design for Glasgow School of Art, 1907.*

24. *Palace Court, London, by J. M. Maclaren, 1892, with a balcony window related to that used by Mackintosh in the Glasgow School of Art.*

128

gable. A little 'dovecot' feature is shown pencilled in. In the end Mackintosh removed the gable and left the dovecot – typical of the unceasing experimenting by which Mackintosh's most original designs of March 1907 were obtained.[17]

With the details of the School of Art it is possible to be a little more specific. The two-light balcony window on the north front, despite its already having appeared in elongated form in the early sketch (it re-appeared again in modified form in the Ruchill Church Hall of 1899) can be closely related to that in J. M. Maclaren's 10 and 12 Palace Court, London (*Architect,* July 22, 1892), particularly in its association with a balcony and a bay window. There is also a similarity in the treatment of the top of Mackintosh's design as first approved in 1896 and Maclaren's bay; but Mackintosh's small bay to the left of the balcony window owes nothing to Maclaren and is easily related to his studies of English vernacular houses, particularly those at Lyme Regis published in the *British Architect* of November, 1895.

On these, all his later bay-window designs were based. The treatment of the area walls and railings in the use of up-curved ends seems to owe something to Smith and Brewer's Mary Ward (originally Passmore Edwards) Settlement, whose design received wide publicity in 1895; but although Mackintosh must have admired this design, he was otherwise uninfluenced by it except possibly in some interior detail. Maclaren's window motif is repeated on the east frontage of the School of Art: the recessed oriels are of a type once common in old Glasgow shops, but the elongated proportions are reminiscent of Shaw (from whom Mackintosh probably learned a good deal about composition). They have lined cills, a curious device which appeared in the design for a club at Campbeltown exhibited at the Royal Glasgow Institute in 1896 by a favourite of Hermann Muthesius, H. E. Clifford.[18]

The doorpiece has Burnet's characteristic architrave stretched far beyond anything which that architect would have contemplated, with block capitals added. The curved gablet which had first appeared in the design for the Royal Insurance Building has also developed in a very original way. The drawings of March 1897 show that the little oriel on the east elevation was originally based on that of Maybole Castle (Mackintosh's sketch of it survives) but was gradually worked into something quite different with a huge corbelstone which is a fantastic exaggeration of the profile of the original as he drew it, and a very subtle and original penetration of the wall surface at the splayed plane. The turret which grows out of it, tapered like the Merriot Church tower, has of course no precedent of any kind. Even where antecedents can be found or suggested, it would be wrong to insist on them too strongly. Motifs may have been independently thought out, and in any case borrowed motifs are transformed both in detail and setting in a remarkably original way. There is no precedent for the design as a whole.

Of his church designs – Queen's Cross 1897 and the competition design for Liverpool of 1903 – not much need be said. Their dependence on Stokes and particularly Henry Wilson (design for St. Andrew's Boscombe for the front; Victoria Cathedral design for much else) has already been sufficiently commented upon by Howarth. However, we should not see Mackintosh as a mere cribber. The Merriot tower which inspired that of Queen's Cross he found for himself, and his brilliant sketches of the Gothic churches which inspired both Sedding and Wilson have, significantly, studies for Liverpool intermingled with them. The thrilling outline of the Liverpool design in any event transcends all indebtedness. The Ruchill Church Hall, of 1899, however, is in his own idiom with an elongated version of the School of Art centre window and bowed cills deriving perhaps from the sixteenth-century Duffus Manse at Elgin. The frontage curves into the stair turret without any break, a treatment earlier adopted by J. J. Burnet in the west gable of the Queen Margaret Union in 1887.

The year 1899 brings us to Windyhill, Kilmacolm, the earlier of his two major

25. Study by Mackintosh, published in 1895, of an old house at Lyme Regis, with a bay window resembling that used by him at Glasgow.

houses. And this is perhaps the place to discuss in a little more detail James Marjoribanks Maclaren (1843–90),[19] suggestions of whose influence have been noted from time to time. Rather surprisingly Mackintosh does not mention him in his lecture notes among *The Architect*'s other star performers, although he and his successors came far nearer to the style of Windyhill than any others. It is unlikely that Mackintosh ever met him. But Keppie probably had; for Campbell Douglas's and Sellars's assistants – B. J. Talbert, Troup, J. M. Brydon, Flockhart, G. W. Browne and Maclaren, and J. J. Stevenson, Douglas's ex-partner – were very much a family. Maclaren was actually a pupil of Salmon, but, according to the *British Architect* of November 7/14, 1890, had been with Douglas for a time before making the predictable transfer to Stevenson in London.[20]

Thereafter he worked with William Young, Howell, and Richard Coad before setting up on his own. He did not live long enough to do much: the Presbyterian church at Dulwich, additions to Ripple Court in Kent, alterations at Ledbury Park, a hotel at Santa Catalina, Las Palmas, a large studio-house in Avonmore Road in London, the small town hall at Aberfeldy and the extension to Stirling High School, his largest job. Just before he died he collaborated with Stewart, a civil engineer, and William Dunn, and won first premium in the abortive Watkin project for an Eiffel Tower for London. The Curries (who had previously employed Devey) were his best clients: for them he designed the Palace Court houses, the farmhouse and steading and at least two blocks of thatched cottages at Glenlyon, in Perthshire, which were finished by Dunn who had formed a partnership with Maclaren's draughtsman Robert Watson. Dunn and Watson reconstructed Glenlyon House, and built the hotel at Fortingal.

The designs for all these Perthshire commissions were illustrated in *The Architect* in 1891–2, rather early to have an effect on Windyhill unless Mackintosh had filed their plates, but since he explored the country whenever he could it is very likely that he had seen them. He may even have had friends or relatives in Perthshire; for in 1906 he designed a hitherto unrecorded little house and shop (for P. Macpherson, now Brough and Macpherson) opposite the parish church of Comrie. Fortingal Hotel was unique at its date, as to a lesser degree was Glenlyon

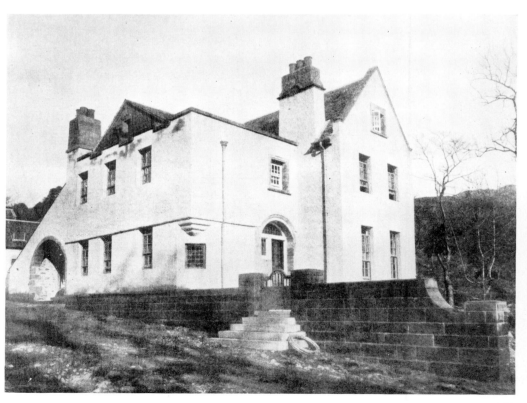

26. Farmhouse by J. M. Maclaren.

House, in its avoidance of the turrets, string courses, moulded openings and sculptured pediments with characterised Scottish baronial up to the turn of the century and beyond; it relied entirely upon a careful appreciation of the proportions of solids and voids and the simple harled finish of true Scots vernacular building. Substitute straight skews for crowstepped ones, take away the solid angles and parapet of the bay, and you have the style of Windyhill almost exactly.

Maclaren's farm house is even more interesting, as we might expect; for he was a far more original designer than Dunn or Watson. This little house has not merely the squareness and robust quality of the Hill House at Helensburgh of 1902 but also a very similar gable treatment and strongly battered chimneys, which had of course been common currency from Voysey's practice throughout the nineties, and on the east side of the house is another feature which anticipates Mackintosh's inventions, a narrow vertical panel of similar family to that in the 'Town House for an Artist' of 1901.[21]

Yet although I feel sure that Mackintosh found the Glenlyon buildings interesting and suggestive the story is not quite so simple. There is an undated design for a large 'Country Mansion', symmetrical round a courtyard, in simple vernacular style but with tall octagonal bays to the court and other Art Nouveau features which have no point of resemblance to the Glenlyon buildings and may well antedate Windyhill. Moreover, a small sketch and the first large finished design for Hill House show that the resemblance to Glenlyon farmhouse was less marked in the early stages. The set-back gable was at first designed quite differently with a small oriel high up, while the round tower in the re-entrant angle was originally corbelled out rather like the Glenlyon House one. The sketch shows that the bow with stone 'shutters' rising directly from the lintel of the window below has no precedent and that it was arrived at by incessant experiment, although Niven and Wigglesworth had done something similar in swelling the wall area between windows at the Sailors' Rest in West India Dock Road, London, of 1896. The simple 'monolithic' treatment of the main entrance of Hill House, however, so different from the archaeologising effusions common at that point in neo-Scottish houses, seems clearly related to the porch of the Fortingal Hotel, basic though the design is.

Mackintosh's last large house in Scotland, Mosside (now Cloak) at Kilmacolm,

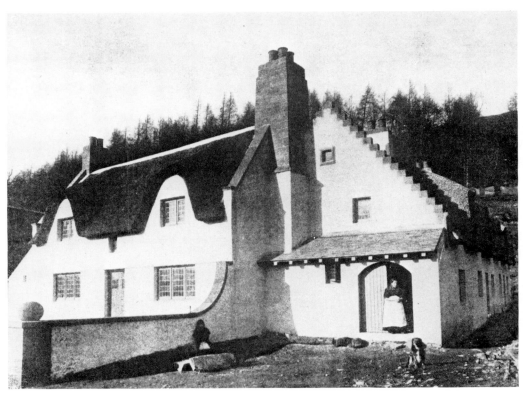

27. Cottages at Glenlyon, Perthshire, designed by Maclaren and completed by Dunn.

shows a more uncompromisingly Scottish approach. As first designed it was a
real Scottish castle with severe rubble walls, crow-stepped gables and a tall three-
storey section which was not built. It had, however, one very original and un-
expected feature: the deep internal window splays of the old Scottish tower houses
were turned inside out, a good example of Mackintosh's ability to see unusual
possibilities in the most conventional things.

From this period two unexecuted designs survive, both very different from
Mackintosh's other work after 1895. One is for a house at Kilmacolm (1902),
rather in the Franco-Scots style of Leiper and, although attractive, not significant.
The other is a very large and ambitious competition design for the National
Bank at the corner of St. Vincent and Buchanan Streets in Glasgow, of 1898.
This design appears to have been suppressed in the past as outside the main stream
of Mackintosh's development, and there can be no doubt that he swallowed at
least some of his pride to woo the bankers. Very probably he would have drastically
re-designed it had he been called upon to execute it and vexed his clients in doing

28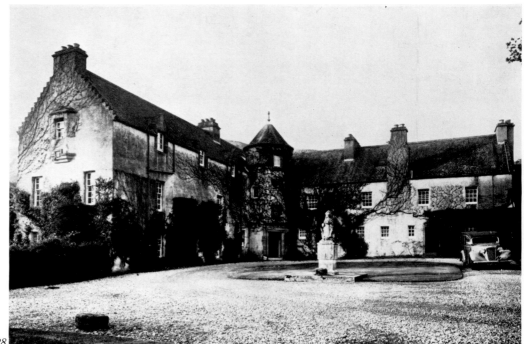

29

*28, 29. Glenlyon House and the hotel at Fortingal,
both by Dunn and Watson. These and other
Perthshire buildings were illustrated in 1891–2
and were likely to have influenced Mackintosh.*

so. Nevertheless the rich Art Nouveau Renaissance of this design shows considerable power and resource in the design of ornament, and perhaps even hints at what Mackintosh's style might have become had it not been for the enforced austerity of the School of Art. It is significant that Mackintosh became friendly with James Salmon Jun. at this time; for the design is related to the Mercantile Chambers, Bothwell Street, Glasgow, designed in 1897. Salmon's design is superior below, but Mackintosh's incomparably finer in the upper parts.

Professor Pevsner (*Pioneers of Modern Design*, Penguin Edition 170) has remarked upon the increase of Baronial influences after 1897. We see it not merely in Hill House but even more markedly in the Daily Record of 1901, where Scots dormers of a simple Scots seventeenth-century pattern, with a bold corbelled cornice and wide cantilevered bays below, are allied to a type of frontage then becoming popular in Glasgow for lane elevations, in which large glazed areas are set back behind unbroken brick piers. The Daily Record windows have Chicago proportions, but are still sashed.

With the Scotland Street School of 1904 it is possible to be a little more specific in baronial antecedents. The basic plan is standard board-school practice (as may be seen by reference to books of school plans published at the time) and so is the fenestration: the education authorities of the time appear to have jibbed at the proposed small-paned windows. Two features other than the finely designed ornament are novel: the setting back of the mezzanines, perhaps a carry-forward from the functional peripheral vestibule and buttress features of the non-premiated Concert Hall design of 1901, and the stair towers. In plan-type the staircases – parallel flights with a solid wall between – were again standard board-school practice. Mackintosh had used the type himself with a bow end at Windyhill and Hill House in the Scots seventeenth-eighteenth century tradition. But at the school he stopped the landing short of the bow so that he could treat it continuously. The suggestion for this mullioned bay through several storeys might be the centre hall-bay of Voysey's Broadleys, which goes back to mediaeval prototypes via Devey, but Thomas Ross's restoration drawing of the Earl's Palace at Kirkwall seems a more natural and indeed an obvious source.

Mackintosh's last significant Glasgow work – and his greatest – the library wing of the School of Art (1907), shows the final shaking off of all identifiable precedent. The design has a soaring quality far beyond the dreams of the designer of the seventeenth-century work at Huntly, Aberdeenshire, to which it has sometimes been likened. The library windows have no doubt a distant relationship to Salmon and John A. Campbell's rear elevations of Hope's steel casement bay windows (Mercantile Chambers 1897 and 124 St Vincent Street 1904), the doorpiece might still have a remote connection with Burnet, but the proportions, the strongly Expressionist forms to be misused in the 'twenties and 'thirties, the recessed south-

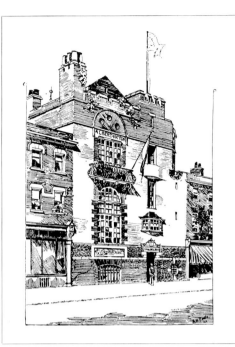

30. Sailor's Rest, West India Dock Road, London, by Niven and Wigglesworth, 1896.

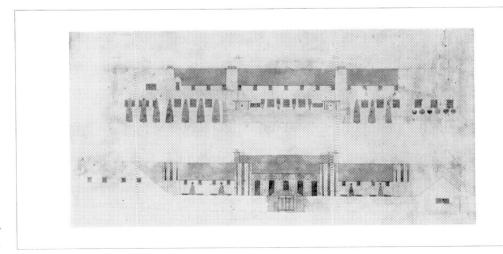

31. Undated sketch for a country mansion by Mackintosh.

ern bay where a brilliant virtue is made of the necessity of keeping within the building line, are far beyond anything hitherto dreamed of.

Yet while I cannot quote any precedent for this section other than the Daily Record for the eastern part of the south elevation, the executed building shows subtle and significant changes from the original designs of March 1907. In order to emphasise the soaring quality of the library oriels, Mackintosh cut the tall parapets of the three northern bays to mere hoods and altered the huge mass of blank masonry above from ashlar to snecked rubble, thus darkening it in tone and making the library stand out, as if it were a tower. At the same time the doorpiece which was originally similar to the eastern one was given a strong and very original Expressionist surround. Subtle changes were also made on the south elevation, chiefly the omission of the conventional masonry top to the uppermost bay. This Expressionist zigzag was to be further developed in the Cloister Room of the Ingram Street Tea Rooms and the Basset-Lowke house at Northampton, but, except for the small Squire studio and Hoppe cottage, Mackintosh built no more.

However much we may feel for the personal tragedy of his last nineteen years, we may not have missed so very much. From 1914 to 1928 important commissions were few in Glasgow. Neither Salmon nor Gillespie designed anything of significance after 1914, and even Burnet's Glasgow office was much less busy than it had been. And when building picked up again in 1927 James Miller's American Classical was triumphant. Even Burnet in the North British and Mercantile Building followed the American pattern, characteristically excelling at it and contriving to be as original as ever in the details, but nevertheless to declare oneself satisfied with the derivative instead of the original meant that the century of the most individual architectural expression ever experienced by Glasgow ends on a sad note.

32. Mackintosh's competition design for the National Bank, Glasgow, 1898.

NOTES

1 *Charles R. Mackintosh*. By Nikolaus Pevsner. Milan, 1950 (in Italian).

2 *Charles Rennie Mackintosh and The Modern Movement*. By Thomas Howarth. Routledge Kegan Paul, 1952.

3 *Charles Rennie Mackintosh*. By Robert Macleod. Country Life, 1968.

4 For James Sellars see *Scottish Art Review* (old series) December 1888, *Transactions of the Glasgow Philosophical Society* 1888, and *Scottish Art Review* (new series) XI 1967.

5 The final published drawings look like Mackintosh's draughtsmanship. The lettering is Roman in deference to the design but the high-pitched diagonal of the 'N' betrays its draughtsman.

6 Entitled 'Architecture' – a lecture read to the Glasgow Architectural Association.

7 The window divided by the column of the arcading is of course set back in a gallery at the original.

8 Bits and pieces of detail reminiscent of this tower also appear in Keppie's Dunloe at Wemyss Bay 1889–90/94. Professor McLaren Young has pointed out to me the remarkable resemblance between the proportions and outline of this tower and a sketch of a late Gothic-dome-capped pinnacle for Witchcombe.

9 No. 8 Great George Street, now destroyed. For illustration see 'Goodhart-Rendel's Roll Call' ARCHITECTURAL REVIEW, Vol 138, pp. 259–64 and Goodhart-Rendel on Pite and Ricardo, *Journal of the Royal Institute of British Architects,* XLIII, p. 177.

10 Edgar Wood had already used this feature though not in a very significant way in the doorpiece of the Manchester and Salford (now William Deacon's) Bank at Middleton in 1892.

11 I have not been able to find a really likely precedent for this. Something like it occurs at Burnet's University Gardens of 1887, but the part containing it appears to be a slightly later addition. Townsend ran the roof through the balustrade in the Bishopsgate Institute of 1894.

12 Rather tentatively in a terrace of flats in Terregles Avenue, Glasgow in 1895. His most interesting design is Bell Aird and Coghill's in Cadogan Street, Glasgow 1900–1. Clifford's interior design received considerable coverage in Muthesius' *Das Englische Haus*.

13 The influence of Voysey does in fact show twice in Mackintosh's work: at the Auchenbothie lodge and in an un-executed design for a golf club house of which only a draughtsman's perspective survives.

14 Most of these were Goodhart-Rendel favourites – see the 'Roll Call.' THE ARCHITECTURAL REVIEW ran a rather similar campaign in its

early years with long biographical articles which are still not superseded.

[15] Like the Slater design (see below) which, as Howarth notes, Mackintosh would have retained because the issue of *The British Architect* contained a report of his lecture. The issue containing the Voysey studio would be retained, because it also contained the 'Keppie' Art Gallery design. Robert Macleod has shown that Howarth is wrong in thinking that the cornice in the 1896 drawings for the Glasgow School of Art was similar to that in the Voysey design – it is in fact the eaves in dead elevation – but it seems to have been a trick of Mackintosh's to give borrowed motifs a different third dimension. See, for instance, note 7.

[16] Ricardo was a particular favourite of *The British Architect,* which complained of the impoverishment of British architecture by the assessors who fought shy of the unorthodox brilliance of his competition designs.

[17] A preparatory drawing of 1907 shows the gable set back behind a parapet and the new storey lightly pencilled in. Mackintosh's studies of Lindisfarne Castle of 1901 show a special interest in severe uncrowned wall planes.

[18] These 'oriels' are very curious. They form one-third of a circle from the inner wall surface and the projection beyond the outer wall surface is quite small. Clifford's are orthodox English canted bays with a straight link, and not curved as here. Though the motif is unusual, the two designs seem unconnected.

[19] Maclaren was a favourite of Goodhart-Rendel. See the 'Roll Call' and 'Rogue Architects of the Victorian Era,' *JRIBA*, LVI p. 251. Part of his inspiration was undoubtedly H. H. Richardson, see the feathery frieze of Palace Court (adopted by Mackintosh in the final Art Gallery design) and the rear porch at Glenlyon farmhouse.

[20] The 'stepping-stone to London'. On this point see *JRIBA*, XV, p. 482 and XVII, p. 607. For the Salmons see *Scottish Art Review* (new series) X, No. 3. Their circle included Leiper, the painter William McTaggart and the sculptors Albert Hodge and Derwent Wood. James Salmon Jun. ('a social and municipal Bolshevik . . . his views on the Parish Council, School Board and Infirmary Managers cannot be published!') was a friend of Mackintosh and a well-known member of the Chelsea Arts Club. He may have encouraged Mackintosh's move south. Both he and his partner J. Gaff Gillespie's Art Nouveau and Modern Movement work deserve better coverage than they have so far received.

[21] Maclaren's brother seems to have continued this idiom at least briefly. See Thomas Maclaren's design for a farmhouse, very similar to Glenlyon, *British Architect*, September 25, 1891 and his Nos. 1–11 George Street, Doune, Perthshire in the same idiom. In 1894, however, he appears to have emigrated to Colorado. His City Hall, Colorado Springs, 1905, is neo-Greek.

MACKINTOSH AND VIENNA

by Eduard F. Sekler

Dr. Sekler here gives an account of the impact of Charles Rennie Mackintosh's personality, and of his designs and those of his wife, on Vienna – which proves this to have been an important stage in his career and at the same time marks it as a turning-point in the course of European architecture.

'A young lady with reddish hair, dressed elegantly in an unusual manner, attracted general attention. Mrs. Margaret Macdonald-Mackintosh, who next to her husband, the Scottish Secessionist Charles R. Mackintosh, is registered as exhibiting . . .'[1], these words from a report in the *Neue Freie Presse* about the opening of the eighth exhibition in the Vienna Secession on November 3, 1900, were followed during the weeks to come by reports and critical articles in several Viennese newspapers.

The *Neues Wiener Tagblatt* restricted itself to a non-committal statement: 'The tea-room by Doctor (*sic*) Mackintosh and his wife must be counted among the most striking achievements which modern art has created.'[2] But the *Neue Freie Presse* in a review on November 11 was more critical: 'The foreign 'moderns' already debauch. Opulently they indulge in pretended simplicity . . . prehistoric magic images, hiding-boxes of the sorcerer, furniture for fetishes . . .'[3] The most understanding review came from Ludwig Hevesi who wrote: 'One of the interiors . . . lies quite beyond good and evil . . . In the total [there is] a simplicity which appears to enjoy itself with virtuosity. From an iron stable lantern or from two lumps of lead it fashions a charming lamp which even gets bought. Bought in Vienna . . . The artists hardly spend their family-life in such rooms but perhaps they have a special ghosts's room in the house, hobgoblin's closet or something like that, as other people have a guest room, and this is the way it looks . . .'[4] After the exhibition had closed the *Neue Freie Presse* on December 29 reported that no less than 24,455 people had visited the show, and had bought 241 works of art at a value of 57,200 crowns.

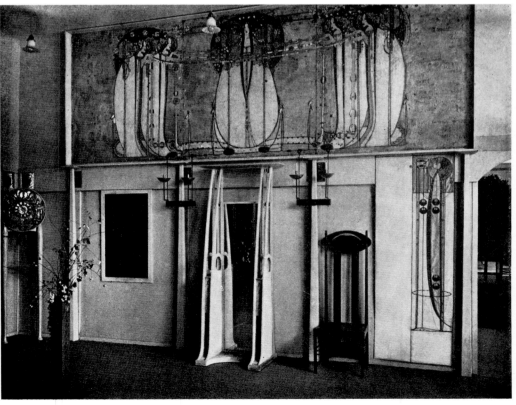

1. One wall of the tea-room, by C. R. Mackintosh and Margaret Macdonald-Mackintosh, exhibited at the 8th exhibition of the Vienna Secession, November 1900.

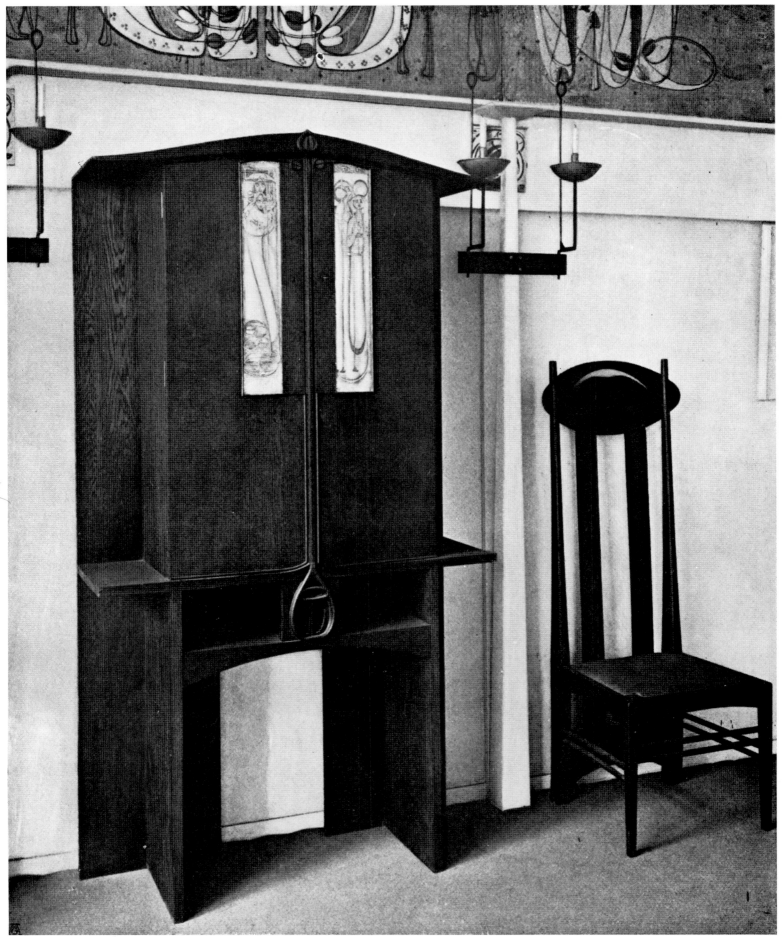

2. Close-up of cabinet, chair and candlesticks at the 1900 Vienna Secession tea-room.

The importance of this highly publicised and successful exhibition for the career of Mackintosh has long been recognised, and a good deal of thought has been given to the relationship between the Glasgow designer and his Viennese contemporaries, notably Joseph Hoffmann. In this connection new evidence has recently become available from unpublished letters.[5]

Josef Hoffmann like many of his contemporaries was highly interested in British design and in all likelihood knew the work of Mackintosh prior to their personal contact, both from avant-garde publications and from the great international exhibition which the Munich Secession had arranged in 1899. Hoffmann did not mention the name of Mackintosh in a letter of April 20, 1900, to Freiherr von Myrbach[6] who was preparing a trip to England, but referred to Ashbee and the Guild of Handicraft alone. However, approximately one month later, on May 29, 1900, Hoffmann's friend Fritz Wärndorfer wrote to the secretary of the Vienna Secession about an impending trip to Glasgow. Since in a letter to Hoffmann he mentioned expressly 'you have sent me to Glasgow . . .'[7], it seems highly probable that Hoffmann was indeed the motivator behind Wärndorfer's trip to Glasgow in the late spring of 1900.

Wärndorfer was an ideal emissary since on the one hand, through education, personal inclination and business connections, he had the closest possible ties to England, on the other hand he was a close friend of Hoffmann and Koloman Moser whose associate he became, when the Wiener Werkstätte was founded.

By the time of his trip to Glasgow preparations must have been under way for the eighth Secession exhibition. Letters in this connection survive from Ashbee who sent a large collection of material. From Mackintosh none has been found except for one which was sent from Glasgow after the artist's return from Vienna. It is dated December 17, 1900, and in it Mackintosh refers to a letter which Carl Moll had written to him on July 15 for the purpose of inviting the Mackintoshes to prepare a special issue of *Ver Sacrum*.

In his belated reply the Scottish architect expressed his gratitude for the reception in Vienna: 'We feel very much indebted to you for this and other honours you and your colleagues have offered us, and we will always remember with pleasure your kindness to us when we were in Vienna. I know well the artistic

3. Another close-up from the 1900 Vienna Secession tea-room.

achievement of your exhibition. I hope it is receiving that public recognition and support which it deserves.' With the letter was a packet of photographs which formed the core of what was shown in the twenty-third issue of *Ver Sacrum* 1901. At a later date the Mackintoshes were invited to exhibit some jewellery at the Vienna Secession and declined: 'We are both very sorry that we have nothing just now to show, and there is hardly time to get anything made. I wonder if Edgar Simpson, a friend of mine called on you this autumn . . .' Since Simpson sent some of his own jewellery in October 1902, the Mackintosh letter is probably prior to this date.

It has been impossible so far to establish accurately how many objects other than the lamps mentioned by Hevesi were sold by the Mackintoshes in Vienna. One cabinet certainly was bought by Dr. Hugo Henneberg, for whom Hoffmann was designing a house at the Hohe Warte. The piece by Mackintosh was placed in the new house side by side with a writing desk especially designed for the purpose by Hoffmann. Hoffmann himself does not seem to have bought anything though he acquired a salt cellar and spoon by Ashbee.

Wärndorfer at first bought a few small items from the Mackintoshes which he mentioned in a letter of October 1901: a silver brooch by Mrs. Mackintosh, a drawing and two prints. But in the spring of 1902 we find him requesting Hoffmann's help in order to interpret and have carried out properly the full-scale drawings which Mackintosh had sent for an entire room – the famous music room. At the same time, in a letter dated April 29, 1902, he refers to Hoffmann's own designs for

4. Writing-room in the house designed by Josef Hoffmann at the Hohe Warte, Vienna, for Dr. Hugo Henneberg. The cabinet by Mackintosh, shown at the Secession exhibition, stands next to a writing-desk specially designed by Hoffmann to fit it.

him which were for a dining room. At the end of this letter Mackintosh is mentioned once more: 'Macksh (*sic*) sends his best greetings to you from Turin and expects you there; he writes that the exhibition building is the basest and meanest theft from what Olbrich did at Darmstadt . . .'[8]

In September 1902 Wärndorfer went to Glasgow whence he sent a picture postcard to Hoffmann which was later used as an illustration, together with other photographs of Scottish buildings, in *Hohe Warte* I (1904/5), 179. On his postcard Wärndorfer wrote: 'Luytchens (*sic*) is the name of the creator of this very charming inn. – Saw today beautiful house by Bailey (*sic*) Scott, white, red roof, shall bring you photographs.'[9]

On December 23, 1902, Wärndorfer wrote to Hoffmann again about his dining room and about the music room which, except for the piano, was almost finished. On the same occasion he alluded in a most interesting manner to a trip which Hoffmann had undertaken earlier in the year: 'Macksh (*sic*) writes that he is furious because you were in Glasgow for two days only, and he is delighted by you more than ever; this indeed seems to be vice-versa.'[10]

From letters by Hermann Muthesius we know that Hoffmann and Freiherr von Myrbach were in London early in December 1902. It is now clear that Hoffmann also travelled to Glasgow. In England he must have studied matters with a view to the project for a metal workshop which eventually led to the foundation of the Wiener Werkstätte. This undertaking seems to have been on his mind since Meier-Graefe had first suggested[11] the possibility of founding work shops for the applied arts in Vienna.

Wärndorfer had written confidentially to Mackintosh about the workshop project and on March 17, 1903, some two months before the actual foundation of the Wiener Werkstätte, the following advice is recorded from the Scottish artist (the original text survives in a German version only, probably Wärndorfer's translation for Hoffmann's benefit): '. . . If one wants to achieve an artistic success with your programme . . . every object which you pass from your hand must carry an outspoken mark of individuality, beauty and most exact execution. From the outset your aim must be that every object which you produce is made for a certain purpose and place. Later . . . you can emerge boldly into the full light of the world, attack the factory-trade on its own ground, and the greatest work that can be achieved in this century, you can achieve it: namely the production of objects of use in magnificent form and at such a price that they lie within the buying range of the poorest . . . But till then years of hard, serious, honest work are still needed . . . First the "artistic" (pardon the word) scoffers must be overcome; and those who are influenced by these scoffers must be taught . . . that the modern movement is not a silly hobby-horse of a few who wish to achieve fame comfortably through eccentricity, but that the modern movement is something living, something good, the only possible art – for all and for the highest phase of our time.'

'Yes – the plan which Hoffmann and Moser have designed is great and splendidly thought through, and if you have the means for it you are not taking any risk, and all I can say is: begin today! – If I were in Vienna, I would assist with a great strong shovel! . . .'[12]

Mackintosh, in fact, did not restrict his advice to words: he actually sent the design for a signet of the Wiener Werkstätte, which Wärndorfer duly conveyed to Hoffmann in a letter of June 24, 1903.

In 1904 the Mackintoshes must have been invited once more to exhibit at the Secession in Vienna because an undated note of acceptance survives addressed to von Myrbach as president of the Secession. Unexpectedly the letter from Scotland is written in a fairly correct German. However, the original Secession movement was beginning to come to an end just at this time; a split formed between two factions inside the Secession and in 1905 the group centered around Klimt, including Hoffmann and von Myrbach, left the Secession.

5. Mackintosh's design for a signet for the Wiener Werkstätte, sent by Wärndorfer to Hoffmann, June 1903.

140

6. The music-room in Vienna designed by Mackintosh for Fritz Wärndorfer, 1902 (now destroyed).

It is striking how Hoffmann and his associates in the Wiener Werkstätte never lost their interest in and admiration for Mackintosh. There is ample proof for this in two undated letters[13] which were addressed to Hoffmann from London by Eduard Wimmer, a close collaborator who was trying to collect material for an exhibition. He visited, among others, Sauter, Shannon and Ricketts, Walton, Voysey and Ashbee's studio. Wimmer was quite discouraged by what he saw and he wrote: '. . . my sole hope after all is only Mackintosh to whom I want to go in a few days.'[14] But he also added a significant remark: 'The evil rumour about Mackintosh is corroborated for me in that he, like most Englishmen, is said to drink a lot but nevertheless could not be called a drunkard, and at present he is supposed to be entirely normal.'[15] I have been unable to find out if Wimmer actually went to Glasgow, but Mackintosh apparently had left unanswered a letter from Hoffmann in this connection; for Wimmer wrote: 'I regret strongly not to have received a reply from you regarding the enquiry at Mackintosh's. I cannot explain it to myself.'[16] Probably the decline of the Scottish master had already set in at that time – a fact of which Wimmer naturally would be unaware but which throws into relief all the stronger the postscript which concludes Wimmer's letter: 'Mackintosh is said to consider his Viennese journey the high point of his life!'[17]

NOTES

[1] 'Allgemeine Aufmerksamkeit erregte eine junge apart gekleidete Dame mit röthlichem Haar. Frau Margaret Macdonald-Mackintosh, die neben ihrem Gemal, dem schottischen Secessionisten Charles R. Mackintosh, als Ausstellerin verzeichnet ist . . .'

[2] 'Zu dem Eigenartigsten das die moderne Kunst geschaffen hat, muss das Theezimmer von Doctor (*sic*) Mackintosh und dessen Gattin gerechnet werden . . .' *Neues Wiener Tagblatt*, November 3, 1900.

[3] 'Die fremden 'Modernen' debauchieren bereits. Sie schwelgen opulent im angeblich Einfachen . . . prähistorische Zaubergestalten, Versteck-

kästen des Zauberers, Möbel für Fetische . . .'

[4] 'Eines der Interieurs . . . liegt ganz jenseits von Gut und Böse . . . In dem Ganzen eine Simplizität, die sich virtuos zu geniessen scheint. Aus einem eisernen Stalleuchter oder aus zwei Bleiklumpen macht sie einen Lichttrager von Reiz, der sogar gekauft wird. Gekauft in Wien . . . Die Künstler selbs verbringen ihr Familienleben schwerlich in solchen Gemächern, aber vielleicht haben sie ein eigenes Gespensterzimmer im Hause, hobgoblin's closet oder so etwas wie andere Leute ein Gastzimmer, und das sieht so aus . . .' Ludwig Hevesi, *Acht Jahre Sezession*, Vienna 1906, 292.

[5] All letters are in the archives of the Secession

or in the estate of Josef Hoffmann unless other indications are given. The author owes a real debt of gratude to Mrs. Karla Hoffmann and to Professor Oskar Matulla who kindly made the letters available for publication.

[6] This letter is now in the possession of the Oesterr. Museum für angewandte Kunst, Vienna. It has been discussed by Wilhelm Mrazek, *Die Wiener Werkstätte* (catalogue of exhibition) Vienna 1967, 12 and by the author in 'The Stoclet House by Josef Hoffmann', *Essays in the History of Architecture Presented to Rudolf Wittkower*, London 1967, 239.

[7] Du hast mich nach Glasgow geschickt . . .' Letter of December 23, 1902.

[8] 'Macksh (*sic*) lässt Dich aus Turin bestens grüssen und erwartet Dich dort; er schreibt dass der Ausstellungsbau der niederträchtigste und gemeinste Diebstahl von den Olbrichsachen aus Darmstadt ist.'

[9] 'Luytchens (*sic*) ist der Name des Erbauers dieses sehr lieben Gasthauses. – Sah heute schönes Haus von Bayley (*sic*), Scott, weiss, rotes Dach, bring Dir Photos . . .'

[10] 'Macksh (*sic*) schreibt, dass er wüthend ist, weil Du nur 2 Tage in Glasgow warst, und ist mehr dennje von Dir entzückt: – das scheint wol (*sic*) vice-versa-zu sein.'

[11] According to the account by Koloman Moser: Hans M. Meuthner and Karl Moser, 'Kolo Moser etc.', *Donaupost,* Bratislava/Pressburg, XVI, 1933, 134.

[12] 'Wenn man mit Ihrem Program (*sic*) einen künstlerischen Erfolg erringen will . . . so muss jeder Gegenstand, den Sie aus der Hand geben, eine ausgesprochene Marke von Individualität, Schönheit und exactester Ausführung tragen. Ihr Ziel muss von allem Anfang an das sein, dass jeder Gegenstand, den Sie erzeugen für einen bestimmten Zweck und Platz gemacht wird. Spaeter . . . können Sie kühn in das volle Licht der Welt hinaustreten, den Fabriks-handel auf seinem eigenen Grund und Boden angreifen, und das grösste Werk, das in diesem Jahrhundert vollbracht werden kann, können Sie vollbringen: nämlich die Erzeugung aller Gebrauchsgegenstände in herrlicher Form und zu einem solchen Preis, dass sie in dem Kaufsbereich des Aermsten liegen . . . Aber bis dahin bedarf es noch mancher Jahre harter, ernster ehrlicher Arbeit . . . Zuerst müssen die 'künstlerischen' (Verzeihung für das Wort) Spötter untergekriegt werden und denjenigen, die durch diese Spötter beeinflusst sind, muss . . . beigebracht werden, dass die Moderne kein dummes Steckenpferd einiger Weniger sei, die durch Excentricität bequem zu Berühmtheit gelangen wollen, sondern dass die Moderne etwas Lebendiges und Gutes sei, die einzig mögliche Kunst für alle und die höchsten Phasen unserer Zeit. 'Ja – der Plan, den Hoffmann und Moser entworfen haben, ist gross und glänzend durchdacht, und wenn Sie die Mittel dazu haben, riskieren Sie gar Nichts und ich kann nur sagen: Fangen Sie heute an! – Wenn ich in Wien wäre, ich möchte mit einer grossen starken Schaufel mithelfen! . . .'

[13] Wiener Stadtbibliothek, *Handschriftensammlung,* I.Nr. 162 136, 162 137.

[14] 'Meine einzige Hoffnung ist doch nur Mackintosh zu dem ich in wenigen Tagen fahren möchte.'

[15] '. . . das böse Gerücht über Mackintosh bewarheitet (*sic*) sich mir dahin dass er, wie die meisten Engländer viel trinken soll aber trotzdem kein Säufer genannt werden könne wie er auch gegenwärtig ganz normal sei.'

[16] Ich bedaure lebhaft von Ihnen bezüglich der Anfrege bei Mackintosh keine Antwort bekommen eu haben. Ich kann mir's nicht erklären.'

[17] 'Mackintosh soll seine Wiener Reise für den Höhepunkt seines Lebens halten!' All translations by the author.

CHE SOFC JEWELLERY OF ARC NOUVEAU

by Robert Melville

The essay that follows refers to material shown at the International Jewellery Exhibition held at Goldsmiths' Hall, London, in 1961, an unprecedented feature of which was a room devoted to Art Nouveau jewellery. The illustrations are from photographs taken in that room by H. de Burgh Galwey.

Robert Schmutzler once declared that the principal carrier of the Art Nouveau style was ornament. I have no reason to doubt that this is a statement of fact, but he drew conclusions from it which seem to me to be questionable. He contended that 'Art Nouveau is essentially a style of ornament,' and although he conceded the existence of Art Nouveau architecture and 'even painting,' he maintained that 'it gave its best in interior decoration and the arts of the book.'[1]

It might have been more correct to call Art Nouveau an ornamental style rather than a style of ornament, for it is one of its characteristics that its decorative devices are practically independent of medium and scale. The coiling and uncoiling lines of a Majorelle bannister would make an embossed motif for a book cover; Van de Velde's design for a capital 'M' would serve admirably as a Guimard portico; Horta's famous inkwell would reduce to a brooch; some of the Tiffany vases would serve as maquettes for street lamps of an unheard-of gracefulness. And now, still haunted by the Art Nouveau room at the International Jewellery Exhibition held at Goldsmiths' Hall towards the close of 1961, I have no doubt that the decorative border round Edvard Munch's well-known 'Madonna' lithograph is a rough sketch for the quintessential Art Nouveau necklace and pendant.

Munch's naked Madonna is a forcible rendering of the Art Nouveau ideal of femininity, which subscribed to the Pre-Raphaelite demand for dreaminess and abundant hair but strikes a more avid note. Deknatel[2] calls this Madonna a representation of the 'ectasy and pain of the act of love,' and it may well be so, for the decorative border is composed of sperms training long wriggly filaments which meander round three sides of the image and end in a foetus-like pendant. The waves of the woman's long black hair are echoed by long curvilinear colour strokes in the darkness around her, like visible waves of erotic vertigo. The decorative border is rough because it is intended overwhelmingly as sign.

I hope I have said just enough about this masterpiece of Art Nouveau to make it evident that if we are going to call the style ornamental we must allow that it puts no curb on expressiveness. All Munch's finest works were achieved in his Art Nouveau period precisely because the long sinuous asymmetrical line, which Nikolaus Pevsner has called the leitmotiv of Art Nouveau[3], perfectly conveys his basic conception of the powerlessness of the individual before the great forces of nature,[4] and I would suggest that whenever the long, sinuous, asymmetrical line informs Art Nouveau ornament it is the automatic, though not necessarily explicit, carrier of the same concept.

But if Dr. Pevsner is right in calling this line the leitmotiv of Art Nouveau, Alan M. Fern[5] is no less right when he says that 'the mere presence of the serpentine curve is not sufficient to define the style.' It has to be what he calls 'a twisting, living thing.' Even so, there are many works in which the specific character of the Art Nouveau style is not attributable to the curvilinear element alone. The fact that the Art Nouveau line is not imitative implies that there is no call to make clear distinctions between the nature of different substances, and in the paintings of Munch, for instance, the paint has a mucous-like quality that invades every form in the picture and can be attributed to a concern with the idea of a primary living substance. A similar tendency to turn all substances towards deliquescence is a contributing factor to the unprecedented nature of Art Nouveau jewellery.

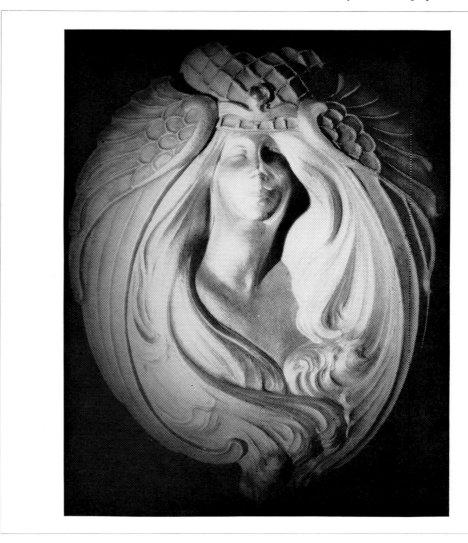

1. Copper pendant by Marcel Bing. The wings are of grey, green and blue enamel.

So a definition of Art Nouveau that takes note only of the curvilinear element is not inclusive enough. Henry-Russell Hitchcock[6] regards the 'humorous and pejorative' descriptions of the style, which refer to eels, noodles and tapeworms, as having some pertinence. Certainly the eels and tapeworms are not unconnected with Salvador Dali's definition, which is the most inclusive and serviceable one I have yet discovered. He calls it the 'undulant-convulsive' style.

Dali's own work has been greatly influenced by Art Nouveau, and one of the most curious features of his contribution to Surrealism – 'his preoccupation with malleability, his passion for softness, which leads him to convert hard objects, like watches, into substances as soft as camembert'[7] – is intimately connected with his enthusiasm for the architecture of Gaudí.

Dali's limp watch is a brilliant witticism, verging on vulgarity. The makers of Art Nouveau jewellery were more subtle, probably because they were not giving self-conscious demonstrations of a 'passion for softness,' and if their most refined designing and workmanship seems often to have been totally devoted to obtaining from metals and gems the look of softer substances, such acts of 'conversion' need not have been fully intentional, and could have arisen from a profound feeling for the general aims of Art Nouveau, succinctly described by Peter Selz as a 'desire for symbolic-organic structure.'[8]

In pursuit of this symbolic-organic structure, the jewellery makers attempted to minimise the distinction between gems and their settings, and to give the gems the look of being, so to speak, a natural outcome of the metal. To give an instance, Wolfers made a buckle in 1898 in which the curvilinear design in relief gave the

144

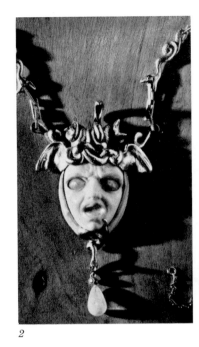

2. 'Medusa' pendant by Phillipe Wolfers, 1898–9: carved ivory, enamelled gold and opal.

3. Fan brooch by Tiffany Inc., c. 1890: opals, green, white, red, yellow, gold.

4. Brooch by Eugène Grasset, with sapphires, cabochons, topaz and enamel; made by Vever, 1900.

2

3

4

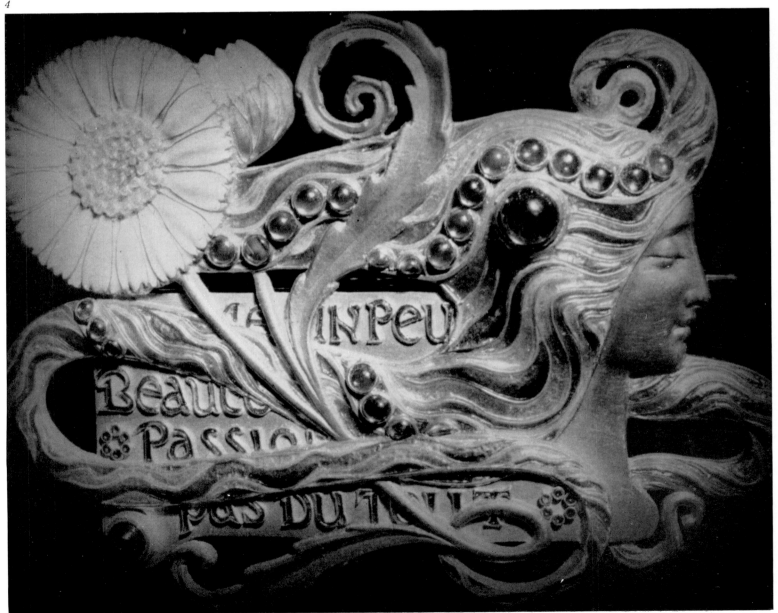

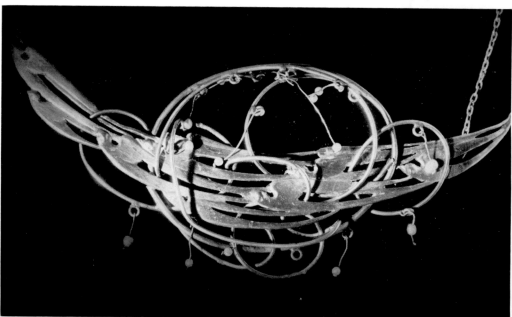

5. Necklet and chain by C. R. Mackintosh, of silver openwork and wire with small pendant pearls; made by Margaret Macdonald-Mackintosh, c. 1905–7.

6. Detail of 'Dragonfly' belt-buckle by Georg Jensen, 1901: silver with opals.

6 5

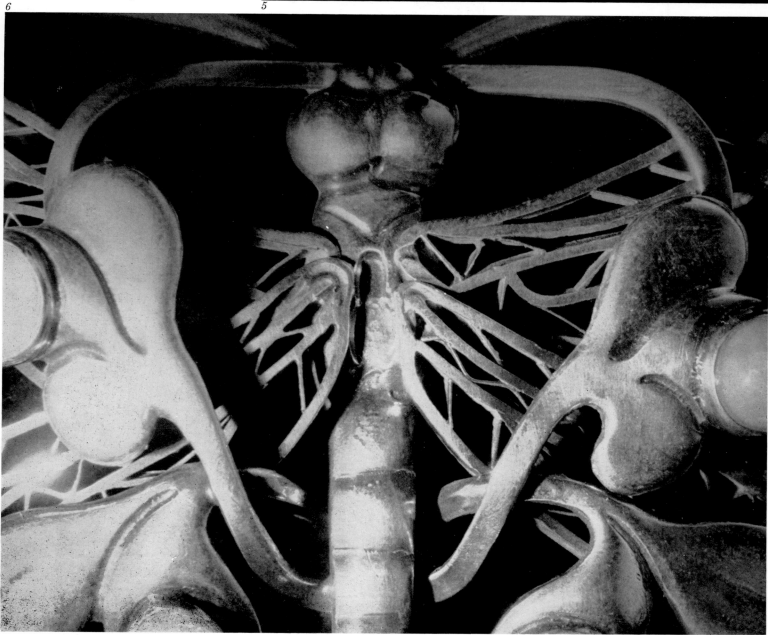

unpierced metal the appearance of having the consistency of one of the fleshier succulents. The design is a highly conventionalised plant form, and the stones placed along the outer edges of the buckle are no doubt symbolic buds or seed-cases, but are more suggestive of a watery exudation as if the metal were mysteriously perspiring. A similar effect was obtained in Van de Velde's 1902 pendant, in which an oval of jade is given a curvilinear setting of gold. The jade looks so much softer than the gold that it seems as if only a miracle prevents the hard translucent oval from going out of shape and lolling over its rim of gold like one of Dali's limp watches.

Human hair serves the same purpose in Art Nouveau design as plant forms and marine fauna and, like these, tends under the pressure of the convention to lose its

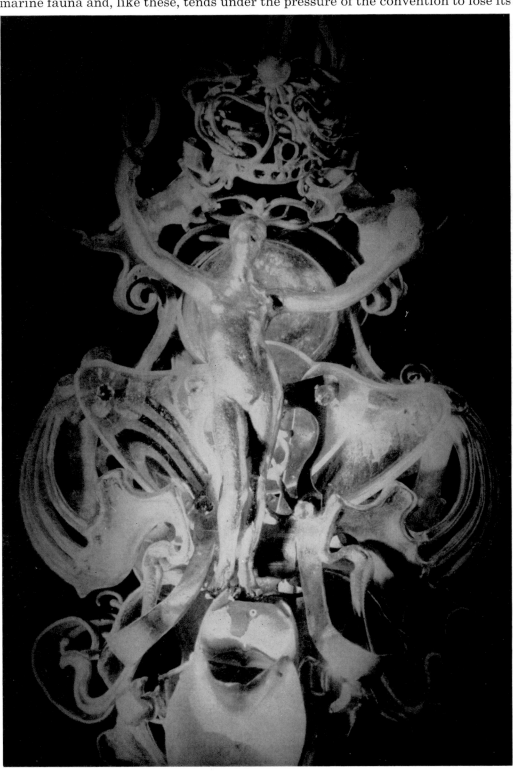

7. Detail of badge by Sir Alfred Gilbert, c. 1891–6: silver gilt, pearls, rock crystal, semi-precious stones.

8

8. *Gold and ivory chain by Josef Hoffmann,*
c. 1925.

9. *Buckle by Henri van de Velde, of oxydised*
silver, moonstones and rose diamonds,
c. 1898–1900.

10. *Gold and jade pendant by van de Velde, 1902.*

9

10

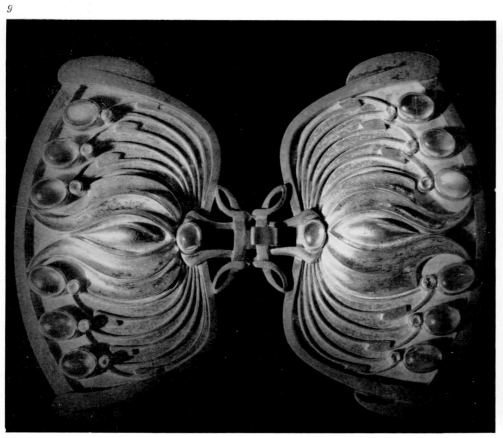

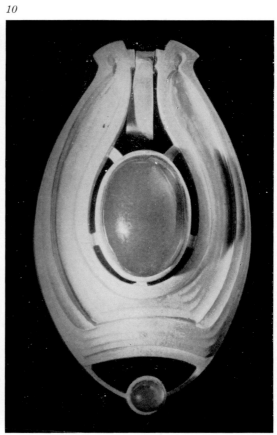

identity. Long flowing feminine tresses lend themselves very easily to flesh-like effects in the metal relief work, and the faces framed by them – usually with eyes simmeringly closed – seem to be emerging from or receding into an ectoplasmic flux.

The designers were not much concerned with the intrinsic value of the gems they used. Their choice of stones was determined by their evocative possibilities, and they would seem to have preferred the gentle pearl and semi-precious stones of cloudier kind to the hard flash of diamonds. But the stone they favoured most of all was the opal, and it is the symbolic-organic significance that they impart to this marvellous and mysterious stone, with its aura of ill-luck and its delicate colours coming and going under a milky bloom, that gives me leave to speak of Munch's spermatozoan chain as if it contains the secret of the spell that the Art Nouveau jewellery cast over us all at Goldsmiths' Hall.

I will have to confine myself to three instances. One of them is the Jensen buckle in silver and opals in which a dragonfly is inextricably involved with a pattern of leaves. The opals are used as terminal points of some of the leaves and operate as glimpses of the interior matter. Jensen conveys the impression that the silverwork is a thin skin, and that where the opals appear the skin has been peeled away to reveal them. The opals take on the look of a softly gleaming mucous slowly emerging from openings in the silver. Even the plant trails and wing skeletons have been

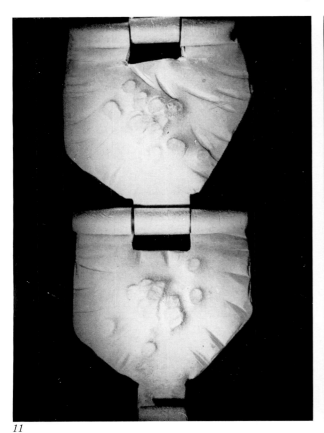

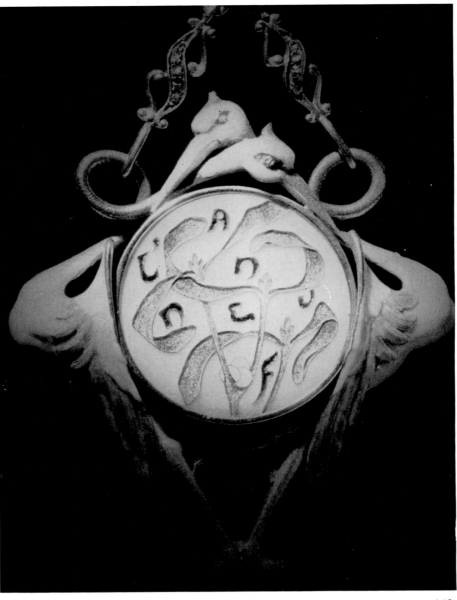

11

11. *Detail of copper gilt bracelet by Karl Schmidt Rottluff, 1912.*

12. *Pendant by Fabergé, c. 1900: round medallion of translucent enamel with light green mistletoe and strawberry-red letters on a yellow base, held by two cast-gold storks enamelled in natural colours.*

12

149

thickened in a way that suggests that they are filled with the same milky substance, and the beauty of the stones turns it into a kind of sacred sap, as if it might be the 'fifth substance' of the Ancients, latent in all things.

My second instance is the famous 'Medusa' pendant made by Wolfers just before the turn of the century. The staring and screaming head of the Medusa is carved in ivory and encircled by a scarf of the same substance. It is surmounted by a tight interlace of enamelled snakes. Two snakes have withdrawn from the central knot to form the coils to which the chain is affixed. Another has coiled itself into the scarf, under the Medusa's chin, and lowers its head to spit out an opal dropper. The Medusa's eyes are also opals. I don't suppose anyone knows whether Wolfers attached a specific symbolical significance to his snake spitting out an opal, but certainly no other stone could have more appropriately carried the significance that springs to mind, and it serves to draw our attention to the fact that the only stones that could be used to translate Munch's decorative border into an actual necklace are opals.

But the 'Medusa' pendant verges on melodrama and tends to break out of the purely decorative field. So my third instance is a Liberty necklace of 1903. It would not have come to mind if I had not seen it in the context of the Art Nouveau

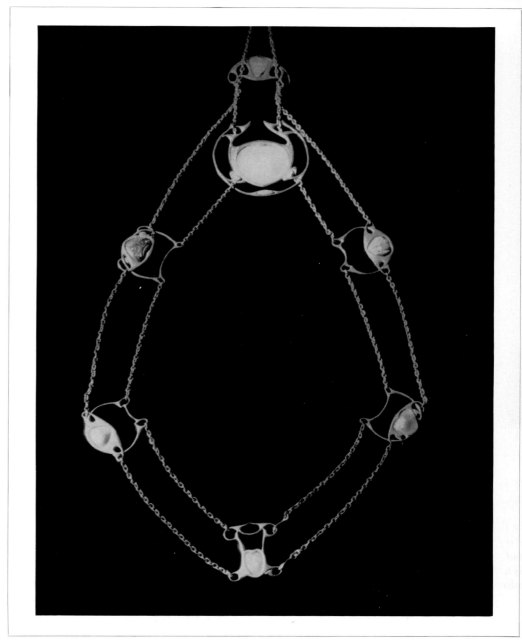

13. Pendant necklet by Liberty & Co.,
c. 1903: gold, opals and mother-of-pearl.

room at Goldsmiths', for it is only on the popular periphery of the undulant-convulsive style, but with its delicate gold chains running between six opals and its complete detachment from overt symbolism, it represented the transformation of Munch's drawing into pure ornament.

When the movement came to an end, and the serpentine line had straightened itself out, what remained was Art Nouveau's equivocal attitude to substance. One can find it even in the daylight art of cubism, for Picasso was still near enough to his own involvement in the Art Nouveau movement to be interested in the adumbrated nude, the nude forming before one's eyes, and, in the 'Girl with a Mandoline' painted in 1910, now in the Museum of Modern Art, New York, the figure is still not finally detached from a kind of space paste. Three years later, Boccioni created the Futurist masterpiece known as 'Unique Forms of Continuity in Space,' which is the apotheosis of Art Nouveau's sense of a soft primary substance.

And to return to jewellery, the splendid copper gilt bracelet made by Schmidt-Rottluff in 1912 looked profoundly at home in the Art Nouveau room in spite of its angularity, for the working of the surface – the puckered edges and the small protuberances like forecasts of Arp's 'navels' – creates the sense of a substance softer than the material used: as one would expect of a German Expressionist, he extolls imperfections rather than potentialities, but the creasing and pimpling doesn't deter one from associating it with Art Nouveau's endless roll of living matter.

NOTES

[1] THE ARCHITECTURAL REVIEW, February, 1955.

[2] F. B. Deknatel, *Edvard Munch,* London, 1950.

[3] Pioneers of Modern Design, New York, 1949. Referred to by R. Schmutzler, *Blake and Art Nouveau,* THE ARCHITECTURAL REVIEW, August 1955.

[4] F. B. Deknatel, *op. cit.*

[5] *Art Nouveau,* The Museum of Modern Art New York, 1960.

[6] Ibid.

LIBERTY METALWORK

by Shirley Bury

*In the following essay Mrs. Shirley
Bury, of the Victoria and Albert
Museum, indicates the significance,
and identifies the designers, of the
silver-ware and jewellery produced by
the firm of Liberty during the last
twenty years of the nineteenth century
and the first few years of the twentieth,
which showed the influence both of
the Art Nouveau movement on the
Continent and of the Arts and Crafts
movement at home.*

In 1959, the firm of Liberty & Co., of Regent Street, presented to the Victoria and
Albert Museum file copies of their catalogues dating from the early 1880s onwards.
These catalogues have been an invaluable source of information about the range of
silver and jewellery which was launched by Liberty's under the title of 'Cymric'
in 1899 – the name being chosen in recognition of the Celtic inspiration which was
claimed for many of the designs. In fact, Liberty silver was strongly influenced by
the English Arts and Crafts and Continental Art Nouveau, both interpreted in
terms of commercial production, which makes it a particularly intriguing study.

Few other firms at this time attempted anything but a cheap mass-produced
imitation of the Art Nouveau. This was true of many Birmingham manufacturers
in search of novelty, who turned out stamped wares in thin silver decorated with
the most popular motifs of the style, female heads set in a waving surround of hair,
plants with stems conforming to the whiplash curve, and so on. Liberty's, however,
and to an appreciable extent the London workshop of the Sheffield firm of William
Hutton & Sons, which under the direction of C. W. Blackman produced some fine
silver in the Art Nouveau manner from 1897 until about 1907, aimed at producing
modish wares showing something of the concern for craftsmanship which charac-
terised the English Arts and Crafts movement.

It is ironic, of course, that the impact of Art Nouveau should have been felt in this
country mainly on the level of commercial production, while the Arts and Crafts
movement remained comparatively unaffected by stylistic developments abroad.
William Morris had helped, by his work and writings, to spark off all the activity
on the Continent, but his followers, in metalwork as in the other decorative arts,
managed to insulate themselves against any counter-influence with a high degree
of success. C. R. Ashbee was one of the few English Arts and Crafts metalworkers
of the time who, possibly as a result of taking part in exhibitions on the Conti-
nent, modified his style slightly in the late 1890s under the influence of Art Nouveau.
Even then, the modification was made unconsciously; for Ashbee continued to
profess his dislike of the style because of what he considered to be its unforgivable
mannerisms. Nevertheless, the enhanced grace and lightness of Ashbee's designs
for silver and jewellery after 1898, and particularly his use of multiple wire threads
separating at their ends in tendril fashion, which appeared as the structure of his
jewellery and as the handles of his bowls and cups, show how well the influence
had been absorbed and transmuted into English form.

The 'Cymric' wares were comparatively late entrants in the field. The firm en-
tered their first mark for silver (L^y & Co) at Goldsmiths' Hall in February, 1894,
probably with the sole intention at first of using it for the Japanese and other
foreign silver which they imported as part of their stock-in-trade.[1] Under an Act of
1842, all such silver offered for sale had first to be assayed in this country. In
April, 1899, as the 'Cymric' scheme got under way, another version of the mark was
registered, and towards the end of the year the range was launched in earnest.
Several pieces were shown at the Arts and Crafts Exhibition, which took place in
November and December, and the firm's Christmas catalogue devotes five pages to
illustrations of 'this new school of silver-work . . . conceived and produced under
the immediate direction of Messrs. Liberty and Co.'

The marks of 1894, 1899 and a third of 1900 were entered on behalf of the firm by

A. W. Howe, the managing director and secretary of Liberty's when the firm became a limited liability company in 1894. It was acknowledged, however, that the prime mover in the scheme was Arthur Lasenby Liberty, the founder and chairman of the firm. At the age of nineteen, Liberty had been appointed manager of the Oriental Warehouse of Farmer & Rogers in Regent Street, one of the favourite haunts of Rossetti and his circle, who came to buy blue and white porcelain. When the warehouse closed down in 1874 and Liberty in the following year opened a similar concern in the same street, his clientele followed him. Liberty soon sought fresh fields to conquer. Inspired by the Japanese brocades that he imported, he started a range of 'Art Fabrics,' with richly textured surfaces and glowing colours which won them an enthusiastic following in this country and on the Continent: *Stile Liberty*, the Italian term for Art Nouveau, shows what an immense impression these fabrics made in Italy.

Liberty had already embarked on production in other fields of the applied arts when he came to silver and jewellery in 1899.[2] Two or three years afterwards, he was to add the range of 'Tudric' pewter to his enterprises. Fortunately his explanation for this move still exists, in the text of a paper on pewter which he read to the Royal Society of Arts in May, 1904.[3] Some years since, he stated, his firm had 'adopted for designs, in silver plate and jewellery, the *motif* and lines of ancient Celtic ornament. The results proving fairly satisfactory, the question arose, "Why not apply the like forms and designs to the manufacture of pewter?" Thus, rightly or wrongly, the pioneers of the revival of Celtic ornament decided to work in pewter on somewhat parallel lines with silver, and came to the conclusion that nothing is produced by the silversmith which may not, as occasion arises, be made in pewter, but with the distinct proviso, that any attempt to imitate the precious metal should be avoided.'

This statement, more ingenious than ingenuous, immediately raises a number of questions. Did Liberty's, for example, really sponsor the vogue for Celtic forms at this time? The answer is that they did not. Without going into the complicated background of the Celtic Revival, it remains true that Alexander Fisher, the silversmith and enameller, who was never noted for his avant-garde designs and, indeed,

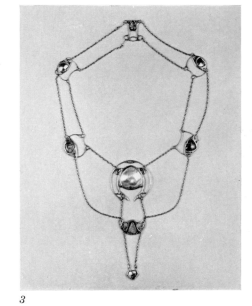

1. Silver buttons with enamelled decoration in blue and red, W. H. Haseler, 1907.

2. Silver and enamelled buckle, designed by Jessie M. King, 1905.

3. Necklace of gold, opals and mother-of-pearl, made by Liberty & Co. (Cymric), c. 1903.

1

2 3

never claimed this particular distinction for himself, was decorating his silver with Celtic interlacing as early as 1896. Moreover, the Liberty designs were not entirely Celtic in inspiration.

It is clear from the firm's published catalogues that there were many other influences less openly acknowledged: traces of the Japanese in scme of the buckles and other items of jewellery, of Henri van de Velde's angular functionalism in cravat pins and brooches, of the *Jugendstil* in certain of the emphatic lines of the bowls and cups. Nearer home, there are silver-mounted claret jugs so reminiscent of some of the most beautiful designs of Ashbee's Guild of Handicraft that it is at first difficult to see any difference between them. The resemblance was not missed by the people associated with the Guild, which was always on the verge of bankruptcy. In 1903, Janet Ashbee was provoked to a despairing entry in the joint journal that she kept with her husband. Citing the thousands cf pounds sunk by Liberty's in this one venture, she asked whether the Guild was justified in its struggle to earn the few hundred pounds necessary for its ccntinuance.[4] Four years later the Guild was in dissolution, less, it must be confessed, as a result of outside competition than of the impossibility of functioning as an oasis of handcraftsmanship in a machine age.

Liberty's, on the other hand, geared their production to both the hand and the machine. The uneven hammered surface of their silver, to which the firm drew particular attention, was achieved by hand, as was the practice of setting silver articles with semi-precious stones, but it is probable, as the designs were mass-

4. Silver candlesticks, designed by Rex Silver, 1905.

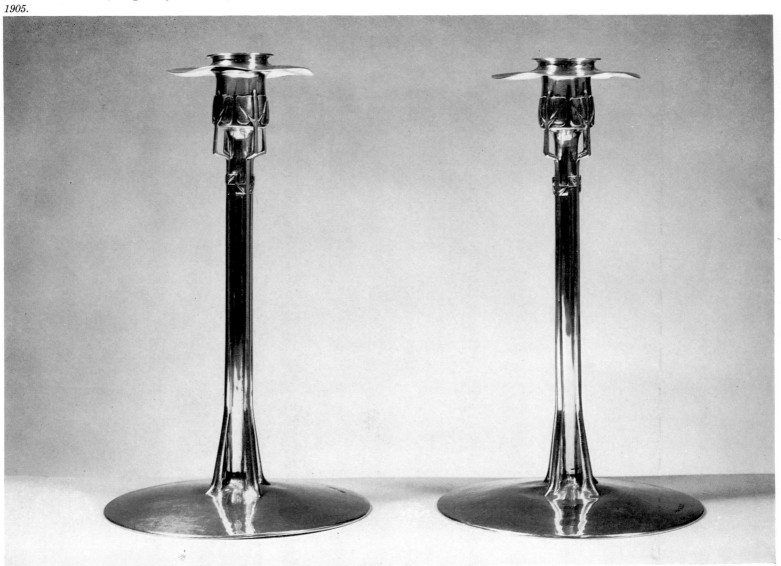

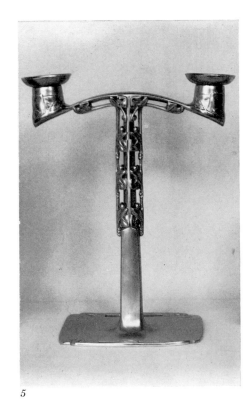

5. *Electro-plated pewter candlestick, probably designed by Archibald Knox, about 1904.*

6. *Pewter butter dish and knife, with green glass liner, probably designed by Knox about 1905.*

7. *Silver sugar bowl and spoon, also probably designed by Knox, 1904.*

produced, that these refinements were the final gloss, put on to forms which were sometimes shaped initially by machine. The names of the workshops which made the Liberty pieces for the first two years after the introduction of the range in 1899 are, unhappily, unknown at the moment. These workshops were probably in London, because of the London mark registered by the firm, and at one time or another included a small concern run in Soho by a man called Myer, whose son sold up the business a few years ago, together with some jewellery which for some reason had never been delivered to Liberty's. Very early on, however, the firm established a connection with Birmingham. Most of the pieces which were exhibited by the firm at the sixth exhibition of the Arts and Crafts Exhibition Society late in 1899 were either designed by or made by Birmingham artist-craftsmen.

A case in point was a silver bowl designed by Oliver Baker (1856–1939), a painter and etcher educated at the Birmingham School of Art, and made by Jessie and A. H. Jones, whose work had been exhibited by the same school at the Society's fifth exhibition in 1896. Another was a silver spoon, ornamented with gold and turquoise, designed and made by Bernard Cuzner (1877–1936), who was just at the end of his training at the Birmingham Art School. These and other pieces must have been prototypes, for the School certainly had no facilities for mass-production, nor would this have been allowed by the local authorities; and Cuzner, for instance, boasted that he himself had never duplicated a piece is his life.

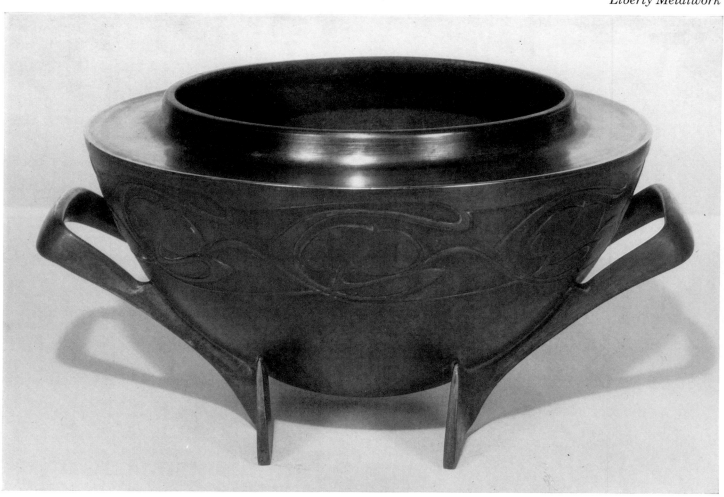

8. Pewter flower bowl, designed by Rex Silver, 1905.

While a number of London workshops probably went on turning out small quantities of work for Liberty's, the great bulk of production was undertaken from mid-1901 by the Birmingham firm of W. H. Haseler, founded by William Hair Haseler in 1870 and from 1896 directed by William Rabone Haseler and Frank Haseler. A new firm was formed for this purpose, known as Liberty and Co. (Cymric) Ltd. and registered at the Board of Trade on May 17, 1901.[5] Arthur Lasenby Liberty and W. H. Haseler appeared on the list of subscribers; the directors were Howe and John Llewellyn, of Liberty and Co., and W. R. and Frank Haseler. The actual financial basis of the firm is made clear in an agreement dated May 22, 1901, whereby Haseler's undertook to sell to Liberty's the lease of their premises in Hylton Street, together with their plant and tools, in return for £2,000 in the form of shares in the new company. Liberty's held shares to the value of £3,000.

After the arrangements for the new company were settled, a mark for L & Co. was entered at the Birmingham Assay Office, and more designs for silver and jewellery were commissioned. A little later, the 'Tudric' pewter range was launched. As before, a careful and economic balance was struck between hand work and machine aids; some of the silver was spun, and the pewter was cast. The factory maintained a high output, but a curious feature of the whole arrangement is that it not only enabled Haseler's to continue with their own work, but to mark a proportion of the Liberty designs as their own. This is apparent, for example, in the enamelled buttons of 1907, which bear the maker's mark of W.H.H. although they appear in a number of Liberty catalogues. Moreover, Haseler's issued their own catalogues illustrating without any reference to Liberty's designs from the 'Cymric' and 'Tudric' ranges.

The question of the identity of the Liberty designers has yet to be solved fully. We do not yet know, for example, who designed the delicate gold, pearl and opal necklace which appears in a Liberty catalogue of about 1903–4. The design policy of the firm favoured complete anonymity, and the names of designers are omitted from the catalogues. Indeed, but for the fact that the firm contributed occasional pieces to Arts and Crafts Society exhibitions, and were bound by the rules of the Society to give details of design and manufacture, and that other pieces were illustrated in periodicals such as *The Studio*, which likewise gave details of their designers, tracking down the artists concerned would be even more difficult than it is. The cost books of the firm, which could have provided this information, were destroyed only a few years ago, while Haseler's, having changed hands, have kept almost nothing in the way of written records.

The earliest designers, who began working in 1899, include Oliver Baker, who although known as a painter had never before attempted anything in this genre, A. H. Jones, who later became an independent metalworker, Bernard Cuzner, afterwards one of the most outstanding silversmiths and jewellers of his generation, and Reginald (Rex) Silver (b. 1879), who after training at two art schools was then working in his father's design studio in London. Arthur Gaskin (1862–1928), who was on the staff of the Birmingham School of Art before his appointment as Principal of the Victoria Street School of Jewellers and Silversmiths in 1902, did some jewellery designs for the firm in the early 1900s. At about the same time, Archibald Knox, a young teacher at an art school in Surrey, began a long career as a Liberty metalwork designer. In 1905 or thereabouts, Jessie M. King (1876–1949), a member of the Glasgow School, was recruited to design both silver and jewellery. Her approach to design is typified by the charming silver and enamelled buckle illustrated here, with its stylised bird and flower motifs.

The astonishing thing about these artists is their youth. Baker and Gaskin were both older, but Baker was new to the field of silver and jewellery, while Gaskin had only been concerned with metalwork since 1898. Baker brought a kind of Renaissance bragadoccio to his work, decorating his silver with elaborate cartouches and elaborately scrolled feet rather in the manner of Alfred Gilbert's work in silver of a decade earlier. Gaskin was content to produce a muted version of his usual style of jewellery design. It was the younger ones, however, particularly Rex Silver and Archibald Knox, who provided the dash and brought the whole venture up to date.

Silver was only twenty-one when he designed the pair of candlesticks which were chosen for illustration in *The Studio* of that year. The squared-off motifs that he favoured evoke some contemporary Austrian designs, and occur again in the pewter candlestick of about 1904, which was probably designed by Knox. Silver's vigour is apparent again in the pewter flower bowl of 1905, the bowl itself cradled in a pair of simple handles, each end extended to form a foot. Silver's jewellery designs were also influenced by work on the Continent: some of his pieces are in the manner of van de Velde, whose jewellery was illustrated in the *Magazine of Art* in 1900. Archibald Knox worked in a similar bold manner; it is likely that the pewter butter dish of 1905 and the silver sugar bowl of 1904 were designed by him.[6] They are all in the Liberty tradition of uncompromising shape and strong ornament.

Given the very fact of their modishness, it is remarkable that these designs stayed in production for so long. Some of the Art Nouveau pieces continued to be issued throughout the 1920s and even, exceptionally, in the early 1930s, although the original Liberty-Haseler agreement came to an end in 1926. Liberty & Co. (Cymric) Ltd. was wound up in 1927. Haseler's continued to work for Liberty's, but the connection was now much less close than before. The break became more or less complete with the war years, when all but four of the pewter moulds disappeared into the war effort. The last member of the Haseler family to be connected with the firm sold up his interests over twenty years ago, and the firm now work

only occasionally for Liberty's. Of the designers who were associated with the venture in its early years, only Rex Silver is still alive, and he has most kindly helped to identify some of his own work.

NOTES

[1] The firm may have made a small beginning as manufacturers of jewellery and silver wares as early as 1894, for when they registered as a Limited Liability Company in November of that year they described themselves as '. . . jewellers, goldsmiths and silversmiths, dealers in gold, silver, precious stones, curios and articles of virtu,' etc. Company file 42342, now at Public Record Office. The files of the firms registering under the Companies Acts of 1862 onwards are an invaluable and hitherto almost completely neglected source of information about Victorian manufactures.

[2] Liberty had also been one of the few people whom Christopher Dresser was able to persuade to take out shares in the avant-garde but short-lived Art Furnishers' Alliance in 1882. Company file 14236, Public Record Office.

[3] *Society of Arts Journal*, LII, 1903–4, p. 626.

[4] Ashbee *Memoirs*, Vol. II, p. 135. (Typescript, Victoria & Albert Museum.)

[5] Company file 70230, Public Record Office.

[6] Silver, Knox (who came from the Isle of Man) and Jessie King all submitted their designs to the firm in London. They were in no way concerned with the practical details of the manufacture in Birmingham, according to Rex Silver.

ART NOUVEAU IN ESSEX

by John Malton

The interior especially, and the elaborate fittings, of the church of Great Warley, near Brentwood in Essex, described below and illustrated by the author's own drawings, constitute the most remarkable example in Britain of ecclesiastical architecture conceived and designed throughout in the spirit of Art Nouveau. The photographs are by Eric de Maré.

During the first few years of this century two men, whose work was rarely conventional, were designing and executing a building of a kind normally thought to need extreme conservatism or at least conformity with precedent in design. These men were Charles Harrison Townsend and William Reynolds-Stephens. They were commissioned by Evelyn Heseltine to build a church and Garden of Rest in the village parish of Great Warley, south of Brentwood in Essex. The building was to be a memorial to Mr. Heseltine's brother, Arnold Heseltine, who had died in 1897.

The ideas that it was wished to have embodied in every aspect of the building and its surroundings were somewhat unorthodox in their emphasis. The programme set the designers was a rigid one which controlled, but fortunately did not stifle, their originality. So that there should be no thought of dwelling morbidly on the facts of burial or thoughts of death, everything in the conception of church and surroundings was subordinated to the purpose of symbolising and illustrating one idea, the idea of the Resurrection. The building, when completed, was presented to the parish. When the church was dedicated in 1904 an explanatory leaflet told the parishioners that:

> 'The primary object of Mr. Reynolds-Stephens in his designs has been to lead the thoughts of the worshippers onward through his decorations to the glorified and risen Christ whose form in the centre of the reredos is to be the keystone of the whole scheme. He has made free use of floral forms throughout the decoration, emblematic of progressive growth in the earthly life, but still more of glorious hope which year by year is emphasised at Eastertide, the time of floral recrudescence.'

From a casual glance through the screen of trees that veil it from the road, the church would appear to differ little from many another simple one in Essex. The two-celled building with wooden belfry and shingled broach spire is native to the more thickly wooded parts of the county. It is most probable that such a traditional external appearance was insisted on, so that there should be no risk of introducing a disturbing element into the landscape. Harrison Townsend, without doubt, could have made here a revolutionary contribution to church design. He was, after all, building at that time his unconventional Horniman Museum at Lewisham. The small church he had built in 1893 at Blackheath near Wonersh in Surrey was a building more nearly of the character that was required of him at Warley.

On entering the churchyard at Warley it is apparent that here is no rustic church, simple because of poverty. The building has simplicity, it is true, but the effect is one of sophistication. In the main, it is the manner in which the surroundings of the church have been contrived that accounts for this. This is a subtle preparation for a church interior which might lose some of its impact if entered from a more conventional churchyard.

In this Garden of Rest there are areas of smooth mown grass and gravel paths and long white benches, cypresses and pleached lime trees. All is carefully tended. It is more like the garden of a country house than a churchyard. There is a near-symmetrical formal layout of paths. The semi-circular one in relation to the apse is lined with regularly spaced rose trees which at once recall those in Charles Rennie

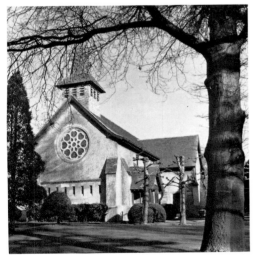

1. Great Warley church, by C. Harrison Townsend and William Reynolds-Stephens, in its formally planted Garden of Rest.

159

Mackintosh's drawing for his house for W. W. Blackie at Helensburgh.

To the west of the church, and at a slightly lower level beyond, are graves with low curbs. Headstones are not allowed, being thought too obtrusive reminders of the dead. Though the view from the lych-gate is right through the church-yard to the half circle of lombardy poplars on the west and the lush country beyond, not a grave obtrudes.

The walls of the church are rough-cast rendered, except for the stone dressings to the door and window openings and the stone plinth mould. The cast-iron rain-water heads are shaped and ornamented with stylised foliage in such a way as to combine with their downpipes to resemble tall stemmed growths. The window openings are mostly plain lancets with simply moulded reveals. There is heart-shaped tracery in the window of the side-chapel and in the rose window at the west end. A rose window such as this is an unlikely thing in a small country church and its presence here again hints at the sophistication of the scheme. The row of small windows below it is an arrangement typical of Townsend's work.

Pevsner calls the exterior 'modestly pretty à la Voysey.' On the other hand, Townsend's work at Whitechapel, Bishopsgate and Lewisham has been adjudged to owe something to Richardson and Sullivan. May not the model here be 'Richardson Suburban'? The treatment of the stone base walls to porch and lych-gate, the form of the exaggerated bellcast of the eaves and the use of shingle siding are all elements common to Townsend and to that style and not to that of Voysey. The timber belfry, to be truly in the Essex tradition, would undoubtedly be faced with regular weatherboarding painted white. The one here, however, is faced with shingles and has three louvred openings to each face, not the usual one. On the top of the spire is a figure of the Dove of Peace with olive branch in its beak. The figure is made of wood covered with copper sheet and is about 2 feet 6 inches long.

The church is entered through a door which, on turning the ring handle, divides surprisingly at three quarters of the way across its width.

2. White-painted seat in the Garden of Rest; lych gate in background.

Some of the internal furnishings of this building are described in *The Studio* for February, 1905, where it is written:

'Although the impression made by the interior of the church is at first glance one of quiet and restful elegance, although there is nothing which immediately asserts itself, and insists upon attention, the more the details are analysed, the more satisfying is the revelation of his (Mr. William Reynolds-Stephens's) inexhaustible variety and of his cleverness in contriving fresh ways of expressing his ideas. Indeed it would be difficult to find an example of modern decoration which will better repay examination part by part and detail by detail so as to see by what thoughtful combination the whole harmonious effect has been built up.'

On entering, the first view of the interior is the sight of the font, framed by the door opening. Its silhouette is somewhat eerie in effect and startles when seen unexpectedly. It does not do this because of any misshapenness of form, for on closer inspection it is found to be a pleasant example of the pedestal statuary that Reynolds-Stephens was doing at that time. It has, however, that strangeness which is inherent in the hint of Arthurian mysticism which is the essence of the whole character of the interior and which is a link between the works of the Pre-Raphaelites and of the Aesthetic movement.

Reynolds-Stephens designed and executed nearly all the interior fittings, but Harrison Townsend, who was responsible for the structure, also designed most of the internal joinery. The pews, choir stalls and wall panelling to the nave are his work. All this joinery is in walnut, and the wall panelling has, in addition, some inlaid patterning in marquetry. The shape of the flowing hood-moulds that span three panel bays at a time is similar to that of those over the tower windows of the Horniman Museum. The outstanding feature of the interior, however, is the bold and effective way in which a diversity of materials has been handled, the juxtaposition of various metals and alloys being particularly successful. In the screen which divides the nave from the chancel this delight in materials is displayed. Brass trees grasp with root-like claws low walls of dark green Irish marble, from which they rise on their shaped stems of cast brass to carry across the chancel in their tightly interlaced foliage, red glass pomegranates, flowers in mother-of pearl, figures of angels in oxidised silver and a cross. On the left-hand side of the screen is the pulpit, whose front is of oxidised copper sheet in the shape of a cross set into a backing of dark grey fossil marble and ornamented with blue pearl.

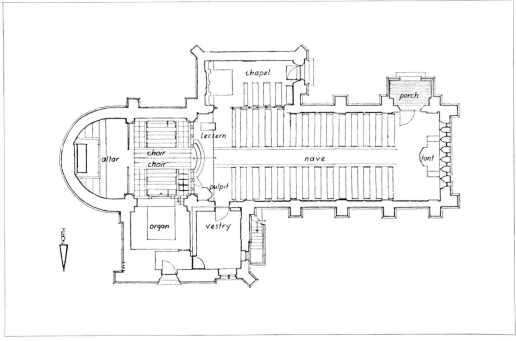

3. *Plan of the Church.*

The cross shape is flanked by trees in green bronze with brass flowers. On the right-hand side of the screen is a lectern of shaped copper sheet with pearl ornamentation. On its top it has short flowering stems supporting a brass book-rest.

The side-chapel screen, which separates it from the nave, ingeniously achieves in walnut the same effect of lightness as does the other in metal. From a low panelled screen of pew height rise hardwood shafts which are kept slim by being paired for strength. They rise one on either side of the low screen from its base. These pairs alternate with single shafts, which rise from claw-like junctions with the head rail of the low screen. The shafts all carry stylised poppy-leaf foliage in openwork carved walnut. This foliage carries a moulded cornice rail which resembles in its sections that of a poppy-head. Pewter plaques in the form of conventionalised poppy flowers are applied to the rail in pairs above the heads of the paired shafts.

The roof to the nave and chancel is a simple boarded wagon vault. In the nave the vault is divided into bays by broad ribs decorated with the forms of conventionalised rose trees and all covered in aluminium leaf. Between the springing of these ribs and the wall panelling below are panels each filled by three lilies rising from their bulbs, again all in aluminium. In the chancel, the vault is divided into strips by narrow aluminium ribs. The whole of the half dome of the apse above the dado line is faced with aluminium sheet on which is formed, by repoussé work, a stylised grape vine (similar to the one embossed by William Morris on the cover of his Kelmscott Chaucer). All is in self-coloured metal except the bunches of grapes which are red.

Below the dado line, the whole of the apse wall is faced in light green Swiss Cippolino marble. The floor of the sanctuary is dark grey marble. The altar rail is of oxidised copper and is carried alternately by slabs of dark green marble and by brass wreaths in the form of crowns of thorns each flowering with three large single roses.

The reredos was designed to contain the central motif, the figure of the risen Christ, which is of copper faced with oxidised silver. The figure stands on a serpent of black oxidised copper with mother-of-pearl enrichments and red beady eye. Altar frontals were worked by the sisters Clewer. It is unfortunate that the reredos has some resemblance to a dressing-table; which brings out again the difficulties of translating elements developed in domestic work to other spheres.

The system of ornamentation developed by the followers of Art Nouveau involved great use of natural forms out of which they tried to evolve a new language of ornament and decoration. For a scheme such as this at Warley, this symbolism of living growth was undoubtedly appropriate provided that it could be adapted to ecclesiastical requirements. In carrying out this scheme the team of designers seized the chance of demonstrating the potentialities of their idiom.

In hoping to show that here was a new style capable of universal application in the new century they were due to be disappointed; for by 1906, when all was complete here, Art Nouveau was a spent force. It had been truly an international style in that Europe of open frontiers, but by 1910 we in England had returned to insularity. Its unorthodoxy had made it expensive in time and labour, both in invention and in execution. Its medium was the skilled handcraft worker (often amateur and sometimes female) to whom leisurely conditions alone were amenable. The thought of machine-made approximations to their work was abhorrent to them. It was no lazy man's style, and no plagiarism, however selective, from the best measured drawings was enough to carry it on.

Trouble was met early on when it was felt that the light coming from the windows on the south side of the choir upset the balance of the scheme by reducing the dominance of the bright silver figure. To rectify this it was thought fit to block these windows. The original windows were removed and are now in the north wall of the chapel at Brentwood School. They were replaced by plain leaded

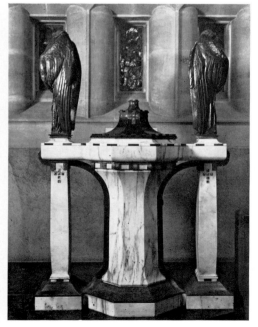

4. The font, designed like most of the interior fittings by William Reynolds-Stephens.

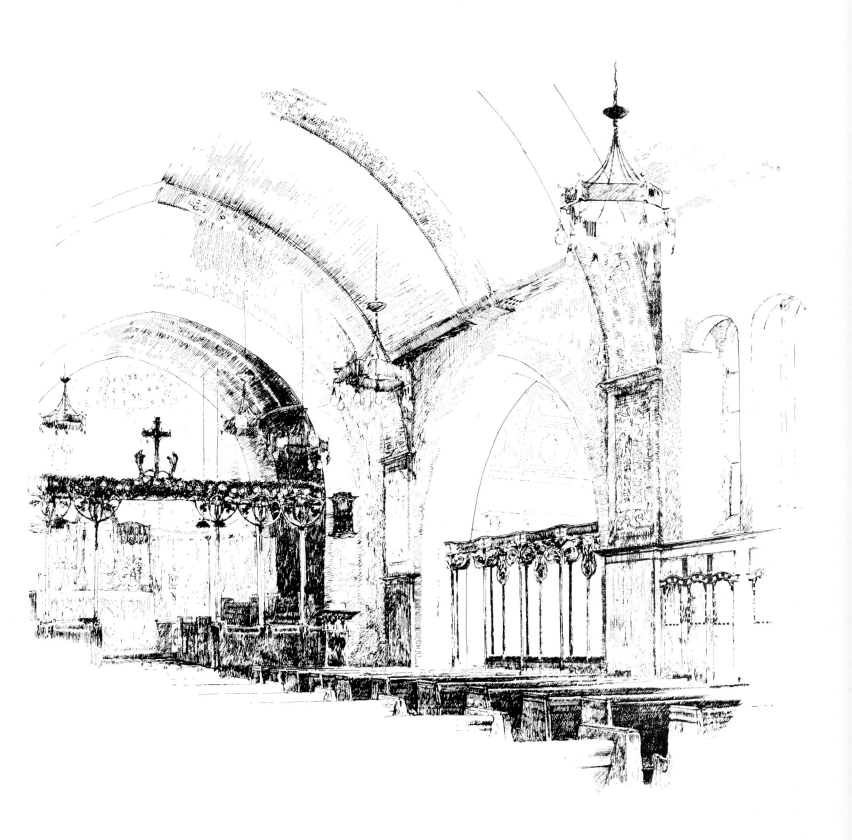

5. *The interior looking east.*

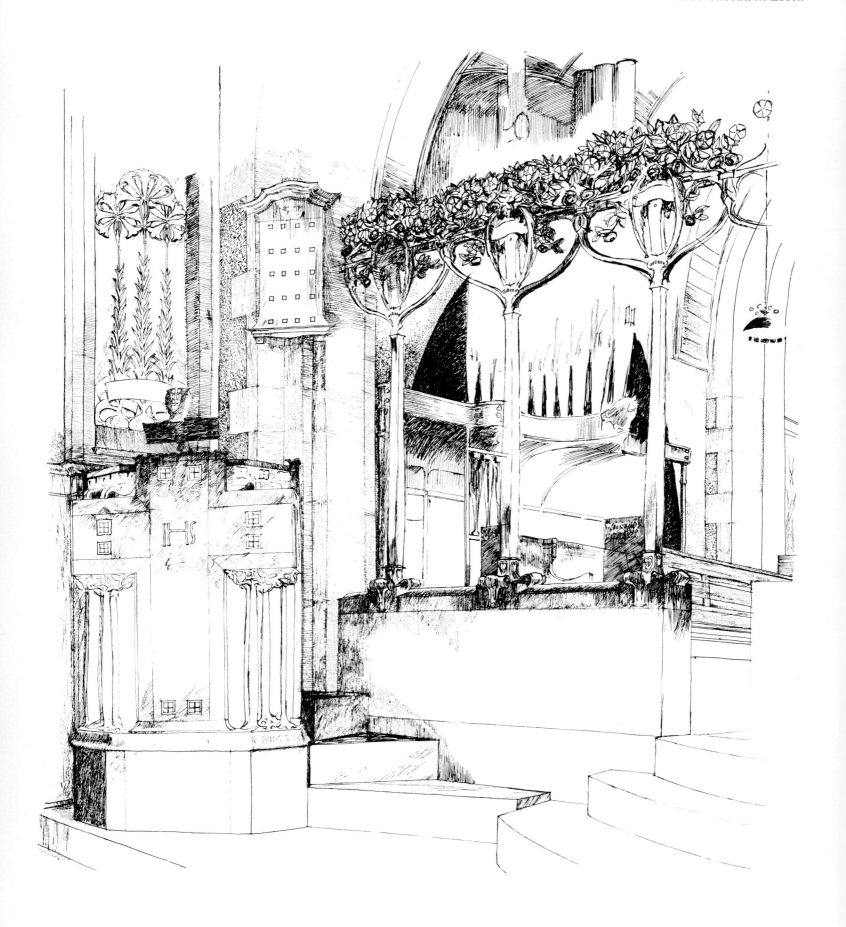

6. *The chancel screen and pulpit.*

lights and the window area was covered inside with a painted panel.

The result is not altogether satisfactory when compared with early photographs taken before the blockage. It is not as easy now to appreciate the detailing of the chancel screen and choir stalls. The obstruction of light has, however, preserved for us the original hangings to left and right of the organ console. The design of each is a single tall stemmed growth rising from a heart. One stem is crowned with holly leaves and berries and the other with rose leaves and flowers. All is in pink, pale green and buff embroidery on a deep blue ground. The holly berries are large red beads and little white beads form the flower sepals. The treatment of the organ is, I think, one of the less successful effects in the church. There does not seem to be a unifying idea here. The organ pipes are displayed. To have hidden them behind a grille would have been too easy a solution perhaps. (Maybe there was conflict with the organ builders.) Anyway, the pipes are, as it were, held back by steel bands which have heart-shaped accents of colour in red glass applied to them. There is also one small angel, like a gilt moth, over the console. The former bright steel bands have tarnished; a rare lapse in this scheme in which such care was taken to choose materials that would last or even improve with age.

There are few painted surfaces inside or out. The surrounds to the lily pilasters are stained (green, of course), and the ceiling panels of the side chapel are painted, and that's about all. Early photographs show the ceiling panels unpainted, but I hardly think they were long in that condition. At that time the wall panelling between pilasters was not yet in place. For the time being there were hangings on the nave walls – all rather like a Baillie-Scott interior. The hangings were in blue and buff. The panels which replaced them have as their crowning mould that persistent motif which is found in all sorts of Edwardian Architecture from the Neo-Wren to the Art Nouveau.

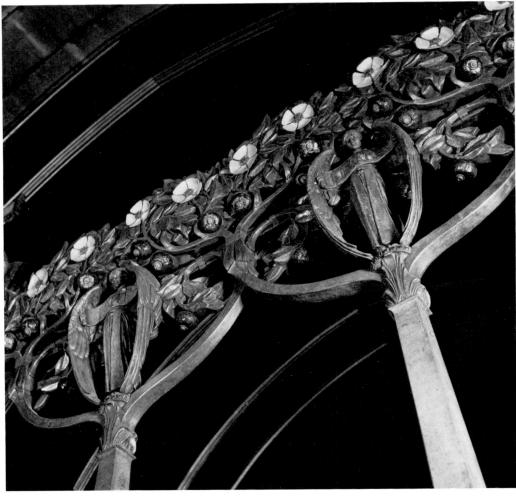

7. Detail of the chancel screen.

165

With their inlay and marquetry work, too, the panels are like the back of the chair designed by Ambrose Heal for Joan Drummond Angus which was exhibited in 1952 at the Victoria and Albert Museum in the exhibition of Victorian and Edwardian Decorative Arts. The bishop's chair and one of the brass candelabra from Warley also went to that exhibition, and were in the section dealing with Edwardian Ecclesiastical Design. These candelabra are similar in shape to the single shafts of the chapel screen, but with modelling of the feet like those of the chancel screen. Harrison Townsend's joinery is everywhere excellent, precise yet robust. The pew ends are most uncommon, with billowing outline and pleasingly quirkish mouldings. The choir stalls are more angular in outline with ornament used in that taut and purposeful way so typical of his work. The brittle leaf ornamentation is markedly similar to that at the Whitechapel Art Gallery.

A principle of design thoughout at Warley seems to have been to keep to the customary elements of church architecture, but to detail them in such a way as to engender surprise only after closer examination. This was a common feature of Art Nouveau work, which so often appears eerie and also has a queer hint of cruelty (all quite unintentionally I should imagine). Can it be due often to the use of plant shapes assembled in an unnatural or symmetrical manner? Take, for instance, the side chapel screen, perhaps the most completely Art Nouveau item here: it has some of this quality, finely wrought, a conventionalising of the forms of the oriental poppy though we know it to be. Once the curious assemblies within the outlines of such work have been revealed, the appearance of the whole to the observer becomes transformed and what has earlier seemed no more than tracery is now seen as an assembly of grimacing faces or menacing forms in the way that overpatterned wallpapers may appear so to a fevered child. This sportive detailing

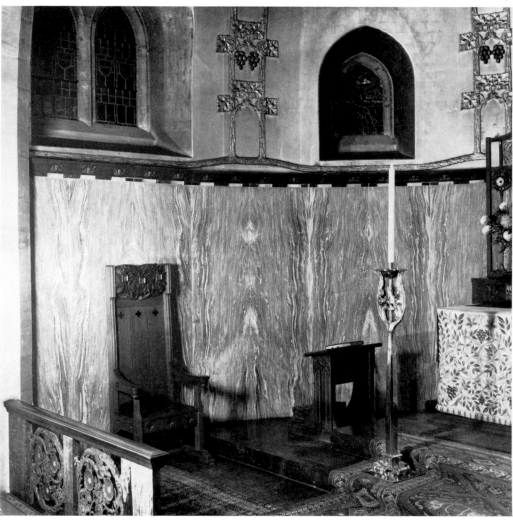

8. The sanctuary.

166

within basically conventional outlines is also evidenced, though not in as extreme a manner, in the handling of belfry, west end, porch and lych-gate.

Then again, Reynolds-Stephens's pedestal statues of children, his 'Castles in the Air,' for instance, are delicate and finely wrought, if sentimental, pieces. His angels here are all that, but have a more haunted Arthurian quality. They, too, are dressed as for Rossetti's Florence. It is in their silhouettes not their detail that strangeness is apparent. The quotation from James Stetham's description of the painting 'The Wedding of St. George' quoted by Ford Maddox Hueffer in his book on Dante Gabriel Rossetti evokes an atmosphere that is present here in some measure.

'One of the grandest things, like a golden dim dream, love credulous all gold; gold armour; a sense of secret enclosure in "palace chambers far apart"; but quaint chambers in quaint palaces, where angels creep in through sliding panel doors and stand behind rows of flowers, drumming on golden bells with wings crimson and green.'

There is a whole choir of little angels in this church, each with six wings as in Isaiah's dream. They appear on the memorial tablet to Arnold Haseltine, on the alms box, on the hymn boards and round the dado of the apse. The belfry has a tinkling carillon. When it plays all becomes so other-worldly that the church can easily be imagined to have walls of brown bread and pineapple chunks and a gingerbread steeple.

The design of the original windows was subordinated to the theme of the whole scheme of decoration. With them, the jewel-in-setting principle was used, by having only incidents of colour in surrounds of plain glass. The apse windows (which have survived and are Whitefriars glass made by Hogan) are themselves jewels in the setting of the whole aluminium apse. The original glass in the chapel window represented 'The Tree of Life' and repeated the root, tall stem, band of foliage with flowers, motif. It was all lightly handled.

The replacement, full of red-robed angel figures (the designers of the replacement windows have taken up the angel theme and worked it to death) is overpowering in this setting of subtle colourings. There are robed figures, two kneeling, one erect, in the three lancet windows now in Brentwood School chapel. They,

9. Detail of the screen to the side-chapel.

10. Base of organ console, with embroidered hangings.

too, are red, against a background of green foliage and blue sky with white stars; but figures and their coloured backings have been kept to small panels in the centre of each light. The rest is mostly plain glass. These windows were designed by Heywood Sumner (who had worked with Townsend at All Saints', Ennismore Gardens). Heywood Sumner also designed the apse windows, the original windows in nave and chapel and the rose window in the west gable. (None of these survive.) The original glass in the seven small windows behind the font was by Louis Davis.

In the account of the work at Warley in *The Studio*, which I quoted before, is written:

> 'By juxtaposing surfaces of stone, wood and metal by relieving salient features in the architectural design with overlaying of metal and with subtle touches of colour, and by contrasting different coloured marbles one with the other, and with details in brass, steel or copper, a charming shimmer of delicate tints has been produced in which nothing is out of line or right relation and in which the necessary accents tell to their full value. Moreover, by this use of natural materials the permanence of the whole scheme is assured. There is no fear that time or wear and tear will upset a carefully devised arrangement by establishing unexpected colour relations or by dulling into invisibility what were intended to be the keynotes of the harmony.'

If it had not been for the wartime loss of the glass, we would still have that carefully devised arrangement. The presence of 'temporary' clear class in some of the windows harms that arrangement little. With such a completely conceived scheme, it becomes essential that all should remain as its authors intended. Just as in its programme as a memorial it was required to emphasise life and resurrection (a mental embalming in fact), so the building, to preserve its impact, has also to be embalmed. The 'culture' in which the building is raised has to be preserved or the illusion will be shattered.

11. The lectern.

WATTS CHAPEL

by Elisabeth Beazley

The little-known building described below, with the help of drawings by John Furnival and photographs by Eric de Maré, is one of Britain's few surviving monuments to the ideals of the Arts and Crafts movement; a chapel at Compton, Surrey, designed in 1896 by Mary Watts, wife of G. F. Watts, R.A. One of its surprising features is the gesso-work that covers the whole of the interior, modestly described by Mary Watts as 'glorified wall-paper'.

Buildings can arouse all kinds of emotion: admiration, awe, derision, depression, amusement . . . For straightforward astonishment it is unnecessary to go further than Compton, Surrey. On the altar in the Watts memorial chapel, an inscription states 'This chapel, designed by Mrs. Watts, wife of G. F. Watts, O.M., R.A., was built in 1896 by her and the people of Compton.' This alone would be enough to whet the curiosity, but when seen in its context further information about this remarkable building and its builders becomes imperative. For, instead of being homespun, amateur or earthy, as might justifiably be expected from such a description, it is an expert, highly successful if unusual realisation of a unique idea. It also forms part of an interesting (historically rather than architecturally) group of buildings which must be one of the few remaining monuments in brick and mortar to the ideals of William Morris and the Arts and Crafts movement.

Towards the end of his long life, Watts,[1] who for many years had been the grand old man of British painting but who was still working at a furious rate, decided to leave London for Compton. It would be truer to say that Mrs. Watts decided; this remarkable woman apparently had the happy knack of not only making the right decisions for Watts, but of also being a charming and sympathetic wife. Thirty years younger than her husband, Mary Watts seems to have provided the energy and drive which were behind the creation of Limnerslease, the house which they built in the depths of Surrey.

Both the Watts's were deeply fond of this wooded country and spent prolonged stays with friends here, but Watts, who was now in his 70s, was fussed by visiting. His special diet (under-cooked beef and fresh cream), the fear that he might be ill while away and cause further inconvenience to his hostess and, above all, the paraphernalia of packing and unpacking, worrying about missing trains (all of which time and energy might have been spent painting) must have made things difficult for everyone. Therefore, Limnerslease was the perfect solution. So perfect that the Watts's soon left London altogether and made it their permanent home. This meant that in addition to the studio, a gallery must be built to house Watts's paintings. Of these buildings there is not much to say architecturally; the house with its mock timbering was in the vanguard of thousands that have since come to Surrey. It has a fine site high above the other buildings; it must have been a pleasant place to live in, being so closely surrounded by, yet above, the trees (the Watts's apparently would not allow a single tree to be felled when the house was built). It was designed by Sir Ernest George and is now converted into flats.

The house, which is about half a mile north-east of Compton village, decided the siting of the gallery and potteries and hostel for potters that were to follow it. This was most fortunate, as the group forms a separate entity and does not compete with the old village and the remarkably fine Norman church. The pottery (which only ceased to function in the 1950s) was another of Mary's ideas, although closely backed by Watts. She had run a pottery-class for workers in Whitechapel. The idea of training the locals crystallised when a new burial-ground and mortuary chapel were needed for the village. This is best described by Mrs. Watts in her *Life of G. F. Watts*[2]: 'A new interest had grown up for us both in the last two years, the building of a chapel for the new village burial ground, his gift to Compton. He did not design it, but suggested that if we proposed to hold a class, the people of Compton

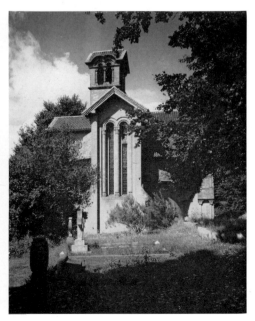

1. The exterior, of hard red brick roofed with Roman tiles.

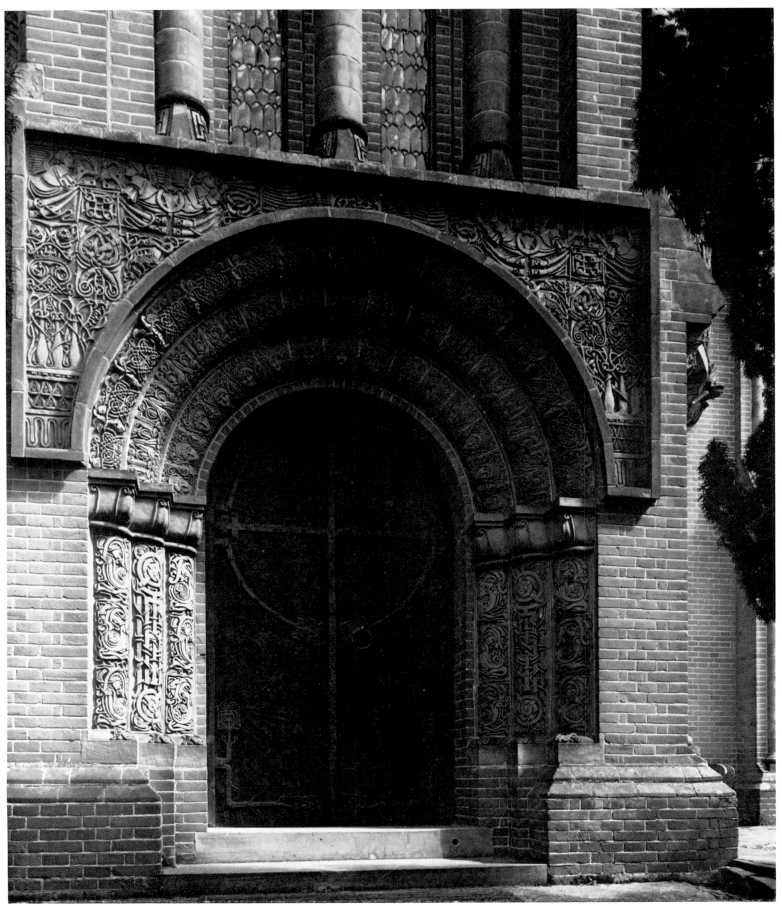

2. The richly decorated main doorway.

might like to come to it and be taught to make simple patterns to decorate the walls; so that by this means a special and personal interest in the new graveyard would be acquired by the workers.'

This mild description and a slim volume called *The Word in Pattern*[3], also by Mrs. Watts, are all that is known to have been written about this remarkable chapel. Far from being amateurish, it is a building of remarkable expertise, not only in execution, a factor which could be attributed to the skill of the builder, but in the assurance and mastery with which the complexity of the original idea has been disciplined so that the parts never detract from the whole. At the end of *The Word in Pattern*, a list is given of those who had worked on the chapel (seventy-one men and women worked on the terra-cotta; often several members of a family are mentioned), but the only designer mentioned is a Mr. George Redmayne who was responsible for the door-hinges. From this it seems reasonable to assume that Mrs. Watts designed the building without professional help.

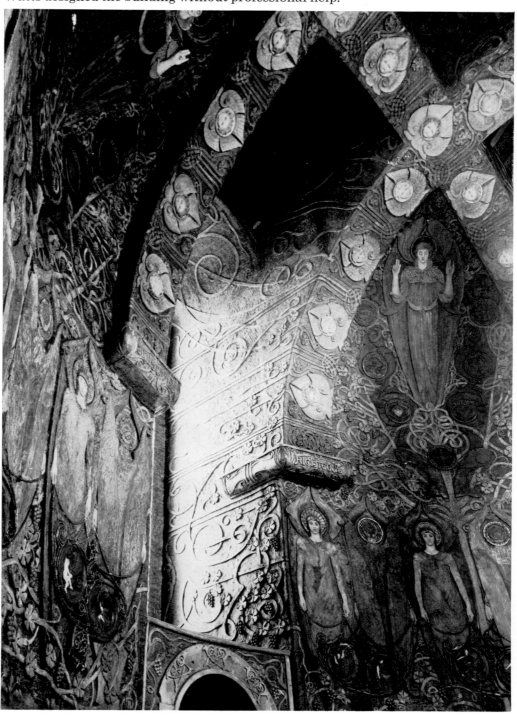

3. A detail of the elaborate gesso-work that covers the whole interior, described by Mary Watts as 'glorified wall-paper'.

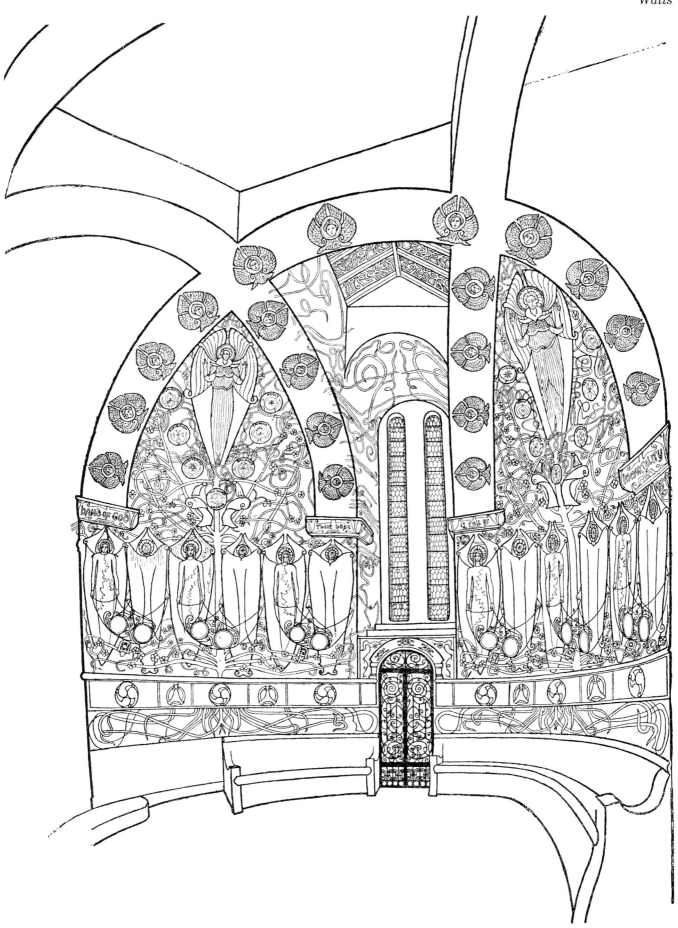

4. A drawing of the interior by John Furnival.

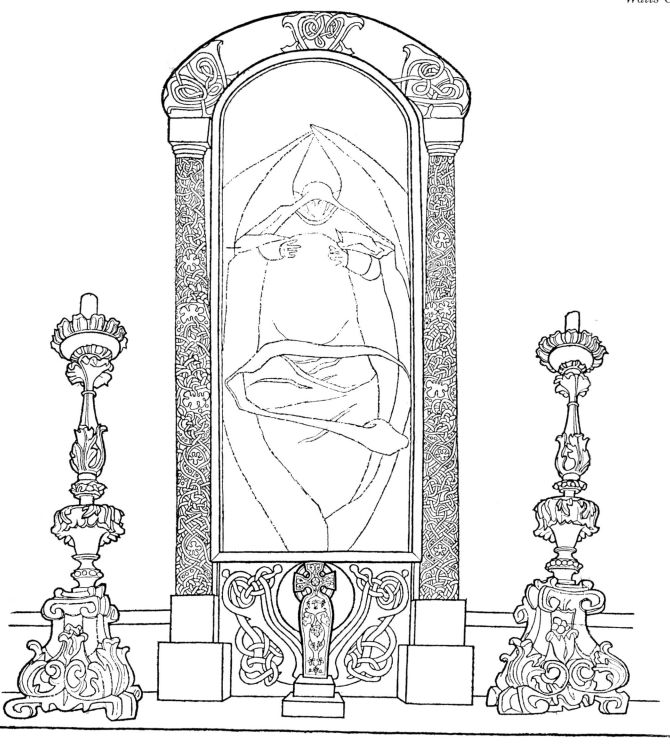

5. The altar, facing the main doorway. Above it is a smaller version of Watts's painting 'The All Pervading', and along the edge of the altar slab is the inscription: 'This chapel, designed by Mrs. Watts, wife of G. F. Watts, O.M., R.A., was built in 1896 by her and the people of Compton.'

The chapel stands on rising ground looking across meadow-land to Compton village. It is approached from below up a narrow curving path which is lined by black Irish yews. These trees hide the building until you are almost upon it, and this, together with their blackness contrasting with the very red brick of which it is built, add drama and surprise to the approach. The bricks, which were made locally, may also have been a surprise to Mrs. Watts who, if one can judge by the other buildings, favoured mellow materials. They still look as if fired yesterday and have the texture and colour of a recently rubbed rubber-brick. This is an advantage because much of the building is faced by terra-cotta mouldings, and these, which naturally will not weather, and the plain brickwork, have remained approximately the same colour, giving the wall surfaces a unity that would never have been retained if a normal brick had been used.

Since it is a small building, whose surface is deeply broken by shadow, the green English countryside can take the shock. The roof is covered with Roman tiles. It is probably these, and perhaps the yew trees which stand as sentinels as cypresses do in Greece, rather than any architectural style, that makes the exterior slightly reminiscent of a renovated Byzantine church (e.g. those in the fortress of Mistra.)

Approaching from below, one is right up to the door and already too amazed by the galaxy of angels and symbolism in the terra-cotta over the door to pause before plunging inside. The impression is of being inside a circular building with massively thick walls and, fleetingly only, of a domed ceiling. Colour and low-relief pattern cover almost every surface, and an extraordinary richness is achieved. It is a mixture of Bavarian Rococo and Art Nouveau with colours taken from the sea bed. The light, coming in at high level and catching remnants of the gold on blue-green

6. The main roof supported by four arches; timber rafters outside the crossing.

7. Low relief decoration, built up in plaster and string.

paint, deepens the illusion of being in a pool of clear water.

But these are impressions only. What has in fact been most ingeniously designed is a cruciform plan on which is imposed a thin drum of 13½ inch brickwork, approximately 24 feet in diameter. The arms of the cross project 6 feet 2 inches beyond the drum, and rise the full height of the building, while the drum is only about two-thirds the height of the main walls (for this reason, the projecting 'transepts' cannot be thought of as buttresses). The window openings are in the end walls of the cross. The impression thus given to anyone inside the building is of immensely thick walls, since the window reveals are the full depth of the arms of the cross from its extremities to the inner surface of the drum. This ingenious if unintentional trick seems an economic way to give apparent weight of masonry with minimum material.

The roof is simply a cross-ridged structure supported on four semicircular arches where the drum cuts off the walls where it meets the cruciform. There is clearly no excuse for imagining a dome, even if the building was entered blindfold with no awareness of its outer form; however, the circular plan of the interior, together with the round arches decorated in the same material as the walls, gives this fleeting illusion.

8. Terracotta decoration on the upper part of the exterior of the drum, which fills the angles of the cruciform plan of the church and gives the interior the effect of a circular building.

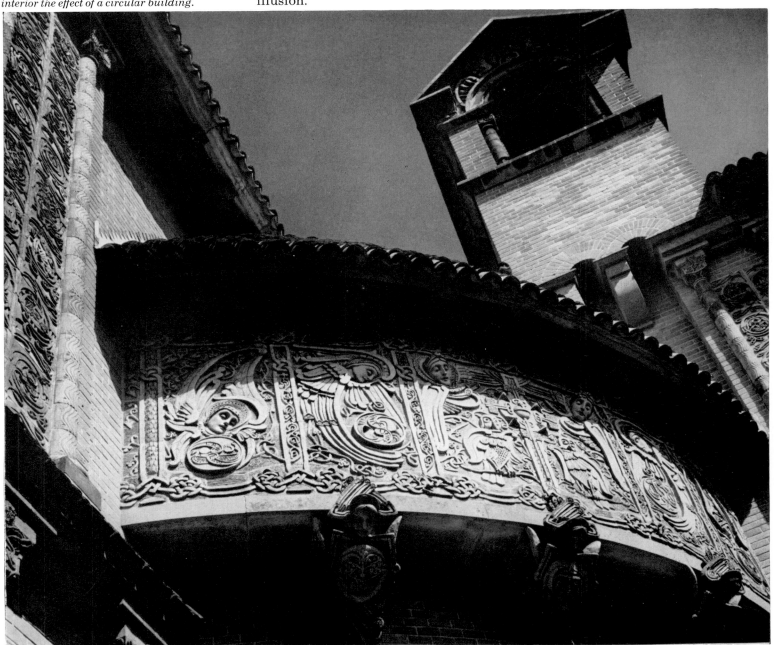

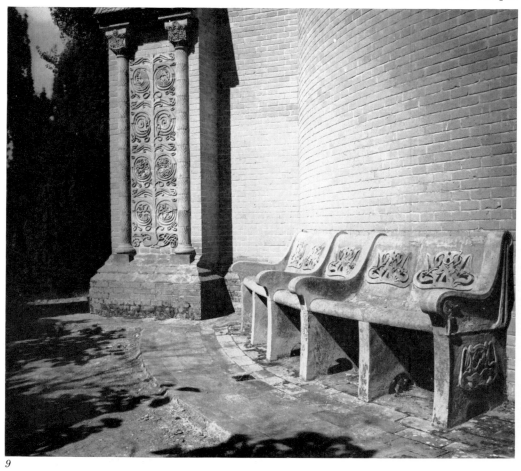

9

9. The seats along the outside wall of the chapel, designed and made in the Watts workshop.

10. The cloister.

10

The decoration of the interior suggests a woven tapestry. It may have been inspired by Watts's saying: 'All creation is the garment of God'; certainly all parts of the design were of deep significance to its creator. From the stone seat that runs round the inside of the building upwards, every inch of the interior is decorated. Angels, medallions, children's heads, take their place in an orderly but flowing design of abstract strap patterns of Art Nouveau, in low relief. 'A solid plastic material called Gesso, its substance plaster of Paris in which a fibrous material is soaked' was the medium in which Mary Watts worked. In places the fibre (like string) has been built up to give reliefs up to $\frac{3}{4}$ inch deep. This depth gives pattern and life even where the actual paint has faded, and the richness achieved is remarkable. It is sad that the only drab thing about the chapel is the picture specially painted to go above the altar. It is a smaller version of Watts's 'The All Pervading' and badly needs restoring. Mary Watts's modest comment on her astonishing

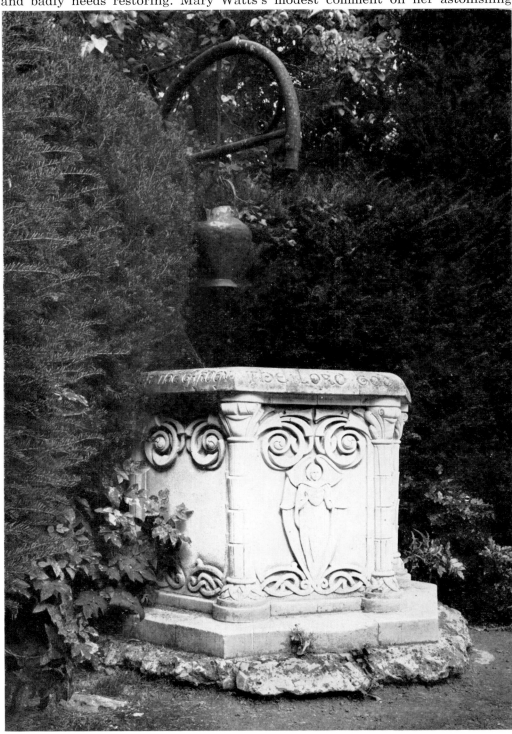

11. A terracotta well-head near the gate; also a product of the Watts workshop.

achievement is 'He (G. F. Watts) had not before realised what I aspired to do in this glorified wall paper.'

The decoration of the exterior is extremely complex and is based largely on Celtic patterns. Almost every design is symbolic, and anyone wanting to study it in detail should refer to Mrs. Watts's explanatory book. It must be one of the last great craft efforts; each piece of terra-cotta has its special significance and few if any are alike (each of the fifteen angels over the door, to take but one instance, has a different face). But what really astonishes is the organised restraint which has prevented this highly imaginative Victorian woman running riot with terra-cotta; the drum, apart from the corbelled frieze, and a large part of the projecting cruciform are built in plain brickwork. In other words, the walls are either highly decorated or completely plain. In this it has something in common with the exterior of Seljuk buildings, whose decoration is so intense that it can only be taken with large areas of plain walling as a foil. The bricks, incidentally, are only $1\frac{3}{4}$ inches deep; the small scale thus achieved gives the impression of a larger building.

In the graveyard there are a number of graves made by the potteries, and also a cloister (very inferior to the chapel). The hostel where the non-village potters lived is now the curator's house. Both it and the Gallery[4] (designed by Christopher Turner) were originally thatched. The Gallery contains a large and varied collection of Watts's paintings. That they are varied is hardly surprising when it is remembered that he lived during five reigns, including the longest in British history, and worked with extraordinary energy through most of them. The fascinating paintings (all by Watts) range from what might well be late eighteenth-century portraits onwards to early twentieth – Picasso was already twenty-five when this child of George IIIs reign, friend of Ruskin and sculptor of Tennyson, died.

NOTES

[1] For biography of G. F. Watts see *The Laurel and the Thorn*, by Ronald Chapman (Faber & Faber).

[2] Published by Macmillan.

[3] Published by the Astolat Press.

[4] The Gallery is open to the public. Compton is about two miles west of Guildford.

THE BLACK FRIAR

by Nicholas Taylor

If the church and chapel described in the preceding essays are unique examples of ecclesiastical architecture, the building discussed below (with photographs by Eric de Maré) is equally unique among public houses. Its interior, rich in sculptured and other ornament, represents a highly successful attempt to create a popular version of the Arts and Crafts decorative style.

Burne-Jones's unlikely kinsman, Stanley Baldwin, called William Morris 'a great, glorious, jolly, human being.' Yet Morris's conviviality – the hearty quaffing of ale which distinguishes him from many left-wing heroes – is less often expressed in his own work than in that of his followers, who enjoyed merry evenings at the Art Workers' Guild in Queen Square. Perhaps the only building in London where it can now be savoured fully is that extraordinary pub, the Black Friar, at 174 Queen Victoria Street, London. An innocuous Italianate block of *c.* 1863 was transformed into a luscious folk-fantasy in about 1905 by H. Fuller Clark, an otherwise unknown architect, and Henry Poole, the sculptor, who was Master of the Art Workers' Guild in 1906. The client was a licensee named Petit.

The result of their collaboration is a priceless work of art, now in the midst of an area 'ripe for development.' The Black Friar should not only be preserved but should be carefully looked after; there are already ominous signs of pilfering and decay in the decor, which has lost some of the original sparkle. Its isolation from the main centres of Arts and Crafts (Chelsea, Kensington, Hampstead) makes it all the more vulnerable.

The Black Friar stands on a narrow triangular site backing on to the railway and overlooking the Blackfriars traffic crossing. The ground floor respectfully continues the mullion-transom grid of the three upper floors, with smooth courses of pink and grey granite and dressings of Portland stone. In detail, however, it displays the familiar chunky forms of English Art Nouveau: in the massive flanking piers of the segmental doorways; in the neat arcaded vents to the cellar; above all, in the sculptural enrichment which offers some foretaste of the thrills within. The doorway next to the bridge has a mosaic tympanum of a black friar and two massive entablatures carved with beasts and devils. The deep mosaic fascia says 'Saloon Bar/174/The Black Friar/174/Brandies'. Small copper panels, of pointing friars, some sober, some less sober, direct the visitor to the Saloon Bar down the alleyway to the left. (The panel shown in the photograph has since been stolen.)

Curiously, the public and private bars on the main corner never received their decoration, except for a uniform cladding in strips of yellowish brown and green marble. The Saloon and Snack Bars, largely tunnelled in vaults beneath the railway, possess all the crammed delights of Poole's work.

Customers in the Saloon Bar can retire from the usual marble-topped bar to the deep, enriched fireplace recess, framed by a broad tripartite arch, which encloses corner seats. Within the general wall pattern of brown and green marble, the fireplace itself is surrounded by dark varnished wood. It has a copper canopy and firedogs surmounted by little devils; the red and green marble surround has a polished copper keystone; the overmantel has a bronze bas-relief of singing friars entitled 'Carols' and is flanked by two friars' heads with swags representing 'Summer' and 'Winter.' There are two splendid gas-lamp brackets of copper. The wooden wall-clock nearby has a bronze relief of two monkeys playing musical instruments and the inscription, 'Tone Makes Music.' In the entrance wall is a stained glass window of a benevolent friar in a sunlit, walled garden.

Dominating the room are two large bronze bas-reliefs. Over the bar, above the caption 'Tomorrow will be Friday,' five friar fishermen hand in a catch of trout and eels to six other greedily expectant friars. Over the three richly marbled

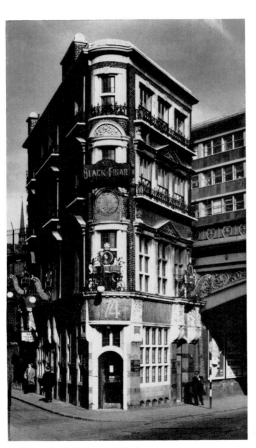

1. The Black Friar public house on its narrow triangular site alongside the railway bridge at the foot of Queen Victoria Street, London.

arches to the Snack Bar is 'Saturday Afternoon,' an equally graphic portrayal of nine friar gardeners, whose produce – grapes, melon, onions, roses – is enamelled in realistic colours.

Because the ceiling is a disappointingly ordinary beam and plaster layout, the Saloon Bar fails to cohere. The Snack Bar, however, is a complete jewel house. The three-bay barrel vault, on its gold, white and black mosaic, has large geometrical medallions and copper friars' heads. Against the end walls are two bronze reliefs: 'Don't advertise, tell a gossip' with a group of friars doing the weekly wash, and 'A good thing is soon snatched up,' with friars pushing a trussed pig in a wheelbarrow. Four little devils, representing music, drama, painting and literature, perch on the cornices below.

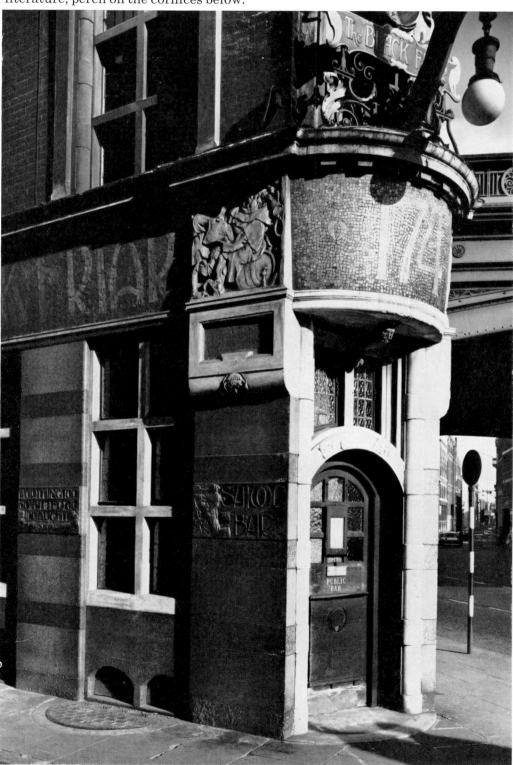

2. Doorway, displaying the familiar chunky forms of English Art Nouveau.

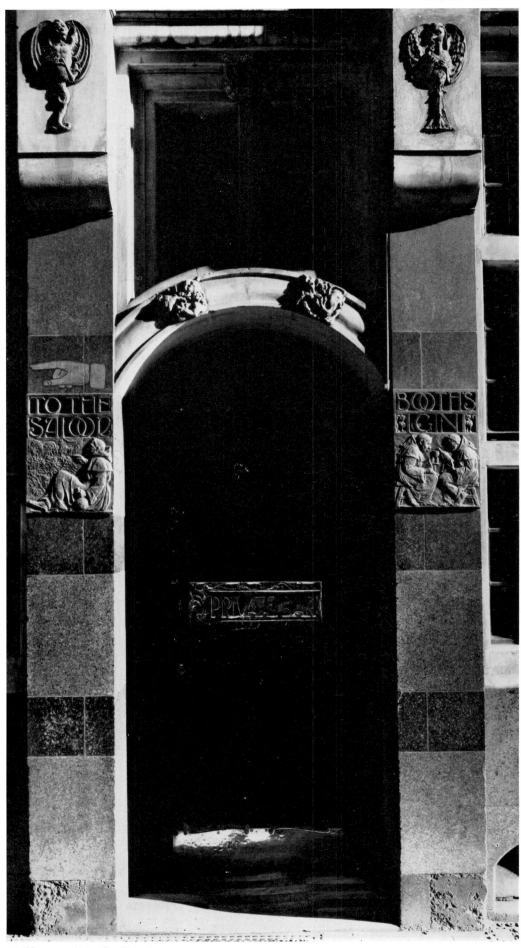

3. *Close-up of pier flanking doorway.*

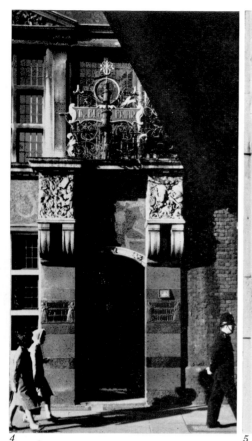

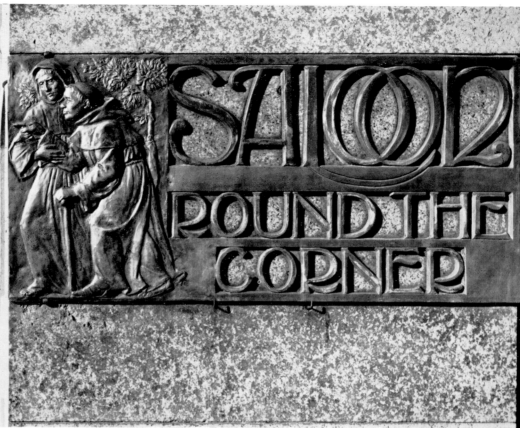

4

5

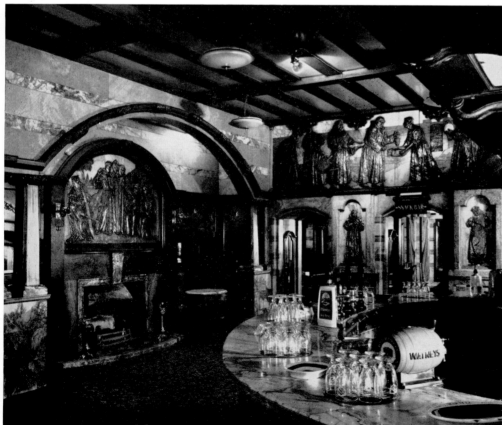

6

7

4. *Another doorway, almost under the bridge.*

5. *Copper panel on an outside wall directing customers to the saloon-bar entrance.*

6. *Inside the saloon-bar.*

7. *Copper gas-lamp bracket in the saloon-bar.*

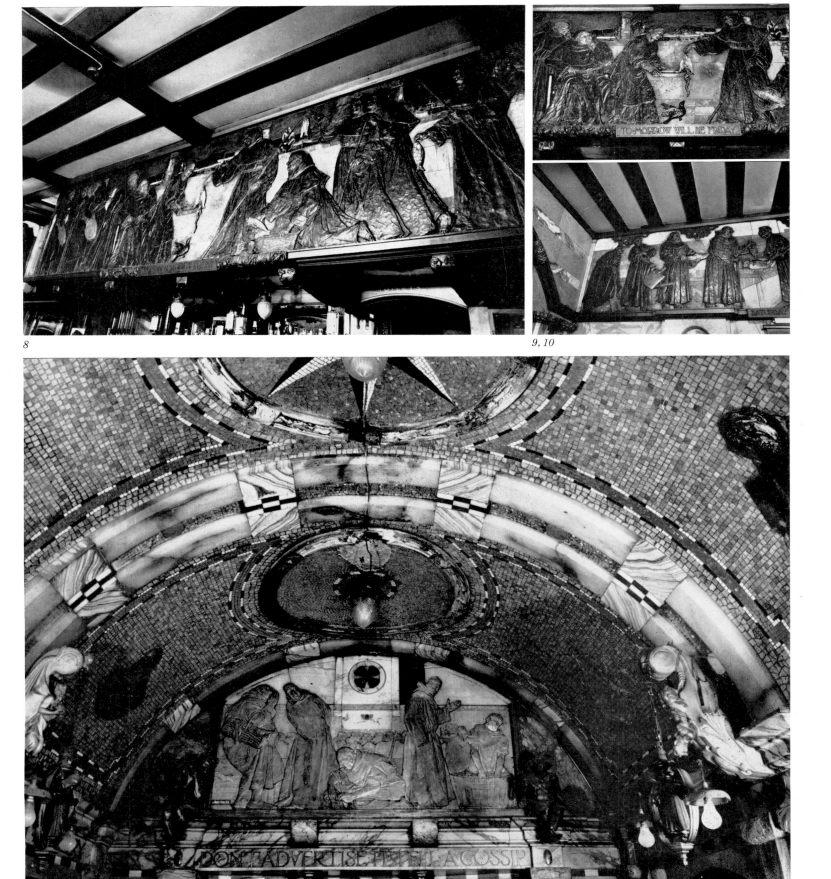

8

9, 10

11

8, 9 and 10. Bronze bas-reliefs in the saloon-bar.

11. Mosaic ceiling in the snack-bar, with bronze relief on the end wall.

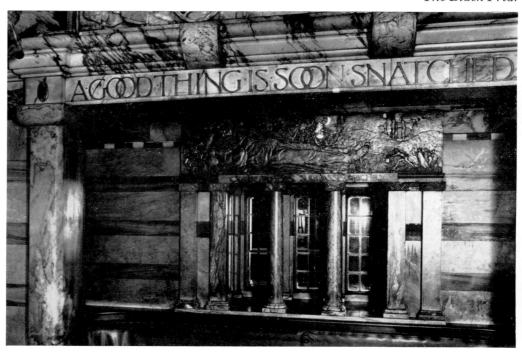

12. Recess at the end of the snack-bar, with marble and bronze decorations.

The side walls are an incredible display: six alabaster capitals illustrating nursery rhymes; sixteen smaller capitals showing animals in odd situations (a frog attacking a mouse, a snake with a sword in its mouth); nicely lettered mottoes such as 'Haste is slow' and 'Finery is foolery'; and four fantastic lamp brackets with alabaster figures of Morn, Even, Noon and Night holding up a bronze friar with water buckets.

Best of all is the extra recess at one end containing a splendid relief of a gross, paunchy, sleeping friar, surrounded by Lilliputian fairies, one with mother-of-pearl wings. The 'window' below, with red marble colonnettes, is merely an arrangement of mirrors. This tunnel-like room is artificially lit throughout; the ventilation holes are boldly expressed on the end walls.

The Black Friar is genuine pop art of its time. The Arts and Crafts admiration for the hand-carved bestiaries of misericords is combined with parody on an intimate scale of all the current raves: the Byzantine splendours of mosaic taught in Lethaby's book; the gross exploitation of marble typical of Harry Wilson; the mother-of-pearl butterfly pinned to a marble wall (Whistler); niches and mirrors derived from Leonard Stokes; swags and cherub-heads (neo-Wren); the combination in 'Carols' of exotic landscape (Italy) with the type of musical instruments used in English country churches in *c.* 1800 (Cecil Sharp).

The real success of the Black Friar is that, like the best contemporary coffee bars, it reinforces vividly the popular prejudices of its customers. The decorative theme was chosen by Petit and Poole because the pub stands on the site of the City's medieval Dominican church. They then exploited the love-hate relationship between ordinary Protestant Britons and the Roman Church. It is the same suspicious fascination with Rome that is shown in Browning's 'Soliloquy of the Spanish Cloister' and in the extraordinary vogue for 'Cardinal' paintings, in which gorgeous red-cloaked prelates were seen scheming and gossiping and enjoying such fruits as celibacy still afforded. The same line in Chaucerian comedy – the knowing grins, the vast paunches (in bas-relief!) – is pursued relentlessly by Poole in the Black Friar, which is probably the only pub of its type in the country. The reason for its uniqueness is of course that breweries and licensees were philistines; the Arts and Crafts patrons were usually the 'progressives,' who believed in temperance reform and preferred to build coffee houses (such as Sir Ernest George's at Newark and Sir Thomas Jackson's at Sevenoaks).

THE GLASS PARADISE

by Reyner Banham

This essay, and the two others that follow it, move on from the Art Nouveau period and its related manifestations, with which the preceding essays in this collection have been mainly concerned, and deal with other revolutionary episodes and personalities that came after and led eventually to a new rationalism and to modern architecture itself. As research into the motivations of modern architecture proceeds, unacknowledged pioneers are being brought to light whose contributions must be set beside those of the masters who have already been written into the record. Outstanding among the missing pioneers is Paul Scheerbart, a Berlin literary bohemian who died in 1915 and a man with a strong claim to be regarded as the true prophet of all-glass architecture.

1. Portrait of Paul Scheerbart, by Oscar Kokoschka, 1915.

The public were less surprised by Lever House[1] than was the architectural profession – and this was logical, for had not a massive body of opinion-making machinery been telling them, since the mid-'twenties, that modern architecture was just a lot of glass boxes? Architects, on the other hand, knew that between the glass legend and the concrete fact there was a great gulf fixed – a gulf forty years wide and as deep as the building industry.

In spite of near-misses like Gropius's *Faguswerke*, and any number of exhibition buildings, in spite of Mies van der Rohe, Lever House was still the first of the glass towers to realise a seminal concept that has lurked in the mind of the Modern Movement since before the First World War. The reasons for this extraordinary lack of phasing may be traced back to the Movement's own view of itself, and particularly to its tendency to try and tidy up its own history as it goes along.

The respectable genealogy of the glass legend is primarily the work of two men: one was Hermann Muthesius, father of the *Deutscher Werkbund*, who wrote in his *Stilarchitektur und Baukunst* of 1902 of the beauties of the Crystal Palace and the Galérie des Machines, station halls, covered markets, and most of the totemic objects of the glass dream – a pioneer re-assessment of the nineteenth century. The other is Sigfried Giedion, whose *Bauen in Frankreich* of 1928 related the architecture of his contemporaries back to Muthesius's canon of nineteenth-century masterpieces and interpolated, with great historical subtlety and erudition, a philosophy common to both. His contemporaries were, of course, delighted to find that they were following such distinguished precedents, most of which were unknown to them until they opened the book.

But if these precedents were, in practice, unknown to them, what precedents did they follow; what motives drove them? What, in fact, had been said and done to further the glass dream between 1902, when Muthesius pointed the way, and 1929, when Giedion's book was shortly followed by others, by e.g. Artur Korn or Konrad Werner Schulz, which dealt specifically and exclusively with glass in building?

One can point first to two respectable contributions, Meyer's *Eisenbauten*, before the First World War, and the *Ingenieur-bauten* of Lindner and Steinmetz after it, which both drew attention to buildings of the type originally praised by Muthesius, but were not particularly slanted toward glass. One sees also that Bauhaus teaching, and the example of the Bauhaus buildings in Dessau, must have turned men's minds in the direction of transparent membranes, even though Le Corbusier's first *pans de verre* were still, so to speak, around the corner of a white rendered wall. But in all these there is no sign of the singing tones of prophecy, the incantatory repetitions, that give a material those symbolic powers, over and above the recommendations of reason, that make it a live component in architecture.

It is to Germany, in the months immediately preceding and immediately following the First World War, that we have to turn to find that prophetic tone; to the period bracketed by the completion of the glass wall of the *Faguswerke*, late in 1913, and the second, 1920, glass-tower project of Mies van der Rohe. Both of these are accounted works of the party of reason, yet both, on examination, are found to have some curious cousins. Mies's glass towers have been justly called Expressionist, while their contemporaries, from Gropius's side, include the first Bauhaus proclamation with its gushing rhetoric about buildings 'like crystal

symbols,' and a three-spired Gothic cathedral on its cover.

All this is commonly written off as an aberration due to 'Post-war Berlin.' But if it was, then it was an aberration that gripped a generation, and must have more in it than meets the eye. In fact, there is a great deal in it, a great deal of the Modern Movement's disreputable ancestry, but as far as the glass legend is concerned, there are two dominant strains, both traceable back to the Werkbund's exhibition in Cologne in 1914. The importance of that exhibition for the glass dream is known, and acknowledged in every history by an illustration of one of the staircases of Gropius's office block in its glass hemi-cylinder. But that is only half the story.

There was also at Cologne for that exhibition a pavilion developed to the glory of glass exclusively, a pavilion that demonstrably had a far greater immediate effect on the imagination of German architects than Gropius's did, for sundry descendants of it can be identified in designs done after the war, including Mies's first faceted design for the Friedrichstrasse skyscraper. The pavilion cannot be comfortably fitted into the history of the Modern Movement – particularly if that history, like Giedion's, is slanted for continuity – because it is so wrong for its time: a primitive geodesic dome of steel and glass, raised on a drum of glass bricks containing staircases with glass treads and glass risers, a design imbued with the homogeneity and visual certainty that Gropius's office block so conspicuously lacks, even allowing for differences in function and form.

The Glass Pavilion was the work of Bruno Taut, and so far exceeds every other design from his drawing-board that one may properly enquire what lies behind it. The clue is given by Konrad Werner Schulz: it was *Paul Scheerbart gewidmet*, and this Paul Scheerbart was *der literarischer Vorläufer und Anreger moderner Glasarchitektur*. Now, the statement that the literary forerunner and instigator of modern glass architecture was Paul Scheerbart will probably come as a complete surprise to English-speaking readers and to many German-speakers as well. In German architectural literature his name is unknown outside the works of Schulz, Platz (two brief references in his *Baukunst der neuesten Zeit*) and some forgotten books by Bruno Taut. In English, there is a glancing reference in Giedion's *Walter Gropius: Work and Teamwork*, but not a word in *Space, Time and Architecture*.

The oblivion into which Scheerbart's name has fallen suggests – and how rightly – that he is not to be numbered among Modern Architecture's respectable ancestors. Handbooks of German literature, unanimously unaware of his architectural interests, record an almost spherical bohemian layabout – and Kokoschka's portrait confirms this – a fringe-member of the Futurist-Expressionist *Sturm* group, born in 1863 and dead in 1915, the author of fantasticated novels, mostly short and decorated by his own hand in Yellow Book style.

Many of these novels can best be described as contra-science-fiction, astral pantomimes, moon romances, astral novelettes and what-have-you. Beyond this, his output included appendices to the Munchausen legend, harem romances, an *Eisenbahnroman* that appears to be the pioneer of that genre of literature whose chief ornament is the *Madonna of the Sleeping Cars*, a 'Hippopotamus' novel (of which more in due course), and a telegraphic romance called *The Mid-Ocean Hay-fever Sanatorium*, in whose very title one perceives something of the vein of practical logic that runs through his one work specifically devoted to the arts of building, *Glasarchitektur*, published in 1914.

Dedicated, as one might have guessed, to Bruno Taut, it is a slim, soberly-presented volume, quite unlike his novels in typography and format, and runs about a chapter to a page – some of the chapters no more than single thoughts noted in a couple of sentences – for 125 pages. These chapters are only loosely connected, though not much more loosely than those of Le Corbusier's *Vers Une Architecture*, and like that work they expound an unpredictable mixture of uninhibited vision and sharp practicality. Both the vision and the practicality draw their strength from the things that Scheerbart knew at first-hand or had seen with

his own eyes – glazed verandas, palm-houses, public halls, searchlights, zeppelins, sanatoria, mirror-panelled café interiors, theosophist publications, the Cologne pavilions of Taut (explicitly) and Gropius (by inference), and much more besides.

The vision he offers is a compound of all these, torn from their contexts, and re-assembled by a mind unrestrained by conventional ideas and received opinions, but buttressed by a shrewd idea of what will, and what won't, work.

The vision of a glass world

'. . . as entirely delectable as the gardens of the Arabian Nights . . . a paradise on earth . . . we shall show no longing for the paradise of heaven'

begins with something that was common knowledge to Scheerbart and most of his readers, the glazed conservatory. This he envisaged becoming ever larger and more important until it had to be emancipated from the house and set up independently in the garden. The glass-world citizen then abandons his old house and moves into the conservatory, which is aesthetically linked to the garden (floodlit at night) by glass walls and screens that extend its structure into its surroundings. As a habitable environment, the conservatory-house, which Scheerbart seems to envisage as something like Taut's glass pavilion, has double walls of coloured glass carried in a reinforced concrete frame clad in mother of pearl or mosaic. Its floors are to be of coloured ceramic tiling, its furniture of glass with brightly enamelled steel legs and upholstery of glistening glass-fibre cloth. Artificial light is to enter the rooms from sources between the double-glazing, and from hanging lamps of oriental style; the heating is under the floor.

The landscape in which the jewel-like house and its floodlit garden are situated is to be a diffuse metropolis, with air-navigation beacons winking from the tops of its taller buildings. Illuminated trains, cars and motorboats, like blazing jewels traverse the night scene, while overhead, zeppelins, brightly-lit themselves and shedding light over the land, cruise toward an air-terminal in a park of experi-metal glass buildings, one of which is a hangar whose roof-space is occupied by an exhibition of models of historic airships, all with their own miniature lights ablaze. The shore line of the Swiss lakes, the outlines of the smaller Alps, are picked out in brilliantly-lit glass hotels, the summits of the higher peaks are floodlit in colour. Venice – or a new movable Venice – is a cluster of huge pyramidal buildings, glazed and illuminated and doubled by their reflections in the calm sea. Tourists, no longer hurrying from distraction to distraction, move calmly from the contempla-tion of one glass wonder to another.

About this vision certain things need to be said. Its inspiration was certainly personal – Scheerbart, it appears, was often poor, cold and miserable in squalid sur-roundings, and had an acquired hatred of the ill-lit and oppressive atmosphere of congested masonry cities. Hence the diffuse planning of the glass dream-world, the gardens and the greenery. Hence, too, the dedicatory motto he pronounced at Taut's Cologne Pavilion

Das Glas bringt uns die neue Zeit
Backsteinkultur tut uns nur Leid
(Glass brings us the new age
Brick culture does us only harm)

and his insistence that the 'metropolis in our sense' must be dissolved. But Scheer-bart, unlike some of the glass-enthusiasts of later generations, was under no illusion that glass was in itself a universal panacaea.

He had too much practical sense for that, and knew the weaknesses and side effects of its use. He knew that it was all too pervious to heat, and insists frequently on the need for double glazing. He knew also of the green-house effects it can produce, and insisted that glass architecture was for the temperate zones, and not the tropics nor the polar regions. He knew that his call for *Mehr Farbenlicht!* – more coloured light – that runs through the whole book, could only reasonably be answered when electricity was more cheap and plentiful than at the time he wrote.

When hydro-electric power came in, he prophesied, then even private persons would have floodlighting in their gardens. He knew from Taut that the making of convincing models of glass buildings awaited more tractable materials than the picture-glass and brass strip then in use, and looked forward to developments in transparent plastics (he names a forgotten proprietary product: *Tektorium*). Beyond that again, he looked forward to even better materials than glass for full-size buildings, and identified laminated glass (zwischen zwei Glasplatten eine Zelluloïdplatte) which had only just come in, as an example of what should be looked for from a lively and developing technology, for

'We stand at the beginning, not the end, of a culture-period.

We await entirely new miracles of technology and chemistry.

Let us never forget it'.

This optimistic view of technology puts him at one with the Futurists, whose works he certainly knew, and in this, as in his long-range prophecies, he is clearly of the party of progress, a member of the mainstream of modern architectural thought. Where he is conspicuously outside that mainstream is in the detail aesthetics of his vision. Whether or not he knew any Tiffany interiors, he certainly knew and admired individual pieces of Tiffany glass, and its aesthetics, notably the nuanced colours that he calls *die Tiffany-Effekte*, inform many of his visualisations. To this must be added an insistence on ornament based on mineral forms and vegetation – perhaps like Louis Sullivan's – and a strong strain of conscious orientalism that directs his thoughts on light fittings, cloths and fabrics, floor coverings, tile-work and so forth.

2. Bruno Taut's glass industry pavilion at the Werkbund exhibition at Cologne, 1914.

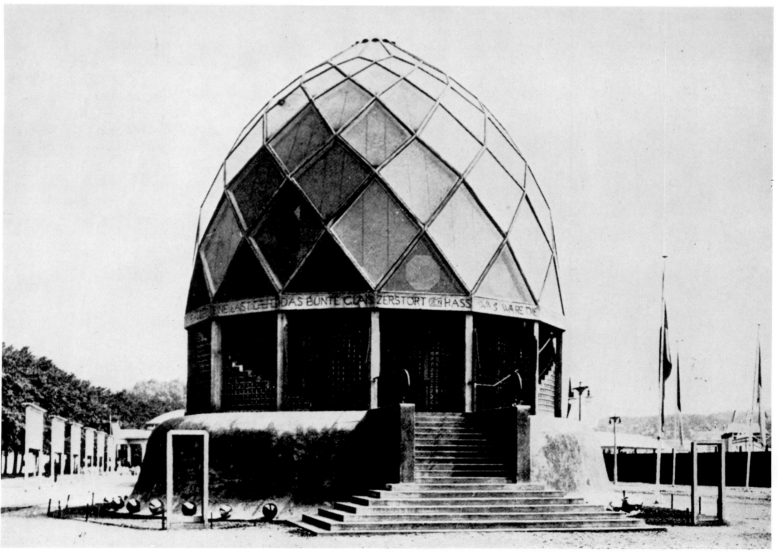

Here, in fact, we see him headed against the supposed tide of Modern Movement ideas.[2] As Charles Mitchell pointed out some time ago, the idea of good modern design for which we have settled is a profoundly classical idea, in opposition to the anti-classicism of much nineteenth-century thought. Scheerbart was no classicist, and for an entirely logical reason: *Hellas ohne Glas* – Greece without Glass. Equally logically he admired those cultures that delighted in coloured glass, in the Orient and in Gothic Europe. Equally logically again, he combated the classicist polemics of Adolf Loos (by implication if not by name) against ornament.

But – and still perfectly consistently – he also saw Gothic architecture as the true forerunner of the great glass and iron structures of the nineteenth century that he admired quite as much as Muthesius ever did, and in this linking back of the *Grands Constructeurs* to the Gothic spirit, he is at one with the French Rationalist tradition from Viollet-le-Duc to Auguste Choisy, the tradition that produced most of the buildings that were featured in *Bauen in Frankreich*. Again, his orientalisms, gothicisms, his interest in theosophy and light-mysticism, which all seem a mile away from mainstream Modern Movement ideas, are no distance at all away from the frame of mind in which Johannes Itten created one of the greatest glories of the Modern Movement, the Bauhaus preliminary course. The Bauhaus connection cuts even closer than this – much of the text of the first proclamation, where it deals with eliminating the barriers between brain-worker and artisan, directly echoes the apocalypse of Scheerbart's *Immer Mutig* (the Hippopotamus novel referred to above) where

'Kings walk with beggarmen, artisans with men of learning'
and the three-spired cathedral in Lyonel Feininger's woodcut on the cover is now seen to be topped, not – as has been supposed – by the three stars of Bethlehem, but by three navigation lights for Zeppelins.

One could pursue the matter further, into the ever-ramifying but ever more attenuated influence of Scheerbart as it runs on into the 'twenties – including perhaps the glass towers of Le Corbusier's *Plan Voisin de Paris*, for they are close cousins to Mies's Friedrichstrasse project, and their form with emphatic vertical accents was later written off by Le Corbusier as a mistake peculiar to German architecture. But the mere pursuit is not the point – it is the necessity and attractions of the pursuit that are the point. Why, in a word, do we have to re-write the history of the Modern Movement?

Not because that history is wrong; simply because it is less than lifesize. The official history of the Modern Movement, as laid out in the late 'twenties and codified in the 'thirties, is a view through the marrow-hole of a dry bone – the view is only possible because the living matter of architecture, the myths and symbols, the personalities and pressure-groups, have been left out. The choice of a skeletal history of the movement with all the Futurists, Romantics, Expressionists, Elementarists and pure aesthetes omitted, though it is most fully expressed in Giedion's *Bauen in Frankreich*, is not to be laid to Giedion's charge, for it was the choice of the movement as a whole. Quite suddenly modern architects decided to cut off half their grandparents without a farthing.

In doing so, modern architecture became respectable and gutless; it entered on what Peter Smithson has justifiably called its Academic phase, when it became a style with books of rules, and could be exported to all parts of the Western world. But having set itself up as something more than a style, as a discipline of pure reason, it had to double-talk fast and frequently to explain its obsession with certain materials, particularly glass and that smooth white reinforced concrete that never existed outside architects' dreams and had to be faked in reality with white rendering.

Clearly, these materials were symbolic, they were totemic signs of power in the tribe of architects. But while concrete has never lacked respectable medicine-men, from Auguste Perret to Pier Luigi Nervi, to maintain its *mana*, the image of

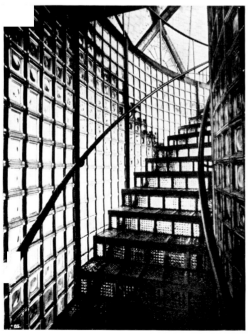

3. Staircase of Taut's glass industry pavilion.

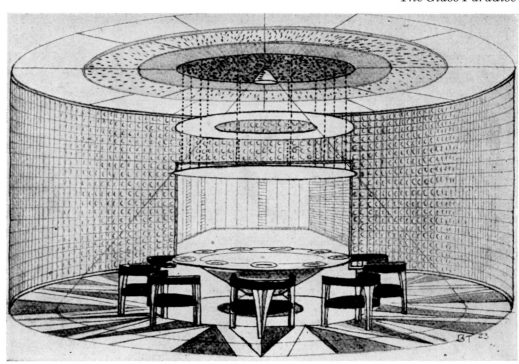

*4. Bruno Taut's project for a glass dining-
room, 1923.*

Gropius as the official witch-doctor of glass has never looked very convincing. On the other hand the fanaticism of a Bruno Taut possessed by the spirit of Paul Scheerbart, as by a voodoo deity, has much more the air.

This is not to say that we now throw away the history of glass in modern architecture as it has been established so far – the position of Muthesius and Gropius among its prophets is not demolished, only diminished. We have to find some space for Scheerbart, as Giedion now clearly recognises. The problem, which is not to be settled by a single essay, is – how much space?

As to his right to that space there can be no further doubt, for if one applies to him the normal test for missing pioneers, that of prophecy uttered in the right ears at the right time, he scores more heavily than many other writers of his day. Not only were his architectural writings known, and in varying degrees influential, among the generation of Gropius and Mies van der Rohe, but at a time when many spoke of steel and glass, he also spoke of water as the natural complement of glass, of the need to temper the white glare of light through glass by the use of coloured tinting, he spoke of America as the country where the destinies of glass architecture would be fulfilled and he spoke of the propriety of the 'Patina of bronze' as a surface. In other words, he stood closer to the Seagram Building than Mies did in 1914. To put him back into the history of modern architecture is to shed upon it precisely what he would have us shed upon it – *Mehr Farbenlicht!*

NOTES

[1] In Park Avenue, New York City. Designed by Gordon Bunshaft of Skidmore, Owings and Merrill and completed in 1952.

[2] Justifying, in the Editors' view, the inclusion of this essay in a volume called 'The Anti-Rationalists.'

POELZIG

by Julius Posener

Hans Poelzig, one of the German masters of the Expressionist 'twenties, can be regarded as an important link between the various preceding anti-rationalist movements and the modern movement which, with its emphasis on rationalism, finally established itself in the 1930's. Poelzig was thus one of those who helped to form the style of the Mendelsohn generation. In this personal memoir by Julius Posener, Poelzig appears, in the early 'twenties, as a master already well-established in the Berlin scene, already exercising a decisive teacher's influence on the generation younger than his own, and even on a generation beyond that, for – as Professor Posener points out – even such mainstream German architects as Hentrich and Eiermann are Poelzig products.

When I presented myself for interview at Brixton for my first teaching job, only one question was asked: the essential one – 'So you want to teach: HOW?'

For a reply, I described the methods of the man who taught me in Berlin, Hans Poelzig. He was indeed a teacher of teachers, and in Berlin, Karlsruhe, London, Leicester, Kuala Lumpur, Melbourne, Shanghai, we have trained young people, whether they know it or not, as pupils at one remove of The Master.

Yet there is no 'School of Poelzig,' as there is a school of Mies and a school of Le Corbusier; for it was quite possible to be Poelzig's pupil – and an enthusiastic pupil – without being in sympathy which his own architecture. I can talk about this with assurance, because it was my own case. I was rather hesitant about joining his class when I had the chance to do so in 1927. I was at that time keen on the English country house and Muthesius; I did not like the new architecture, and I did not even like Poelzig as a man. In fact I had tried another master first, a very north-German, conservative architect who dubbed any student who would produce a scheme with a flat roof 'modern,' meaning not far removed from bolshevist. The experience made me try Poelzig as a possible lesser evil.

I had already seen him once or twice giving 'crits'. Somewhere, against the display wall, a straight blue column of cigar smoke could be seen rising from the middle of a cluster of youngsters of the long-haired type, and a voice could be heard from under the cigar-smoke discussing, discoursing, incisive, loud, very articulate and more than slightly tinged with Berlin Cockney.

When he rose from his stool to move to the next scheme, one would become aware, first, of his head. He wore horn-rimmed spectacles under a forehead which rose like a tower, though its extreme height was somewhat mitigated by the Poelzig cut, a fringe of dark hair cut pony-fashion. From this summit immediately above the

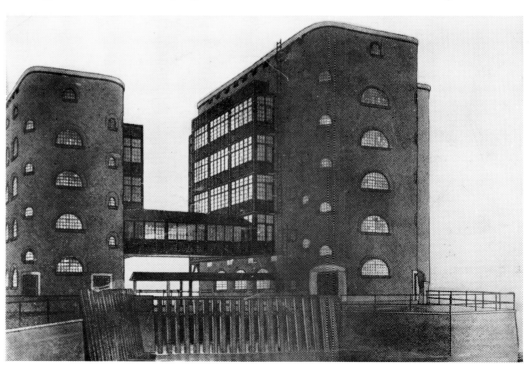

1. The Werdermüehle, Breslau (now Wroclaw), 1907.

forehead the cranium sank steeply down to a second prominence right above his neck. He had a broad nose, a wide mouth, somewhat rubbery. He was heavily built, but not fat. And while one watched him giving 'crits' one became aware that he was two things which usually tend to exclude each other: he was both very vivacious and very calm, his liveliness resting, as it were, on a ground of assurance of himself.

He used to say that he was the son of the driver of a brewer's dray and of the Countess Poelzig. I thought at the time this was a joke, and a fitting one, because there was in him something of the Cockney and of the aristocrat. But he *was* the son of the Countess Poelzig. His father was an Englishman, G. A. Ames, and he never appeared at all in Poelzig's life. His father and mother separated before Poelzig was born, and Ames obtained a Court injunction that his youngest son was not to carry his name. So he was called Hans Liese, after his foster-father, a village schoolmaster in whose house he grew up not far from Berlin. Later he adopted his mother's name, but she also vanished out of his life almost immediately. All this, to some extent, was to the good. It is the sort of story one finds at the beginning of the biography of men of vitality and independence. With those antecedents one either becomes such a man or one succumbs.

Poelzig's way of breaking me in was characteristic. He had, in one of the first 'crits,' accepted my scheme and been rather positive about it. So I went to the clay room to make a massing model – he insisted on this – where he joined me after a day, took the scheme to bits mercilessly and dismissed me with the advice not to kill him yet but to have two beers and a long walk and then start the thing again from scratch. The jolt was administered consciously. It formed part of his method, and it helped.

He used to give us short programmes, ranging in time from one to three weeks. Often they formed part of a project he had in hand at the time: 'If I had not tried my hand at it myself, I could not know how difficult it really is,' he would explain. If a student found a solution he had not thought of, he would adopt it and mention the student's name in the publication. It seemed as though he himself rarely

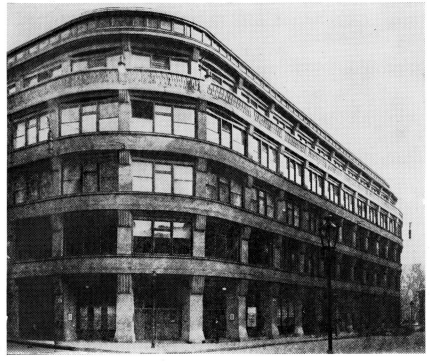

2. Department store, Breslau, 1910.
3. Water tower, Posen, 1912.

had a preconceived solution. In his special Master Class at the Academy – which was distinct from his studio at the College of Technology – he let pupils go on quite a long way with a scheme and then gradually took over and shaped it in his own way.

A student asked him once if a certain programme should be treated in one block or in pavilions. 'How would I know?' he asked. 'If I had the answer pat I would not be a teacher.' His own work never entered into the discussions. When someone would say: 'But you have done such a thing in the Capitol Cinema,' he would reply curtly, that the Capitol was not what they were talking about. Different architectural idioms were spoken in his class, ranging from Schinkel to Gropius. He would not interfere. I once heard him recommend a design of a certain 'dryness, full of character'. His own work was exuberant and fantastic. One acquired an appreciation of what he did. It was inevitable, knowing the man as we came to know him. Even imitation crept in. But the last thing he wished to produce was little Poelzigs. He wanted to help us to proceed in our own direction.

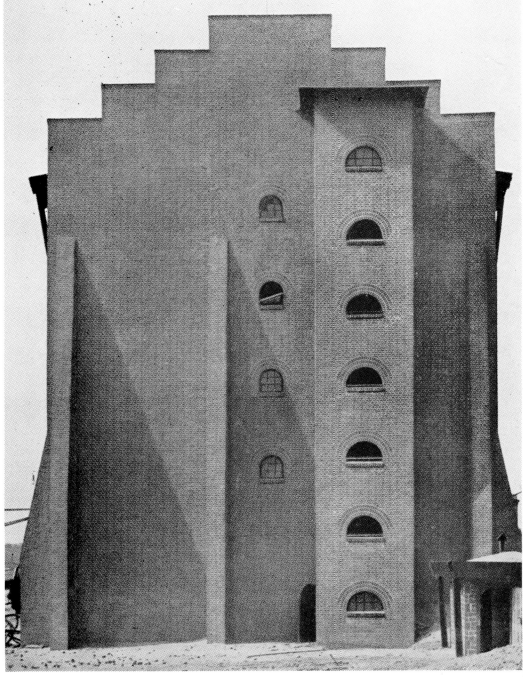

4. Chemical factory, Luban, 1911–12.

When a programme was finished, he took the better part of two days to criticise it. It was a cumbersome process. He would begin at one end of the display wall and ask the student to explain his scheme. The man whose scheme came next had to criticise, after which a general discussion ensued which he would sum up. If the scheme was accepted, the student would proceed with it; if not he went in for the next programme. The 'crit' was conducted in such a way that every aspect of a certain programme was put to the discussion, and at the end of the two days we felt that we had come to grips with this particular type of building. This was his method, and the discussion among students supplemented it. We students who became teachers – and I think it has become obvious by now *why* we did become teachers – have tried, subsequently, to adopt it according to our abilities and temperament, and it is my hope that it may not end there, and that some Chinese in Kuala Lumpur or Croat in Zagreb may carry on the Poelzig tradition of teaching into the next generation.

To many of us, Poelzig's own architecture remained a matter of indifference. The influences which were to shape our work came in almost every case from outside his class. This is one thing. One's approach to design is quite another. This came from Poelzig. Segal and Koenigsberger, Eiermann and Wachsmann, Müller-Rehm and Hentrich: it is difficult, judging by their work, to find a common denominator among them. Yet none of them has ever denied his debt to Poelzig.

Where does Poelzig stand in present-day architecture? He was born in 1869. So he is of Behrens's generation; but his work never gained the influence of Behrens's industrial buildings. In those books which describe the evolution of our architecture one finds the work of Wagner, Loos, Voysey, Behrens, Gropius, Mies, Le Corbusier; mention is made of the influence of Muthesius; but Poelzig, if mentioned at all, is only represented by a few early works such as the Posen water-tower, the

5. Project for the Haus der Freundschaft, Istanbul, 1916.

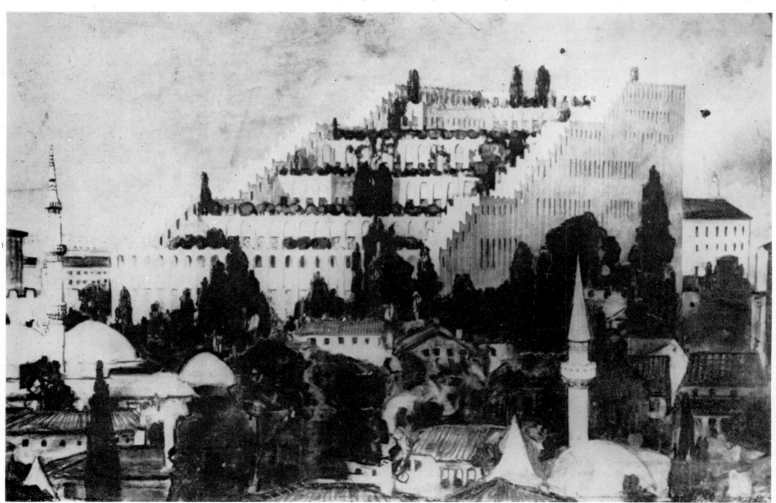

196

chemical works at Luban and the Breslau department store.[1] He is treated as an 'also ran'. Was he a German Lutyens, a man whose artistic capacity is beyond doubt, but whose work remains outside the stream of the movement? This is not entirely the case.

For one thing it is significant that Lutyens never tackled industrial architecture, whereas Poelzig did. For another, Lutyens followed tradition even in his early country houses, while Poelzig's designs hardly ever did. A comparison between Lutyens's 'Orchards' and Poelzig's design for the Werdermüehle, Breslau, of 1907, speaks for itself. At the same time, a comparison between this design and the almost contemporary industrial architecture of Behrens and Gropius shows why Poelzig's work was denied the immediate influence those works exerted. In Behrens's and Gropius's work, elements which have become fundamental in the new architecture were for the first time convincingly treated by architects: the steel framed structure with glass panels, the curtain wall. There is a framed part in the

6. Grosses Schauspielhaus, Berlin, 1919: auditorium.

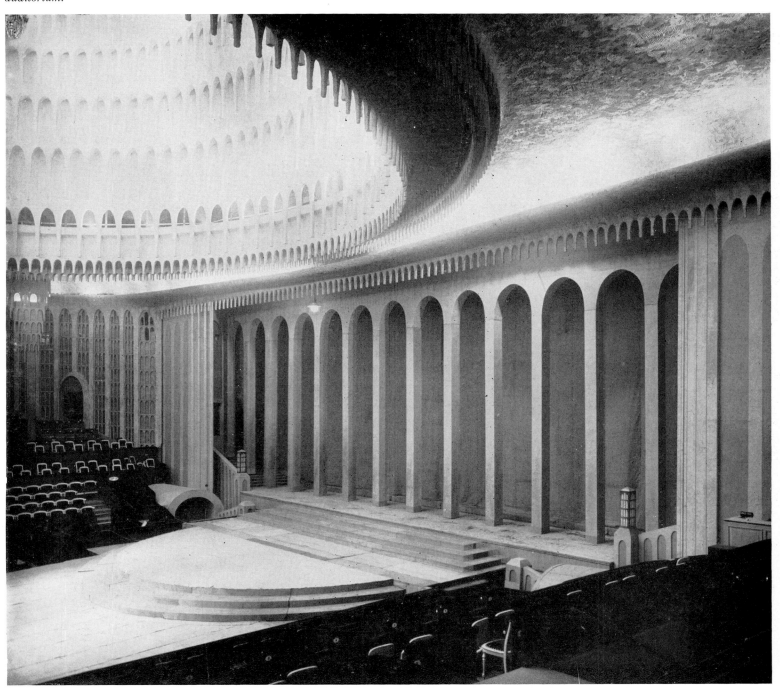

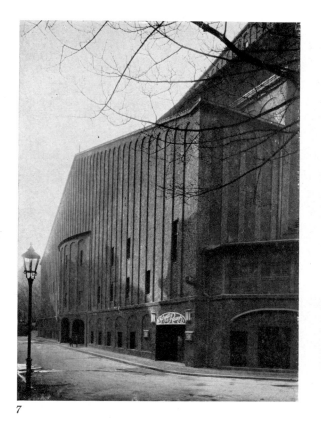

7

8

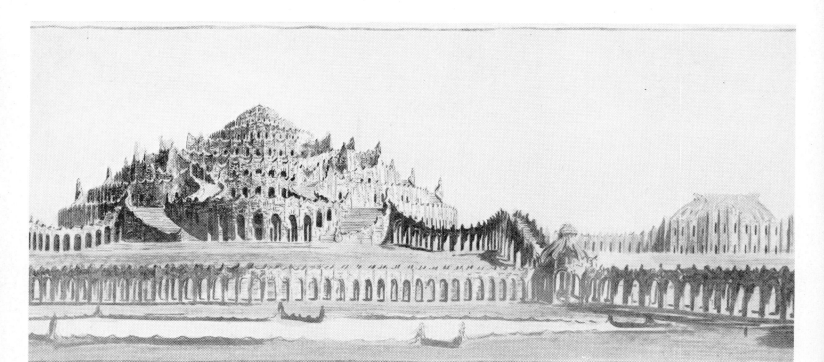

9

7, 8. *Grosses Schauspielhaus, Berlin, 1919: exterior and foyer.*

9. *Project for Festival Theatre, Salzburg, 1920.*

Werdermüehle, but it might as well have been built in timber. Certain timber frames with glass infilling in old English inns look rather similar. And anyhow, this framed structure is only an aside in the Werdermüehle, whose main structure is load-bearing walls of brick.

The same is true of the Luban factory; and even the Posen tower, which is a steel-framed structure, has not the quality of the steel and glass architecture of Behrens and Gropius. The three lower steps look as though they were built of timber. The big steel piers stand inside and appear only in the tall stage above the third roof, and here again the panels between these steel supports are subdivided into small sub-panels including high and narrow windows. The last stage, which projects again, might be called a curtain wall with a continuous ring window; yet here also is applied the small-scale panel which is characteristic of the whole building. Behrens's turbine factory has large windows between visible steel supports. In Gropius's Alfeld and in the Werkbund factory the curtain wall is shown as a continuous glass sheet held up only by glazing bars. In Posen, on the other hand, Poelzig played a game of recessions and projections which conceals and reveals the main structure, and the large, unified surfaces of contemporary architecture are nowhere in evidence.

This is an analysis, not a criticism. Poelzig's building may be more interesting than the turbine factory and it is probably better than Gropius's Werkbund structure which – let us admit it – is not solved architecturally; the entrance part in particular, that unrelated bit of 1914 Schinkel, can hardly be defended. Yet the building points forward beyond its period; Poelzig's tower uses current elements of industrial building of that time, such as those of railway sheds or workshops, and combines them into a monumental structure.

And this is, I think, characteristic of the man. He may have been aware of new possibilities, but they did not, fundamentally, excite him. He was even on his guard against them. In 1919, he became, for a short while, chairman of the *Deutscher Werkbund*; but it was for a short while only. Again, in the later 'twenties, he joined the *Ring*, a group of progressive architects, but there again he soon found himself in opposition. He might have said, with Napoleon, that to a master doctrines serve only to carry on in one's own direction.

Looking again at the Posen tower and the Luban factory one cannot deny that he did follow a direction and that his use of existing everyday elements of industrial buildings was highly original. Nor can it be called traditional, unless one thinks of the functional tradition of, say, the London docks. However, what separates them from even that tradition is their massing and the contrast between parts within the group which is very much his own way of shaping a project.

With this approach an architect was not well placed in a period of fast transition. When he built his industrial buildings he was in the lead. He did not invent any strikingly new shapes; but nobody before him had considered those humble units of the industrial shack and lifted them on to the plane of architecture. Neither his structural conceptions nor his elevational treatment appear to have contributed anything essential to the architecture we have accepted today. It is almost painful to compare his buildings for the Breslau Memorial Exhibition of 1913 with Max Berg's Centennial Hall built on the same occasion. Poelzig's designs, using always the means at hand, developed towards those great spatial phantasies, the House of Friendship in Istanbul and the Salzburg Festival Theatre. Neither is more than a project, but they are the culmination of his work in the war and the years immediately following it. When, in the 'twenties, he had again to design industrial buildings, he fell back upon a schematic verticalism, but at this time, not only were his own earlier factories in existence but Mendelsohn had built Luckenwalde.

However, Mendelsohn belonged to the next generation, that of Gropius, Mies and Le Corbusier, the generation which created the new architecture. None of Poelzig's

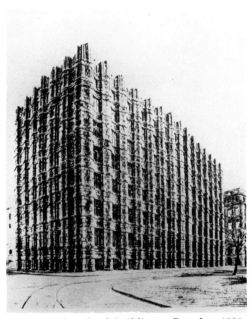

10. Project for a bank building at Dresden, 1921.

generation has been able to progress beyond the point they had reached about 1910, and Behrens is no exception. This holds good at least for the great architects in Germany. The summit of Perret's work lies in the early 'twenties. But after Le Raincy, he too was eclipsed by the next generation and, even more than the Germans, fell back upon set formulae.

More than the Germans: neither Poelzig nor Behrens ended by presenting one frozen, immutable type of design, as Perret did. Behrens submitted to the impact of 'periods.' Poelzig, more consistent, proceeded to realise his own architecture and in so doing proved an even greater liberating force.[2] It is difficult for us, after the event, to enter into the problems of that deeply agitated epoch. Looking back from the middle of the century, with the revolution in architecture, in art in fact, closed and digested, we see a straight road, leading from Wagner to Gropius, Mies and beyond. In the early 'twenties, these same architects produced slices of utopia: the *Pavilion de l'Esprit Nouveau* and the early villas of Le Corbusier, the Einstein Tower and Luckenwalde, Mies's brick villas and models of glass towers. They were essays, experiments, but as they stood they were not much use to their owners, who invariably maltreated them in order to adapt them somehow to their needs. Thus it happened that the villa in Garches was filled with Victorian furniture and the villa in Poissy left to rot from the day it was built – and these two are utopian buildings of the *late* 'twenties even.

Poelzig's contribution may be summed up in the designs for Istanbul and Salzburg by which he is still best known. In both, an important urban-or-landscape situation is crowned by architecture. The huge chunk of steps, hanging gardens, which, incidentally, contains a perfectly workmanlike plan – Poelzig used to stress the fact – would have introduced a new element into the skyline of Istanbul. It was designed in 1916, and is certainly the best and one of the earliest of those stepped buildings with which architects experimented in the 'twenties. The building is in one block, with different levels carved out of it. The lateral walls in particular are almost Mendelsohnian in the way in which different levels are contained in one surface.

The Baroque ziggurat of Salzburg appears more utopian, and it may be doubted if the interior of the first version, in particular, could have been carried out to convey the impression of the drawing. This, of course, is 'frozen music' – Poelzig liked to quote the tag. He used to say that he would examine his pupils in music, not in drawing, before admitting them to his class. But a conception of this kind requires ornamental detail as exquisite as that of the rococo, and for this reason, not because of any technical difficulty, the scheme was bound to remain on paper.

11. Sketch for stadium and radio tower, Berlin, 1927.

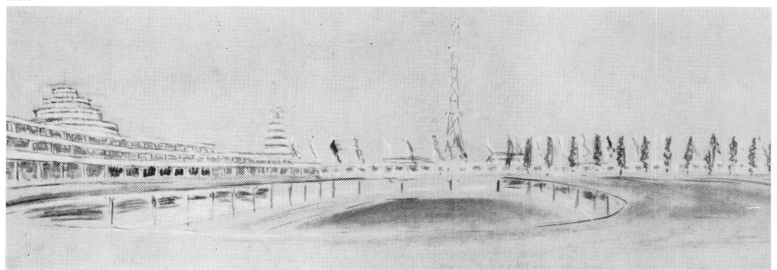

This is not necessarily the case with the third version of the interior whose galleries, successively projecting further into the theatre space, anticipate later solutions by Mendelsohn and Gropius. Poelzig's spatial phantasies never appear false, never become *Kitsch*; but they invariably threaten to become just this when carried out in this century – i.e., two hundred years after Neumann; witness the luminous columns in the foyer of the Grosses Schauspielhaus of 1919. One need not include in this judgment the stalactite roof which crowns the auditorium. The dome had been specified by the client before Poelzig took over the alteration of the old Circus Schumann into a 'Theatre for Five Thousand,' and the stalactites were, in the first place, an acoustic device. Poelzig went so far as to try to take out a patent for it. I am not denying, of course, that the resulting shape was very welcome to him; that it makes the cupola truly Poelzig. It was a modern auditorium with

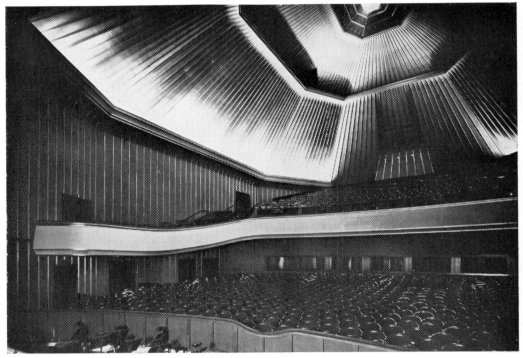

12

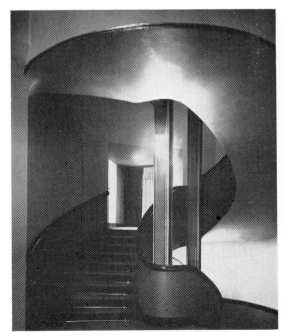

12, 13, 14. Capitol Cinema, Berlin, 1925:
auditorium; staircase 13　　　　　　　　　　　14

amphitheatrical seating sloping down towards the forestage under the cupola, where the arena of the circus had been. It was not merely an imitation Alhambra.

Looking again at the illustrations of the buildings I have here discussed, I would, faithful pupil though I am, not consider it altogether desirable if architects should start playing around with Salzburg Festival Baroque; nor, for that matter, would Poelzig. And yet we have experienced, have we not, a return to sculptural architecture; witness the later work of Le Corbusier. And although nobody would dream of designing a bank like Poelzig's project for Dresden of 1921, or an office building like his fire station of 1917, for the same city, conceptions like these touch us more closely now than they did in the years of unchallenged functionalism. So, also, does the fenestration of the Luban factory and even that of the Werdermüehle. We followed the way of frame and bay structure until we reached a dead end, and for fifteen years now we have been trying to regain our freedom, to mould, diversify, enliven, rhythmicise these schematic buildings. Poelzig never lost his freedom. It is the very nature of the man. This is why he never followed a doctrine, be it functionalism, classicism or even expressionism, as Behrens did. This, also, is why he was a sovereign teacher, and why he has never formed a 'school of Poelzig', though nobody – with thirty-five years of teaching – had more ample opportunity of doing so. From his freedom modern architecture can still learn something.

NOTES

[1] Posen and Luban are illustrated in Dr. Banham's *Theory and Design*; Breslau and Luban in Professor Pevsner's *Pioneers*.

[2] This aspect of the 'twenties can also be examined in the work of Finsterlin.

NINE SWALLOWS-NO SUMMER

by Nikolaus Pevsner

The early history of the modern movement is always written as though all that mattered after 1900 had been done on the Continent and in America. In the following article (a postscript on the beginnings of rationalism to round off the anti-rationalist episodes on the preceding pages) a selection of British examples is discussed which give Britain a role in the first stage of twentieth-century architecture. Some of the buildings shown will for most readers amount to a real discovery, although no concerted action resulted from them, and consequently nothing like an accepted style.

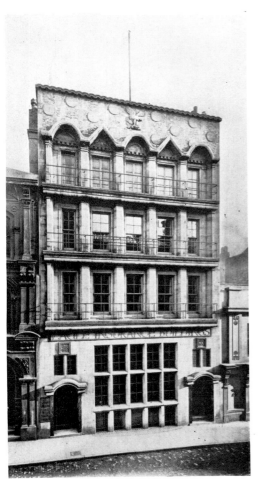

1. Eagle Insurance building, Birmingham, by W. R. Lethaby, 1900.

Very little is generally known of England's share in progressive early twentieth-century building. Not that it amounted to much, if we think in terms of international architectural development. There was in England between 1900 and the First World War neither an architect at the same time as revolutionary and as consistent as Garnier or Loos, nor a movement as widespread amongst the architects of the generation just coming to the fore as that leading to the foundation of the Werkbund in Germany. But there were a few individual architects working independently of each other and carrying out designs just as advanced, or nearly as advanced, as those Continental and American examples which appear in the textbooks to illustrate early twentieth-century architecture at its most adventurous.

A tradition of contemporary form was still entirely absent ten years after the end of the War. Thus when Peter Behrens built New Ways for Mr. Bassett Lowke at Northampton in 1925, in what we now call the modern idiom, the bewildered citizens of Northampton did not know what to link it up with. Its flat roof and bare white walls necessarily appeared much more shocking over here than in a country which had seen Behrens's, Gropius's, Taut's and Poelzig's work of 1910–20. For what could even the most appreciative of the British public have been familiar with that might have led up to the style of New Ways? What had been happening in British architecture between 1900 and 1925? Three things mainly.

1. An official style had been developed that might aptly be called Edwardian Imperial, the style of Buckingham Palace, the Admiralty Arch, the London County Hall, New Delhi and New Pretoria, the Piccadilly Hotel, Selfridge's, Aldwych and Kingsway, a style mixed of English Palladian and that specifically American blend of Neo-Classic with Ecole des Beaux Arts which prevailed at the Chicago Exhibition of 1893 and culminated in the work of McKim, Mead and White.

2. There was the happy and comfortable Tudor traditionalism either of the more imitative Guy Dawber or of the more original Voysey-Baillie Scott type. This had by 1900 achieved a wide success and was being copied more or less well in private houses all over the country.

3. Ernest Newton had popularised an equally happy and comfortable though more formal Neo-Georgian, based in fact not on the style of the Georges but on that of William and Mary and Queen Anne as re-introduced earlier on by Nesfield, Webb and Shaw. Up to 1900 it was decidedly less popular than the Tudor traditionalism. But when Voysey's style began to filter down into the suburban builders' formulae, the importance of Neo-Georgian, especially for the houses of the well-to-do, grew rapidly until, by about 1920, it had superseded the Tudor taste almost entirely.

Between these three trends of revised traditionalism nothing seemed to be left of that adventurous spirit which had made Norman Shaw play with elements from whatever style took his fancy, had spurred A. H. Mackmurdo, Charles Voysey, Baillie Scott, Charles Rennie Mackintosh and Ashbee in the 'eighties and 'nineties to achieve a new freshness and cheer by means of untried, non-period forms, though as a rule within a general period atmosphere, and had lent Townsend the courage to place into the set pattern of London such demonstratively novel façades as those of the Whitechapel Gallery and the Horniman Museum.

In the Horniman Museum of 1900 there is indeed nothing left of the nineteenth

203

century's historicism – far less than in any of Voysey's and Mackintosh's houses; but of the spirit of the twentieth I cannot discover any trace either, nothing of its Back-to-Fundamentals attitude, nothing of the new functional approach, nothing of the new sympathy with industrially produced materials, nothing of the new distrust of ornament.

It was to find these qualities that I once again perused the architectural papers of 1900 to 1914. Here are my scanty results. I expected to find more in commercial and industrial than in domestic architecture. This proved right. Three buildings, all designed in 1900, must be singled out above all: W. R. Lethaby's Eagle Insurance in Birmingham, sensitive and restrained, H. Bulkeley Creswell's Queensferry factory by the estuary of the river Dee, twelve miles from Chester, bold, logical and dignified, and Bateman and Bateman's printing works for George Jones and Co. in Cornwall Street, Birmingham, equally novel in its motifs but less masterly in the treatment of these motifs.

Lethaby, the pupil of Norman Shaw and ardent admirer of Philip Webb, combines the large ground-floor windows of Shaw's Tudor tradition with Webb's chamfered piers and alternating rounded and pointed top arcading (cf. Webb's surprisingly original house no. 19 Lincoln's Inn Fields of 1868-9). He adds, however, of his own, the extremely simple fenestration of the first and second floors, the odd but convincing plain disks that adorn the top parapet and the balcony railing of the first floor, as sparing in detail as anything done to-day and at the same time as graceful as anything Lethaby designed. The way in which the ground-floor windows grow straight out of the ground is also bolder than the Tudor traditionalists would have liked.

Bateman went further in general simplification, but lacks Lethaby's delicacy of line and proportion. The quick rhythm of the windows, subdivided into innumerable small panes by stone mullions and transomes, has nothing traditional. The alpine-looking roof, with the three rows of dormer windows, is curious but hardly convincing. Ornament is discarded to an extent that would have satisfied even Adolf Loos.

Lethaby and Bateman and Bateman were, of course, not the only architects of their generation to feel the need for innovation, and yet distrust the easy novelty of Art Nouveau. One of the most interesting representatives of this semi-traditional, semi-functional, outlook was Leonard Stokes. His Telephone Exchange at Southampton, for instance[1] would certainly have deserved illustration, although period conventions are in Stokes's work just a little more binding than in Lethaby's Eagle Insurance, and decoration is a little more florid. A comparable attitude is traceable here and there in buildings by Halsey Ricardo, Gerald Horsley, Dunn and Watson, Niven and Wigglesworth, and – amongst the younger generation – the early designs of Charles Holden and C. H. Reilly.

However, as far as functional logic, straight-forward presentation and fearless novelty of form go, nothing in British architecture about 1900 emulates the Queensferry Factory by H. Bulkeley Creswell (of Honeywood and Grigblay fame). He here achieved something just as independent as anything Behrens did before the last war – and achieved it in 1901, when Behrens was still entirely under the spell of Art Nouveau. The dignity of labour and the might of the machine are expressed as strongly here, though perhaps not quite as concentratedly, as in Behrens's famous turbine factory of 1909. The block shape is imposing, the sloping buttresses show strength, the sturdy tower self-reliance. Buttresses as well as tower are functionally justified. The windows with their cast-iron lintels are also functionally in the right position, besides being aesthetically very well placed. The building is constructed with iron stanchions and girders. The façades are of brick.

The new technique of steel skeleton construction spread in America before it was adopted in Britain. It calls, of course, just as the somewhat later reinforced concrete construction does, for simplicity of façade design. The Americans were the

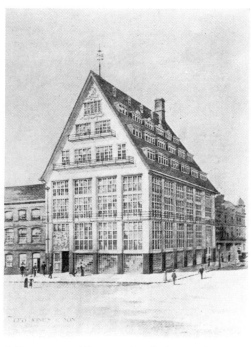

2. Bateman and Bateman's printing works, Cornwall Street, Birmingham, by George Jones, 1900.

first, too, to reduce façades to mere two-dimensional abstracts of the structural system of the interiors behind. In Britain the earliest example of this gridiron system of façade design[2] known to me is the 800-foot long Singer factory (by an American firm) at Kilbowie near Glasgow. This was illustrated in *Concrete and Constructional Engineering*, Vol. 1, 1906/7. Other factories followed soon: e.g. – to mention the most interesting examples in reinforced concrete – the extension of Peek Frean's in Keetons Road (1912)[3], Siemens's rubber workshops at Woolwich (also 1912), the new offices of G. and H. Weir's of Cathcart (1914-15)[4], and the motor works of Assol Johnston's at Dumfries (1915).

While this straightforward expression of steel and concrete construction was accepted in England without much opposition, where academic pretensions were not roused, it took longer to acclimatise it in City and West End architecture. All the earliest steel-framed buildings in London – the Ritz Hotel of 1906 by Mewès and Davis, the Morning Post by the same architects, Mackenzie's Waldorf Hotel, the river extension of the Savoy Hotel by Colcutt and Hamp (all of 1907-9), and the many more put up immediately after the passing of the London County Council General Powers Act of 1909 – conceal their structural boldness behind heavy masonry and sumptuous decoration. The same is true of the earliest ferro-concrete structures such as Arthur Blomfield's Friars' House in Broad Street,[5] the King Edward Building of the G.P.O. by Sir Henry Tanner and L. G. Mouchel, the pioneer of reinforced concrete in England,[6] the W.1 Post Office in Wimpole Street by the same architect and engineer,[7] the Royal Automobile Club by Mewès and Davis and the Y.M.C.A. building in Tottenham Court Road.[8]

Selfridge's store by Daniel Burnham and Frank Atkinson (1909) is probably the first example of a West End façade in which the vertical supports are separated by nothing but glass and metal, although here again it is not easy to recognise the principle behind the Barnum bombast of the columnation.

3. Factory at Queensferry, by H. Bulkeley Creswell, 1901: the most advanced British building of its date.

4, 5. Two early examples of concrete factory-building, dating from after about 1905 when the gridiron principle was imported from America: the Singer factory at Kilbowie and the Assol Johnston works at Dumfries. Neither displays the dignity of Creswell's Queensferry building of 1901.

6. The Kodak building, Kingsway, London, by Sir John Burnet, 1911.

3

4

5

6

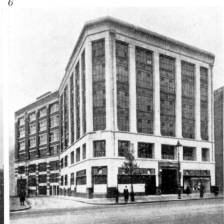

A few years later Sir John Burnet in his Kodak Building (steel frame) of 1911, and Sir R. J. Allison in his Stamford Street warehouse for H.M. Stationery Office, of 1913-14 (reinforced concrete) laid it bare or nearly bare. It is eminently characteristic of the transitional attitude of that phase that Burnet went further in the simplification of the system in the Keeley Street than in the Kingsway façade. Immediately after the Kodak Building he repeated the same system in his Wallace Scott Tailoring Institute at Cathcart, completed in 1914. The earlier verticalism is, however, now replaced by an emphasis on the horizontals just as clearly heralding the industrial style of 1930–40 as does the somewhat objectionable semi-classical semi-Egyptian decoration. There is not a long way from here to the style of Western Avenue or Carrera's.

No comparable effect of concrete on domestic architecture is to be noticed in England before 1930. Houses were built of concrete blocks as early as the 'sixties,[9] but their appearance is in no way different from that of brick cottages. The situation was not materially altered either by the foundation of the Concrete Institute in 1908 or by the general news interest in concrete at that time. The competition for cheap concrete cottages set by *Concrete and Constructional Engineering* in 1914 resulted in a large number of designs but hardly any of specific concrete character. The same applies to an estate of 457 cottages at Crayford built by the Rural Housing Organisation Society for Vickers's and published in 1915.

All the more surprising is it to see that the only English private house of the early twentieth century which looks as if it might have been designed about 1935 with a view to expressing the structural characteristics of concrete is a normal brick building, a house at Stafford designed in 1908 by Edgar Wood (1860–1935), the Manchester architect. This appears almost as bewildering an anachronism as H. B. Creswell's factory. Where can Wood have got the idea of these flat roofs from? Where these unmitigated blocks or the concave curve of the recessed centre? If it were not for the slightly Tudor-looking windows, who would not mis-date this house?

The situation is still more complicated by the fact that J. Henry Sellers, who in 1909 went into partnership with Wood, built a small block of offices in 1908 for Dronsfield Bros. of Oldham of strikingly similar character and just as daring a spirit. From the partnership there issued such novel and adventurous buildings as

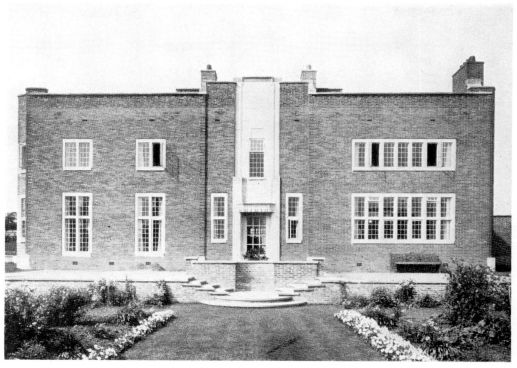

7. House at Stafford by Edgar Wood, 1908. Its flat roof and other stylistic characteristics suggest a building of around 1930.

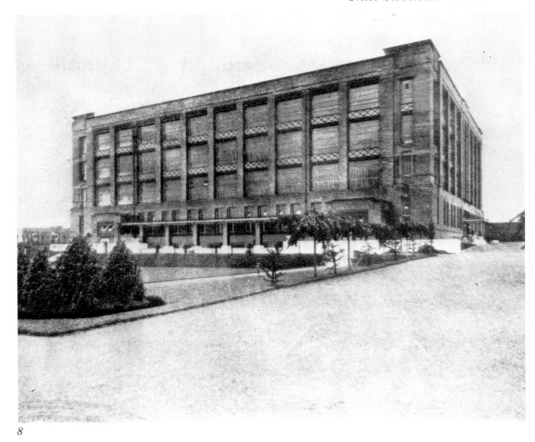

8

8. *Reinforced concrete warehouse for the Stationery Office, Stamford Street, London, by Sir R. J. Allison, 1913–14.*

9. *Tailoring Institute, Cathcart, by Sir John Burnet, 1914.*

10. *Block of offices at Oldham by J. Henry Sellers (who worked with Edgar Wood), 1908. Again its date makes it one of the early twentieth-century pioneers.*

11. *Roger Fry's house, 'Durbins', near Guildford, 1911–12.*

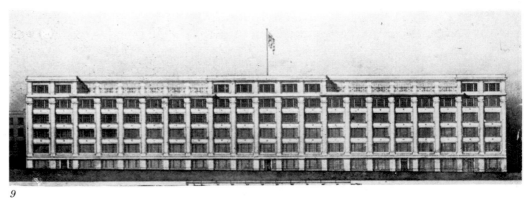

9

10

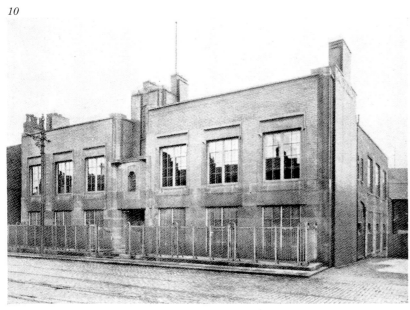

11

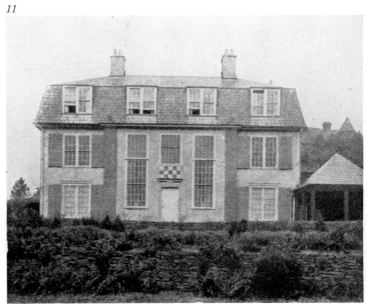

the Elm Street and Durnford Street Schools at Middleton, Manchester, with motifs that stand just midway between Townsend's Art Nouveau and the Western Avenue style. Amongst Wood's other works known to me from magazines and also from photographs kindly given me by Sellers, the Independent Labour Club in Milton Street, Manchester,[10] and the weird Church of Christ Scientist in Victoria Park, Manchester (1904), should be mentioned.[11]

Roger Fry's 'Durbins,' near Guildford, stands, one might perhaps say, in a similar position to the early twentieth-century Neo-Georgian trend as Wood's and Mr. Sellers's houses do to the Tudor tendency. Both are essentially free of period imitation, yet in certain features – the symmetry of the façade and the shape of the windows – 'Durbins' is reminiscent of the past. There is no doubt at the same time that Edgar Wood and Mr. Sellers are the stronger architectural personalities.

However, it is precisely houses such as that at Stafford, baffling as it must appear to the historian, which make one realise how far Britain was, in about 1910, from an accepted new style. Interesting architects and successful individual achievements were by no means lacking, but a logically progressing Modern Movement – this statement remains valid – was absent until after 1925.

NOTES

[1] Illustrated in THE ARCHITECTURAL REVIEW, Vol. 8, 1900, p. 41.

[2] Which should by no means be confused with the system underlying such wrought-iron and glass façades in Art Nouveau forms as that of the Brussels Palais du Peuple by Horta (1896–99).

[3] Ill., *Concrete and Constructional Engineering*, Vol. 7, p. 883.

[4] Ill., *Concrete and Constructional Engineering*, Vol. 10, p. 438.

[5] Ill., *Concrete and Structural Engineering*, Vol. 3, 1908–9, p. 113.

[6] Ill., ib., p. 436, seqq. and Vol. 4, p. 159, seqq.

[7] Ill., ib., Vol. 3, p. 203 and Vol. 4, p. 81.

[8] Recently demolished. Prior to these there existed a few large concrete railway buildings, goods sheds, stores, etc., at Manchester, Bristol, London and Newcastle. These are illustrated in *Concrete and Structural Engineering*, Vol. 1, 1906–7, pp. 13, 109, 303. Amongst slightly later noteworthy examples of concrete in England, I may mention the domes of Westminster Cathedral (by Bentley) and the Hampstead Garden Suburb Free Church (by Sir Edwin Lutyens).

[9] In Vol. 25 of *The Builder* (1867) concrete cottages at Selling in Kent are illustrated. The firm of W. H. Lascelles published designs for concrete cottages by Norman Shaw in 1878, by Norman Shaw and Ernest Newton in 1881 (cf. *The Builder*, 1881). Some of them were actually erected at Croydon (cf. *Concrete and Structural Engineering*, Vol. 3, 1908–9, p. 294, seqq.). The Jury Building at the Paris Exhibition of 1878 was designed by Norman Shaw and built of Lascelles concrete blocks (cf. *The Builder*, 1878).

[10] Ill. ARCHITECTURAL REVIEW, 1910, pt. 1, p. 103.

[11] For Wood we have J. H. G. Archer in *Transactions of the Lancashire and Cheshire Antiquarian Society*, LXXIII-LXXIV, 1963–4, 153–187.

Index
Bold figures indicate illustration page numbers